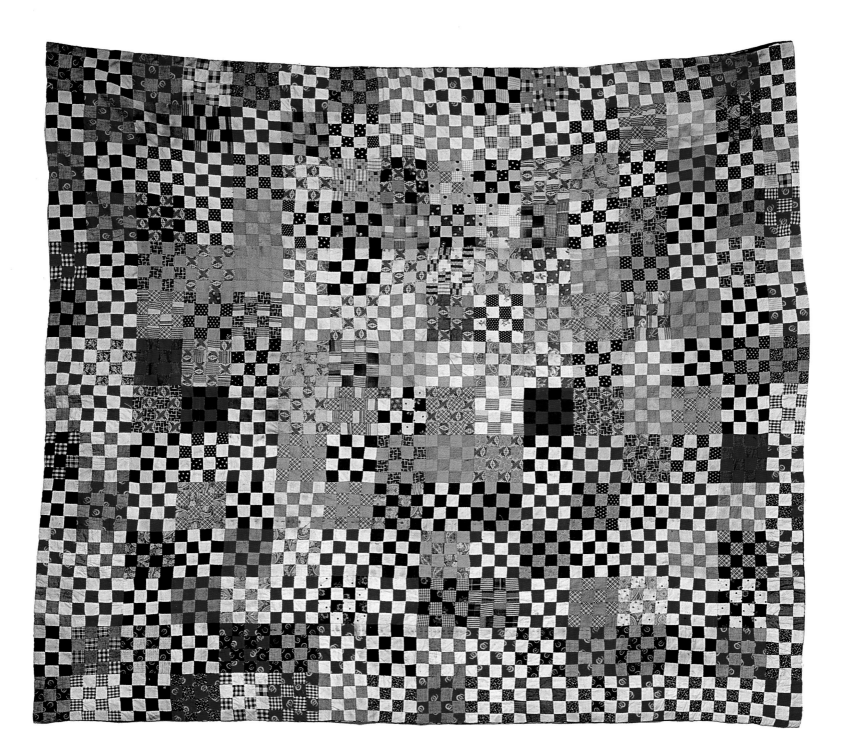

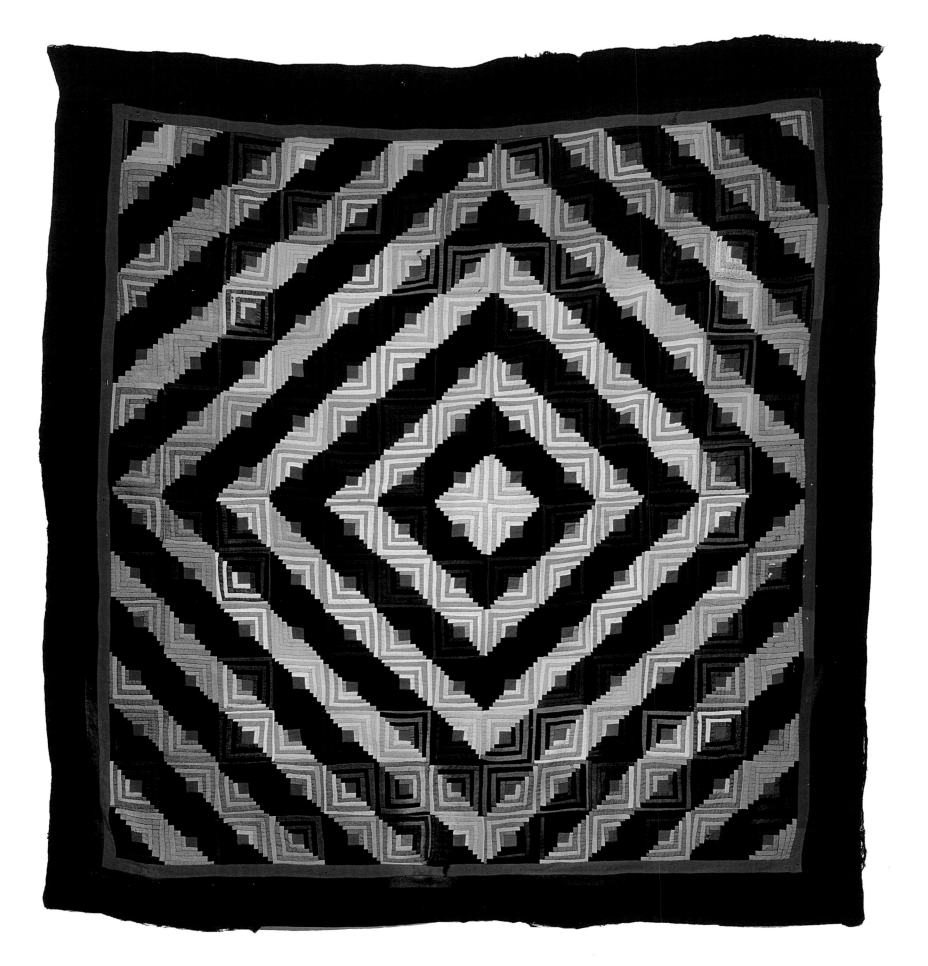

The QUILT

A History and Celebration of an American Art Form

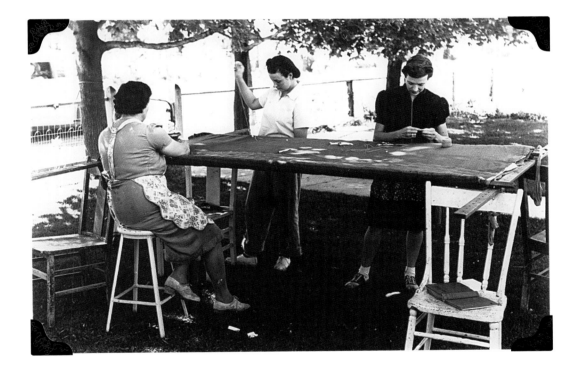

BY Elise Schebler Roberts

⤾⤿

Voyageur Press

First published in 2007 by MBI Publishing Company and Voyageur Press, an imprint of MBI Publishing Company, 400 1st Avenue North, Suite 300, Minneapolis, MN 55401 USA

Voyageur Press titles are also available at discounts in bulk quantity for industrial or sales-promotional use. For details write to Special Sales Manager at MBI Publishing Company, 400 1st Avenue North, Suite 300, Minneapolis, MN 55401 USA.

To find out more about our books, join us online at www.VoyageurPress.com.

Editor: Kari A. Cornell
Designer: Jennifer Bergstrom

Printed in China

Library of Congress Cataloging-in-Publication Data

Roberts, Elise Schebler.
 The quilt : a history and celebration of an American art form / by Elise Schebler Roberts.
 p. cm.
 Includes index.
 ISBN-13: 978-0-7603-2688-6 (hardbound w/ jacket)
 1. Quilts—United States—History. I. Title.
NK9112.R595 2007
746.9'7—dc22
 2007011533

On the front cover:
Photograph courtesy of the International Quilt Study Center,
University of Nebraska-Lincoln, 2000.004.0001

On the frontispiece and contents page:
Images courtesy of the Washington County MN Historical Society,
Photographs by Tomy O'Brien

On the title page, left:
Photograph courtesy of the Renville County MN Historical Society

On the title page, right:
Photograph courtesy of the Library of Congress

On the back cover:
For the Crazy Quilt Throw: Photograph used courtesy of the the Illinois State Museum

For the Taubman Quilt: Photograph used courtesy of the Permanent Collection of
The Sherwin Miller Museum of Jewish Art, Oklahoma City, Photo by David Halpern

Photograph courtesy of the Library of Congress

Acknowledgements

I would like to thank several people for providing information, photographs, and stories. Without their help, this book would not have been possible. I extend heartfelt thanks to the following museums and archives: Alexis Gould, Birmingham Museum of Art; Angie Goebel-Bains, Illinois State Museum; Anita Loscalzo, New England Quilt Museum; Candace Perry, Schwenkfelder Library and Heritage Center; Callie Stewart, Bennington Museum; Clemency Wright, Victoria and Albert Museum; Deanna Bonner-Gant, Maine State Museum; Donna Baron, Alaska History Museum; Eric Blevins, North Carolina Museum of History; Erin Schleigh, Museum of Fine Arts, Boston; Jenny Yearous, North Dakota Historical Society; Jill Holt, Oklahoma History Museum; Jill Koverman, McKissick Museum; Jim Geyer, Pioneer and Historical Society of Muskingum County; Joan Knight, Virginia Quilt Museum; Jodi Evans, State Historical Society of Iowa; Joey Brackner, Alabama Arts Council; Judy Schwender, Museum of the American Quilter's Society; Karen York, Sherwin-Miller Museum of Jewish Art; Kay Walters and Anne Books, Wisconsin Quilt Museum and Research Project; Kevin Johnson, Kentucky Historical Museum; Kieran Orr, Florida History Museum; Lana Eckman, New Mexico Farm and Ranch Heritage Museum; Martha Dailey, Bidwell House Museum; Megan Aikman, Rocky Mountain Quilt Museum; Michelle Hansford, Powers Museum; Michelle Simpson, Historic Arkansas Museum; Nancy Sherbert, Kansas Historical Museum; Nao Nomura and Marin Hanson, International Quilt Study Center; Pearl Yee Wong, Michigan State University Museum; Rich Malley, Connecticut Historical Society; Sandra Duncan, San Jose Museum of Quilts and Textiles; Susan Denney, Panhandle-Plains Museum; Suzanne Flynt, Pocumtuck Valley Memorial Association; and Wendell Zercher, Heritage Center of Lancaster County. Thanks to the following organizations: Barb Thoni, Dane Area Agency on Aging; Beth Milham, Rhode Island Aids Project; Betty Nielsen, Freedom Quilts; Jennifer Belt, Art Resource; Carole Roper, National Ovarian Cancer Alliance; Catherine Roberts and Tana Angerman, Quilts of Valor; Diana Cross, Bureau of Reclamation; Don Beld and Sandi Carstensen, Home of the Brave Project; Gail Bakkom and Patricia Cox, Minnesota Quilt Research Project; Janece Shaffer, Names Project Foundation; Judith Kronmeyer, New Jersey Quilt Guild; Kathleen Kresner, Warm Embrace; Kathy Cueva, Prayers and Squares; Liz Teerlink, Utah State Quilt Guild; Lois Dawson, Tuesday Morning Group; Lyn McCollum, Marcia Way-Brady and Linda Mercer, Boise Peace Quilt Project; Nancy Mambi, Minnesota Textile Center; Patti Brown, Quilts for the Coast; Susan Roach, Louisiana Quilt Research Project; Susan Watson, American Red Cross; and Virginia Spiegel, Fibreart for a Cause. And finally, I'm grateful to the following individuals: Alex Anderson, Alice Norman, Ami Simms, Betsy Marvin, Barbara Chilton, Bonnie Coston, Bryan Dyzuiken, Caryl Gaubatz, Cassandra Williams, Cissy Serrao, Eloise DeSpain, Heather Fox, Helen Kelley, Jane Shaw, J. Michelle Watts, Jean Ray Laury, Jimmie Ann McLean, Joan Hobgood, Jonathan Shannon, Katie Burton, Kyra Hicks, Linda Dreyer, Marla Barry, Nadene Zowada, Patricia Linder, Rosalynn Webster Perry, Rose Werner, Sandra Dallas, Scott Murkin, Sharon Rowley, Sherri Wood, Shirley Barrett, Stella Rubin, Susan Deal, Susan Else, Susan Shapira, Terry Clothier Thompson, Terry Grimlie, and Vivian Eby.

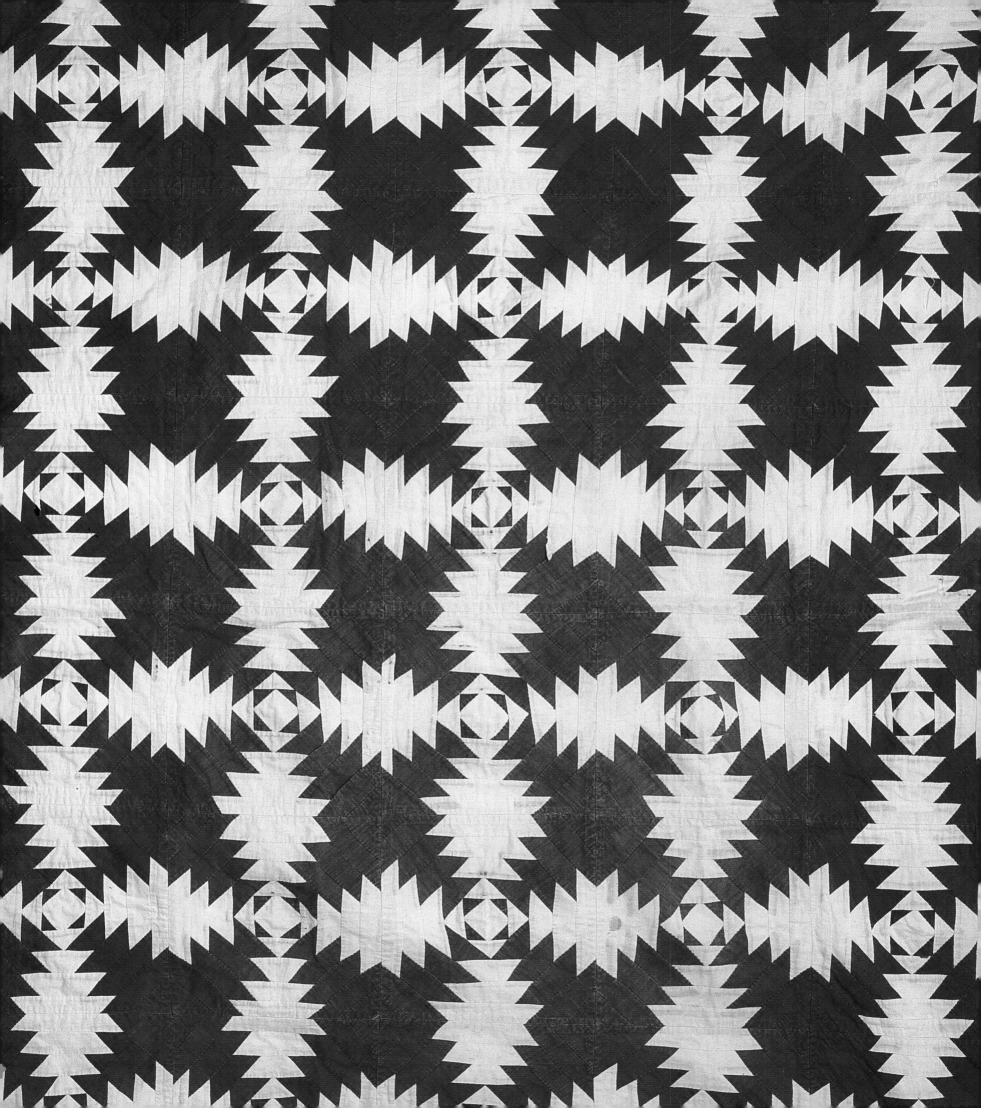

Contents

Ever since I learned to read, I have wanted to create stories and share them with readers as my favorite authors did for me. I have also always admired quilts—but I never imagined that one day, my twin passions, storytelling and quilting, would come together as perfectly as heirloom patchwork.

In 1994, as my wedding day approached, I longed for a beautiful heirloom wedding quilt to decorate the home where Marty and I would begin our lives together. Unfortunately, none of my friends or relatives quilted, and we couldn't afford to purchase an heirloom quilt on our tight student budget. I soon realized that if I wanted a beautiful heirloom wedding quilt, I would have to make it myself.

The town where we lived didn't have a quilt shop, so I purchased an instruction book and fabric and taught myself to quilt. My first project was a simple nine-block sampler, not the elaborate king-size bed quilt I had envisioned, but I was proud of my handiwork and eager to attempt a more challenging project. I bought more pattern books, browsed through quilting magazines, and sought advice from more experienced quilters on the Internet, learning through trial and error.

A few years later, with several quilts to my credit, I embarked upon another lifelong goal: to write a novel. I knew I wanted to write about friendship, especially women's friendship and how women use friendship to sustain themselves and nurture one another. I also wanted to write about women's work and how "women's work" is valued, whether it is paid work outside the home, volunteering within the community, or raising a family.

Young writers are often advised to "write what you know," and since I knew quilters—their quirks, their inside jokes, their disputes and their generosity, their quarrels and their kindnesses—one could say that in my case, the subject chose the author. Quilters, who invest so much of themselves into their creations, ideally discover the intrinsic value of their work. Perhaps even more important, quilting is a wonderful artistic outlet that draws the quilter into a wider community of talented, supportive women and men who teach and encourage one another. Novices find themselves warmly embraced by more experienced quilters who are eager to pass along their traditions. Quilters form enduring bonds of friendship that time, distance, and hardship cannot overcome.

Quilters and the quilts they create inspired me to write *The Quilter's Apprentice*, the first of what grew into an enduring, beloved series. But I am only one of countless many to find inspiration, comfort, warmth, and sustenance in the

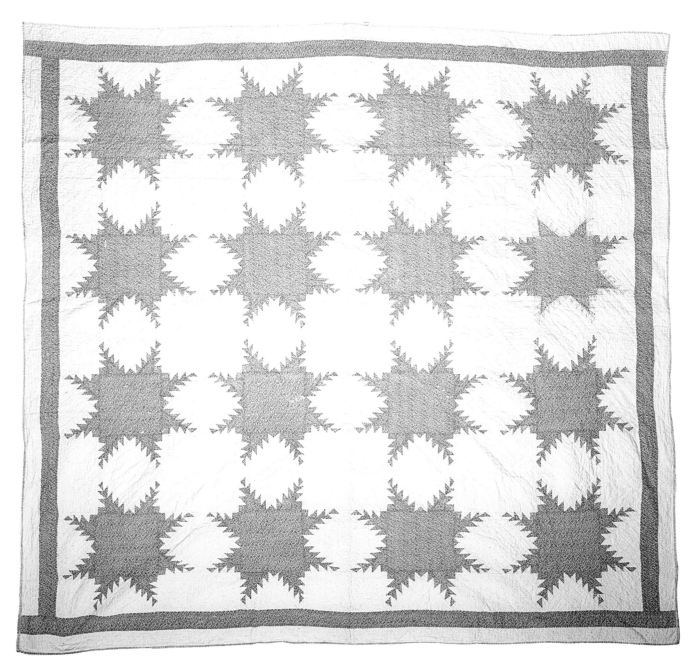

beauty, history, and folklore of quilts. In *The Quilt: A History and Celebration of an American Art Form*, Elise Schebler Roberts presents the rich heritage of American quilting in what is sure to become an essential volume in every quilt lover's library. I invite you to read on and discover how the art of quilting will inspire you.

Introduction

My lifelong interest in quiltmaking can be traced back to my grandmother, Barbara Loretta Werthmann Schebler. Although most people knew her as "Lorett," a nickname she acquired sometime in her teens, to me she was "Grandma." My grandma was not a woman of mythic proportion. To my knowledge she never saved anyone's life, wrote the Great American Novel, or found a cure for diabetes, although I think she would have liked to have done so. She lived an ordinary life, in sometimes extraordinary times.

Born in 1900, she had an eighth-grade education, a reserved personality, and a dedication to hard work. She was farm girl turned city wife. She married at 22, had two children by age 24, an unusually small family for the time. Thirteen years later, at the height of the Great Depression, she had my father. While my father was starting grade

Loretta's cross-stitch quilt and cutwork tablecloth are typical mid-twentieth century kit designs. Loretta chose the bright pink floss because it was one of her favorite colors.
Photo by Greg Winter and Lee Sandberg, Minneapolis, MN

school, my grandmother watched her older sons go off to service in World War II. Her eldest, a 20-year-old medic, was captured at the Battle of the Bulge and spent the remainder of the war in German prison camps. Grandma kept his letters, the writing filled with loneliness and fear. I don't know what she wrote back, but I bet it was something practical. She wouldn't have wanted him to know that she was also scared.

My grandma's great passion was needlework. She could sew, crochet, embroider, tat, needlepoint, and cross-stitch. When her daughter-in-law, my mother, taught her basic knitting stitches, Grandma presented my sister and me with complex knitted two-piece skirt sets a few months later. Needlework was my Grandma's reward for doing housework. She did her "chores" in the morning, and the afternoon was her time to create. You never asked her what she was making; it was almost always a gift for one of three sons, three daughters-in-law, or sixteen grandchildren.

Grandma started quilting in her late 50s. She didn't drive, and by then rarely took the bus, so all her needlework came from Herrschnerr's catalog. New to quilting, she became a fan of the kit quilts available in the 1950s and 1960s. She mastered appliqué and the quilting stitch, and she loved the cross-

stitch quilts. In just ten years she made ten full-sized quilts, all the while keeping up with her other needlework projects. She gave three quilts to her daughters-in-law.

When I was seven years old, my grandma had the first of three major strokes. The doctors told her she would never walk again, and each time she proved them wrong. But the one thing she could never master after her first stroke was the skill required to thread and hold her needle.

I never saw my grandma cry about this, but I imagine she was devastated. Needlework wasn't just a hobby, it was the creative embodiment of her life—there was needlework, therefore she lived. By the time my grandmother had her first stroke, my mother was teaching me

embroidery, and I remember Grandma watching me with a sad smile. Perhaps she found it comforting that that one of her grandchildren inherited something from her, besides a stubborn streak and a relentless search for perfection.

After Grandma was well again, she decided to give the remaining quilts to her granddaughters. There were seven granddaughters and seven quilts. She pulled the quilts out of their drawers, but one was missing. Seven granddaughters, six quilts—this wasn't going to work. I'm sure my grandmother was frustrated, but always the practical woman, she substituted an exquisitely embroidered cutwork tablecloth for the seventh quilt. She would make a raffle. She numbered the quilts and the tablecloth, and

each of us would draw a number. To make sure it was fair, we would draw in order of our age.

I am the middle granddaughter. I had to wait for three much older, almost grown-up cousins before it would be my turn to visit Grandma. Each week, I'd ask if it was time, and each week I'd be told no. Finally, it was my turn. I drew my number, and Grandma took me into the sewing room. We opened up the dresser drawer. There, wrapped in tissue paper was—the tablecloth. I had a tantrum right there, while my sister cheered, knowing she was getting a quilt.

At eight-years-old, I just couldn't see why I had to get the tablecloth. My mother placed the tablecloth into the cedar chest for safe-keeping along with my sister's quilt and I was somewhat appeased. Six years later, Grandma died from her third stroke. My grandfather gave me all of Grandma's needlework supplies, which filled my entire bedroom, but the missing quilt was still nowhere to be found.

In the meantime, I found new appreciation for my tablecloth. It graced our dinner table when I turned 16, 18, and 21. I used to look at it, and remember my frustration the day I got it, and feel bad about how I treated my grandma. Yet I still wanted one of my grandma's quilts for my own.

After my grandfather died in 1982, my dad called to say they had found the quilt. He told my aunts that to be fair, I would give the tablecloth to them and take the long-lost quilt in its place. I had a tantrum right there. I was under no circumstances about to give up the tablecloth. Grandma *gave* me the tablecloth, she knew nothing about finding this quilt; it was the table-cloth that bound us together. My dad made some calls to my aunts, and they rewarded my loyalty by allowing me to keep both quilt and tablecloth.

Since then, the quilt has become a touchstone in my life. Its bright pink skirt and perfectly stitched top graced my lonely bedroom after my divorce and my guest room after I remarried. I have lost the quilt twice, once in the back of a closet, and again at a quilt show where a friend rescued it. The quilt always comes back home to me. I thank my grandma, for both the belated gift of the quilt and the gift of a lifelong passion for quilting.

The story of my grandma and her quilts is but one of the many stories that, when pieced together, form the history of the quilt in America. As I worked on the outline for this book, it became apparent that one book could not possibly encompass the entirety of quilt research that exists today. During the past two decades, professional and volunteer researchers have

made great strides in the field of quilt research, and groundbreaking information was being presented even as this book went to print. I decided, therefore, to focus on quilting as a social world, telling the stories of people and groups throughout history who have made quilting an essential part of their lives.

Part one examines the reasons people quilt: to commemorate, celebrate, grieve, take social action, or to be part of a community. These chapters include stories from both the 250-year history of American quilting and the practice of quilting today. Some of the stories and quilts may be familiar while others will be entirely new. I'm grateful to be able to include several essays by world-renowned and emerging quilters and authors, including Jean Ray Laury, Alex Anderson, Ami Simms, Cissy Serrao, Patricia Cox, Sandra Dallas, Kyra Hicks, and Hilary Fletcher.

Part two is a field guide to quilt styles, containing photographs, definitions, and a short history of common American quilt styles. I have made every effort to include both historical and contemporary examples of each quilt style.

And finally, part three is a tribute to the people who preserve and study our quilting heritage. Without their efforts and dedication, this book and others documenting the history of the quilt could not exist.

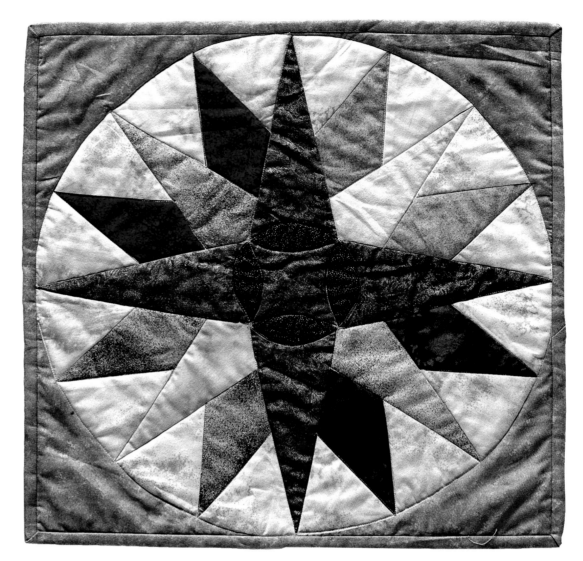

Whether you are quilter, quilt lover, or both, I hope that you find among these pages new ideas, treasured memories, and an even greater appreciation for the complexity and beauty of the quilt.

—Elise Schebler Roberts

LEADERSHIP COMPASS WALLHANGING
Date: 2005 **Maker:** Elise Schebler Roberts, Minnesota **Size:** 18" x 18" **Owner:** Elise Schebler Roberts

This is one of 13 wallhangings made for doctoral students in the Educational Leadership program at the University of St. Thomas in St. Paul, Minnesota. It was designed on Electric Quilt's EQ5 Software using a Mariner's Compass block. Photo by Greg Winter and Lee Sandberg, Minneapolis, MN

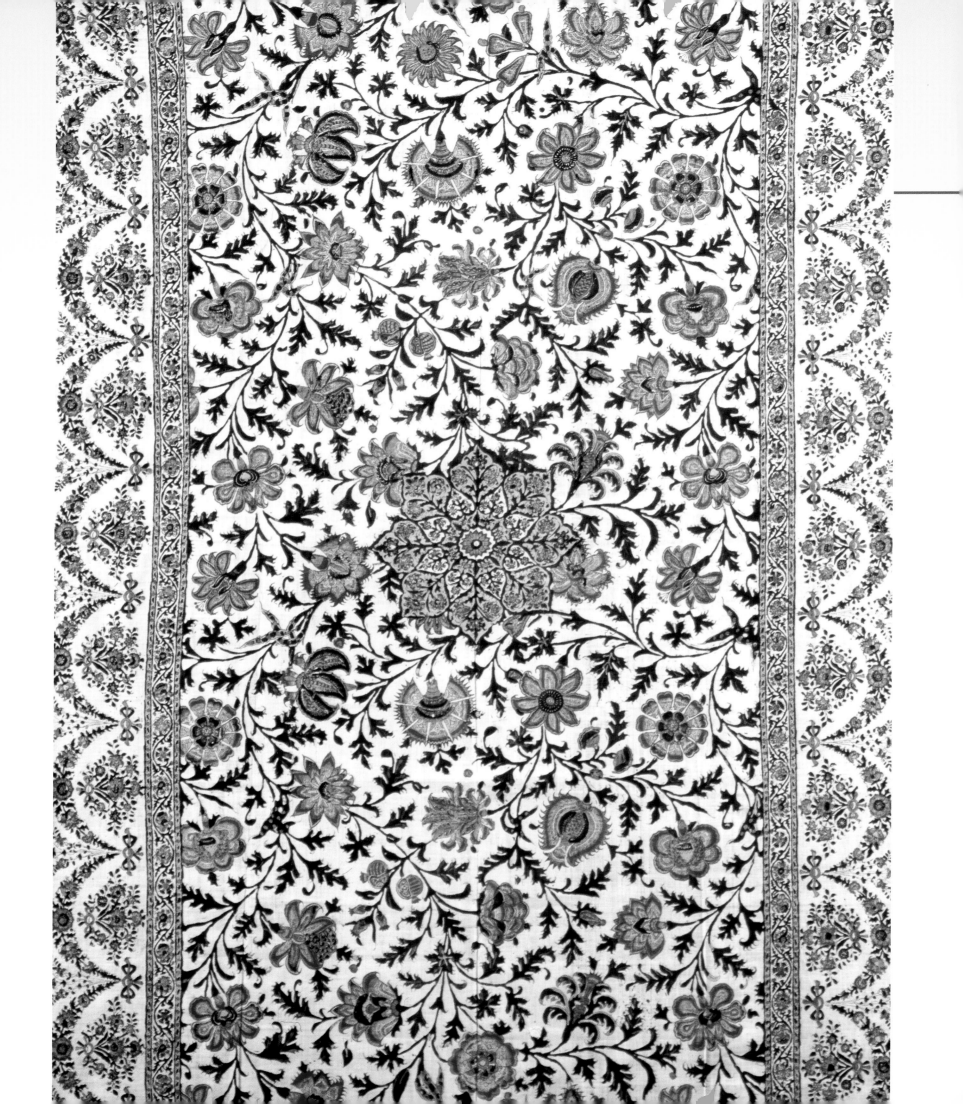

Old World AND *Eastern Traditions* IN *Quilting Prior* TO *1750*

…one feather bed quilt bolster and blankets and half the pewter together with half the linen to my daughter Sarah Wilcoxon…

From the will of Cranage Wilcoxson, Sproston, Chester County, England, January 25, 1731

PALAMPORE

Date: ca. 1750–1770 **Maker:** Unknown, probably made in India **Size:** 49" x 71" **Owner:** Historic Textile and Ethnic Costume Collection, University of Nebraska-Lincoln, 1989.001.007

To hold an old quilt and study the pattern of the fabrics, the contour of the quilting, or the wear and tear on the blocks is to take a step back in time. Quilts bind us to the stories of their makers and are chronicles of history. Each completed quilt is a testament to perseverance and each unfinished top is full of promise. Quilt fabrics, colors, and design provide insight into the era of the quilt. Intricate red and green appliqué speaks of the nineteenth century, perhaps of a quilter with both time and money. Feed sacks and scraps talk of the Great Depression and a quilt-maker who makes the most of the little she owns. The overall condition of the quilt tells the tale of its use; those in very good condition were probably "best" quilts, used only for special occasions, perhaps made for a wedding or

Palampores, a type of bed curtain, were made exclusively for the European trade market. Although palampores were made in India, they often contained European design elements such as the floral swag border on this example.

Detail, center motif, Palampore Courtesy of the Historic Textile and Ethnic Costume Collection, University of Nebraska-Lincoln, 1989.001.007

used for company. Quilts showing lots of wear served their purpose by keeping people warm.

Fabric is fragile. The sun bleaches the colors and years of use destroy the fibers. Only a small number of the quilts made before the nineteenth century survive today, making them all the more precious. But enough remnants of very early quilting traditions exist to tell us that the practice of quilting and patchwork is ancient. These artifacts tell of a tradition that began in Asia and Northern Africa, before eventually spreading across the world.

A patchwork bed canopy discovered in Egypt is the oldest piece of patchwork found to date. It dates from 980 BCE and was likely owned by a member of the wealthy ruling class. The canopy, which is housed in the Egyptian Museum in Cairo, consists of painted or dyed squares of leather, in pinks, yellows, blues, and greens and is embellished with symbols of Egypt, including antelope, lotus flowers, and scarabs.

Archeologists have found decorative silk quilts in Chinese tombs dated to the Eastern Zhou dynasty (770–221 BCE). A well-established silk production industry existed in China during this dynasty, and the government established an administration and rules to regulate the industry.

The oldest quilted object discovered is a linen carpet, found in a Mongolian tomb, that dates from 100 BCE to 200 CE. The well-preserved carpet features animals and spirals worked in backstitch and a background of diamond or cross-hatched quilting using a running stitch. Contour quilting, similar to the stipple used by present-day quilters, surrounds each animal.

A slipper found in Samarkand (Uzbekistan) is also quilted using a spiral pattern. Found in an excavated rubbish pit of a Tibetan military outpost from 800 CE, the slipper is worked in felt and patched with leather. It appears to be cut from a larger item of quilted clothing, which would be the first example of recycled quilting. This slipper is now in the British Museum in London.

In the early twentieth century, British/Hungarian researcher Sir Marc Aural Stein excavated the Cave of the Thousand Buddhas, at Dunhaung, discovering a ninth-century CE altar cloth. This relic is a patchwork of rectangular pieces of cloth, each believed to be offerings made by pilgrims to the caves. Many of these people were poor, and pieces of their clothing were the only gifts they had to offer. The altar cloth is now in the British Museum.

A Quilt is a Quilt by Any Other Name

The word "quilt" has different meanings for each of us. A quilt is an object of warmth and comfort, a creation we labored over, and an historic artifact representing a particular time, place, and culture. We use the word as a verb to describe our actions—I *quilt*, they are *quilting*, she *quilted*. And we also proudly use it as the root of another noun to say "Yes, I am a *quilter*." We use the word "quilt" everyday, maybe countless times each day, yet many of us may not know the origin of this evocative word.

Early Romans slept on a "culcita," which was simply a stuffed sack or cushion, usually tied in the center to hold the inner layer to the outer layers. As the Romans traveled northward in Europe, the word traveled with them. In France, "culcita" became "cuilte." In English it evolved first as "cowlte" and eventually became "quilt." The meaning also changed, to designate a covering for the top of a bed, and quilted clothing was sometimes referred to as a "quilt." Today, the definition has expanded to include quilted wallhangings and table coverings.

The word "counterpane," also used to describe bed linen, is derived from "culcita" and the latin "*pannus*," a piece of cloth. The stitches tying the cloth together were called "counterpoints," a term used to describe a quilted bed linen. In Renaissance Europe, these words were sometimes used interchangeably with "quilt," and appear in writings from that time period. Many words, for one idea: filler layered between two pieces of cloth, held together with thread, keeping people warm.

❧

FOLLOWING THE OLD MATERIAL TRAIL

By the end of the first millennium quilting traditions were well-established in Asia and the Middle East, spurred along by flourishing textile industries. Silk produced in China, cotton in India, and finely woven linens in Egypt were all available and traded along routes first in the east, and eventually extending into Europe. Over the next 700 years, goods and ideas traveled along the routes with crusaders, traders, and adventurers, into the homes and hearts of people thousands of miles from Asia.

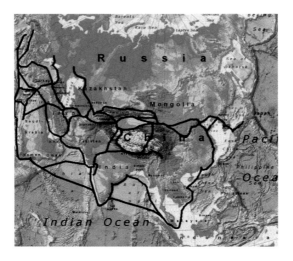

This map shows the major routes along the Silk Road. Traders brought silk and other goods across Asia and India to Mediterranean Sea ports, where they could be sent to economic centers across Europe such as Paris and London. Courtesy of Wikimedia Commons

Crusades Carry Quilting Traditions to Europe

Although trade between southern Europe, the Middle East, and Asia began before the birth of Christ, the greatest mechanism to opening routes and importing ideas were the Crusades of the eleventh, twelfth, and thirteenth centuries. Although the intent of the Crusades was to "recapture the Holy Land" from Muslims, the Crusades inadvertently provided an opportunity for people who had never left their birthplace to travel, encounter new ideas, and return home with them.

The first textile tradition imported by way of the Crusades was quilted armor, which was widely used by Muslims in southern Mediterranean regions and in present-day Turkey. The Crusades also paved the way for new eastern trade routes. These routes covered more than 7,000 miles, connecting Europe with Egypt, Iran, Turkey, India, China, and Japan. Now referred to as the Silk Road, these routes provided a more reliable and consistent supply of materials to Europe. From the twelfth through the fifteenth centuries, trade relationships with the East extended from the southern European countries to the northern countries. Fabrics and quilts were available first to the very wealthy, then to those of lower economic standing.

The demand for Eastern goods became so great that around 1600, both England and Holland created companies devoted exclusively to trade in Asia. The Dutch East India Company operated from 1602–1798, establishing colonies in South Africa, Indonesia, and Ceylon, particularly controlling the spice trade. The British East India Company settled in India around 1623, maintaining trade controls there until 1874. The development of Britain's East India Company and colonization of India coincides with the beginning of European colonization of the Americas, and ultimately contributed to Britain's growth as a nineteenth-century world power.

❧

QUILTING CULTURES OF ASIA AND THE MIDDLE EAST

Trade with China and India brought fabrics and quilting traditions to Japan, where they evolved into a high form of art and spiritual expression. The Japanese, like the Romans, slept on a padded mattress. The "futon" was stuffed with cotton waste, and the layers were sewn together with long stitches. Some futons were decorated with motifs featuring family crests or flowers. The Japanese textile tradition eventually became part of the country's spiritual and social traditions. The two religions practiced in Japan, Shinto and Buddhism, incorporated the creation and preserva-

tion of textiles into their religious activities. Buddhist monks wore patchwork clothing, and patchwork banners were hung to decorate Shinto temples. In the Shinto religion, all objects have spirit and meaning, and the emphasis is on reverence for the life in this world, as opposed to preparing for an afterlife. To the Shinto, a gift of patchwork, which required time and money to produce, was believed to bless the recipient with a long life.

Textiles were also a valuable trade item and functioned as a form of currency in some of Japan's economic circles. The ruling class wore brocades and patterned silks. The merchant, agricultural, artisan, and seafaring classes wore cotton, resist-dyed or stenciled with indigo. This dye, which had been used in Japan for thousands of years, became part of the quilting tradition for both bedding and clothing.

Cotton textile production reached a high art form in India by 900 CE. Weavers, fabric designers, dyers, printers, and painters were all involved in the production of chintz, elaborate, brightly colored fabrics adorned with flora and fauna of the subcontinent. Quilting industries soon sprung up in Surat and Calcutta. Calcutta had both a tussur silk industry, which processed fiber from a native silk worm, and a cotton industry. This fabric was used to make textiles for both local markets and the new trade markets in Europe.

Indian quilts became a major export to Europe. Lisa Evans, a Massachusetts quilt historian, notes that by the early 1600s quilts of both white calico and painted fabrics were both available, and affordable, in northern Europe. Evans also notes that Portuguese traders provided Indian quilters with examples of the emblems and motifs popular in Europe. To make their work more appealing to the European consumer, the Indian quilters then created quilts and palampores (bed hangings), combining Indian animals, such as elephants and birds native to the Indian sub-continent, with European flowers such as tulips and roses.

Quilted clothing, particularly kaftans and coats, became the standard attire of the Ottoman Empire. Kaftans dating from the sixteenth and seventeenth centuries are constructed of silk broadcloth or brocade and usually quilted with a running stitch. Bed quilts of similar construction were found at the court Suleiman the Magnificent. Foreign ambassadors could expect to receive a gift of quilted clothing during their visit as a sign of respect.

Quilted Armor

Perhaps the most ubiquitous and practical quilted items were the various forms of quilted armor used

The word "calico" is believed to have derived from the word "Calcutta."

during the first half of the second millennia. Quilted armor originated in Asia. There are records of its military use in China, Korea, Japan, and India, including a sixteenth-century Japanese ruler named Hideyoshi, who owned quilted armor and gave a vest made from Indian pre-quilted cotton to one of his subjects. Quilted armor was traditionally channel quilted and metal or horn stays were inserted into the gaps created by two or more rows of parallel stitching. Quilted armor first appeared in Europe around the twelfth century, and by the fourteenth century soldiers in England, France, the Germanic states, and Italy were wearing it into battle. For the upper class this armor was usually made from sturdy, well-padded linen or cotton canvas and worn under chain mail. The common soldier might simply wear a padded shirt. Quilting expanded to other pieces of armor, including linen caps for under metal helmets, shin pieces, and gauntlets. Metal plates were added to some clothing to increase their protection against the weapons of the day, which included arrows, spears, and small swords. When firearms became available in the sixteenth century, quilted body armor was no longer sufficient protection and the construction of quilted armor declined and quilting of clothing increased. Quilted clothing was warm and practical. Wearing exquisitely quilted clothing indicated the owner had financial means to

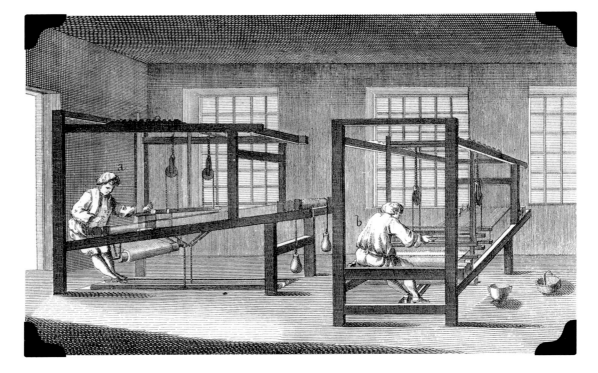

This illustration of European weavers, ca. 1750 is from the Encyclopédie, ou dictionnaire raisonné des sciences, des arts et des métiers produced by French writer and philosopher Denis Diderot between 1751 and 1766. These volumes describe the arts, sciences, and trades of Europe and include detailed drawings of workers plying their trade. Courtesy of Beinecke Rare Book and Manuscript Library, Yale University

purchase such a garment, or the free time available to quilt it themselves.

Quilt ownership as a sign of Wealth

In Europe, local and regional quilting industries developed to compete with the importation of quilts from the East. As European workers created quilts to be sold in their own markets, they also developed more elaborate quilting designs, reflecting the artistic tastes of the location and time period. Expensive fabrics and the vast amount of time required to produce quilted bedding and clothing meant that at first only the very wealthy and privileged owned quilts. One of the earliest documented quilts was created in Sicily around 1395. The quilt, a solid white, whole cloth trapunto bed hanging, is designed in three pieces. The quilting tells the legend of Tristam, which is often attributed to the legends of King Arthur. This quilt may have been created as a wedding gift for a member of the nobility. The island of Sicily became a center for Italian quilting, and the Sicilian cable stitch was a hallmark of the work.

In the sixteenth century, whole cloth silk quilts were created in France, Italy, Spain, Portugal, and England. Quilted and padded leather curtains were used as church doors in Italy. Another large center for silk quilts was the Mediterranean Island of Chios, east of Greece in the Aegean Sea, which boasted a native silk industry, uncommon outside of Asia. In the Netherlands quilted clothing became popular for the wealthy. In France, quilting influenced the design of seventeenth-century women's clothing. Petticoats were heavily quilted and embellished in floral and geometric designs. Not wanting to hide their beautiful and expensive garments, women began to wear dresses that where draped open from waist to hemline. Also at this time France began importing cotton from India, called "Indiennes," which became a staple in the growing fashion industry.

Development of Cottage Quilting Industry in Great Britain

While the wealthy owned the quilts, the servants were sewing them. It was not long before the servants began incorporating quilting into their home lives, using whatever fabrics and fillers were available to them: remnants of clothing and other bed linens, goose or bird feathers, foliage or paper. Some of these households, especially in northern England, Scotland, Wales, and Holland began to specialize in creating quilts to sell to wealthier customers. Called cottage industries because the production is focused within the home as opposed to a factory, these small businesses quickly

The Royal Quilt

Since only the rich could afford quilts at first, many European royal families owned or made quilts. Listed in an inventory of the possessions of King Henry VIII of England are both "quyltes" and "coverpointes." They were made of cotton, linen, and silk. He also gave gifts of quilts to some of his court members, including 23 to his fifth wife, Catherine Howard, prior to their wedding. The marriage didn't last long, as King Henry had her beheaded for infidelity, but the quilts apparently survived. The king's daughter, Queen Elizabeth I, listed numerous quilted dresses in her wardrobe. Elizabeth's cousin, Mary Stuart, also known as Mary, Queen of Scots, was an avid needle-woman. A bed hanging at Hardwick Hall in England is attributed as her work. It is applied patchwork of cream velvet fabric embroidered with birds, flowers, and butterflies in black silk thread. The courts of Maria Therese, Empress of Austria, are credited with creating a wedding quilt around 1770 to honor the marriage of her daughter, the infamous Marie Antoinette to the French King Louis XIV. The elaborately appliquéd quilt is rumored to have been used as evidence for Marie Antoinette's extravagance during the French Revolution.

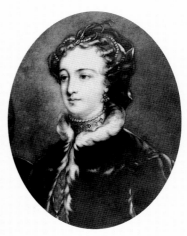

Mary Stuart, known as Mary, Queen of Scots, was heir to the Scottish throne through her father, King James V of Scotland, who died when she was a few days old. This portrait shows her around 1580, seven years before she was executed at Elizabeth's orders. Ironically, Elizabeth died in 1603 without an heir, and Mary's son James became King of both England and Scotland. Library of Congress

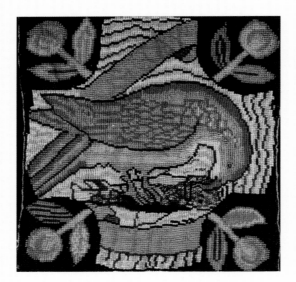

THE OSPRAY

Date: 1570 **Maker:** Mary, Queen of Scots, and Elizabeth, Countess of Shrewsbury, England
Size: 10.25" x 10.75" **Owner:** V&A Images/ Victoria and Albert Museum, London, England

Mary Stuart was a cousin of Queen Elizabeth I. She was also a potential rival for the throne of England. Fearing a coup if Mary kept contact with her supporters, Elizabeth had Mary imprisoned through much of the 1570s. This embroidered image is part of a larger hanging panel made by Mary when she was imprisoned at Sheffield Castle.

grew into a viable means of income for men and women.

The growth of cottage industries was helped along by a drastic change in climate conditions. Between the years 1550 and 1850, a time known as the Little Ice Age, the average temperature in the Northern Hemisphere dropped 3 degrees Fahrenheit. This was enough of a drop to negatively impact agriculture, increase the spread of disease, and create a colder and sometimes damper climate throughout the year. For quilters this was good news, as warm coverings were necessary for the survival of the population, and there seems to be a correlation between the Little Ice Age and increasing popularity of quilting both as an occupation and avocation.

Rise of Regulation of the Quilt Industry in Europe

In most cultures, production of goods eventually requires regulations. Ideally, these regulations help both producer and consumer, by establishing protection of production rights and enforcing standards for quality. One of the earliest organizations in Europe was put in place to protect textile-related industry-linked producers of armor with producers of clothing. In 1272, the Fraternity of Tailors and Linen Armorers of Linen Armor of St. John the Baptist was chartered in London by Edward I. This guild was formed in response to the need for tailoring skills in the creation of fabric armor, and operated for nearly 400 years.

As the demand for quilts increased, the demand for textiles with which to make those quilts also grew. In 1631 a royal proclamation by England's Charles I permitted importation of fabrics, including chintz and silk, from the East Indies. The major importer was the British East India Company. Thirty years later a chamber of commerce was organized in Marseilles, France wholly for the promotion of the country's fledgling textile industry. At about the same time, cotton print works were established in other northern European countries, including England and Holland. The market was closed to Scotland, however, until 1707, when Parliament finally allowed the exportation of Scottish textiles, a boon for western Scotland.

The development of a northern European textile industry created friction with Asian importers, and in the first quarter of the eighteenth century England and Germany placed bans on the importation of Asian cottons and calicoes. By mid-century the English quilting industry had progressed to the point that a patent was issued for a method that created a machined cloth with the look of hand stitching.

CUSHION COVER

Date: ca. 1786 **Maker:** Henry Lane Haines,
England **Size:** 22" x 22" **Owner:** V&A Images/
Victoria and Albert Museum, London, England

*Henry Lane Haines created this cushion cover
using printed and plain cotton fabrics. Little is
known about him. The center medallion is a
Four Patch block, which was used in both
England and the American colonies.*

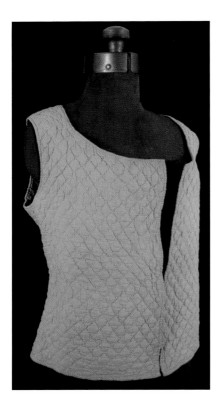

WAISTCOAT

Date: ca. 1800 **Maker:** Unknown, probably
made in Provence, France **Owner:** Linda Ames
www.vintagetextile.com, Keene, New Hampshire

*This handquilted vest is typical of French
quilted clothing from the eighteenth and early
nineteenth centuries. Provençal plant-based dyes
made from wild sumac, saffron, and sunflower
petals are used to create the bright yellow fabric.*

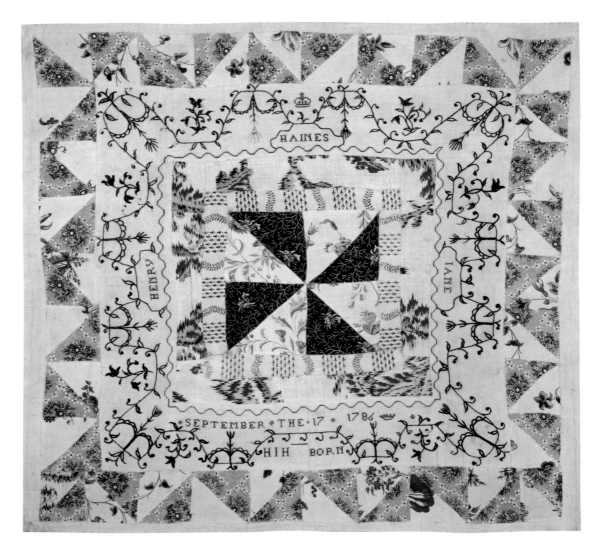

THE ROOTS OF AMERICAN QUILTING

The first successful European set-
tlements in what would become the
eastern United States were estab-
lished in the early 1600s. By the
mid-1700s, these new colonies pri-
marily were settled by people from
northern Europe, who brought with
them a variety of quilting tradi-
tions. Quilted clothing, especially
petticoats, continued to be popular
on the western side of the Atlantic
Ocean. Appliqué on linens and
clothing flourished. Patchwork, which
was not widely used in eighteenth-
century England, gained footing in
the colonies, where the access to
new fabric was limited and needle
artists had to make do with the
resources at hand, usually old
clothes and bed linens. By 1770, the
relationship between the colonies
and England had cooled, which
further restricted the import of
fabrics. The Revolutionary War
(1776–1781) and the development
of a United States textile industry
in the early nineteenth century
paved the way for a new type of
quilting that is uniquely American.

Piecing Together the History of the Quilt

How do we know about the early history of quilting? Quilts are fragile, and textiles rarely survive more than a few centuries, so we must look to historical documents for much of our information. Household inventories from the sixteenth through nineteenth centuries provide some information. Often produced upon the death of a homeowner to establish title of ownership, these lists are a snapshot of a family's property at that point in time. Unfortunately, only households of significant wealth would require a legal listing of property, so information about the number of quilts in working-class households is still elusive.

Popular literature of the time period can also provide clues. For example, two Medieval poems mention quilts. In the twelfth century "Le Lai De Desire," an immortal man woos a mortal woman. The poem describes the marriage bed, which is covered by a quilt, made of two silk fabrics in a checkerboard pattern. "Parzival," a thirteenth-century poem by Wolfram von Eschenbach, tells the story of one of King Arthur's knights, and mentions the presence of a quilt in the Grail Castle. Sir Walter Scott, the nineteenth-century author of *Ivanhoe*, describes quilted armor in another work, *Marmion*, a novel of sixteenth-century Scotland. In it he describes battle dress with "Dress'd in his steel-jack, a swarthy vest, with iron quilted well."

Diaries and travel journals for the time period provide a third source of information about quilts. In 1516, Portuguese merchant Duarte Barbosa traveled to India and noted in his journal that "They also make here very beautiful quilts and testers of beds, finely worked and painted and quilted articles of dress."[1]

Research into the history of early European quilting traditions requires tenacity and a bit of luck. Few quilts or documents survive to tell the story. However, researchers do continue to uncover new material in libraries, historical organizations, and local government records.

❧

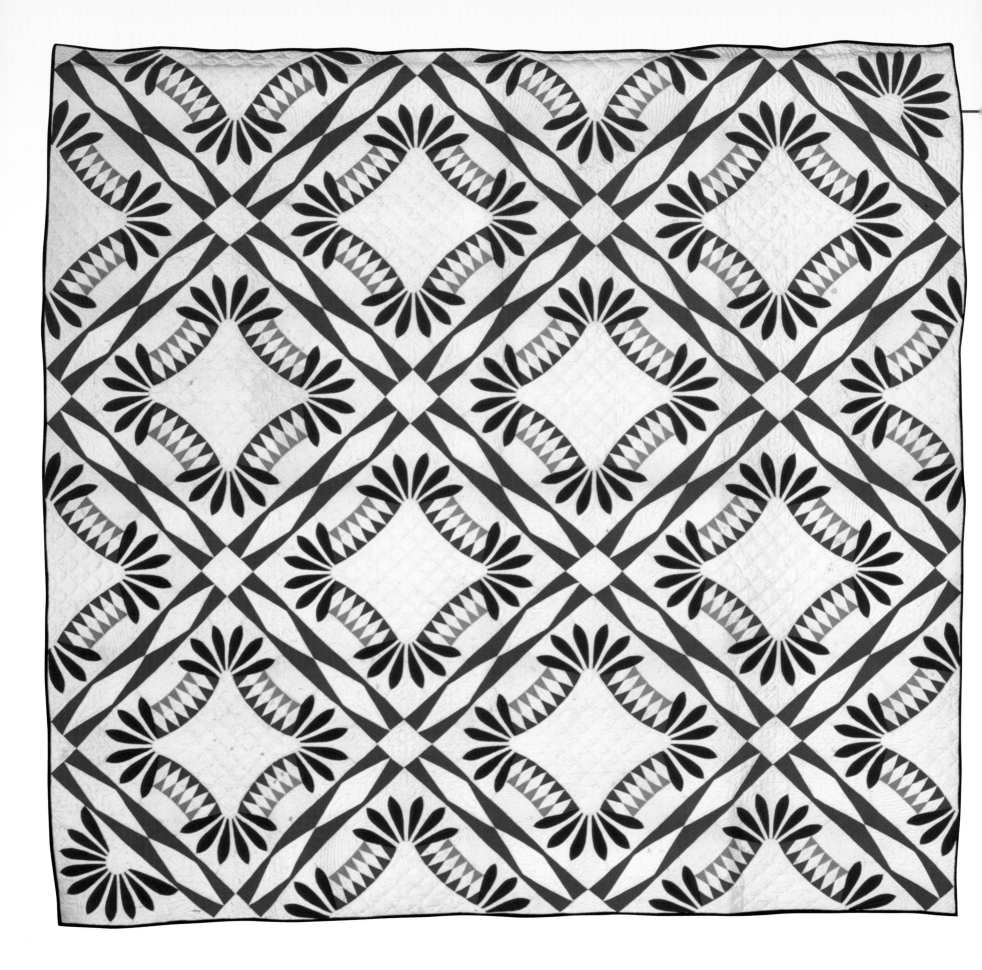

Chapter 2

Quilting in a New World

1 Blue bed quilt 5.00
1 Old calico quilt 1.00
1 pieced woolen quilt 3.75
1 old pieced quilt 1.50
1 old pieced quilt light colored 1.75

Estate of Capt. Abner Pinney, Worthing, Franklin County, Ohio, May 6, 1805, from
New England Culture of the Ohio Frontier, 1996

WHIG'S DEFEAT

Date: ca. 1852 **Maker:** Louisa Green
Furches Etchison, Davie, North Carolina
Size: 85" x 87.5" **Owner:** North Carolina
Museum of History

Louisa, her mother, and sister completed this
quilt for her wedding in 1852. The family
name for this quilt was Tennessee Beauty.

Detail, Whig's Defeat
Photograph used courtesy of the
North Carolina Museum of History

Life in the early colonies was harsh. New England winters were cold and snowy, while Virginia summers were hot and humid. Colonial women had to learn to cook with new and unfamiliar foods, including varieties of corn, fish, and native berries. She was the family candle maker, doctor, child-care provider, educator, and farmer. Women were also responsible for the production and care of all textiles the family needed, including the cloth used to make clothing and bedding.

The immigrants to the American colonies brought along textile manufacturing traditions from Europe, which included spinning, weaving, knitting, and quilting. In the seventeenth century, woven coverlets were more common than quilts, partly due to unavailability of cloth and lack of time

for their construction. Colonists may have brought a few quilts with them, and some utilitarian quilts were made. One of the earliest household inventories to mention quilts comes from the estate of Captain George Corwin of Salem, Massachusetts. When he died in 1685, his inventory listed one flowered calico quilt.

By the eighteenth century, quilts were more commonly listed in household inventories. The oldest known surviving colonial quilt is the Saltonstall quilt, made in Massachusetts around 1704. This silk, velvet, and brocade quilt contains two-patch and four-patch variation blocks, with a winged angel appliquéd in the center. It has no batting and measures approximately 75 by 82 inches. The quilt contains the remnants of the paper patterns used to piece the block, including pages from a 1701 Harvard College catalog. The maker is believed to be Sarah Sedgwick Leverett, wife of Massachusetts Bay Colony Governor John Leverett. Quilted clothing, petticoats, caps, and skirts popular in Europe were brought to the colonies by English and Dutch settlers in New Amsterdam, modern-day New York. Advertisements for quilted clothing in mid-eighteenth century colonial newspapers indicate that quilted garments had become common in the New World as well.

Eighteenth-century quilt styles followed the styles of Europe. Medallion-style quilts with appliquéd, pieced, or embroidered elements; simple patchwork quilts; and whole cloth quilts make up museum collections and quilt surveys made of the time period. The Faith Trumbell Chapter of the Daughters of the American Revolution owns a cotton and linen medallion quilt made by Mary Greer Denison of Stonington, Connecticut, in 1759. The center medallion is worked with crewel embroidery designs featuring birds

MERMAID PETTICOAT

Date: ca. 1775–1800
Maker: Sarah Halsey, Connecticut
Owner: Connecticut Historical Society

Sarah's petticoat features elaborate quilting designs including a mermaid with a comb and mirror, a stag, a leopard, and a lion. It was worn underneath an "open robe," a dress with skirt looped away from the front to display a decorative petticoat or underskirt.

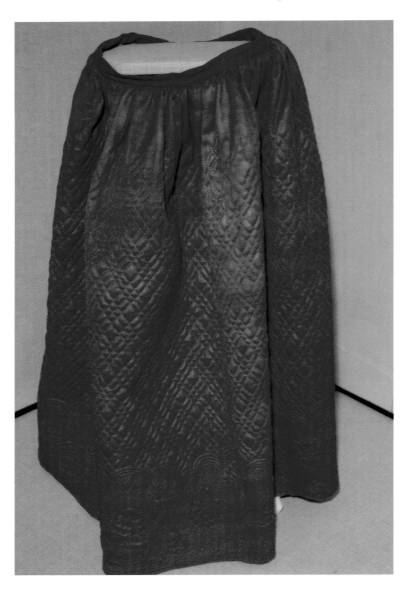

and flowers. Mary also stitched her name and date in the lower center part of the medallion. The Bidwell House Museum in Monterey, Massachusetts, owns a dark blue, glazed wool whole cloth quilt, circa 1775. It is intricately quilted with vines, pineapples, and hearts.

The eighteenth century was a tumultuous time for the colonies, characterized by rapid population growth. In 1700 the non-native population was approximately 250,000. Seventy-five years later the population was nearly 2.5 million. What was once a series of isolated communities strung along the Atlantic coastline connected only through their relationship with the European homeland had become a network of 13 or more regionally governed colonies, extending hundreds of miles inland, each with its own trade commodities and needs. While many of the settlers were English, others were French, German, Dutch, Scandinavian, and African. The colonies had moved into an age of scientific enlightenment and new American inventions were developed, such as the Conestoga Wagon and Benjamin Franklin's lightening rod.

The colonists were also subjected to a series of European wars that were fought around the world, including in North America. The Seven Year's War (1756–1763), sometimes referred to as the French

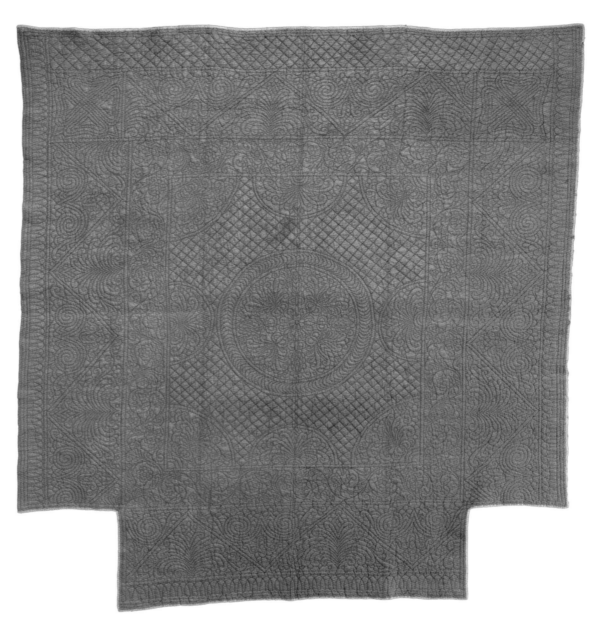

and Indian War, was a battle for worldwide colonial domination between Great Britain and France. In North America, much of the war was fought in New York, Pennsylvania, and Quebec. English colonies and their Native American allies, the Iroquois, battled the French Canadians and their Native American allies, the Algonquin and Huron, over settlement and trading rights to land west of the Appalachian Mountains and east of

GREEN SILK WHOLE CLOTH

Date: ca. 1765 **Makers:** Anna Margarethe Munthe, Anna Catherine Munthe, Mette Andrea Christine Munthe **Size:** 82" x 87" **Owner:** Minnesota Historical Society

The Munthe sisters made this quilt in Norway and it was brought to Minnesota when the family immigrated in the mid nineteenth century. The center design is an intricately quilted rose. This was probably intended to be a "best" quilt, to be used only on special occasions.

American quilting began to diverge from European quilting style in the second quarter of the nineteenth century.

the Mississippi River. By the end of the war, France had lost most of its colonies in the Americas and around the world, and Great Britain emerged as the most powerful, colonizing government.

It was the French and Indian War that sparked the American Revolution. Great Britain, realizing the expense required to defend its colonial empires, enacted a series of taxes against the colonies to fund their defense. The Stamp Tax of 1765, which required a taxed stamp on newspaper, letters, and playing cards, united the colonies in protest against England under the mantra "no taxation without representation." The American colonies had little representation within the English Parliament and therefore no protection against taxes. Colonists first attempted to resist the tax by staging a series of economic boycotts against goods produced in Great Britain. Many colonists, however, felt that it was time to make a complete break from the British government. Over the next ten years, altercations between American colonists and the British government became more frequent, eventually culminating in direct conflict at Lexington and Concord, Massachusetts, on April 19, 1775. This battle was the catalyst for war, and by July 4, 1776, the American colonies had declared themselves the United States of

America, a new nation separate from any European governance. France, a former foe, became the United States' primary ally. The war continued until September 3, 1783, when Britain and the United States signed the Treaty of Paris, ending direct hostility and establishing boundaries for the United States and British North America.

QUILTING BECOMES AMERICAN

The end of the American Revolution did not have an immediate impact on quilting style in the United States. Women still made the medallion-style quilts, whole cloth quilts, and mosaic-style one-patch or four-patch designs that were in vogue in Great Britain and the rest of Europe. One design that became popular during the last quarter of the eighteenth century was the hexagon, and a variety of hexagon quilts were made in both England and the United States during this time period. The Newark Museum in Delaware owns a hexagon patch quilt top made by Catherine and Susan Springer, a mother and daughter from New Castle, Delaware. This top was paper-pieced; the patches were cut using a cardboard template and then each patch was sewn on to a newspaper pattern. The patches were then stitched together, and the paper remained inside until the quilt was

finished. This quilt, which measures 70 inches square, remains unfinished. The newspaper pattern pieces have dates ranging from 1792 through 1803.

American quilting began to diverge from European quilting style in the second quarter of the nineteenth century. By that time, the United States had established a significant domestic textile production industry in New England, which processed the cotton grown in the south. Atlantic trade routes also continued to bring textiles from Europe, India, and Asia. Americans had access to a greater variety of fabrics in larger quantities than during the previous centuries. More East Coast Americans lived in towns and cities, making exchange of quilting ideas easier, and the increased expansion of American settlement across the continent ensured that quilting traditions would spread. Quilting became a more desirable activity, as women's roles focused directly on house and children.

Three major quilt style changes emerged during this period. American quilters began to adopt an orderly, pieced block style; whole-top pieced designs were developed, such as the Star of Bethlehem; and appliqué designs were made using individually cut and stitched pieces instead of chintz whole cloth motifs.

European block quilts were made of simple pieced blocks, randomly assembled. American quilters began to take those blocks and alternate them with a plain block, or piece blocks into borders and strips, often alternating with a plain strip. Earliest patterns were Four Patch and Nine Patch, and a variety of stars, including the LeMoyne, or Lemon Star, and Ohio Star. Patterns quickly became more complex. Around 1830 Elizabeth Mackelfresh Shipley of Baltimore

HEXAGONAL PATCH TOP

Date: ca. 1792–1803 **Makers:** Catherine and Susan Springer, New Castle, Delaware
Size: 71" x 71" **Owner:** The Newark Museum/Art Resource, New York; Collection of the Newark Museum, New Jersey

Catherine and Susan Springer spent more than 10 years piecing this top, which for unknown reasons was ultimately left unfinished. The Hexagon patch is found in quilts from both England and the United States.

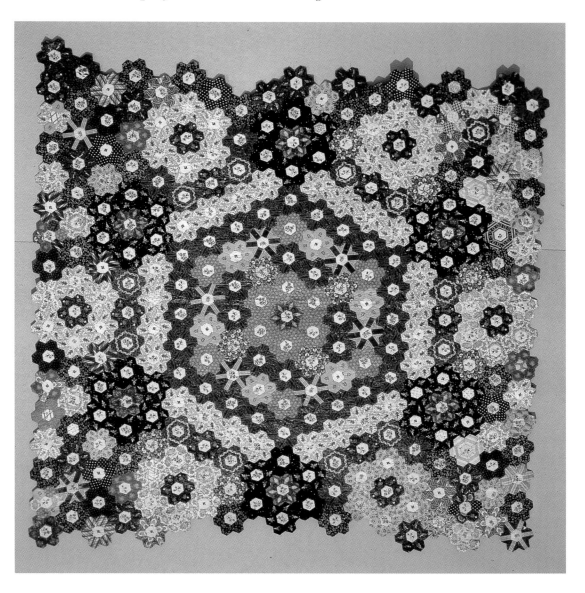

County, Maryland, made a pieced quilt using a 5-inch square Delectable Mountains block—plain triangles with sawtooth pieced edges. When finished, the quilt contained a total of 324 blocks.[1]

Whole top pieced designs such as the Star of Bethlehem, later known as the Lone Star, also emerged at this time. These designs may have evolved from the medallion-style quilt, making a very large pieced central block the focal point of the quilt, or in some designs the entire quilt top. Star of Bethlehem quilts became popular in the United States during the 1830s and 1840s. A quilt in the Winterthur Collection at the Winterthur Museum in Delaware uses the Star of Bethlehem as the focal point. Mary Jane More of Mill Creek Hundred, Delaware, pieced the top in 1837 and quilted it in 1839. The large, central Star of Bethlehem is set with smaller stars of the same pattern, then framed with alternating sawtooth and star borders.

Chintz appliqué, also known as *broderie perse*, was a popular appliqué style in the first half of the nineteenth century.

By the end of the first quarter of the century, however, quilters were experimenting with a different appliqué style, using layered pieces cut from a variety of fabrics to create flowers, trees, animals, United States flags, eagles, and many other

designs. This style was often used in a block format. Quilts from the time period may contain multiple blocks of the same style or are album style containing up to several dozen blocks worked in different appliqué patterns. The acme of this design is the Baltimore Album Quilt, which was popular in the late 1840s and early 1850s. Quilters who worked in the Baltimore Album style created intricately appliquéd blocks, which required advanced quilting expertise and a significant amount of time to complete.

Many American quilts also included motifs distinctive to the United States. American eagles appeared in quilts as appliqué and quilted designs. Pieced and appliquéd American flags were created for their own use or as part of a quilt, and unique quilt blocks, such as Whig's Defeat were named for the American experience.

QUILTS ON THE ROAD

By the second quarter of the nineteenth century the United States was a country on the move. In 1783 the United States governed land extending west to the Mississippi River. When the United States purchased the Louisiana Territory from France in 1803, the country's size doubled, extending from western Louisiana north and west to what would become western Montana. By

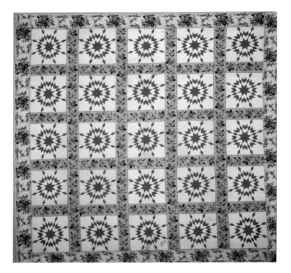

HARVEST SUN OR STAR

Date: ca. 1840–1850 **Maker:** Hottie Mitchell, Lexington County, South Carolina

Each star in this quilt has 72 pieces and Hottie Mitchell has perfectly matched the fabric in between the stars. The sashing between the blocks is chintz.

Broderie Perse

Broderie perse is a French term meaning "Persian embroidery." This embroidery style, which originated in ancient Iran, originally featured Middle Eastern floral designs and animals worked in a darning stitch. In seventeenth-century Europe, the term *broderie perse* came to be used for a quilt style where chintz cutouts, usually of flowers, plants, and animals were appliquéd to a solid color whole cloth fabric. Basic styles were used for the cutouts, the most popular being a medallion style with a large central motif and an overall pattern where appliqués are intentionally or randomly applied across the top. The fabric was imported from India to northern Europe, and the *broderie perse* style was particularly popular in France and England. Immigrants to America brought this quilt style with them in the seventeenth century, and it remained popular into the early nineteenth century.

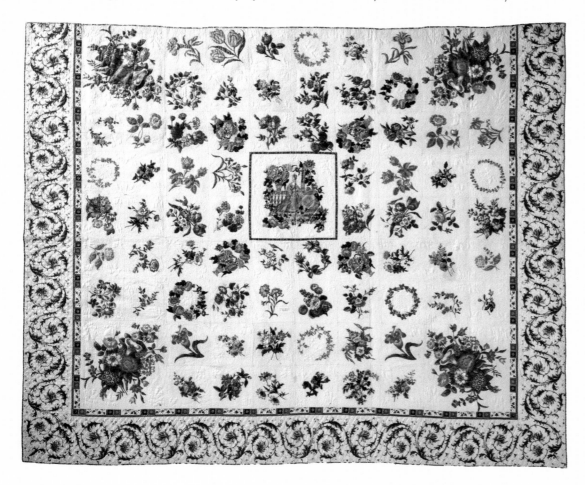

MEDALLION

Date: ca. 1843–1844 **Maker:** Unknown, from Ohio or Pennsylvania **Size:** 110" x 93"
Owner: International Quilt Study Center, University of Nebraska-Lincoln, 1997.007.0479

This quilt includes a center chintz medallion, surrounded by smaller album-style blocks.
Many of the blocks include the signatures of the makers.

1853 the United States had legal control of the area making up the contiguous 48 states. The area between the Atlantic Ocean and the Mississippi was well populated by European immigrants and American migrant families by the 1840s, and many were looking westward for their next move.

The first wagon trains left Missouri for Oregon along the Oregon Trail in 1843. The Mormon Trail from western Illinois to Salt Lake City, Utah, opened in 1846. The California Trail was established from Missouri to northern California in the 1840s, and the route was swarmed with miners after gold was discovered at Sutter's Mill, California, in 1848. From the 1840s through the 1860s, approximately 500,000 settlers had traveled along one of these trails to new homes. By the 1870s, most immigrants were able to travel west by train and the trails were essentially closed.

Traveling overland was no simple matter, and timing was absolutely essential. Leave too early in the season and there would be insufficient grass to feed the many animals required to pull wagons along the trail. Leaving too late in the season increased the chances that the group would be snowed in while traveling through one of the mountain ranges before reaching the Pacific. Travel was optimal along the 2,000-mile trails between mid-May and late August, but the going was always slow. On a very good day a wagon train might cover 20 miles, while on other days, foul weather, rough terrain, or broken wagons slowed the advance to a mile or two. The entire journey lasted between four and five months.

A family's entire possessions, including provisions for the trip, needed to fit into a prairie schooner, which was about half the size of the Conestoga wagon. The prairie schooner was the size of a farm wagon, and when fully loaded with supplies and equipment weighed just 2,500 pounds. There was little room in the wagon for people, so adults and children usually walked. The road was dangerous. Harsh weather conditions, strenuous work, and disease, especially cholera, claimed the lives of approximately 10 percent of the travelers.

Despite the difficult conditions, pioneer women, whether traveling a few hundred miles or across the continent, brought some quilts with them, made a few along the way, and made many more while getting settled. Many of the quilts made by the pioneers were utilitarian and used until they were threadbare. Those that remain tell the story of the quilter who made them.

Quilt historian Mary Bywater Cross has spent several years studying the quilts of immigrants along the Oregon Trail. In her book

Treasures in the Trunk: Quilts of the Oregon Trail, she describes 61 quilts made by women who traveled the trail between 1840 and 1870. Of those quilts, 27 were made before the women left on the trail, just 4 were pieced along the trail, and the remainder were made after arriving in Oregon, or left unfinished.

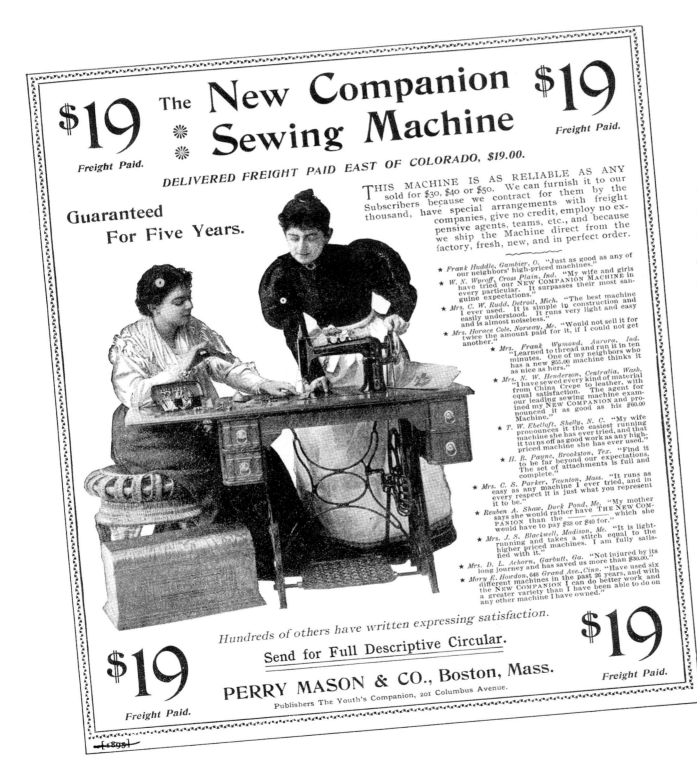

Isaac Singer marketed the first "home" sewing machine in 1858. Soon other companies designed their own machines, bringing the speed and accuracy of industrial sewing into American homes. The time-saving machines were affordable, too, when purchased on the new installment plan.

Quilts of the Pioneers

by Sandra Dallas

Sandra Dallas creates fictional, yet believable quilting heroines through her nov-els, introducing readers to Civil War bride Alice Bullock in Alice's Tulips, *and 1930s farm wife Queenie Bean in* The Persian Pickle Club. *Her attention to his-torical detail exhibits exceptional research skills, honed through a 25-year career as reporter and bureau chief for the Rocky Mountain Region of* Business Week. *Sandra is also the author of numerous nonfiction works, including* The Quilt that Walked to Golden, *a history of Colorado quilts and quiltmakers.*

In this essay, Sandra reflects on the diary of Hazel Green and the quilting traditions that pioneer women spread across the country.

The composition book with its worn marbleized boards and maroon binding sat in a pile of books at an antiques show in Denver, ignored by all but one browser. As a snoop into the lives of long-dead women, I was drawn to the hum-ble journal. I opened the diary to find the inside covers cluttered with merchants' cards and death notices clipped from newspapers. The writing on the lined pages was sparse, and there was no mention of famous people or momentous events, the sort of thing that attracts historians. Instead, there were bits of doggerel, notes on the weather, a record of callers. But the everyday words of this diary, begun in 1884, jumped out at me: "April 20th: The holey Sabbath…cold & raine & snow[.] this is my 83rd birth day darke and dreary."

The octogenarian was Hazel Green, who told little about herself in her jour-nal. But she revealed that she was a quilter, and like other pioneer women, she prized her quilts. On the last page of the journal, dated July 24, 1885, she wrote out her will: "My small rocking Chair I wish for Friend Libbie…My Craze Quilt is for Libbie too." Perhaps Hazel saw her quilt as her legacy, a prized possession that Friend Libbie would value long after Hazel's death. Maybe it was Hazel's bid for immortality. It is doubtful that the woman considered her quilt a work of art. Few women did in those days.

Hazel lived in an era in which female art went unrecognized. Pioneer women quilted to make warm bedcovers; only incidentally were their quilts considered things of beauty. The quilts that collectors today hang on walls as dynamic graph-ics were spread on the ground under covered wagons, washed in mountain streams and scrubbed on rocks—used up, most of them. Some were recycled as batting for another generation of quilts.

Quilts served many purposes for pioneers. Women on the Overland Trail in the 1850s and 1860s traded them to the Indians for food and moccasins. They spread them over the tops of wagons to keep out the rain—and in at least one instance, to keep Indian arrows from penetrating the wagon sheet. They used their quilts as

shrouds. A Nebraska woman wrapped her dead infant in a doll's quilt for burial. Helen Rich, who was an elderly novelist when I met her in 1963 in Breckenridge, Colorado, the early gold-mining town where she lived, told of a baby wrapped in a quilt, laid out in a section of a sluice box, and buried in a prospect hole. I wondered if a bereaved mother had taken a tiny bit of comfort in knowing that her child, dead in a strange land, was spending eternity wrapped in a quilt she had made.

Women weren't supposed to bring their quilts with them on the trek west. A Montana gold miner wrote home to his wife in Minnesota, telling her to take blankets because quilts "get torn too easy." But what woman would leave behind the quilts lovingly pieced with her own hands or those of her friends? Many women fighting the loneliness of gold diggings and remote homesteads found solace in the quilts they brought with them, especially the friendship quilts made up of Churn Dash or Chimney Sweep squares signed by far-away friends. Such quilts were presented to pioneer women as going-away presents, and both givers and recipients knew they might never again see each other again in this world. When "I get lonesome all by myself, I read the names on the pink and white 'Irish Chain' quilt the school children pieced for me," wrote a schoolteacher who had moved to Evans, Colorado, in 1870.

Westering was not a movement for women. In a time when it was believed men and women lived in different spheres of influence, women were assigned the world of home and hearth, friends and family. Men journeyed west for economic opportunity and personal freedom. But what was there in the West for women? Personal freedom for females was an alien concept. Women traded their comfortable homes in a civilized land for mining-camp shacks and sod huts in a dangerous wilderness. They cooked over campfires, washed themselves and their clothing in mountain streams—if they had water at all. They gave birth in isolated cabins and lost husbands and children to the hardships of the trail. Many helped with men's work of mining and farming, although few husbands returned the favor by cooking and laundering. The weak died, but the women who survived, despite the hardships, grudgingly came to love the new land and their newfound independence. And they were rewarded for their struggles. Colorado was the first state in the nation to give women the right to vote.

During those years of hardship, women found little time to make any but the simplest quilts—scrap quilts, string quilts, one-patches, and they were often tacked, because tacking took less time than quilting. Later, as pioneer women found leisure time for sewing, they chose the same quilt patterns selected by eastern women, designs their friends sent them or that they found in the popular women's publications, such as *Godey's Lady's Book* and *Peterson's Magazine*.

Their choice of patterns surprised me. I'd have thought these women would have incorporated symbols of their new homes into their quilts—mountains,

prairies, cattle brands, mining implements. But such designs in pioneer quilts were rare. Instead, western women chose stars and flowers and schoolhouses, bold geometrics such as Log Cabin and Courthouse Steps. And when crazy quilts became the craze, western women made as many of these useless assemblages of silk and velvet scraps as their counterparts elsewhere.

Why did they pick such traditional patterns? I think it's because the designs represented civilization. Despite their westering experience, western women were Victorians at heart, and their idea of culture was the world they had left behind. So after they tamed the harsh land, these women imported carved walnut furniture and velvet draperies and made their quilts in Drunkard's Path and LeMoyne Star. I believe that while their husbands placed little value in female handiwork, western women were as proud of their quilts as their eastern sisters. Those quilts were their heritage, every bit as much as their part in settling the West. Like Hazel Green, pioneer women treasured their quilts not just as bedcovers but as mementoes of their lives, precious reminders of themselves to be cherished long after they were gone by daughters, sisters, and perhaps a beloved Friend Libbie.

∂∽∾

Quilts Brought Along the Trail
Quilts brought by pioneer women might be treasured family heirlooms, quilts made for the journey, or remembrance gifts from family and friends whom the travelers might never see again.

Matilda Robison King traveled a lot during the 1840s. She and her husband Thomas were members of the Latter Day Saints church. They left New York State in 1840 for the Mormon settlement in Nauvoo, Illinois. In 1846, they moved to Iowa, then Missouri to prepare for a journey to the Mormon settlements in Utah. Matilda and Thomas finally arrived in Utah in 1851, and settled in Millard County. One of Matilda's prized possessions, a red and green appliquéd Washington's Plume quilt in a Princess Feather variation, followed her across the country from New York to Utah.[2]

Not all immigrants traveled the overland routes to the west. A few, such as 28-year-old Mary Elizabeth Simpson of Brunswick, Maine, took a ship south along the Atlantic, around Cape Horn at the southern tip of South America, and north along the Pacific to San Francisco.

Mary arrived in San Francisco around 1861, where she joined two brothers already living in Stockton, California. She brought with her a Friendship Star quilt, made in 1860, containing the signatures of family and friends back in Maine. Mary was one of California's early suffragettes. She became treasurer of the California State Women's Suffrage Educational Association in the late 1800s and president of the San Francisco Susan B. Anthony Club in 1916, at the age of 83.[3]

Quilts Made Along the Way

Few quilts were made along the trails. During the day women walked the trail, cared for children and animals, and collected local food to supplement diminishing provisions. When the wagons stopped for the evening, women made dinner, mended clothes, and prepared the family's bed. This left little time for quilting. But a few determined quilters were able to piece quilts despite the limited time and resources.

In 1851, Almedia Grimsley Morris, her husband and small daughter, left Washington County in eastern Iowa for Oregon. Among the items they took with them was a bolt of solid purple fabric. This fabric was used for two purposes, as baby clothes for the daughter Almedia would have in 1852, and as part of a Wandering Foot quilt pieced along the trail in 1851. The Morris family arrived in Oregon in November 1851, and joined Almedia's parents, who had traveled the trail in 1847. The Morris

J&P Coats and Clark Threads used nostalgic images on calling cards to market their quilting threads.

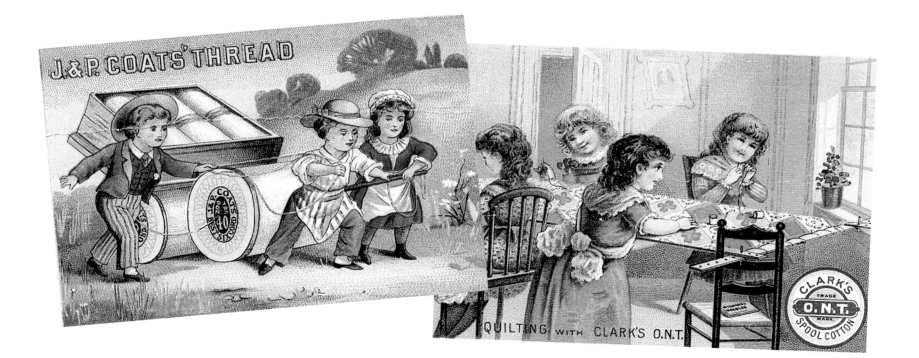

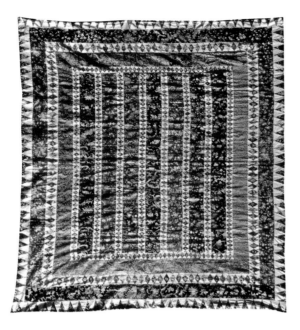

BARS WITH DIAMOND SASHING

Date: ca. 1800–1849 **Maker:** Unknown, possibly from New England **Size:** 95.5" x 103" **Owner:** Courtesy of Michigan Traditional Arts Program Research Collection

The top of this quilt was made in the early 1800s from paisley wool shawls, which were popular during that time. Nearly a century later it was quilted using a 1940s sateen fabric for the backing.

family staked a claim in Benton County, Oregon in 1852.[4]

Mary Margaret Hezlep, aged 15, traveled the California Trail with her family, which included her mother Melvina Shuey Hezlep, grandmother Margaret Shuperd Shuey, and several aunts. The 1859 trip took nearly seven months. Along the way Mary and her family pieced a quilt using the Nine Patch Flying Birds block, which is also known as the Road to California. Mary's family in Illinois had helped cut the pieces the previous year. The blocks are inscribed with the names of the family members traveling with the wagon train, the dates they left Illinois, and the date of their arrival in Columbia, California.[5]

Quilts They Made After the Move

Many more pioneer women made quilts after they settled in new homes. The patterns may reflect those popular at the time they left the eastern United States or new patterns popular in the era in which they are made. These quilts might be made in honor of a new home, or as a way to remember the journey.

Elizabeth Currier Foster came over the Oregon Trail from Missouri in 1846 at the age of 14. She was an orphan, traveling with an older brother, an older sister, and her brother-in-law. They were on the trail seven months. Elizabeth married James Foster in 1848 and settled in Benton County, Oregon. Despite raising seven children, she found time to make numerous quilts for the household. One of these quilts is an appliquéd Rose of Sharon which she finished in 1854. Some of the blocks in this quilt were started while Elizabeth was still living in Missouri; the remainder were made after her arrival in Oregon.[6]

One quilt physically holds the memories of its maker. The family calls it the Quilt that Walked to Golden, but its pattern is better known as the Lone Star. Mary Jane Burgess left Columbus, Ohio, in 1864 for Golden City, Colorado. Her traveling companions were her husband, Thomas, who had previously been to Golden and intended to start a hotel business in conjunction with the Colorado gold rush, two-year-old daughter, and her husband's brother and family. In order to bring as many clothes as possible, Mary wore most of her clothes, in layers, during the long trip. Mary's husband became a successful business man, while Mary set up a household. The clothes she wore on her trip eventually began to wear out. But Mary was frugal; she saved those clothes, cut them into diamonds, and made the Lone Star quilt sometime later in the nineteenth century.[7]

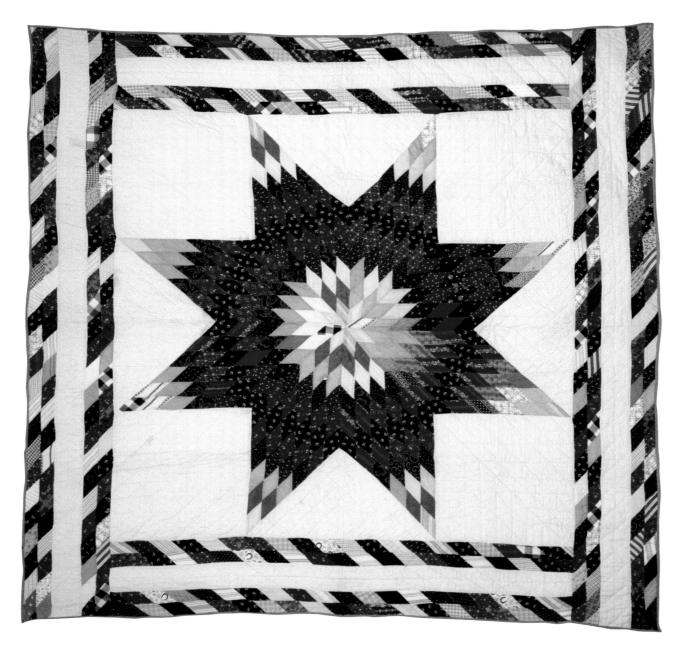

THE QUILT THAT WALKED TO GOLDEN

Date: ca. 1865–1900

Maker: Mary Jane Burgess, Golden, Colorado

Size: 76.5" x 77.75"

Owner: Rocky Mountain Quilt Museum, Golden, Colorado

Based on the Lone Star pattern, this quilt is handpieced and handquilted. Little else is known about Mary Jane and any other quilts she might have made.
Photo by Povy Kendal Atchison, Denver

In less than 75 years, quilters in America changed an entire aesthetic taste from European designs to distinctly American designs. This was due in part to rapidly changing trade routes, successful development of domestic textile production, and continental migration patterns. During the next 150 years, the number and styles of quilting patterns would increase ten-fold. Quilts were destined to be more than just cherished gifts; they became vehicles for social action, fundraising, and community building. Quilts created new business opportunities and eventually moved from bed coverings to objects of art.

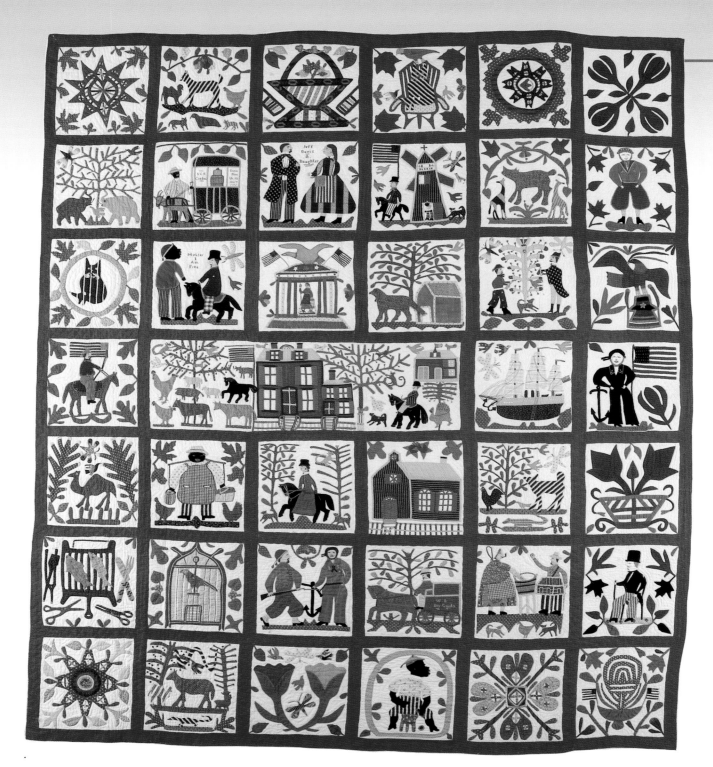

Commemorative Quilting

When making quilts became a popular fad, I turned to that pastime. I decided that I would make an embroidered record of the persons responsible for Oklahoma's history. Then the thought came—"Why not add the incidents making up that history?"

Camille Nixdorf Phelan, Chronicles of Oklahoma, December 1935

RECONCILIATION QUILT

Date: 1867 **Maker:** Lucinda Ward Honstain, Brooklyn, New York **Size:** 84.5" x 97" **Owner:** International Quilt Study Center, University of Nebraska-Lincoln, 2001.011.0001

Lucinda's family owned slaves until 1827. After the state of New York abolished slavery in that year, her family's former slaves continued to live in the same neighborhood, where she saw them regularly. This probably influenced some of the blocks in her quilt.

Detail, Reconciliation Quilt
Courtesy of the International Quilt Study Center, University of Nebraska–Lincoln, 2001.011.0001

Tana Angerman quilts the red, white, and blue top, using a long-arm quilt machine she's nicknamed Electra, a heroine of Greek mythology. Her two small sons play on the floor of her sewing room, occasionally helping, picking up dropped pins and needles, and sometimes getting in the way. Tana needs to finish the quilt. It is one of many quilts going to soldiers wounded in Afghanistan or Iraq that will be distributed through the Quilts of Valor project. It is Tana's hope that the quilt's warmth and bright colors will provide some comfort during treatment and reassurance when the soldier returns home. Tana sees first-hand the pressures of military service and the effect combat wounds have on body and soul. She and her husband grew up in military families, and her husband is now stationed at F. E. Warren Air Force Base in Wyoming. While Tana quilts in the twenty-first century, she is carrying on a tradition that reaches back to the

Quilts are visual documents of our nation's history.

beginnings of our country—using her quilting skills to honor the people and events that create our nation's story.

Quilts are visual documents of our nation's history. They can be made to celebrate an important event or record a tragedy. These quilts will not allow us to forget that we are indeed bound together as a nation despite ethnic, religious, political, and economic differences. A quilt is considered commemorative for many different reasons. Some are ordinary quilts that have led extraordinary lives, such as the many quilts that survived the Civil War. Although made in designs common for the time period, the quilts provided warmth to soldiers or raised money to protect citizens. Other quilts were specifically created to remember an event, perhaps a centennial or bicentennial. These quilts often include blocks representing contemporary versions of historical events. And quilts that are made to protect and warm a specific group of people may also be considered commemorative. Those quilts made for victims of disaster and war have the potential to be kept for generations as a remembrance of past adversity and as hope for future successes.

THE CIVIL WAR

During the Revolutionary War, women used their needles to pro-vide clothing, banners, and flags for the men fighting the long battle for freedom from England. Women also stitched during the War of 1812 and the Mexican-American War of 1846–48, although very little documentation exists of quilts made specifically in commemoration or in support of these wars. Some Album quilts of the mid-nineteenth century do include appliqué blocks that represent events in the new nation's history. A quilt in the collection of Vermont's Sherburne Museum contains a block dedicated to Major Samuel Ringgold, who served in the Mexican-American War. Many twentieth-century commemorative quilts include events from the early nineteenth century, especially as they relate to the community of the quilt's origin. The Civil War is, therefore, the first national war to be recognized by quilters on a large scale.

From a modest beginning of just thirteen states located predominantly along the Atlantic coastline in 1776, the United States grew rapidly in both population and territory. By 1853 the United States had "purchased," claimed, or had ceded to it the entire area that now makes up the contiguous 48 states.

Politically managing this vast amount of land created problems within the federal government and between the states, as differences in economic needs and social interests

became more apparent. One of the main points of contention was the issue of slavery. The northern states had abolished slavery earlier in the century, while it remained an institution in the south. Despite several legislative attempts to bring the sides together, the debate over slavery escalated.

By February 1861, seven states had seceded from the United States to form the Confederate States of America (CSA). Over the next three months a total of eleven states joined the CSA: Virginia, North Carolina, South Carolina, Georgia, Tennessee, Arkansas, Texas, Louisiana, Mississippi, Alabama, and Florida. Border states Missouri and Kentucky maintained representatives in both the United States and Confederate States governments, and the area now known as West Virginia seceded from Virginia in order to stay with the Union.

On April 12, 1861, the Civil War ignited when Confederate troops attacked Fort Sumter in South Carolina. The war, which was fought predominantly in the South, would claim the lives of more than 600,000 soldiers and injure more than 400,000. In addition to these lives lost, there were thousands of civilian casualties and thousands of displaced residents of all colors. Property damages, especially to homes and businesses in the South, were incalculable.

United States Sanitary Commission

At the start of the Civil War, numerous charitable groups formed to provide services to the military and its soldiers. The War Department authorized the United States Sanitary Commission in June 1861 in an attempt to coordinate the efforts of these volunteers. The Commission organized medical supplies for Union soldiers, supervised the conditions in hospitals and trained nursing staff.

For the first time in U.S. history, large numbers of women volunteered their time in professional capacities. In addition to providing bandages and supplies, they organized fundraising Sanitary Fairs, generating several hundred thousand dollars, more than three million dollars in today's terms.

The U.S. Sanitary Commission also asked women to sew clothing and quilts for the soldiers. During the war, more than 250,000 quilts were distributed. Measuring 48 inches wide and 84 inches long, the quilts were intended for use as bedrolls or to cover hospital cots. Most of these quilts were lost, worn out, or buried with the soldier. Today, only five known examples survive. The only publicly owned quilt is in the Lincoln Memorial Shrine in Redlands, California. While these quilts were intended to be used rather than to commemorate, the volume of quilts made in this short time

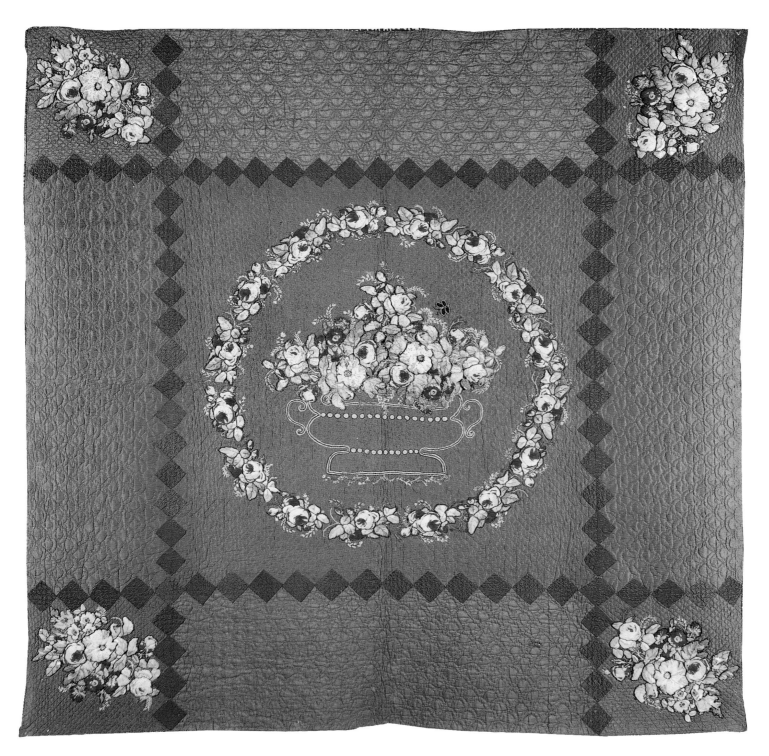

GUNBOAT QUILT

Date: Ca: 1857–1865 **Maker:** Martha Jane Singleton Hatter, Selma, Alabama **Size:** 66.5" x 65.5"
Owner: Birmingham Museum of Art, Alabama; museum purchase with partial funds from
the Quilt Conservancy

Martha used the broderie perse *technique as a medallion appliqué, to create a quilt that raised
more than $1,000 for Alabama gunboats. The quilt is made from cotton, taffeta, and silk, and
includes trapunto.*

by so many women is a testament to their commitment to family, friends, and country.

Alabama Gun Boat Quilts

Quilting to support the Civil War efforts was not limited to the Union. While high cloth prices and low availability limited the number of quilts provided to soldiers, a few dedicated Confederate women used their skills to create beautiful fundraising quilts. Notable among these quilts are the Alabama Gun Boat Quilts.

By the second year of the Civil War, the Confederate military lacked the resources to protect cities situated on major waterways. One of these cities was Mobile, Alabama. In the winter of 1862, southern women began raising money to purchase a gun boat to protect the city. Women offered small cash donations, sold objects of value, and created quilts to be auctioned.

Six gunboat quilts were made, and two are still in existence, one in the Birmingham Museum of Art, and the other at the First White House Museum in Montgomery. Martha Jane Singleton Hatter Bullock created both quilts. She was a widow with two sons serving in the Confederate Army. The quilts use an appliquéd medallion design popular in the early nineteenth

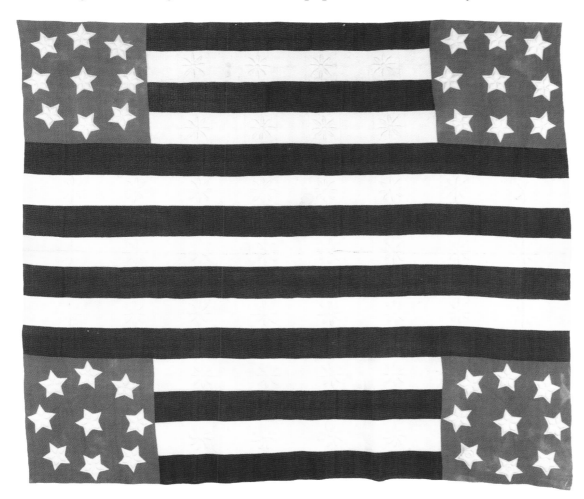

CONFEDERATE SECESSION QUILT

Date: 1861 **Maker:** Mrs. Green McPhearson of West Point, White County, Arkansas

Wife of a Confederate officer, Mrs. McPhearson made this finely quilted patriotic quilt to commemorate Arkansas as the ninth state to secede from the Union. From the Collection of the Historic Arkansas Museum, Little Rock, Arkansas

century. The first quilt was auctioned, paid for and returned for a second auction. The second quilt was auctioned four times. Martha's financial contribution to the Gun Boat fund exceeded $1,000 in 1862, equivalent to $20,000 in 2007.

Unfortunately, Mobile never received its gunboat, as the funds raised amounted to a small portion of the $80,000 required to purchase the boat. In spring 1862 the funds were disbursed to area hospitals.

The Reconciliation Quilt

The bitter Civil War finally came to an end on April 9, 1865, when General Robert E. Lee surrendered to General Ulysses S. Grant at Appomattox Courthouse, Virginia. Six days later Abraham Lincoln was assassinated by southern sympathizer John Wilkes Booth, creating both sorrow and new animosities within the country. It would take several generations for the nation to recover from the devastation of the war. The period of reconstruction in the south, which officially lasted until 1877, had mixed results. While some federal support was provided, the economy remained depressed, as many families and communities lacked the resources to rebuild. People of all races struggled to adapt to the new social structures brought on by the elimination of slavery.

One of the most valuable quilts in the collection of the International Quilt Study Center, Lincoln, Nebraska, is Lucinda Ward Honstain's 1867 Reconciliation Quilt. This exquisitely appliquéd quilt contains 40 original pictorial blocks. Each block has a scene depicting domestic or public life before or after the Civil War. Politically charged blocks contain images of Confederate President Jefferson Davis and African-American freed men. The belief is that the maker wanted to mark the period of reconciliation between north and south following the Civil War.

Lucinda had first-hand experience with slavery. She was born in Ossining, New York, in 1820 and spent most of her life in New York City. Her parents owned slaves until 1827 when New York enacted an emancipation law. Her father was a dry goods merchant. In the quilt, she included scenes common during her childhood. This was obviously not her first quilt, but only one other quilt came down through the family. Both quilts are part of the International Quilt Study Center collection.

The Reconciliation Quilt is valuable as a snapshot of the memories of one woman during Reconstruction. As of 2002, the quilt also held the world-record price for a quilt sold at auction. In 1991 Sotheby's in New York auctioned the quilt for $264,000.[7] A few years later it was acquired by quilt collectors Robert and Ardis

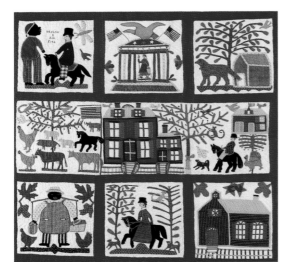

Detail, Reconciliation Quilt
Courtesy of the International Quilt Study Center, University of Nebraska–Lincoln, 2001.011.0001

James. This quilt was one of 1,100 quilts that the couple has donated to the International Quilt Study Center.

CENTENNIAL QUILTS

Celebrating the birth of a nation, an organization, or an idea is an opportunity for quilters to show off their skills and appreciation for history. The centuries-old tradition of quilting is ideally suited for the commemoration of historical events, giving quilters the opportunity to practice the craft of their forebears. New materials, patterns, and techniques allow the quilter to experiment, and produce a fresh and inspirational interpretation of the event. Since quilts are typically large projects made by combining individual blocks, assembling a quilt is a great way to bring together many members of a community.

The United States Celebrates 100 Years

The year 1876 was notable for many reasons. Alexander Graham Bell patented an invention that would forever change communication around the world—the telephone. The presidential election between Republican Rutherford B. Hayes and Democrat Samuel Tilden ran into a roadblock, with vote total in four states disputed. Hayes won the contested votes when he agreed to end Reconstruction in the former Confederate States. General George Custer engaged

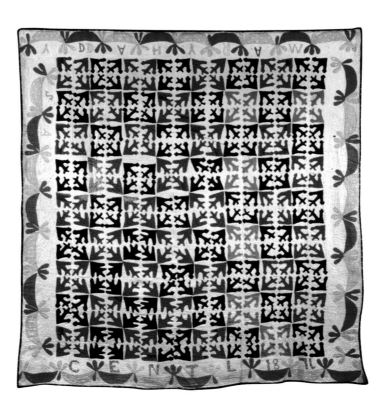

Lakota and Cheyenne warriors at the Little Big Horn River in Montana, resulting in the death of 263 soldiers. And the United States of America turned 100 years old on July 4.

This was a joyful occasion for much of the country. The nation was just recovering from the trauma of the Civil War, a long period of time when there was little to celebrate. Honoring the United States' birth was an important part of the healing process. The country was also in the midst of an industrial revolution and continental expansion. The Centennial was an opportunity to proudly showcase this growth.

The Centennial International Exhibition opened in Philadelphia on May 10, 1876. Philadelphia, the city where independence was originally proclaimed in 1776 and where the Constitution was written, was a nat-

CENTENNIAL QUILT

Date: 1876

Maker: Mary Haddy, Cape Cod, Massachusetts

Size: 86" x 88"

Owner: Collection of the New England Quilt Museum, Lowell, Massachusetts, gift of the Binney Family, 1991.25

Mary Haddy appliquéd the following on the horizontal borders of the quilt: MARY HADDY S A CENTL 18 76. The quilt is hand-quilted and hand-appliqued. The appliqué motif appears to be an orginal design. Photo by Ken Burris

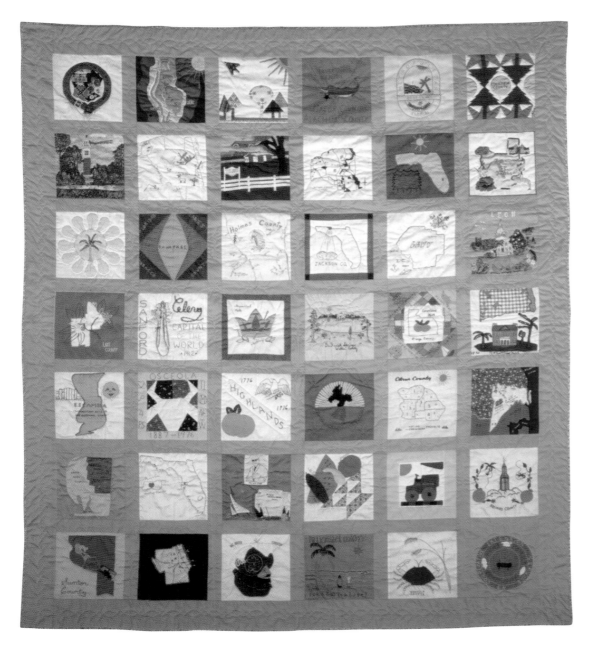

FLORIDA BICENTENNIAL QUILT

Date: 1976 **Maker:** Extension Homemakers Group of the Florida Cooperative Extension Service **Size:** 75" x 87.5" **Owner:** Museum of Florida History, Florida Department of State

Members made 42 blocks, most representing Florida's communities. Among the blocks are Sanford, the celery capital of the world; Suwannee, Florida's largest tobacco producing county; and the Extension Services official seal.

ural choice to host the nation's birthday. Exhibits included new developments in agriculture, science, and technology including the latest harvesting machines, electrical lights, and the telephone. There were pavilions representing the world's nations and an innovative Women's Pavilion, where, for the first time at a major fair, the work of women was exhibited as an economic product.

Needlework of all types, wood-

carving, and inventions, such as the Life-Preserving Mattress designed by a woman from New York, could all be found in the Women's Pavilion. One of the most popular exhibits at the fair was the Japanese pavilion, where the arts and crafts of Japan were displayed for the first time in the United States. Japan had recently entered the world trade markets, and its culture was still a great mystery to much of the world. Exquisite porcelain vases with crazed or cracked finishes and silk clothing designed with a seemingly random patchwork known as *yosegire* intrigued American attendees. The Japanese style appealed to Victorian-era Americans, and their newly acquired taste for opulence. The art world in general was enthralled with the aesthetic styles from Japan and China, and soon the textile industry followed suit. Lush silks and velvets became more readily available and quilters used the scraps from these luxurious fabrics in their quilts. The art of Japan is often credited as the inspiration for the wildly popular crazy quilt patterns of the late nineteenth century.

Across the country women also created centennial quilts using red, white, and blue fabrics and decorated the quilts with flags, eagles, and other patriotic symbols. These quilts were one of the first commemorative decorative arts produced in the United States.

Spirit of '76

In some ways, 1976 was eerily reminiscent of the 1876. The nation had just exited from the bitterly divisive war in Vietnam. Political strife and illegal practices had forced the resignation of Richard Nixon. Steve Jobs and Steve Wozniak created the Apple I microprocessor, an invention that would change the way the world communicates. And the country was ready for another birthday.

Communities large and small began planning activities several years in advance. From July 4, 1974, through December 31, 1976, CBS Television aired Bicentennial Minutes. The series featured Hollywood celebrities and famous politicians. Starting with the words "two-hundred years ago today" Americans were regaled with 60-second tales of the events leading up to the Independence. For a country so recently at odds, the Bicentennial was an opportunity to forge solidarity.

The 1976 Bicentennial is often credited with instigating the late twentieth-century quilting renaissance. In fact, interest in quilting and other handcrafts had grown significantly since the late 1960s, fueled by the Baby Boomer "back-to-nature" philosophy and the growing women's movement, which fought for increased recognition of women's work. The Bicentennial did create a very public occasion for women to exhibit their quilts, and it brought people together to make community bicentennial quilts. The community quilts were often intended as presentation quilts, and contained blocks depicting historic events, people, and places in the region.

The Dane County (Wisconsin) Bicentennial Quilt is one example of a quilt project that truly brought an entire community together for its production. Inspired by other community-based quilt projects in Wisconsin, the University of Wisconsin Extension Office solicited block contributions from the 60 municipalities that made up the county. Each was asked to create a block that would depict an important event or place in its history. In a unique demonstration of unity and sharing, all 60 municipalities participated by contributing a quilt block. The patches were assembled in Mazomanie around the central feature of the quilt, the county seal, which was sewn in Belleville. Blocks include the oldest Catholic Church in the county at Roxbury; the first Rural Free Mail delivery in the state at Bristol, and the wetlands surrounding Dunn. At the March 1976 Dane County Heritage Days, the pieced quilt top was stretched on a rack and attendees were invited to help with the quilting. By the time the quilt was finished, more than 3,000 people participated in its construction. The quilt is now housed at the Dane County Area Agency on Aging building.

DETAIL, DANE COUNTY BICENTENNIAL QUILT

Date: 1976 Maker: Citizens of Dane County, Wisconsin Owner: Dane County Area Agency on Aging, Madison, Wisconsin

This pieced and embroidered block of the Commercial House was contributed to the Dane County, Wisconsin quilt project by the citizens of the Village of Black Earth.

The 1970s Redefined Quiltmaking as We Knew It

by Jean Ray Laury

Jean Ray Laury is a quiltmaker, designer, teacher, and writer. Her quilting career began in 1956, when she created an unconventional quilt about her children to satisfy requirements for a Masters Degree in Art from Stanford University. She is a prolific and creative quilter, and author of many books and articles on quilting and crafts, including The Creative Woman's Getting-It-All-Together at Home Book, Ho for California: Pioneer Women and Their Quilts, *and the children's book* No Dragons on My Quilt. *Her quilts appear in one-woman and group shows around the country.*

In this essay, Jean remembers the beginnings of the late twentieth-century quilting revival, and quilting's role during that time in the development of women's support networks, and ultimately the feminist movement.

PRESIDING OVER THE BOARD, PART OF THE HOUSEWIFE'S FANTASIES SERIES
Date: ca. 1970s **Maker:** Jean Ray Laury, Clovis, CA
Size: 22" x 32" **Owner:** Jean Ray Laury

The feminist movement led to the reevaluation of women's roles. This panel, part serious and part tongue-in-cheek, sees corporate overtones in a common household task. Humor was crucial in these life-altering transitions. Jean used wool felt, floss, thread, appliqué, and embroidery in this quilt.

A young reporter approached me during the festive opening of a mid-1970s exhibition of my work. He asked me, in a whisper, "Are these pieces positive or negative?" He referred to a series of panels called "The Housewife's Fantasies," and he'd been scrutinizing them. His worried look betrayed fear of opening a hornet's nest.

"They're definitely positive," I said. "I'm a housewife, so of course they are positive." Relief flooded his face, and he subsequently photographed my work and me, and wrote a great review.

His apprehensions were typical of the '70s, and many women felt the same way…a little threatened by feminism. It was a feeling similar to what many traditional quilters felt when contemporary quilts first gained guarded recognition. The traditionalists didn't view the newer work as part of a continuum, but rather as something separate.

The Fantasies Series actually dealt with the realities of daily life. In one of the quilts, a woman floats above the steam at her ironing board. I named this quilt "Presiding Over the Board," suggesting that she met challenges each day that were equivalent to those of corporate life. Running a home is a business involving a packed schedule (work, school, appointments, games, performances, practices), personnel (children, husband, relatives, friends, teachers), maintenance (doctors, dentists, repairmen), and social demands (inlaws for holidays, thank-you notes, business entertaining, time with friends, church events). With so many tasks to juggle, any woman pursuing her art would inevitably run into conflicts.

When I taught classes, I encouraged women to discuss their lives. All seemed to lack the time to devote to their own work, but experienced a heart-felt responsibility to support other family members in their goals. Hearing about this dilemma time and time again led me to write *The Creative Woman's Getting-It-All-Together-At-Home Handbook*. I interviewed many women for the book, and found them to be insightful about their problems, full of humor, and articulate in expressing their concerns about their own need for creative expression.

Although I talked to these women 30 years ago, their thoughts are just as valid today, when more women work outside the home, often without relinquishing any of their household responsibilities. The idea of finding space and time resonated with women everywhere then just as it does now. The mail I received in response to the book indicated that I had touched a sensitive nerve and reached an eager, receptive audience.

An important facet of my work has always been the support I received from other women. When I married, I was aware that my mother-in-law would have selected someone quite different from me for her son. She'd have preferred a dedicated shopper who was more social. When my husband headed back to graduate school, we decided I'd attend, too, with our two-year-old son in tow. It was my mother-in-law who sent me a check every month (made out to me, not to him) to ensure that I'd stay in school, too. That overwhelmingly important gesture prompted my keen desire to help other women and it created a bond between the two of us. I received my master's degree in design, and along with it a confidence that has been essential in my quilting and writing.

During the 1950s the U.S. Information Service asked to borrow my first quilt as part of a traveling international exhibit. Suddenly, I was able to communicate with women all over the world, through the medium of quilting, and the world expanded.

I received tremendous encouragement in my work from many other women. Among them, Roxa Wright, then creative crafts editor at *House Beautiful Magazine*, commissioned me to write my first article, "Creative Stitchery," which included an early quilt. She in turn introduced me to the editors of *Family Circle, Better Homes and Gardens*, and *Woman's Day* for which I designed quilts in the

1970s. I taught classes, lectured, and wrote. My husband's constant support made this possible since it required a sharing of many responsibilities. Of course I would never have married a man who didn't provide such support, and I offered the same support for his work.

My overall recollection of the '70s is this: Women assisted and bolstered one another. We experienced similar pressures of changing roles and radically changing attitudes. It was, indeed, a liberating, exciting time for women. And the landscape of quilt making expanded at an incredible pace, just as opportunities for women did. I attended the first quilt conference in the country, held in Ithaca, New York, followed by one in Lincoln, Nebraska, and after that, shows slowly began to flourish across the country.

During the 1970s, a friend and I started summer workshops at a mountain resort in California. The brochure stated that these workshops were about fiber arts, but in essence they became support groups and consciousness-raising sessions. I recall the year two men applied. We knew we'd have enjoyed having the men in class and didn't want to be sexist, but we realized that part of our success was because of the all-female enrollment. This seemed like a territorial stance, but a necessary one at that time. An all-female environment encouraged sharing, as many women were hesitant or reluctant to express themselves openly and would defer to men when they were present.

In the 1970s, I enriched my world by teaching extensively in Canada and Europe. But no matter where I was, when we talked about quilting, we talked about women's lives. That was true later, in the 1980s and 1990s, when I taught in South Africa, Australia, and Japan. Women's issues were universal.

Changes were occurring in women's roles at a rapid pace, and many quilters found this disconcerting. Quilting had always been a safe-haven, a shield from social concerns, and now feminist ideas were sneaking in and altering traditional roles. Even quiltmaking was changing and the emphasis on technique was being usurped by concerns of artistic challenges. I was stunned the first time a group of students wanted to know how many stitches to stitch per inch to create perfect quilting. Perfect stitching in a quilt, I responded, is like perfect typing when writing a book. If you have nothing to say, it hardly matters how perfectly it is said. This was not the answer they wanted. They were seeking the comfort of a set of standards.

I realized that many of them felt threatened (along with the marginal few who felt liberated). Values were changing, and the quilts that reiterated our great-grandmother's work, however nicely, were no longer award-winning. The traditional qualities they had always valued no longer rated high, and perfect workmanship had been dethroned. Many were afraid of and bewildered by the changes, and in need of structure, or guidelines.

It was with quilting groups that I most often felt "out of it." I was marginally accepted as an artist (exhibitions establish some legitimacy), but in academic art, needlework was low in the hierarchy totem pole. Publications gave me some degree of credibility, but if it was difficult for me, with books and exhibits to back me up, what was it like for quilters who were just starting? Or for those who just wanted to quilt but had no interest in quilting as a profession?

Where did I belong? I wasn't quite at home anywhere. As a designer and a quiltmaker, I wanted to be part of the quilting community. It was important for me to be there.

It was among other teachers at quilt conferences and symposia that I discovered lasting friends, confidantes, and co-workers. We had faced similar challenges, and were profoundly supportive of one another. Together, we helped other women realize their creative potential and the rewards of their work.

The '70s was a significant period of change, new directions, and reevaluation in quilt making. The feminist movement, the bicentennial and the hippie back-to-the-Earth movement, contributed new ways of looking at quilts. None of these approaches tossed out the old, but we discovered that we no longer needed to copy the work of our predecessors. The 1970s are a rich part of our documented history that led to the vibrant, teeming, energy-filled world of quilt making today.

The past always informs the present. And eventually our present, too, will become the past and will inevitably be absorbed into the growing continuum.

MY WEEK AT A GLANCE

Date: ca. 2005 **Maker:** Jean Ray Laury, Clovis, California **Size:** 49" x 60" **Owner:** Jean Ray Laury

According to the maker, "Women's lives involve hundreds of interwoven decisions and plans which seldom work smoothly. Plan a party, and the plumbing will go berserk. Arrange lunch with friends and your root canal tunes up. It's the way life goes, and this panel celebrates the inevitable discrepancies with color and humor." Jean used wool, felt, paint, floss, silkscreen, appliqué, embroidery, and thermofaxed computer lettering to complete this quilt.

Lewis and Clark Bicentennial

The United States government acquired land from France that would eventually become the states of Arkansas, Colorado, Iowa, Kansas, Louisiana, Minnesota, Missouri, Montana, Nebraska, New Mexico, North Dakota, Oklahoma, South Dakota, Texas, and Wyoming. The deal more than doubled the physical size of the country. President Thomas Jefferson commissioned the Corps of Discovery to record the natural history of the area, build relationships with the native people, and search for an all-water route to the Pacific Ocean. The Corps, led by Meriwether Lewis and William Clark, left St. Louis in 1804 and returned two years later. While the explorers did not find the water route, they did develop relationships with many native people, and perhaps most important, they recorded detailed information about the land and people in their travel journals. The Louisiana Purchase ultimately led to the expansion of the United States across the North American continent, increasing the amount of land for settlement by immigrants from around the world and putting into motion years of conflict with the native people who inhabited the land.

The United States celebrated the Lewis and Clark Bicentennial from 2004 to 2006. During the nation's bicentennial, committees formed around the country at the state and local levels to bring together people of Native American, European American, and African American backgrounds and coordinate centennial activities. Thousands of people from around the country and the world attended events like the Clark on the Yellowstone, sponsored by the National Lewis and Clark Bicentennial Council and hosted jointly by the National Park Service and the Crow Indian Nation at Pompey's Pillar, Montana. Held in July 2006, the event introduced visitors to present-day and historic Crow Nation culture, Corps of Discovery historians and artists, and members of the Corps of Discovery II, a group of volunteers who re-enacted the original 1804–1806 expedition in real time. The goal of each commemorative event was to acknowledge, celebrate, and sometimes protest the United States' purchase and exploration of the Louisiana Territory.

The Corps of Discovery Bicentennial was also an opportunity to share the art of quilting. Windham and Moda fabrics both released Lewis and Clark fabric lines. The Windham collection featured reproductions of early nineteenth-century prints, while quilt historians Barbara Brackman and Terry Clothier Thompson designed the Moda quilt fabric line featuring prints and checks in 1800s colors and designs. Hancock Fabrics offered a Lewis

and Clark Block of the Month in its stores across the country. Paducah, Kentucky, was home to William Clark. To honor this connection, the Museum of the American Quilter's Society installed five life-sized Lewis and Clark statues on the museum's ground. Quilt artists designed their own quilts in response to guild challenges and public shows as well as for community presentations.

Mapmakers: An Award-Winning Quilt by Cassandra Williams
Oregon quilt artist Cassandra Williams creates quilts that document events that have affected the American people and the Pacific Northwest. Her quilt Mapmakers won the best of show award at the Lewis and Clark National Competition held at the August 2003 American Quilters Society Quilt Exposition in Nashville, Tennessee. The quilt was purchased by the Museum of the American Quilter's Society and traveled the country during the Bicentennial. Cassandra's quilt shows intricate detail and accurate representations of Fort Clatsop, Oregon, where the expedition wintered in 1805–1806, and earth-covered lodges, a common sight in the Northern Plains during the early nineteenth century.

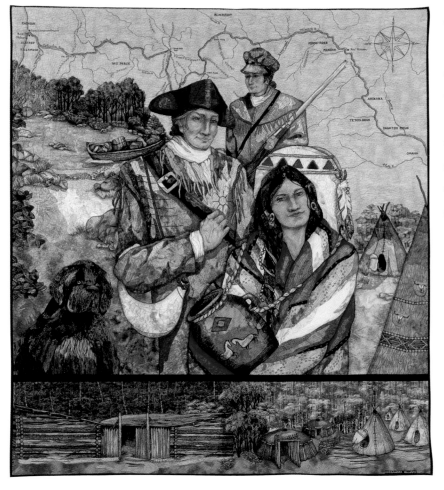

THE MAPMAKERS

Date: ca. 2003 **Maker:** Cassandra Williams, Grants Pass, Oregon **Size:** 56" x 65.5" **Owner:** Collection of the Museum of the American Quilters Society (MAQS), Paducah, Kentucky

Cassandra's experience as a painter helps her create realistic images of people and places. The Lewis and Clark National Bicentennial Committee requested the quilt be exhibited at museums along the trail during the three-year bicentennial celebration.

The quilt is named for William Clark, who was responsible for creating an accurate map of the relatively unknown land included in the Louisiana Purchase. The quilt also features Meriwether Lewis and Sacagawea, the only woman known to have traveled with the Corps of Discovery. The quilt design elements are enhanced by fabric paints and beads.

Celebrating 300 Years of Oklahoma History

Quilts are an excellent medium for telling a story that is nearly too grand for words. Quilt blocks can act as chapters in a book, facilitating the maker's story, and encouraging the viewer to investigate further.

One such quilt, the Oklahoma History Quilt, was donated to the Oklahoma Historical Society in 1935. This remarkable quilt, made by Oklahoma City native Camille Nixdorf Phelan, is an embroidered masterpiece depicting 300 years of Oklahoma history. The quilt is a testament to one quilter's tenacity and love of history.

In the 1920s, Camille had a passion for embroidery and enjoyed copying pictures to cloth using that technique. "When making quilts became a popular fad, I turned to that pastime," Camille explains. "I decided that I would make an embroidered record of the persons responsible for Oklahoma's history.

Then the thought came—'Why not add the incidents making up that history?'"[1]

In order to complete this quilt, Camille spent two years studying Oklahoma history. She researched old records, corresponded with historians, and was able to talk with many people who were part of Oklahoma's recent history. Camille worked on this quilt during the Oklahoma Dustbowl and consequent Great Depression, a time of great sadness and extreme population mobility as families lost their land and were forced to move on. Camille later said she was influenced to create a patriotic quilt because "in most of the published records of this formative period, the sordid and rough element has been exploited to the exclusion of the cultural and artistic…and I want to express my own appreciation for the 'Land of the Mistletoe.'"[2] In doing this, Camille included blocks that represented political events, such as Napoleon signing the Louisiana Purchase; historical events like the Oklahoma Land Run of 1889 and the state's first oil well; and famous people, including football legend Jim Thorpe. And no quilt depicting Oklahoma history would be complete without showing appreciation for Native American contributions to the state's history. Although the story Camille presents is sometimes romanticized, her

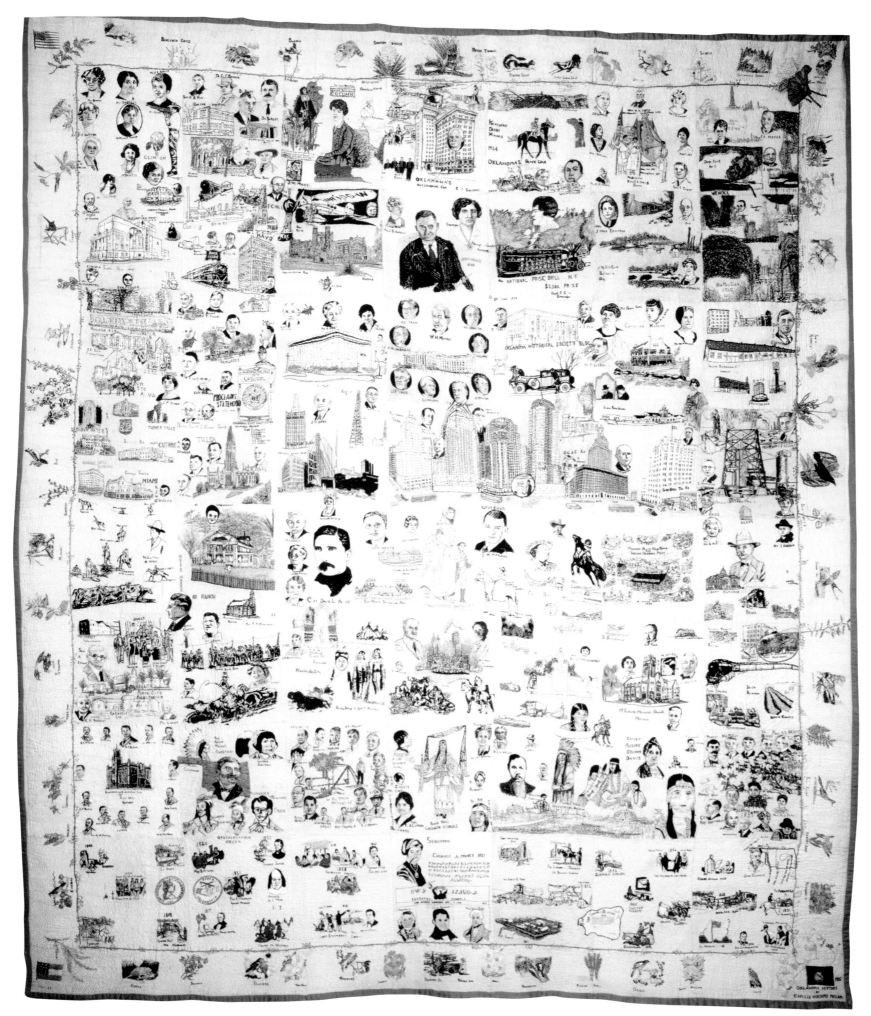

work shows a conscious effort to accurately portray the Native American peoples who lived in Oklahoma over the 300-year time period, including the Cherokee, Osage, Kiowa, and Creek.

The entire quilt, which consists of 51 blocks, took four years to make. Camille spent many hours sizing her drawings to the blocks, creating the outlines of faces, and later adding the expressions. In her own words, "Every stitch of the embroidering is my own work and I spent all my spare time for four years on actual construction." The quilting alone used 20 100-yard spools of thread.[3] Camille proudly presented the Oklahoma History Quilt to the Historical Society at a banquet in Oklahoma City on November 30, 1935.

REMEMBERING TWENTIETH CENTURY WARS

The history of twentieth-century United States includes two devastating world wars and four other conflicts. As the century began, America was still recovering from the Spanish-American War, and by the end of the century memories of the Gulf War were still fresh in mind. Almost all families have stories of loved ones who served. Stories of survival, heroism, imprisonment, and death are recorded by the nation's quilters.

World War I

The United States entered World War I in 1917, but the war had raged across central Europe for three years prior. United States loans supported Allied war efforts against invading Germany, but until 1917 we maintained diplomatic relationships with Germany that prevented entering the military sphere. That changed in February 1917 when Germany rescinded the rights of neutral nations, and President Woodrow Wilson requested from Congress the right to arm merchant ships. On April 6 the United States officially declared war on Germany. The United States participation was short but significant. Eighteen months later on November 11, 1918, the war ended. This date, originally known as Armistice Day, is now celebrated as Veteran's Day, a date to honor all Americans with military service. Although the period of American involvement was short, 4,734,991 Americans served, and more than 111,000 lost their lives.

Red Cross Quilts

Clara Barton founded the Red Cross in 1881 as a liaison between members of the armed forces and their families, and to provide relief in times of disaster. The Red Cross developed local chapters, which promoted community-related first aid and public health nursing pro-

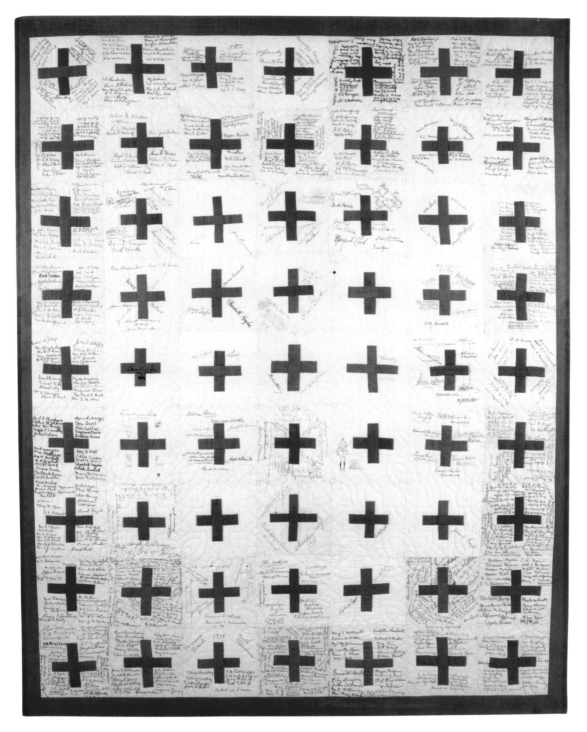

RED CROSS SIGNATURE QUILT

Date: 1918 **Maker:** Santa Monica Grammar School, Santa Monica, California

Owner: American Red Cross

Students made this quilt to show at a Liberty Fair held in Santa Monica in 1918. The quilt features more than 900 signatures, including Theodore Roosevelt and Helen Keller.

grams. When the United States entered World War I, membership in the Red Cross jumped from 17,000 to 20 million as people looked for ways to exhibit their patriotism.

Quilting in general became less popular the first part of the twenti- eth century. Increased textile pro- duction in the United States meant fewer women needed to make household textiles themselves. Many women associated quilting with the crazy quilts of their grand- mothers, which no longer matched modern aesthetic tastes. With the

DETAIL, RED CROSS SIGNATURE QUILT

Courtesy of the American Red Cross

rise in war-related patriotism, however, women returned to patchwork quilting, which in turn reserved important fabric resources for the military and created an outlet for social activism. A unique design was developed, the Red Cross Signature Quilt, a red cross pieced into white background fabric. According to Indiana quilt historian Xenia Cord, the December 1917 issue of *Modern Priscilla Magazine* included a pattern supplied by the Red Cross for this quilt, which recommends that the quilt be used to generate funds for the war effort. Some Red Cross quilts were made for personal use on the homefront, but many were used to raise money for Red Cross work. Individuals paid between 10 and 25 cents to have their names included on the quilts.

Hundreds of these quilts were made, and many examples still exist. The Red Cross owns several of them, including a 1918 Signature quilt. This quilt features more than 900 signatures, including those of Theodore Roosevelt, Helen Keller, and Mrs. Woodrow Wilson. The Santa Monica, Los Angeles Grammar School celebrated this quilt's eightieth anniversary by making a new quilt, which also has 900 signatures. The 1998 quilt includes the signatures of late twentieth century philanthropists, humanitarians, presidents, and other celebrities, including Steven Spielberg and Dolly Parton.

World War II

The Treaty of Versailles, signed in 1919, brought an end to World War I, but planted the seed for World War II. The terms of the treaty intended to punish Germany for starting the war, requiring that Germany pay reparations to the Allied countries damaged by the war, relinquish control of its overseas colonies and some of its surrounding territories, and limit the size of its army significantly. As a result, the 1920s and 1930s were a time of poor economic conditions, cultural isolationism, and political extremism in Germany. It was under these dire conditions that Adolf Hitler and the Nazi Party rose to power. In the late 1930s, Hitler's army invaded central European countries and persecuted its own Jewish, gay, atheist, and communist citizens. Germany violated the nonaggression pact it had signed with the Soviet Union in June 1941 when German troops marched across the Soviet border. Germany went on to attack northern European countries in 1940. Once Germany joined forces with Japan and Italy to form the Axis powers, a second world war seemed inevitable.

As in World War I, the United States supported allied Europe through financial loans and equipment. American sentiment, however, was against entering into war

until the Japanese bombed Pearl Harbor, Hawaii, on December 7, 1941. This event thrust the United States into war with Japan and Germany. More than 16 million men and women served in Europe, Africa, Asia, and on the home-front. The increased need for war materials did provide new jobs and opportunities for young women, housewives, and men unable to serve overseas, helping to pull the country out of the economic depression. For nearly four years the country was immersed in war-time activities. Recycling cans and papers for use in the war effort, shortages of personal items such as shoes and clothing were commonplace. Quilters found it difficult to find new fabrics and sewing notions.

The war in Europe ended in May 1945, when Allied Forces and Germany entered a peace agreement, just a few days after Hitler's suicide. The Pacific War ended four months later, when the United States dropped the atomic bomb on Hiroshima and Nagasaki.

Gold Star Mother's Quilt

During World War I and World War II, families of service people posted star flags in their windows to

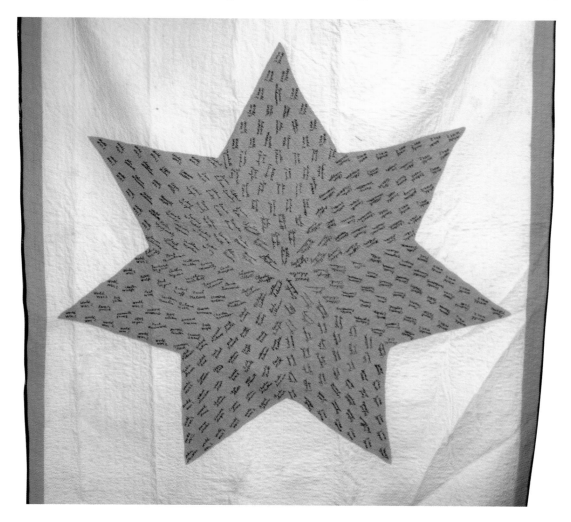

GOLD STAR MOTHER'S QUILT

Date: ca. 1944 **Maker:** Mrs. Earl E. Shaeffer, Zanesville, Ohio **Size:** 68" and 88"
Owner: Collection of the Pioneer and Historical Society of Muskingum County, Zanesville

Mrs. Shaeffer used a Star of Bethlehem pattern to create this quilt. It is the only known quilt in the United States to honor the mothers of gold star veterans. Photograph by Stephanie Kline, Zanesville, Ohio

Mrs. Earl E. Shaeffer, of Zanesville, Ohio, had a gold star flag. Her son, Charles, died in France on June 12, 1944, just one week after the D-Day Normandy invasion.

acknowledge that a family member was serving the country. The War Department issued a series of protocols for displaying the flags. A blue star flag recognized service overseas, a silver star acknowledged that the service person was wounded, and families who lost a member overseas were given a gold star flag. During World War II, more than 400,000 gold star flags hung in windows across the country.

Mrs. Earl E. Shaeffer, of Zanesville, Ohio, had a gold star flag. Her son, Charles, died in France on June 12, 1944, just one week after the D-Day Normandy invasion. She was a member of the Gold Star Mothers Club of Muskingum County, a group of women who had all lost children in World War II. Mrs. Shaeffer made this Gold Star Mother's Quilt in the last year of the war, to honor all the war dead from the county. Each of the seven points has 49 stars, all embroidered with a service person's name.

Opal Marie Ray Bevington of Fort Wayne, Indiana, was more fortunate. Her son Forest survived the war and brought home a souvenir. Forest was serving with Company D of the 44th Army Division in the Austrian Alps. In early 1945 they captured a Nazi military post in Brenner Pass. The Nazi flag was still attached to the flag pole, and Forest brought it home. Opal used the red background to cut patches for tulips in her new quilt. The striking quilt is still in the family's possession, the bright tulips commemorating the safe return of her son.[4]

The Korean War

The Korean War is sometimes called the Forgotten War. It lasted three years and five million people served, many of whom had seen action during World War II. The Korean War, however, unfolded while the United States was enjoying post-World War II prosperity. With adequate military resources remaining from the previous war, the Korean War did not require great sacrifice on the home-front. Fewer Americans were involved in the war on a day-to-day basis than had been in the past.

Hostility between democratic and communist governments played out on the Korea landscape in 1950. United Nations allies sought to halt the advance of forces from the Soviet Union, China, and communist Korea as they marched south through the Korean Peninsula. Soldiers and sailors endured harsh weather conditions and unfamiliar terrain. Casualty rates were somewhat lower than in World War II, and service times shorter. By summer 1953, the United Nations and the communist invaders agreed to a division of Korea at the 38th Parallel, separating the peninsula into communist North Korea and democratic South Korea.

USA Veterans Signature Quilt

Few American quilts are identified as representing the Korean War, perhaps due to the short length of the war, or because during the 1950s quilting was not a popular form of needlework. There are current projects created in memory of those who served during the Korean War era. The USS *Kidd* Veterans Memorial Museum in Baton Rouge, Louisiana, exhibits one of these quilts. The USS *Kidd* is a Fletcher class ship that served in both World War II and Korea, and was decommissioned in 1964. Veterans of both wars are invited to sign the USS *Kidd* Signature Quilt, which hangs inside the main entrance. The quilt also includes signatures from soldiers who participated in other twentieth-century wars.

The Vietnam War

The end of World War II and the division of Germany into Communist East Germany and Democratic West Germany initiated a period of conflict, commonly known as the Cold War, between the United States and the Soviet Union. During the Cold War, which spanned more than four decades, the United States and the Soviet Union battled for control over communist and Democratic countries around the world. In the late 1950s and early 1960s a new hot-spot of communist activity developed in Vietnam.

President John Kennedy was the first U.S. leader to make the commitment to protect South Vietnam, sending 400 U.S. Army Special Forces to train South Vietnamese soldiers in 1961, and 16,000 troops just prior to his assassination in 1963. In 1965 President Lyndon Johnson approved the first direct military actions. Over the next ten years, 3,400,000 service members would be deployed to Southeast Asia, where more than 57,000 would die, and many would be held prisoner or be counted as missing in action. Controversy over the war in Vietnam divided the United States. College students all over the country protested against the war and the protests were not always peaceful. At Kent State in Ohio, four students were killed when members of the Ohio National Guard fired on students at an antiwar protest that turned violent. In a 1967 New York protest, six Vietnam veterans marched in a peace demonstration, the first members of Vietnam Veterans Against the War. The Vietnam War was the first televised war, and citizens watched the day's events unfold on the TV screen while they ate their evening meal. Families were split over the 1972 presidential elections, which pitted pro-war incumbent Richard Nixon, against the perceived radical anti-war George McGovern. For some families

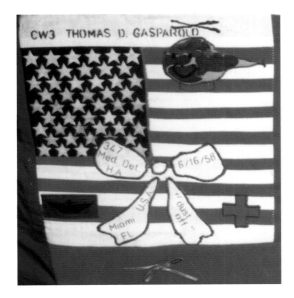

Detail, Operation Desert Storm Quilt
Collection of the Museum of Florida History,
Florida

it was many years before the rifts healed. While Nixon did win a second term, the majority of citizens no longer supported his policies in Vietnam. In April 1975, the United States abruptly left Vietnam after the capitol, Saigon, was overrun by the Communist guerilla troops.

Veterans returning from Vietnam faced an uncertain future. Many felt they left one hostile country and returned to another as the number of political protests increased in the early 1970s and became more personal. Veterans were harassed, ignored, or criticized for their participation. Many found it difficult to return to American society after the deprivations of Vietnam. Returning Vietnam veterans also faced serious health issues. Exposure to Agent Orange, one of the primary chemicals used as a defoliant in advance of military actions, created serious illnesses, resulting in disability and premature death for thousands. Agent Orange also has been linked to birth defects in the children of the veterans.

Gerald LeFevre was one of these veterans. By 1988 his health was severely compromised. During the war he experienced contact allergies, causing him to lose skin off his hands and other parts of his body that had come in contact with Agent Orange. In the 1980s he suffered from emphysema, cancer of the lungs, stomach, and lymph nodes, and congestive heart failure.

He died shortly thereafter. Gerald's wife, Jenny, became one of the Agent Orange Widows, a group dedicated to seeking support for Vietnam War veterans suffering from exposure to the chemical. She started a project called the Agent Orange Quilt of Tears, a collection of many quilts, each containing blocks made in memory of Agent Orange victims and in support of their families. These quilts are exhibited at veteran's reunions, health-care centers, and other public locations. The exhibits include information on the health risks of Agent Orange use and a journal where visitors may record memories of the victims.

The Persian Gulf War

If the Vietnam War was the first televised war, the Persian Gulf War was the first to be broadcast live, as it was happening, from the moment war was declared on January 16, 1991. Iraqi President Saddam Hussein, who had been taunting the international community for several years, had invaded Kuwait, a neighboring oil-rich country and ally of the United Nations.

Although the war itself only lasted a little longer a month, nearly 700,000 U.S. service people were deployed to the Persian Gulf over an eight-month period. They were joined by military forces from more than 30 countries, including Great Britain, Italy, Kuwait, and Australia. American forces conducted a brief air

war, disrupting communications along the Iraq-Saudi Arabian border and in Baghdad, and destroyed the Iraqi Presidential Palace. New computer-driven war technology, short battle duration, and improved medical services kept death tolls low, and the United States achieved its mission to liberate Kuwait quickly.

During the Persian Gulf War, quilting was experiencing a renaissance that had begun in the late 1960s. These new quilters took quiltmaking in new directions, creating quilts that visually documented their lives and their feelings about world events. Many quilters have made quilts to commemorate the war. In 1992, the Houston International Quilt Festival hosted Women in the Eye of the Storm, a Gulf War quilt exhibit. Many of the quilts submitted to the Lands End All-American Quilt contest in 1992 depicted the war. Families of veterans have used uniforms and photos to create memory quilts.

Operation Desert Storm Quilt

Marsha Bean, an elementary school teacher in Coral Springs, Florida, had both a son and a daughter serving in the U.S. Navy during the Gulf War. To commemorate her own children and other soldiers serving in the war, she started the Operation Desert Storm Quilt. What began as a personal home-front project grew into a statewide initiative. As word of the project spread, other military families heard of Marsha's project and sent blocks representing their servicemen and women. Ultimately, the 250 blocks made in Florida and elsewhere were combined to create a 12-foot by 30-foot quilt. The quilt is made in predominantly patriotic colors: red, white, and blue. Most blocks contain the names of loved ones serving in the Gulf and bits of clothing, medals, photographs, embroidery, ribbons, and paint. The quilt hung in the Capitol Rotunda for the 1991 Freedom Festival, and was donated to the Museum of Florida History in 1992.

OPERATION DESERT STORM QUILT

Date: ca. 1991 **Maker:** Marsha Bean and others, Florida **Size:** 12' x 30' **Owner:** Collection of the Museum of Florida History, Florida Department of State

Pictures, ribbons, and embroidery adorn blocks sent to Marsha Bean, each representing a man or woman serving in the Persian Gulf. More than 500,000 people served in the short war, and many came from National Guard units.

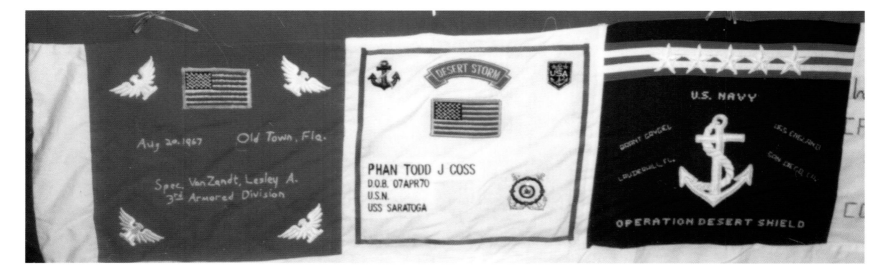

Storm Windows Quilt

Caryl Gaubatz served as an Army Nurse with the 41st Combat Hospital in Saudi Arabia and Iraq from November 1990 to April 1991. Caryl was also a quilter, and on a brief visit home picked up a small amount of quilting fabric so she could do some handpiecing in her tent. She started an Attic Windows quilt, using the fabric from home and fabrics she found in Saudi Arabia and Iraq. A large portion of these fabrics were green Army cravat bandages, which are issued to every soldier. She placed these bandages in the center of the attic window blocks to represent the constant presence of the U.S. military. In the very center of the quilt is an American flag, representing the many small flags brought over by military personnel as a patriotic reminder of duty. Her colleagues gave her other fabrics for the windows, including bandanas, handkerchiefs, and uniform pieces. Caryl traded a box of cereal for one Army nurse's boxer shorts, which became one of the window frames. The quilt was handpieced overseas, and Caryl quilted it after she returned home. She exhibited the quilt at the 1992 International Quilt Festival. Caryl now lives in Garden Ridge, Texas, and is a fiber artist.

September 11, 2001

Like the 1941 attacks on Pearl Harbor, the events of September 11, 2001, were unforgettable. On a beautiful fall day, 19 men trained by the terrorist group Al Qaeda hijacked four airplanes, two in Boston, Massachusetts, and two in Washington, D.C. Two of these planes were deliberately flown into the twin towers of the World Trade Center in New York City, one into the Pentagon, and the fourth crashed in a field in Pennsylvania after the

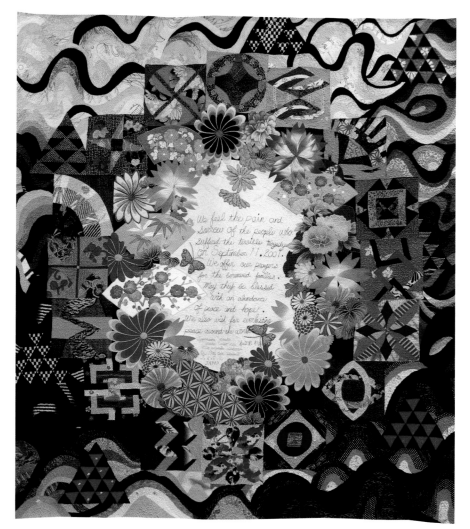

FREEDOM QUILT

Date: ca. 2001 **Maker:** Yasuko Saitoh and students, Japan

Size: 75" x 86.5" **Owner:** Rocky Mountain Quilt Museum,
Golden, Colorado

*This quilt is made from the same silk fabrics used in women's and
children's kimonos. Symbols within the quilt include native Japanese
flowers and shippo, the symbol for peace.*

passengers tried to regain control of the plane. The towers collapsed less than two hours after impact. In total, 2,976 people were killed in the attacks, including members of the New York Police and Fire Departments. Planes nationwide were immediately grounded, stranding millions of people in airports for three days. Subway service was halted and bridges were closed, forcing Manhattan workers to walk the many miles home, or remain in town until service was restored days later.

The outpouring of support for victims and their families was immediate and significant. The American Red Cross was inundated that very day with blood donors and other charitable organizations were swamped with requests to help. Memorials to victims appeared at the locations within hours. Quilters did their part, making comfort quilts for the immediate care of survivors, and later producing quilted works of art memorializing that day.

Freedom Quilt—A Gift from Japan to the United States

The Freedom Quilt was commissioned by Marty Kishiro, the presi-

dent of a Japanese distributor of quilting books, to honor the events of September 11. He donated silk fabric to quilter Yasuko Saitoh, who worked with eight of her students to make the final quilt. The images in the quilt represent the Japanese symbols for peace and protection. In the center of the quilt is the message: "We feel the pain and sorrow of the people who suffered the terrible tragedy on September 11, 2001. We offer our prayers for the bereaved families. May they be blessed with an abundance of peace and hope. We also wish for everlasting peace around the world." The quilt was exhibited at quilt shows around the country, and now resides at the Rocky Mountain Quilt Museum in Golden, Colorado.

September 11 Quilts and the War on Terror

The attacks of September 11 brought forth the support and generosity of an entire nation. Within hours after the crash of Flight 93, quilters began making survivor quilts. One month later, the United States sent troops to Afghanistan to search for members of the Taliban and diminish the power of Al Qaeda, the perpetrators of the attack. This military action was the beginning of the War on Terror.

The Iraq War

In 2003, the United States escalated the War on Terror by sending troops into Iraq. Although the 1991 Persian Gulf War had ended more than ten years earlier, Saddam Hussein had remained in power and was considered a threat to neighboring countries. American troops captured Hussein and attempted to stabilize the region. Thousands of soldiers, men and women, suddenly found themselves going overseas, leaving behind parents, husbands, wives, and children. Quilters again responded to need, providing quilts to honor the dead, protect the injured, and comfort the survivors.

Freedom Quilts

Iowan Betty Nielsen, like many around the world, watched the events of September 11 in horror. Seeking a way to make sense of the attack, she made five Freedom Quilts expressing her feelings for the United States. Then she felt God was calling her to give a greater comfort. Betty and her husband, Dennis, founded Freedom Quilts to provide quilts and comfort to survivors of 9/11 victims. Betty's friend Patty Archer helped sew the quilts. In just a few months they were joined by hundreds of quilters nationwide. As word of the project spread, support came from across the country, as people donated quilt blocks, quilts, and fabric. With the help of church leaders in New York and New Jersey, in December 2001, Betty delivered 1,554 quilts to New

WAR PAINT

Date: ca. 2001 **Maker:** Betty Nielsen, Fonda, Iowa **Owner:** Betty Nielsen

This is one of five original Freedom Quilts made by Betty to honor the victims of September 11. It will be on exhibit when the World Trade Center Memorial Museum opens in 2010. Photograph by Buntrock-Salie Photography, Storm Lake, Iowa

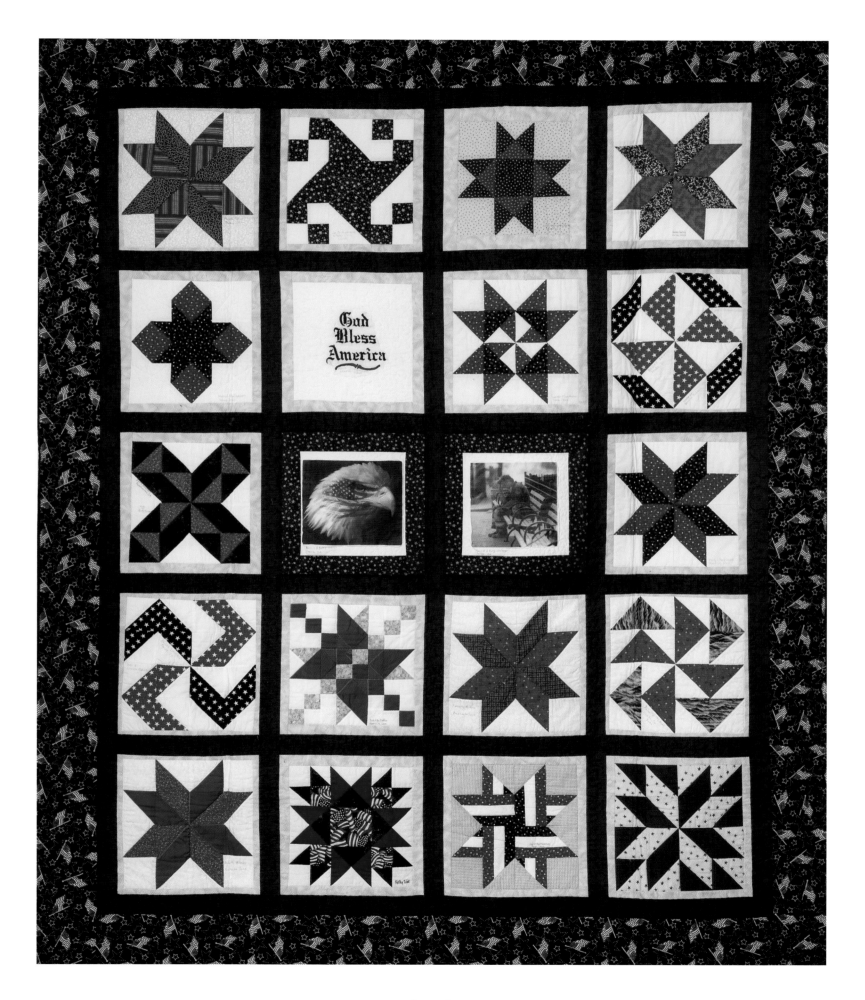

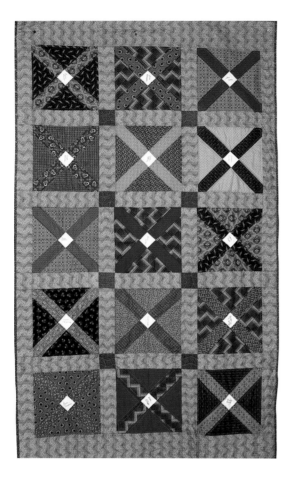

HOME OF THE BRAVE QUILT

Date: ca. 2006 **Maker:** Donald Beld,
Redlands, California **Size:** 48" x 84"
Owner: Unknown

Most Home of the Brave quilts are modeled
on the soldiers quilts distributed by the
United States Sanitary Commission during
the Civil War and use reproduction Civil War–
era fabrics.

York City, short of her goal of 2,500. In January she issued a new call for more quilts through her website, online newsletter, and victim's advocacy groups. Church groups, youth groups, and individuals complied. She returned to New York that summer with more quilts. Betty's website, www.freedomquilts.net, includes letters of thanks from husbands, wives, children, and friends who have received one of Betty's quilts.

In 2004, Betty extended her project to include the families of soldiers killed in Afghanistan and Iraq, and by October 2005 she had distributed 438 quilts to families, with the help of local schools and congress people, who identified families in need. That same year Freedom Quilts also donated 239 quilts to Hurricane Katrina victims. Recognizing that 9/11 survivors still grieve, Freedom Quilts continues to bring quilted comfort to them. To date the group has distributed more than 5,600 quilts through schools, churches, service people, and friends. Freedom Quilts provides quilts to both immediate and extended family members, even if that means sending many quilts in memory of one person.

The War Paint quilt is one of Betty's five original Freedom Quilts. Betty selected two photos for this quilt. The eagle and flag symbolize the emotions of the nation on September 11 and the fireman rep-

resents the hopes and fears of the families. The quilt itself represents the men and women serving our country, both overseas and on the home front. In 2010, this quilt will leave Betty's home in Fonda, Iowa, for its new home in the World Trade Center Museum.

Home of the Brave Quilt Project
Men and women in Afghanistan and Iraq risk their lives every day. Some will not come home alive. The families left behind experience a mixture of sadness, anger, and pride. Don Beld, a California quilter and historian, started a grassroots movement to honor the dead and recognize their families by providing a special quilt to the next of kin.

Chapters in 40 states and Washington, D.C., make replicas of the U.S. Sanitary Commission quilt, which was distributed to Union soldiers during the Civil War. Quilters may submit one block, an entire top, or a completed quilt to the chapter. The quiltmakers embroider each quilt with the soldier's name. Each state chapter arranges their own special ceremonies to present the quilts to the families of the deceased.

The Iowa Chapter also sponsors Operation Cuddle-Ups, an organization that makes baby quilts for the children born to the families of those serving in the military. In 2006, the Iowa Chapter also presented a memorial quilt of Iowans

killed in the war to the State of Iowa, which now hangs in the state capitol in Des Moines.

Quilts of Valor Foundation
Catherine Roberts founded Quilts of Valor Foundation (QOVF) in 2004 when her son Nat was deployed to Iraq as part of Operation Iraqi Freedom. A health-care professional and now mother of a soldier in a combat zone, Catherine founded QOVF with two missions. The first is to provide a Quilt of Valor to all combat wounded service members, whether their wounds are physical or psychological. The second mission is to teach children sewing skills and civic involvement by sewing a Quilt of Valor.

QOVF manages a three-part network of volunteers to create the quilts. The first group is called the Quilt-topper and members make the quilts and provide the backing. Quilt-toppers work as individuals or in groups; some quilt guilds have created Quilts of Valor as their primary charity project. The second group in the network is called the long-armer, which donates batting, thread, and provides quilting services. The final member of the network is the chaplain or social worker who uses his or her connections to medical facilities around the world to identify the wounded and coordinate the presentation and bless the quilt if requested. All quilts include a label and a presentation case.

By December 2006 more than 52,000 service people had been wounded in Afghanistan and Iraq, and at least 7,000 of them had received Quilts of Valor. Thousands of volunteers have spent $900,000 creating the quilts. As the number of wounded grows and more service people are called overseas, Catherine knows that the work has just begun.

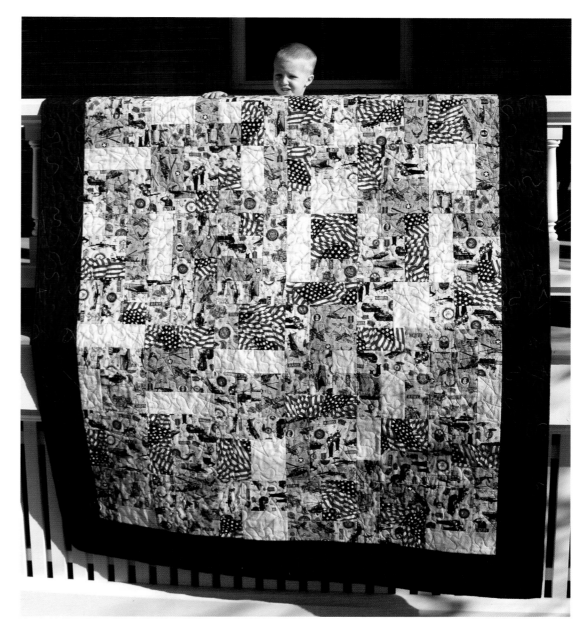

QUILT OF VALOR

Date: 2006 **Maker:** Tana Angerman, Cheyenne, Wyoming **Size:** 58" x 68"

Owner: Unknown

Tana's son was photographed with her quilt on the porch of her home at Warren Air Force Base in Cheyenne, Wyoming. Many Quilts of Valor include patriotic fabrics and themes.

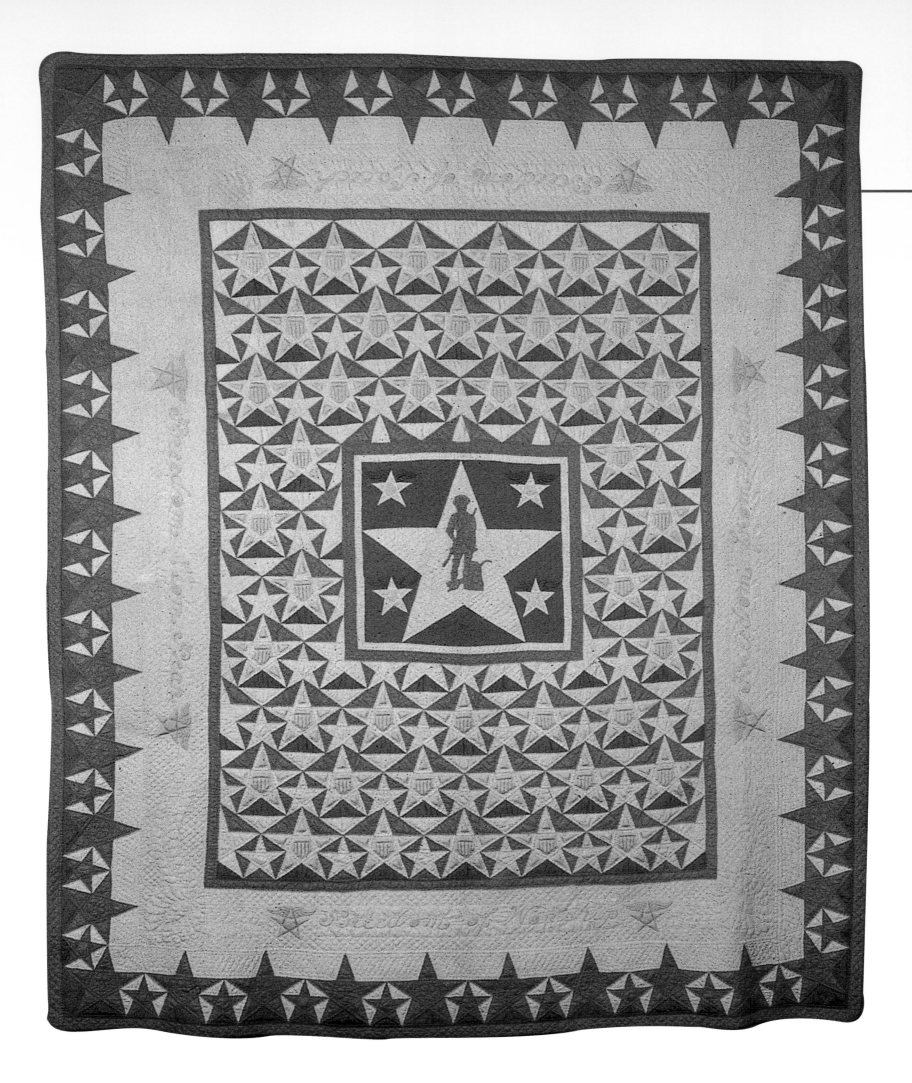

Quilting for Social Change

The steeple of the old Westchester N. E. Church, on E. Tremont Ave., caught fire. Not much damage was done to the church, but the water just about ruined its new green carpet. I often think how many quilting parties the Ladies' Aid Society must have given to buy that carpet.

Beatrice L. Stalter, WPA interview, August 26, 1936

An 1837 abolitionist mother in Philadelphia makes a cradle quilt in memory of an anonymous slave woman whose children are sold away from her. One-hundred-thirty years later, the granddaughters of slaves in Alabama form a quilting cooperative to provide income desperately needed when their husbands are fired from their jobs for exercising their right to register to vote. In Boise, Idaho, today, women and men work to spread the message of peace, using quilts as the medium of communication. United States history contains many acts of social expression. Artists find creative and useful ways to advance their favorite causes, and quilters are among the most prolific artists. The surviving quilts are a testament to their passion, fears, hopes, and tenacity.

FOUR FREEDOMS

Date: 1943 **Maker:** Bertha Sheramsky Stenge, Chicago, Illinois **Size:** 84" x 102"

Owner: Collection of the Illinois State Museum

Bertha's quilt celebrates four freedoms of life in the United States: Freedom of Speech, Freedom from Want, Freedom of Worship, and Freedom from Fear. The center image was inspired by a Norman Rockwell painting.

Detail, Four Freedoms
Collection of the Illinois State Museum

POLITICAL MOVEMENTS

Politics, the theory and practice of running governments, infuses our lives. Each day we are involved with the practice of governance, whether it is the management of families, cities, states, or countries. When we agree with the laws of governance, we are often silent. When we disagree, we vocally share our concerns. We band together in formal and informal groups to exert authority and ensure our voices are heard. In the United States disagreement has come over issues of human rights, health care, and war. Some people become associated with a number of similar movements: many women's suffragists were also active abolitionists and temperance supporters. Some people devote a lifetime to one single cause. Those who quilt add a visual dimension to the protest, as well as leave a tangible historic record.

Abolition/Antislavery

The controversial practice of slavery in the United States preceded the Civil War by hundreds of years. When our forefathers wrote the Declaration of Independence in 1776, they included the phrase "all men are created equal," but rights were not extended to people of color, and slavery was allowed to continue in the United States and its territories. By the early 1800s slavery was abolished in the northern states.

At the same time southern cotton plantation owners became more dependent on slaves to harvest their crops. With the patenting of Eli Whitney's cotton gin in 1794, the device became available on southern cotton plantations. The gin, which made it much easier to extract the cotton seed from the fiber, allowed plantation owners to expand their crop, requiring large numbers of workers. Using slaves reduced costs and increased production.

Slavery expanded in the south despite legislation in 1808 banning the importation of slaves from Africa. The smuggling of slaves continued, and the United States government appeared to ignore the problem by admitting states to the Union that allowed slavery. With the passing of the Missouri Compromise of 1820, the government tried to achieve balance by ensuring that slave and free states would be admitted to the union in pairs. But the Nebraska-Kansas Act overturned the Missouri Compromise in 1854, and states were once again granted the freedom to choose whether or not to allow slavery.

The bloodshed that followed was only a precursor to the long, devastating Civil War to come. Pro-slavery and abolitionist groups raced to settle Kansas, creating two separate territorial capitals: the abolitionists in Topeka, and the pro-slavery settlers in Lecompton, near Lawrence.

Many associated with the abolitionist groups were actually Free Staters, a group that was opposed to slavery because it brought large numbers of black people to the community. These people wanted Kansas to be an all-white territory, so they fought on the side of the abolitionists. The opposing sides launched violent guerilla warfare against each other, resulting in the death of 55 combatants and innocent citizens and significant destruction of property.

Several groups had long advocated abolition, including the Quakers and free blacks. The first abolitionist society, the Pennsylvania Society for the Relief of Free Negroes Unlawfully Held in Bondage, was founded April 14, 1775, in Philadelphia. The Society's goal was to provide jobs and education to escaped slaves. At that time, Pennsylvania and many other northern states still allowed slavery. The issue of slavery was overshadowed by the Revolutionary War and the task of building a new country during the early 1800s. But the movement really took hold when William Lloyd Garrison founded the American Anti-Slavery Society in 1833. Society members agreed that slavery, while allowed by the U.S. Constitution, was against natural law, and therefore illegal. The society's primary goal was to end slavery in the United States, and members took an active role in promoting the society and in legislative activities.

In five years the organization had attracted more than 250,000 members, including escaped slave and abolitionist Frederick Douglass, who served as an eloquent spokesperson for the plight of the slave and author Lydia Marie Child, who edited the society's annual compilation of anti-slavery writings, the American Anti-Slavery Almanac.

The role of women in the abolitionist movement was controversial. Women had few legal rights of their own, and were just becoming active in political and social causes of the time. Some women, such as Harriet Beecher Stowe and sisters Angelina and Sarah Grimke, were outspoken advocates for abolition, while others stayed behind the scenes, providing much-needed logistical support by circulating anti-slavery petitions, fund-raising, and teaching in schools for escaped slaves.

Many women used needlework to express their views on slavery, abolition, and war. Today many of these women remain anonymous. Not concerned with their role in history, but focused on the needs of the present, these women provided quilts and other handcrafted items to sell at Anti-Slavery fairs.

The purpose the Anti-Slavery fairs was to raise funds for society publications and provide money to agents helping escaping slaves. The first fair was held in Boston in 1834 by the Massachusetts Anti-Slavery Society, and other communities, including Philadelphia and New York City, followed suit. The fairs continued until the outbreak of the Civil War more than 20 years later, when people used their talents to support the Union.

Some groups made album quilts that included the names of local abolitionist society members, and anti-slavery statements· One cradle quilt sold at the Philadelphia Female Anti-Slavery Society Fair in 1837 urged the purchaser to "Think of the Negro mother, when her child is torn away." Quilts were also made to provide warmth to escaped slaves. In 1840 the Girls' Anti-Slavery Society of Shrewsbury, Massachusetts, made and sent quilts to the escaped slaves at schools in southern Canada, which had become the safest place for former slaves to settle.

The Hadley Abolitionist Quilt

While Quakers were long associated with the abolitionist movement, they lent their support quietly. Some Quakers, however, thought they should actively participate in abolitionist projects, which led to a schism within the group. At the 1842 Indiana Yearly Meeting for Sufferings, where members discussed actions to take on behalf of persecuted populations, radical group members presented a petition to presidential candidate Henry Clay to free his slaves. Clay was in Indiana as part of his campaign for the presidency and asked to attend the meeting. Although he was able to avoid addressing the issue, more conservative society members felt that the radical members had outstepped the bounds of the mission. The two sects decided to part ways, and the Indiana Yearly Meeting of Anti-Slavery Friends was formed, which took an active abolitionist role.

ABOLITIONIST QUILT, DETAIL

Date: ca. 1840 Maker: Deborah Coates, Lancaster, Pennsylvania Owner: Collection of the Heritage Center of Lancaster County

Deborah used a popular mid-nineteenth-century abolitionist image for the center of her quilt. The same image was also used on china, penwipes, and other household items.

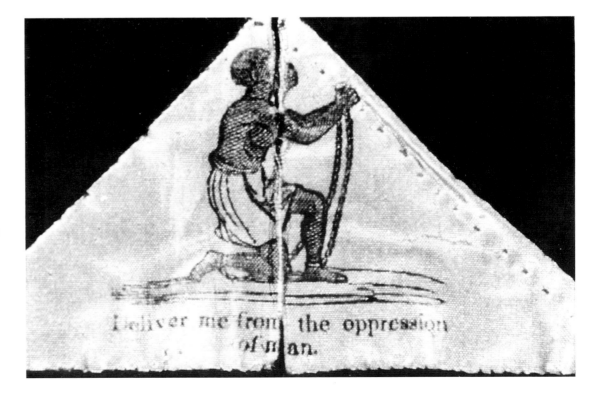

That same year, women of the Anti-Slavery Friends group of Clinton County, Ohio, and Wayne County, Indiana, made the Hadley Abolitionist Quilt. Each of the 16 blocks is signed by its maker, including the Harvey and Hadley families, prominent Clinton County citizens. The quilt may have been made as part of the healing process after the trauma of separation from the main meeting. The groups existed separately until the late 1850s, when they reunited to form one meeting.

Deborah Coates Abolitionist Quilt
This quilt is part of the Underground Railroad quilt code controversy. Quiltmaker Deborah Coates was the wife of Lindley Coates, a Pennsylvania abolitionist and a Quaker. According to the 1837 list of the American Anti-Slavery Society Officials, Lindley was one of the managers for Pennsylvania. His role was to direct the society's activities in Lancaster, Pennsylvania. According to R. C. Smedley's 1883 historical documentation of the Underground Railroad in that part of Pennsylvania, the Coates house was used as a stop on the Underground Railroad. In the 1840s Deborah made a quilt displaying abolitionist sentiments, including a stamped figure of an African-American kneeling and in chains. The quote "Deliver me from the oppression of man" is embroi-

dered under the image. At some point in time, the quilt was divided in half, possibly in an inheritance dispute between Deborah's two granddaughters. The quilt was cut through the center, evenly dividing the kneeling man stamp. Sometime later the two pieces were reunited and sewn back together. The quilt is now safely in the collection of the Lancaster Heritage Center.

Temperance

After the Civil War, women became concerned about a variety of social issues, especially the problem of alcoholism among men. In a time when men held most jobs and controlled the majority of household budgets, alcoholism posed a particular threat to families. Fathers who became alcoholics had trouble holding jobs and supporting their families. Children of alcoholics often lacked necessary food, shelter, and clothing. Mothers also feared the violence that often accompanied high alcohol consumption. Two solutions presented themselves— temperance, meaning people should consume alcohol in small quantities only, and total abstinence.

In 1874 the Women's Christian Temperance Union (WCTU) was founded, the first organization to bring women together in the fight against alcoholism. The group appealed to the average housewife to advocate total abstinence. The

movement, which began in Ohio and New York, successfully spread across the country in less than a year. Although the WCTU originally focused on alcoholism, the movement was predominantly concerned with women's civil rights, and by the end of the century they were involved in the woman suffrage movement. The organization is now the world's oldest nonsectarian, voluntary women's organization and supports reform in marriage and divorce laws, women's shelters, nutritional programs, and world peace issues.

The WCTU selected white and blue as the colors of their organization, symbolizing purity. Individual members made quilts using patterns that signaled their support of the temperance movement. Two quilt patterns often associated with the temperance movement are the Drunkards Path and the Double T, which appear in many colors, but are frequently seen in blue and white color combinations. WCTU Unions also sponsored group-made quilts for auction and signature quilts with the names of members. One of these quilts, known as the Crusade Quilt, was made in 1876 to honor the women of the December 24, 1873, Crusade in Hillsboro, Ohio, where more than 70 women marched upon the local taverns to pray for temperance. The Crusade quilt contained the inked signatures of 3,000 women who were WCTU members in 1876.

Chattanooga, Tennessee, WCTU Quilt Top

Elizabeth Fisher Johnson formed Tennessee's first WCTU chapter in Memphis in 1875, just one year after the national organization began. Chapters were founded in other Tennessee cities shortly thereafter, and in 1882 the Tennessee WCTU was formed, with Elizabeth as its first president. By 1887 there were 130 local chapters, including the Tennessee Black WCTU, an affiliate of the all-white WCTU. While state support for temperance and prohibition waxed and waned in the nineteenth century, the WCTU was also active in other types of reform, particularly reform work related to women's and children's welfare.

The Chattanooga quilt top was designed by Mrs. M. C. Kemp of the Chattanooga WCTU chapter. Funds from the signatures on the top went to the Frances Willard Home "for working girls," built by the chapter in 1897. The top was made in 1898 and 1899. Each of the 42 blocks has an appliquéd white wagon wheel with patron's signatures embroidered within the wheels. The Chattanooga chapter disbanded in 1977, and four years later the chapter president, Mrs. Beulah Pope Troutman, donated the top to the Tennessee State Museum.

T-BLOCK

Date: 1883 **Maker:** Grandma Jones, Minnesota
Size: 66" x 80" **Owner:** Collection of Edith
Buhler, Minnesota

*This quilt is signed and dated by Grandma
Jones. Little is known about the quiltmaker.
The blue and white fabrics represent the
colors of the temperance movement.*
Photo by Greg Winter and Lee Sandberg,
Minneapolis, Minnesota

Woman Suffrage and the Feminist Movement

Quilting and the woman suffrage movement were linked from the beginning. Susan B. Anthony, one of the movement's leaders, was an accomplished quilter by her mid-teens, and she later gave speeches for woman suffrage at quilting bees, an intimate setting that allowed her to appeal to each woman's abilities and needs.

Women who owned property actually had the right to vote in several colonies, including New York, Massachusetts, New Hampshire, and New Jersey. New Jersey's first state constitution stated that "all inhabitants" had voting privileges, and women took advantage of this vague wording. During the Revolutionary War several states changed their laws to allow *all free adult males* the right to vote, and eliminated the property ownership requirement. This revoked women's rights even if they were property owners, and by 1807 no state allowed women the vote.

The woman suffrage movement developed out of the abolitionist movement. Women were primary organizers of anti-slavery associations in the 1830s, despite efforts by

FLORIDA SESQUICENTENNIAL AND 75TH ANNIVERSARY OF WOMEN'S SUFFRAGE QUILT

Date: ca. 1995 **Maker:** Florida Quilt Guilds **Size:** 63.5" x 74" **Owner:** Museum of Florida History, Florida Department of State

Quilt guilds from around the state of Florida submitted blocks for this quilt, which was completed by members of Quilters Unlimited of Tallahassee, Florida. The top was hand and machine pieced, then handquilted.

both church and state to restrain the activities and opinions of women. In July 1848, the first women's rights convention was held at Seneca Falls, and at this meeting a controversial declaration of sentiments was approved. The document mirrored the language of the United States Declaration of Independence and stated clearly the injustices American women suffered. The women's rights movement continued to gain momentum until the outbreak of the Civil War, when many women felt they should help the war effort and work toward citizenship and suffrage for people of color.

By 1870 the movement had resumed its work on women's issues. The National Woman Suffrage Association and the American Woman Suffrage Association formed in 1869, the same year Wyoming became the first territory to allow women the right to vote. Susan B. Anthony, Elizabeth Cady Stanton, Carrie Chapman Catt, and many others appeared at public events to protest the exclusion of women from the democratic process.

In 1886 the Woman Suffrage Amendment actually reached the Senate Floor but was defeated. Gains were made predominantly in the western states and territories, many of which were writing their first constitutions during this time, and woman suffrage activists were able to reach important lawmakers. In the western states, women were also more likely to be property owners. Some historians have suggested that granting women the right to vote was a way to off-set the votes of newly enfranchised African Americans. By the early twentieth century, woman had earned the right to vote in 18 states, including Colorado, Idaho, Washington, and Utah. The Nineteenth Amendment, which granted all women the right to vote, finally passed in 1920.

The struggle for equality did not end when women gained the right to vote. Without economic or political power, women struggled for the rest of the century to retain good jobs, achieve equitable marriage and divorce rights, and find safe and affordable child care and decent health care. The women's movement of the 1960s and 1970s fought for these same issues and lobbied to pass an Equal Rights Amendment to protect the rights of women. A constitutional amendment was never passed, but both the federal government and most states now have laws that protect women's rights.

The Art Quilt Movement: Building Blocks of the Revolution

American society changed drastically in the last four decades of the twentieth century. The turbulent era of the 1960s encouraged artists and crafters to look at their work in new ways, and seek inspiration from nontraditional subjects. Everyday objects such as soup cans and vacuum cleaners became artwork when Andy Warhol included them in his paintings and Claes Oldenburg incorporated them into his sculptures. Paintings with unusual color combinations and large geometric shapes shared exhibition space with the old masters. The feminist and civil rights movements prompted more galleries display work by previously marginalized artists: women and people of color. Artists use their artwork to make social statements on issues as diverse as poverty, inflation, and war. At a time when American society was divided politically, it was also divided artistically, as proponents of "modern art" clashed with admirers of traditional fine art.

Societal changes were the fuel for the resurgence of American quilting. The 1960s back-to-nature movement encouraged a post-World War II generation to learn handcrafts, including quilting. Many of these new quilters had professional training in painting, drawing, and other art forms and were influenced not only by the traditional forms of quilting, but by the world of modern art. Making quilts that were not intended for beds, but to hang on walls, art quilters used many different art forms to enhance their quilts. Not everyone appreciated the end results, and the debate continues over whether art quilting is still "quilting" or another art form.

Civil Rights

The Thirteenth Amendment abolished slavery and the Fifteenth Amendment guaranteed citizenship rights to men of all races. But passing these important laws did not ensure that prejudicial practices would cease. African Americans in particular were subjected to discrimination in both the North and the South. They found it difficult to find adequate jobs, were refused service in stores and restaurants, and were barred from using public facilities, even in states outside of the Deep South. People of color were often the victims of unfair voting practices, including the assessment of exorbitant poll taxes and literacy tests. Groups such as the Ku Klux Klan threatened the safety of African Americans and members of the KKK ruled many of the political and social organizations that would ordinarily protect minorities.

The period of relative world-wide peace and prosperity that followed World War II gave people a chance to examine the inequities within the United States. The Civil Rights movement of the 1950s and 1960s brought together black and white, northerners and southerners, in the effort to take back rights that had been granted 100 years before. In 1954 the U.S. Supreme Court banned segregation in public schools in the now famous *Brown* vs. *Topeka, Kansas, Board of Education* case. In 1955, Rosa Parks refused to give her seat to a white man on a Montgomery, Alabama, bus, an act that began a year-long bus boycott. In his 2005 obituary for Parks, journalist Wayne Greenhaw recalled that Parks later used the quilt as metaphor to describe her experience. "When that white driver stepped back toward us, when he waved his hand and ordered us up and out of our seats, I felt a determination cover my body like a quilt on a winter night."

Over the next ten years, acts of protest, civil disobedience, and military strength pushed public institutions to integrate. Televised coverage of 1960s race riots in Harlem, Detroit, and Watts communicated the violence and despair associated with racism. White America could no longer ignore the forces driving the races apart. Many traveled from the north to share the burden of protest and assist in the voter registration process. The work was dangerous and people were injured and killed for their participation. Yet, through the combined efforts of both black and white, rich and poor, African Americans were finally allowed to register to vote. The struggle against racial prejudice and the push for equal civil rights continues to this day.

Freedom Quilting Bee

From the enactment of the Fifteenth Amendment in 1870 until the Voting Rights Act of 1965, African Americans met with resistance as they registered to vote. In the late 1950s and early 1960s, unfair literacy tests, exorbitant poll taxes, and violence and intimidation prevented many African Americans from exercising their full rights to vote. In some parts of the south, men and women were fired from their jobs for registering to vote. This was particularly a problem in Wilcox County, Alabama, where many families lost their homes and work for black men became scarce. In an attempt to help these families, Francis Walter, an Episcopal priest and civil rights worker, helped found the Freedom Quilting Bee in 1966. The Bee's purpose was to provide jobs for community women to replace part of the income lost when the men lost their jobs for registering to vote. Through

Official State Quilt

Be it resolved by the Legislature of Alabama, both houses thereof concurring, that in recognition of a meaningful symbol for a state quilt, the Pine Burr Quilt is hereby designated as the official state quilt of Alabama.

Acts of Alabama, No. 97–111

Alabama may be the only state to have an official quilt. On March 11, 1997, the Alabama Legislature designated the Pine Burr Quilt the official state quilt of Alabama. This legislation recognized the quilters of Gee's Bend, the efforts of the Freedom Quilting Bee and its role in the civil rights movement. The Pine Burr Pattern is made by folding hundreds of three-inch squares into triangles that are then sewn onto a foundation block in a circular pattern. Due to its difficult and time-consuming technique, only a few quilters today still make this pattern.

The Pine Burr block was made by Qunnie Pettway, of Alabama. The block is made of folded fabric squares, creating a three-dimensional design. Photo by Steve Grauberger, courtesy of the Alabama Center for Traditional Culture/Alabama State Council on the Arts

the Bee, women could work in a communal atmosphere and utilize skills they already possessed to create quilts for markets outside of the county. Father Walter took 100 quilts back north with him, and quickly sold them to stores and individuals in New York City. News of the cooperative quickly spread.

Bloomingdales and Saks were the primary stores to carry Freedom Bee quilts. Estelle Witherspoon, the first president of the Freedom Quilting Bee, is credited with bringing the quilts of Alabama to the attention of the Smithsonian Institution. The quilts were exhibited at the Institution's Annual Folk Life Festivals in the 1970s.

Women came from all over Wilcox County to work at the Bee, full or part-time. In 1968, the Bee purchased land and built a production facility, daycare, and homes in Alberta, Alabama. Sears, Roebuck and Company, which supplied fabric to the Bee, became one of the group's major clients. The Bee made quilts and pillow shams for Sears to sell in their stores and catalog. In the 1990s imported quilts from China flooded stores, including some of the Bee's client stores. The Bee could not compete with the exceptionally low prices of these imported quilts. Product diversity became a necessity, and the Bee became a resource for kitchen textiles and conference bags for clients like American Express and the United Methodist Women Meeting. The Freedom Quilting Bee continued to be the largest employer in Wilcox County through the 1990s.

The quilters of Gee's Bend, Alabama, made famous through books and the quilt exhibit that toured art museums around the country in 2002, first gained national recognition through the Freedom Quilting Bee. The community had been known locally for its quilts since the 1920s, and 30 percent of Gee's Bend women worked in the Bee during the 1960s and 1970s. In 2006, the United States Postal Service offered images of the quilts on a series of first class stamps.

SEEKING PEACE IN OUR TIME

Quilters use their skills to advance causes around the world, and in the late twentieth and early twenty-first centuries that cause is peace. Since 1960, American society has endured three wars, civil rights struggles, poverty, natural disasters, and two violent attacks on public buildings. Following the advice of Ralph Waldo Emerson, groups and individuals create quilts as a bridge to understanding cultural differences and the effects of war on our world.

Peace cannot be achieved through violence, it can only be attained through understanding.

Ralph Waldo Emerson

Boise Peace Quilt Project: Waging Peace from the Quilting Frame

Located in southwest Idaho, surrounded by mountains and desert, Boise, Idaho, is the home of the Boise Quilt Project. Started by 35 quilters in 1981, it has grown to include hundreds of participants across the country who care about the quality of life on Earth. The nonprofit group creates Peace Quilt Awards to honor peacemakers throughout the world. Quilting experience is not required of new members, but a dedication to a peaceful world is.

The Boise Quilt Project awarded the first Peace Quilt in 1982, to the people of Lithuania, when the country was still part of the Soviet Union. Through the gift of the quilt, which contained scenes of Idaho and peace, the makers hoped to create friendship and an understanding of the human commonalities of family, nature, and community. Over the past 25 years, the group has made and distributed dozens of peace quilts to groups and individuals, musician Pete Seeger, farm activist Cesar Chavez, Rosa Parks, and the beloved Mr. Fred Rogers. Believing that quilts are a powerful art form capable of communicating across national boundaries, the project continues to create quilts as political statements, to promote peace and share friendship with people across the world. Recipients include the citizens of Hiroshima, the Peace Camp at Greenham Common, England, and the women of Nicaragua.

In November 1984, the project made the National Peace Quilt, incorporating blocks from each state which represented children's visions of peace. The project asked all 100 senators to spend one night sleeping under the quilt, hoping to keep the idea of peace foremost in their minds. Project members then embroidered the name of each senator on the quilt. The quilt was accompanied by the appeal "REST beneath the warmth and weight of our hopes for the future of our children, DREAM a vision of the world at peace, ACT to give the vision life." Sixty-seven senators did respond to the children's request and spent a night with the quilt. The quilt's journey as it moved across the country from one senator to another is featured in Barbara Herbich's film *A Stitch for Time*.

The Work of Quilt Artist Sharon Rowley

Seattle, Washington, quilter Sharon Rowley creates art combining the themes of peace and nature. She frequently uses the crane, an international symbol of peace, and the Japanese Kanji symbol for peace in her quilt designs. She shares her work and her visions through exhibitions at galleries through the Pacific Northwest. Her quilt In Harm's Way, which incorporates both of these symbols, is in recogni-

IN HARM'S WAY

Date: 2002 **Maker:** Sharon Rowley, Seattle, Washington **Size:** 40" x 38"
Owner: Sharon Rowley

Humanitarian, political, and environmental issues are entwined in Sharon's quilt. This quilt was juried into the 2002 Pacific Northwest Quiltfest held in Seattle, Washington. Photograph by Mark Frey

tion of the environmental consequences of war, specifically the war in Afghanistan. In fall 2001, Kazakh ornithologists feared that thousands of migrating birds, including the rare Siberian crane, would not make it to their homes, as their migration path took them across war-torn Afghanistan. Bombs, airplanes, and reduced habitats created hostile conditions for both humans and animals. In 2002 just one pair of cranes with one chick were sighted along the flyway. International concerns continue for the environmental casualties of war.

QUILTERS SPELL RELIEF

Quilts provide warmth and security. Quilters know that giving a quilt to someone in need aids recovery. Programs large and small, longterm and short-term, help victims of natural disaster, acts of terrorism, and domestic abuse. Quilters generously donate their time and materials to create quilted safety nets for those in need.

Mennonite Central Committee

The Mennonite Central Committee (MCC), the relief and peace branch of the Mennonite Church, formed in 1920 as a response to oppressive conditions in the new Soviet Union. The committee's purpose is to provide support to those in need due to hunger, war, and refugee status.

Quilting is an important part of the relief effort. During World War II, North American Mennonites collected clothing and made quilts for refugees in Europe. Many of these quilts were shipped from a center in Ephrata, Pennsylvania. An Keuning-Tichelaara, a Mennonite resistance worker in Holland, received 50 of the quilts in September 1945. Having no mattresses for the constant stream of refugees through her home, she stuffed mattress cases with quilts. An kept 18 of these quilts. In 1994 she passed the quilts along to Lynn Kaplanian-Buller, an American. The quilts are now part of the exhibit Passing on the Comfort, which traveled North America in 2005 and 2006.

The MCC works through local branches to raise money. An important part of the fundraising is the Mennonite World Relief Sale. Hundreds of Mennonite and Amish quilts are auctioned each year, along with other arts and crafts. In 2006, the Twin Cities Relief Sale featured quilt, an appliquéd friendship quilt, sold for $4,200, an area record. Money raised at the sale is used for world-wide hunger relief, economic development, and to fight AIDS/HIV in Africa.

Project Linus: Providing Security to the Smallest

Few things are more affecting than a child in need. Karen Loucks started Project Linus in 1995 when she saw an article in *Parade Magazine* about a toddler who used her blanket for comfort during chemotherapy treatments. Karen began to make children's blankets, which were distributed at the Rocky Mountain Children's Cancer Center in Denver, Colorado. Named in honor of the Peanuts character who is perpetually seen holding his favorite blanket, Project Linus now has chapters in every state.

Project Linus is an all-volunteer organization headquartered in Bloomington, Illinois. "Blanketeers" quilt, crochet, or knit coverings in sizes to cover babies through teenagers. The project's mission is to provide security coverings to ill, traumatized, and needy children. Hospitals and shelters distribute the blankets. Project Linus has collected blankets for children of 9/11 victims, Hurricane Katrina victims, and many health-care agencies.

HURRICANE KATRINA QUILTS

Hurricane Katrina, one of the largest and most destructive hurricanes in United States history, hit the Gulf Coast in August 2005. It nearly

destroyed New Orleans, Louisiana; Gulfport, Mississippi; and towns all along the Gulf of Mexico. Hundreds of thousands were left homeless, and thousands died in the storm and during the ensuing evacuation. Many more were separated from family and friends, some briefly, others for months. Within days quilters and guilds organized their own relief efforts.

Quilters Comfort America

Houston, Texas, became a destination for refugees. Houston-based Quilts, Inc., sponsor of the International Quilt Festival, responded with a two-part program. The first part provided information and encouraged donations to the American Red Cross Disaster Relief Fund. Quilts, Inc., matched quilters' cash donations to the Red Cross dollar for dollar, donating $10,000.

The second part of the project was to provide bedding for New Orleans refugees, many of whom were housed in the Astrodome. In two weeks, Quilts, Inc., received more than 12,000 quilts and numerous other pieces of bedding. Quilts were distributed to refugees at the Astrodome and in shelters in Houston and Mississippi.

Quilts for the Coast

Patti Brown, the owner of a North Carolina quilt shop, grew up in Waveland, Mississippi. She lived there in the 1960s when the town survived Hurricane Camille, thinking it was the worst disaster that

Patti Brown and friends hold a Quilts for the Coast donation quilt before the distribution in Waveland, Mississippi. Nearly every building in Waveland was damaged or destroyed during Hurricane Katrina, so most of the population was left homeless.

would ever hit Waveland. Hurricane Katrina proved her wrong. Despite a solid hurricane preparedness plan, Waveland was nearly destroyed.

In the hurricane's aftermath, Patti coordinated Quilts for the Coast. Her goal was to give some beauty back to remaining Waveland residents. Working with well-known North Carolina quiltmaker and teacher, Pepper Cory, Patti was able to reach quilters across the nation, asking for donations of quilts and quilt blocks. She received more than 700 quilts. In mid-December, Patti and Pepper made their way to Waveland, with quilts, clothing, and other donations. A tent was erected over the remains of Christ Episcopal Church and the quilts were distributed from that location following a thanksgiving worship service. Patti posts pictures of the 730-plus quilts on her website as an enduring legacy to Waveland.

Chapter 5

Quilting for Identity

Gosh, I finally finished the Red Bottom Tepee quilt so I'm going to tell you a few things about it. The four red petal-like corners represent the four cardinal winds and directions. When we pray we do everything four times. The tepees in a circle means there is strength and unity, and the four in the corners means there are other clans of Assiniboines scattered to the four winds, but we still remember them and they us.

Almira Buffalo Bone Jackson in Morning Star Quilts by Florence Pulford, 1988

TULIP TREE

Date: ca. 1850 **Maker:** Unknown, Woodford County, Kentucky **Owner:** Collection of the Kentucky Historical Society Museum

An unknown slave owned by Alice Haggin made this quilt. The makers of most slave-made quilts remain anonymous, as household records do not include this type of detail.

Detail, Tulip Tree
Collection of the Kentucky Historical Society Museum

Making a quilt allows the quiltmaker to tangibly say "Here I am, I count." If I say "I am a quilter," I am creating an identity for myself, and a link to a larger community. Sometimes quilters define themselves further, identifying themselves by ethnicity or nationality, by gender, or by a certain belief system.

Black Women Have Always Quilted
by Kyra Hicks

Kyra Hicks taught herself to quilt in the early 1990s. Her work has been exhibited at the Smithsonian Institution's Renwick Gallery, Chicago's Museum of Science and Industry, and the Wadsworth Atheneum in Hartford, Connecticut. Her story quilts document her experiences as a young, black single woman, and Kyra teaches the creative story quilt process in workshops around the United States. Kyra is the author of Black Threads: An African American Quilting Sourcebook *and* Martha Ann's Quilt for Queen Victoria. *She showcases African American quilting news on her blog, www.BlackThreads.blogspot.com.*

Kyra's essay describes her early encounters with African American quilts and quilters, and how she has grown as storyteller and quilter through her connections to the Women of Color Quilter's Network.

The first time I was motivated to quilt was in 1991 when I stood in the Taft Museum in Cincinnati, Ohio, and viewed Stitching Memories: African American Story Quilts. I just knew in my soul that I was meant to tell stories through quilts. I wanted badly to be on the walls with Faith Ringgold, Michael Cummings, Clementine Hunter, and others. I couldn't let the fact that I'd never quilted, personally knew any quilters, nor owned a sewing machine stop me.

So, I learned. I glanced through quilt magazines at the supermarket and borrowed library books for the basics. I did not care for the traditional-style quilts typically featured. Mostly the magazines and books preached precision, balanced color pallets, and sharp, matching points. To no avail, I craved articles about bold colors, African Sunbonnet Sue patterns, or unique quilt designs. Where were Black quilters in the magazines and quilting how-to books? Just months after the Taft Museum experience, I made my first quilted wall hanging about my experiences as a University of Michigan MBA graduate student.

I was so excited about quilting that I wanted to learn more about the history of African-American quilting. In fact, I talked my Black Feminist Thought professor into letting me write a paper on the topic. I found scant articles or scholarly work at the time. The primary text I found was Eli Leon's catalog *Who'd A Thought: Improvisation in African-American Quiltmaking* (1988) and an article on the "Aesthetic Principles in Afro-American Quilts" (1983), which declared that quilts by Black folks shared five principles:

Strips construction

Large-scale designs

Strong, contrasting designs

Off-beat patterns

Intuitive approach to design and color

Finally, a recipe for an African-American–made quilt! My Black Feminist Thought professor wrote in bright, red ink on my essay that I had much more research to do—I had to seek the breadth and depth of African-American quilt history. My amateurish research was too narrow. I'm too embarrassed to share what grade I received.

A postage stamp and grace intervened. I read a magazine article about Dr. Carolyn Mazloomi, the founder of the Woman of Color Quilter's Network. I mailed her a letter saying I was a quilter and was glad to know there were other African-American quilters. I put a snapshot of my only wall hanging in the letter. Dr. Mazloomi wrote back, encouraged me to continue quilting and asked me to send her a photograph of my next piece. She welcomed me into the community of quilters of color.

Black women have been quilting in America for ages. Dr. Gladys-Marie Fry documented slave quilting in her landmark text, *Stitched from the Soul: Slave Quilts from the Ante-Bellum South* (1990). *The New York Times* ran an article on June 10, 1893, about quilting and other needlework pieces titled "Work of Colored Women. Some Excellent Exhibits Made by Them at the World's Fair" in Chicago. Elizabeth Lindsay Davis surveyed the National Association of Colored Women (NACW) club activities in *Lifting as They Climb* (1933). The NACW was founded in 1896. Many NACW chapters, such as the Willing Workers of Detroit, the Monday Evening Charity Sewing Club of Texas, and the Sallie Stewart Needle Craft Club of Kansas City quilted to raise money for chapter activities. Nancy Callahan documented one African-American rural quilting cooperative's efforts in *The Freedom Quilting Bee* (1987). In 1992, the *New York Times* again examined quilting with Barbara Delatiner's article "What Quilting Means to Black Women." Noted quilt historian and Quilters Hall of Fame inductee Cuesta Benberry best summarized black quilting activities in *Always There: The African-American Presence in American Quilts* (1992) and Roland Freeman introduced us to hundreds of Black quilters and their stories in *Communion of the Spirits* (1997). Nora Ezell shared her personal experiences quilting in *My Quilts and Me: The Diary of an American Quilter* (1999).

As a Black woman I sometimes felt I quilted in isolation. My isolation centered on being accepted as a quilter. My quilts did not look like any in the quilt magazines. I made up my own patterns. I appliquéd words on to my quilts. Calico fabric and pastel colors bored me. I sang through my quilts using kente cloth, African prints, and loud-colored cottons. I still had not met other Black quilters locally.

Dr. Mazloomi must have felt the same way and took action. In pre-Internet

days, quilting magazines devoted a few pages in each issue to quilter pen pal exchanges, quilt club requests, round robin swaps, and quilt pattern sales. I wonder how Black quilters felt reading ads selling Mammy, Aunt Jemima, Little Black Sambo, or Pickaninnie block and tea towel patterns. The February 1986 issue of *Quilter's Newsletter Magazine* included a tiny request for "Black quilters worldwide" to contact Carolyn Mazloomi. Claire E. Carter, aRma Carter, Cuesta Benberry, Melodye Boyd, Michael Cummings, Peggie Hartwell, and Marie Wilson responded. Under Dr. Mazloomi's leadership, the Women of Color Quilters Network (WOCQN) was founded. The organizations objectives were to:

- Foster and preserve the art of quiltmaking among women of color.
- Research quilt history and document quilts.
- Offer expertise in quiltmaking techniques to enhance the skills of all quilters of color.
- Offer authentic, handmade, African-American quilts and fiber art to museums and galleries for exhibition.
- Assist in the writing of grant proposals related to quilt making for those persons who may have such a need.
- Aid members who wish to sell personally created work at the best price possible.
- Host quilting workshops and act as consultant for organizations seeking African-American lecturers and teachers.
- Provide advice and services for quilt restoration and repair.

The WOCQN has thrived in its 20 years. At one time, the WOCQN had more than 1,000 members worldwide. Sixteen issues (1987–1995) of the now-defunct WOCQN newsletter are in the American Folk Art Museum library collection in New York. Carolyn Mazloomi has curated many WOCQN exhibits. Three WOCQN national exhibits and catalogs include *Spirit of the Cloth: Contemporary African American Quilts* (1998), *Threads of Faith: Recent Works from the Women of Color Quilters Network* (2004), and *Textual Rhythms: Constructing the Jazz Tradition, Contemporary African American Quilts* (2007).

I thrived as a Black quilter by being a member of the WOCQN. Dr. Mazloomi continued to encourage me. Cuesta Benberry pushed me to research African-American quilt history more thoroughly than my University of Michigan graduate school experience. This time I talked to experts and conducted surveys.

From the industry study, Quilting in America, I learned that one in 20 American quilters are African American. In other words, there was an estimated one million African-American quilters in 2000 spending $118 million on quilt-

ing. In 2000, nearly 1,000 quilters responded to my online survey about their quilting. Nine percent of the respondents checked African American. Forty five percent of the Black quilters were 45 to 54 years old. More than one third started quilting between 1990 and 1996. Most of the Black quilters (57.3 percent) showed equal preference for traditional and contemporary quiltmaking styles; 26.9 percent preferred or only made contemporary quilts.

The Internet is connecting Black quilters as never before. Both exhibiting and everyday quilters are showcasing their works on personal websites. African-American quilting guilds have club websites. African-American quilting discussion groups meet constantly on Yahoo, including the African-American Art Quilt group hosted since 1998 by Carole Lyles Shaw. A few Black quilters, such as Elle, the Sew Chick, and Sonji Hunt, blog or write an online diary about their creative quilting process. Some quilters, like Cheryl Sterling-Zeinz, have experimented with quilting podcasts. You can link to several of these sites from www.Black-Threads.com/links.html.

Black women have always quilted and I'm proud to be part of the tradition and the community.

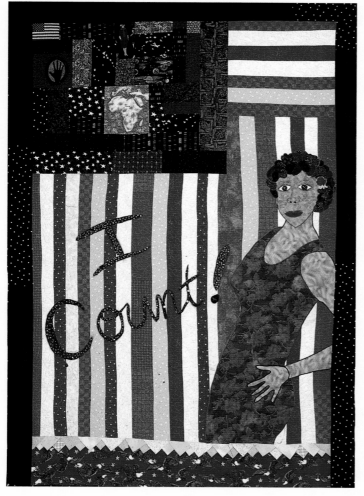

I COUNT!

Date: ca. 2005 **Maker:** Kyra E. Hicks, Arlington, Virginia **Owner:** Kyra E. Hicks

Kyra's work explores political and social themes as they relate to the world of single Black females. In I Count, Kyra has merged symbols of the United States and Africa, acknowledging the historical roots of African Americans. Photograph by David Smalls

African-American Quilts

African-American quilters and their work have been an important, although often invisible part of the country's quilting history. For much of the nineteenth and twentieth centuries, all quilts were attributed to white women, even if the quilt clearly appeared to tell the stories of people of color.

Gladys-Marie Fry spent much of the 1970s and 1980s researching slave-made quilts. She received a letter from the officer of a southern historical society stating that few slaves were able to sew, and that all clothing made on plantations was made by the mistress.[1] This letter reinforces the belief that slaves were unlikely to make quilts for plantation use, and any quilts they made for themselves would be of poor quality. At the same time Fry received this letter, she was collecting well-made Antebellum quilts, which included strong African elements such as suns, animals, and asymmetrical designs. These quilts were made by slaves for use in their quarters.

All the abolitionist quilts featured in the previous chapter are credited to white women. The currently known abolitionist quilts were created within the context of predominantly white anti-slavery groups, and it would not have occurred to these women at that time to note if quilts were made by former slaves or free black people. The

reduced economic and political power of African Americans played a large part in the invisibility of American-American quilting because if and when their work was acknowledged, often it was viewed as inferior. As we settle into the twenty-first century, the interest and scholarship in African-American quilting has increased, and surprising discoveries have been made regarding the large number of African-American quilts and the women who made them.

Slave-Made Quilts

Throughout history it has been difficult to identify slave-made quilts. The family traditions surrounding the pre-Civil War southern quilts usually attribute them to the white mistress or simply mention that a slave helped. In her 1990 book *Stitched From the Soul*, Gladys-Marie Fry writes, "Many of the various roles and contributions of slave women to plantation life have been swept under the rug of history," an eloquent way of noting that the work of black women was viewed as unimportant.[2] Fry takes a fresh look at southern quilting traditions and identifies the important roles of slave women as weaver, knitter, and seamstress.

Textile production on southern plantations was predominantly done by slaves, sometimes under the supervision of the mistress. While in Africa men had been the primary textile producers, on the plantation this role fell

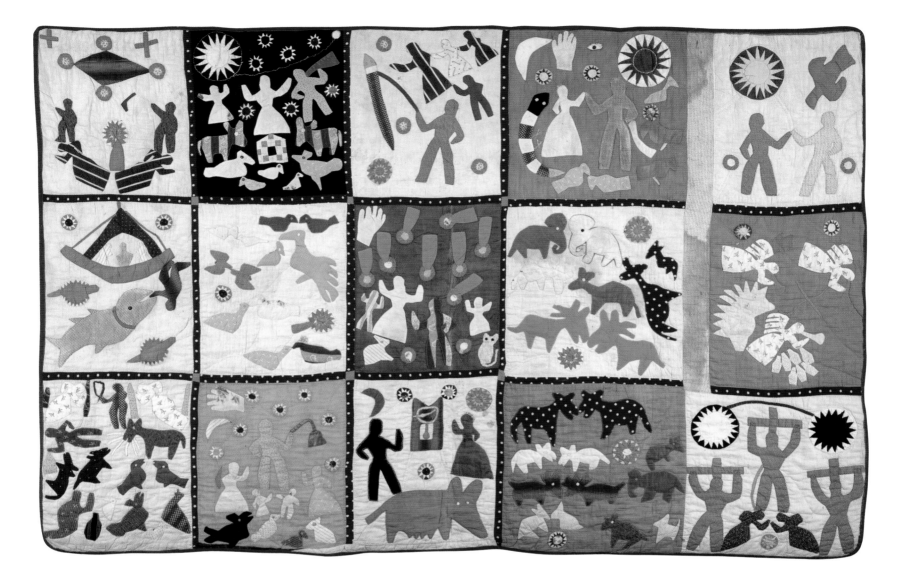

to the women. Quilts produced for use by the white family usually reflected the tastes of the mistress, or popular designs of the period in which they were made. These quilts used high-quality fabrics in large quantities.

Few quilts made for use in the slave quarters survive. They were used up, lost, or destroyed by fire or other disaster. The quilts that survive have innovative designs and bold colors, often reflecting African textile traditions. Pieced and appliquéd, they are scrap quilts, constructed from old clothing and remnants from plantation-house sewing.

Harriet Powers

Aside from Harriet Tubman and Sojourner Truth, Harriet Powers is probably one of the best-known former slaves. Two of her quilts, both made after the Civil War, survive, and both have been well-published and studied. Both quilts tell stories through the use of appliquéd blocks. Harriet was a Georgia slave born in 1837, and would have began sewing in the 1840s, a time when appliquéd quilts had become very popular. African storytelling traditions are evident in Harriet's quilts, as each individual block tells a complete

PICTORIAL QUILT

Date: 1895–98, Athens, Georgia

Maker: Harriet Power, American, 1937–1911, Cotton plain weave, pieced, appliquéd, embroidered quilt

Size: 68 7/8" x 105"

Owner: Museum of Fine Art, Boston, Bequest of Maxim Karolik, 64.619

Harriet Power made her Pictorial Quilt using cotton plain weave. It is pieced, appliquéd, embroidered, and quilted. Photograph © Museum of Fine Arts, Boston

The Underground Railroad Quilt Controversy

In 1999 a thought-provoking book, *Hidden in Plain View*, presented a history of an Underground Railroad Quilt Code. Immediately, there was controversy: some people hailed the book as a groundbreaking opportunity to tell a long hidden story, others believed the book lacked credibility. The first side accused the second of discounting African-American oral traditions as a legitimate historical resource, and the second side accused the first of ignoring the written documentation. In the meantime people have shifted from one side to the other, some distancing themselves from their original acceptance, others seeking that important documentation.

On the surface the question appears to be a simple one: Were quilts used along the Underground Railroad prior to the Civil War as a means to communicate with African Americans escaping from slave states in the south to free northern states and beyond? And can this be supported by the historical record? The answer has turned out to be anything but simple.

There are several factors complicating the issue. First, like many oral traditions, the original source is unclear, and the stories about the "quilt code" are sometimes conflicting. Second, to date, there is no original written documentation from the mid-nineteenth century about such uses of quilts on the Underground Railroad. Third, many of the names ascribed to quilt blocks were not universally used in the mid-nineteenth century.

Hidden in Plain View was not the first book to mention Underground Railroad quilts. The acclaimed 1984 book *Hearts and Hands: The Influence of Women and Quilts on Society* mentions that quilts were used to denote safe houses on the Underground Railroad. But *Hidden in Plain View* is the first book to provide a detailed description of the meaning of quilt patterns, which has not yet been documented through written historical records. And *Hidden in Plain View* was widely read outside of the traditional quilt history audience, so many people formed opinions about the book's factual content.

Mysteries capture the imagination, and the quilt code is no exception. Real or fictional, it is a story of triumph over adversity. So it is no surprise that its story has quickly spread through the population as fact. In the early twenty-first century, the quilt code blocks appeared in school curricula, museum exhibits, popular quilt books, and at a Iowa rest area. The Farrow-McDaniel family, the resource for *Hidden in Plain View*, has created its own museum, explaining their version of the code, and featuring other African-American artworks.

In order to bring evidence from the written record to African-American quilting, historians Cuesta Benberry, Barbara Brackman, and Gladys-Marie Fry have published well-researched books that present current historical documentation regarding the nature, use, and design of African-American quilts. And there have been excellent twentieth and twenty-first century quilting projects that commemorate the role of the Underground Railroad in American history, including the Ohio exhibit Threads of Freedom and the three Connecticut Freedom Trail Quilts.

There is one more important issue at stake, and that is the value of the oral tradition in research. For millennia, community history was passed from one generation to the next through stories. The written tradition is relatively new in human history and was adopted by various cultures at different times, and for many cultures oral tradition is still a preferred transferral method.

It is interesting that the quilt code stories should appear at the same time that well-respected oral history works were being published. Studs Terkel, David McCullough, Stephen Ambrose, and Tom Brokaw all successfully use oral tradition in their work. Even the written record is imperfect, diaries record what their owners think happened, and public documents are sometimes amended. The best historical documentation combines both written and oral accounts. We know from the written record that all people, including nineteenth-century slaves, communicated hidden thoughts through works of art and music. Sometimes the written accounts of those thoughts are discovered much later, because before the controversy no one thought to look for them.

The controversy of the quilt code is a valuable experience for the field of quilt history. It encourages us all to take a critical look at the information we collect and the resources we use. Quilt history as a professional field is relatively new and will continue to have growing pains, which will help us refine and improve our work. Each time we are presented with a controversy, we learn a little more about ourselves. The Underground Railroad Quilt Code. Story, whether truth or fictional, is now part of our quilting history, so it is incumbent upon all of us, whichever side of the issue we feel we are on, to share our stories responsibly.

story, often biblical or historical. Harriet was "discovered" in the 1880s by Jennie Smith, who saw her Bible quilt at a cotton fair in Athens, Georgia, which showcased southern products and promoted tourism in the area. Jennie offered to buy it, but Harriet turned her down. Several years later, Harriet needed money and agreed to sell the quilt to Jennie. Jennie wrote 18 pages of handwritten notes, explaining the stories behind each of the quilt's blocks and her impressions of Harriet Powers. Jennie exhibited the quilt at the 1895 Atlanta Cotton States and International Exposition, where it was seen by an international audience and eventually donated it to the Smithsonian Institution. This quilt led to a commission for Harriet, the now-famous Pictoral

AMISH CRAZY QUILT

Date: 1901 **Maker:** Elizabeth Kaufmann Hershberger, Arthur, Illinois **Size:** 67" x 78"
Owner: Collection of the Illinois State Museum

Elizabeth's family moved to Illinois from their Amish community in Ohio when she was a child. This quilt includes traditional Amish colors using the nationally popular Crazy Quilt style. She made several other quilts, while raising seven children.

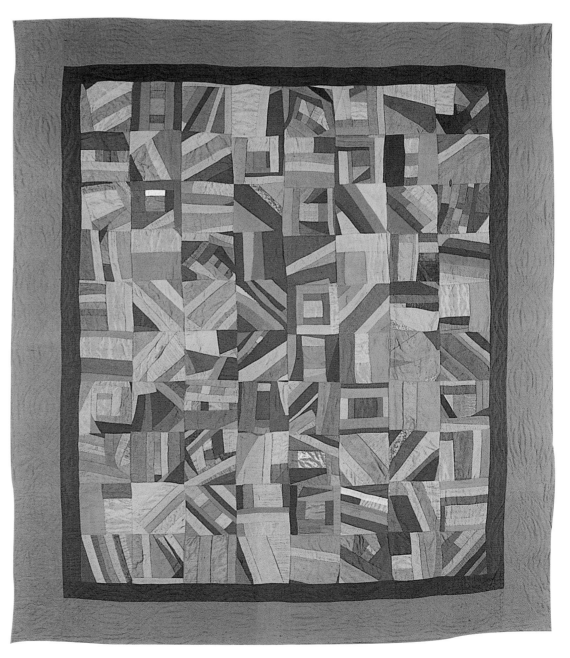

Quilt, which was made in 1898 for the president of the Union Theological Seminary in Atlanta. It now resides in the collections of the Boston Museum of Fine Arts.

AMISH

The Amish began immigrating to the United States from Switzerland and the South Rhine region of Germany in the 1700s. By the early nineteenth century, the Amish, who had originally settled in Pennsylvania and New York, also moved west into Ohio, Indiana, Illinois, and Iowa. In daily practice, conservative Amish continue to live a life rooted in the traditions of eighteenth-century rural Europe, avoiding most "modern" technology and contact with non-Amish.

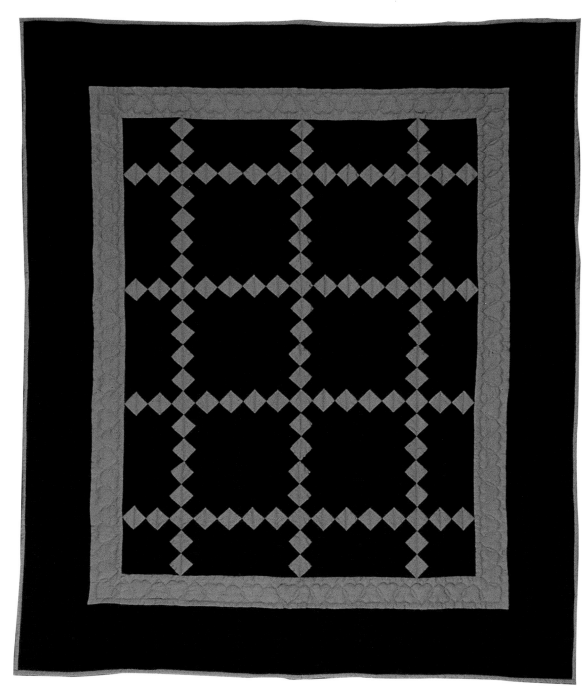

AMISH DOUBLE NINE PATCH
Date: 1986 **Maker:** Lena E. Miller
Size: 82" x 68" **Owner:** Minnesota Historical Society

This Double Nine Patch quilt was made by Lena Miller, a member of an Amish community in Preston, Minnesota. The quilt's bold colors and heart, flower, and star stitch patterns are common in traditional Amish quilts.
Photograph used courtesy of the Minnesota Historical Society, 1987.43.1

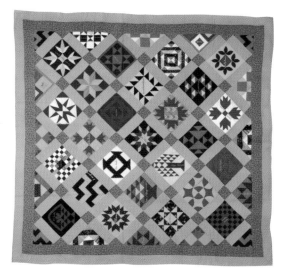

AMISH FRIENDSHIP SAMPLER ALBUM
Date: ca. 1876–1900 **Maker:** Friends of Annie Risser Horst, Middleton, Pennsylvania
Size: 79" x 79" **Owner:** Courtesy of Michigan Traditional Art Program Research Collections

Annie was a teacher, and this quilt may have been made as a going away present. It contains the signatures of her family and friends.

FUR MAT

Date: 1800–1900

Maker: Emily Barr, Alaska

Size: 43" x 43"

Owner: Collection of the
Alaska State Museum

*This Eskimo pieced or patch-
work mat contains skins of
birds and seals, including the
King Eider and the common
loon. Native cultures in the
United States and Canada also
created patchwork coverings
from tanned hides.*

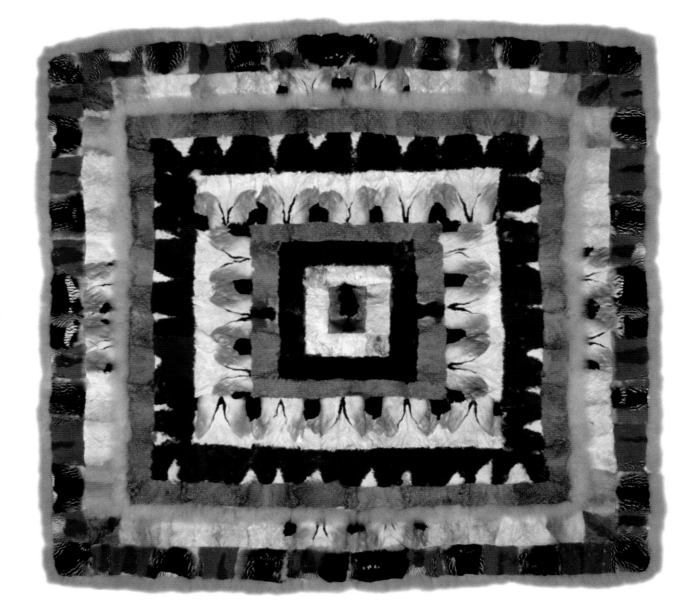

In 1966, the New Order Amish split from the Old Order Amish over several issues, including use of modern agricultural methods, and the tradition of salvation.

Most Americans are familiar with the Amish community through its quilts. The Amish tradition of quilting developed in the mid-nineteenth century when Baltimore Album and intricate patchwork patterns were popular. Amish quilting used elaborate quilt top designs and the earliest known Amish quilts are whole cloth with intricate quilting. Amish quilting as it is practiced today, featuring the use of contrasting dark and light solid fabrics arranged in strong geometric patterns, was not developed until the later part of the nineteenth century. While all Amish quilts have some similarities, they vary in style between communities. The Diamond in the Square pattern was used almost exclusively in Lancaster County, Pennsylvania.

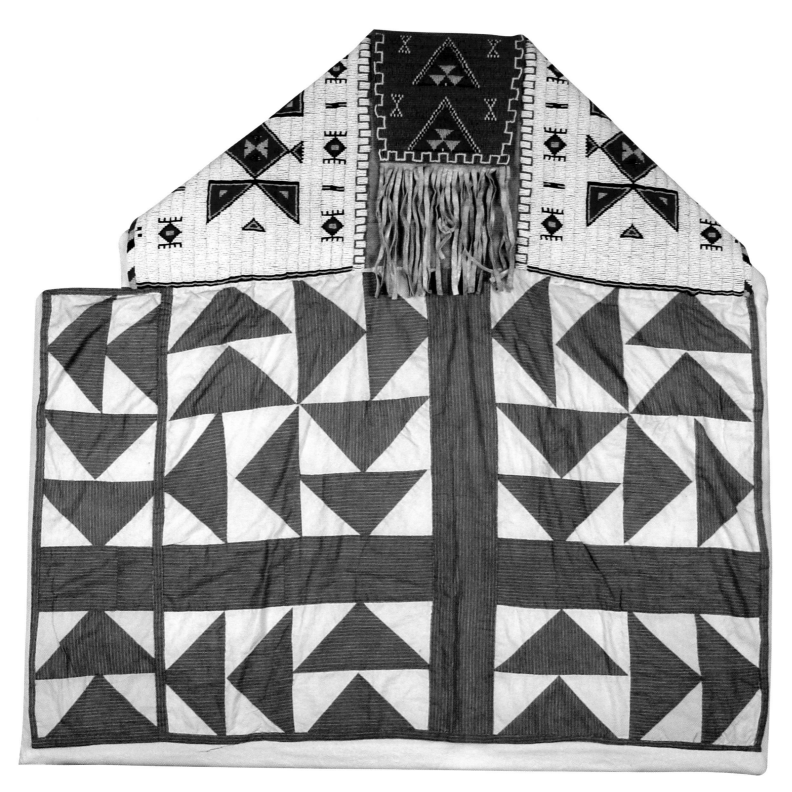

DAKOTA (SIOUX) SOFT CRADLE

Date: ca. 1890–1919 **Maker:** Unknown, Standing Rock Reservation, North Dakota and South Dakota **Size:** 35" x 41.75"

Owner: State Historical Society of North Dakota

A traditional beaded leather cradle is merged with a quilted cape, using techniques learned at missionary and boarding schools.

The cape pattern is commonly known as Dutchman's Puzzle. The soft cradle was often a gift to the mother, from the father's family.

Ohio Amish quilts have the greatest variety of patterns, and the most intricate blocks such as Rail Road Crossing and Churn Dash. Ohio Amish quilts are more likely to combine blocks in sampler style quilts.

The greatest change to Amish quilting over the past two centuries is the development of a very lucrative retail market in which to sell the quilts. By the 1970s, the world had discovered Amish quilting, and the demand for Amish quilts and Amish-style quilts rose dramatically.

Quiltmakers sell their quilts in several ways. Some simply put up a "Quilts for Sale" sign outside their home. Others work with retail specialists to sell quilts through their showrooms, catalogs, or retail websites. Quilting for the outside world can be complicated. It is difficult to keep up with demand and continue to create quilts for the Amish community. Trends may dictate that Amish quilters making quilts for the

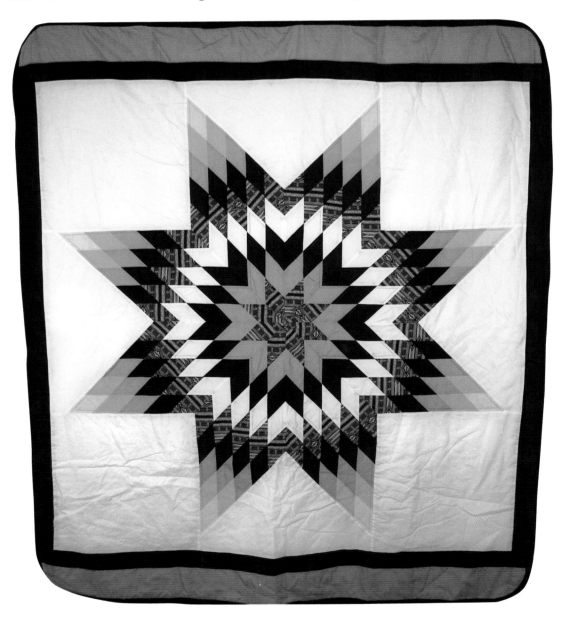

LAKOTA STAR

Date: ca. 2006 **Makers:** Members of the Lakota Star Quilt Cooperative, Bridger, South Dakota **Owner:** Lakota Star Quilt Cooperative

This is one of many quilts made by the Lakota Star Quilt Cooperative Project using donated fabrics. The project is raising funds for a permanent salesroom that will include exhibits about the history of star quilts in the Lakota community. Photo courtesy Kathleen Kesner

outside world use colors and fabrics that are not traditionally Amish. And, there are a large number of Amish-style quilts on the market that are not Amish-made, and may be of inferior quality. Today, a genuine Amish-made quilt may easily sell for more than $2,000.

AMERICAN INDIAN

The history of native people in the Americas is at once tragic, heroic, spiritual, and epic. The subjugation of native people in the United States is well-documented, and, coupled with surviving oral traditions, the American Indian is one of the most romanticized groups in the world.

For Europeans, the history of Native America begins in 1492, when Christopher Columbus sailed into the Bahaman Island he named San Salvador. Although the tradition followed that Columbus "discovered" the New World, the people already living there had millennia-old agricultural, hunting, family, and artistic traditions. Over a 400-year period, European immigrants and Native Americans shared and fought over the land that would eventually become the United States, until the 1890s, when the government of the United States officially claimed all remaining land, and confined most Indians to reservations in the western half of the country. Under U.S. rule, Native American children were sent to boarding schools where they studied western traditions, including Christianity and the English language. Native Americans were not granted the basic legal rights of United States citizens until 1924 with the passage of the Indian Citizenship Act of 1924.

In the 1960s the Minneapolis-based American Indian Movement became a formidable champion of native rights. Slowly, their work began to pay off and cultural rights were returned. The 1978 Religious Freedom Act granted protection for traditional native religious practices. The Native American Graves Protection and Repatriation Act of 1990 provided a mechanism for the return of culturally significant artifacts to tribal descendants. Also enacted that same year was the Indian Arts and Crafts Act. This truth-in-advertising law protects both artist and consumer, by insuring that any item marketed as Indian was indeed produced by Indian artists.

Native American and Hawaiian quilting evolves out of a European American tradition. Contact with settlers and missionaries provided quilting instruction, while native cultural and art traditions influenced form. Traditional favorite motifs include stars, eagles, and cultural icons. Contemporary Native American and Hawaiian quilters may include photos, political statements, and pictorial appliqué.

History of Hawaiian Quilting
by Cissy Serrao, Poakalani and Co.

Cissy Serrao is a fifth-generation Hawaiian quilter, and daughter of Poakalani and John Serrao, two of Hawaii's top quilting designers and teachers. Cissy is also a quilt teacher and has been the driving force behind Poakalani and Company, one of the primary sources for Hawaiian quilt patterns and instruction in Hawaii. She has published several books with her parents, including The Hawaiian Quilt: A Spiritual Experience *and* Poakalani Hawaiian Quilt Patterns.

In the following essay, Cissy provides a history of Hawaiian quiltmaking, a unique quilt style that fuses the cultural elements of the native Hawaiian quiltmakers with the quilting techniques of the Euro-American teachers.

In 1820 the royal wives of two reigning Hawaiian chiefs were invited aboard the brig *Thaddeus* for what has come to be known as the first quilting circle ever held in the Hawaiian Islands. This gathering was just the beginning of an art that would flourish over the next 175-plus years. This original quilting circle would play an integral part in recording the history of the Hawaiian people.

Quilts made in Hawaii back in the 1820s were done in the patchwork style. Hawaiian women tediously cut the material into patchwork squares and sewed them back together in the way early European missionaries had taught them. Hawaiians found the work of making quilts confusing for two reasons. First, they could not understand why they should cut up material only to sew it back together again. They felt it was a waste of time and precious material, and Hawaiians are raised to never waste anything.

The second reason quiltmaking didn't make sense to the Hawaiians was because the weather did not get cold enough to warrant the use of quilts. But the Hawaiians, being good students, watched, learned, and listened and then adapted quilting to their own unique style.

The Hawaiian women made their quilts from their tapa, the clothing that they wore before foreigners came to the islands. The quilt designs would eventually be created in a 1/4 or 1/8 design; the Hawaiian quilters would take a full piece of material, fold it into their 1/4 or 1/8 design, cut out their pattern and lay out the quilt. Any excess material was then given back to the missionaries for their quilts.

Hawaiian women turned to the beautiful flowers that grow on the islands, such as the mokihana, the liko lehua, the ulei berries; ancient gods; legends; and their sovereign nation status for inspiration when designing quilts. Other Hawaiian quilt designs encompassed their travels from Tahiti and flag quilts, which symbolized their Hawaiian identity in a rapidly changing world. The islanders named

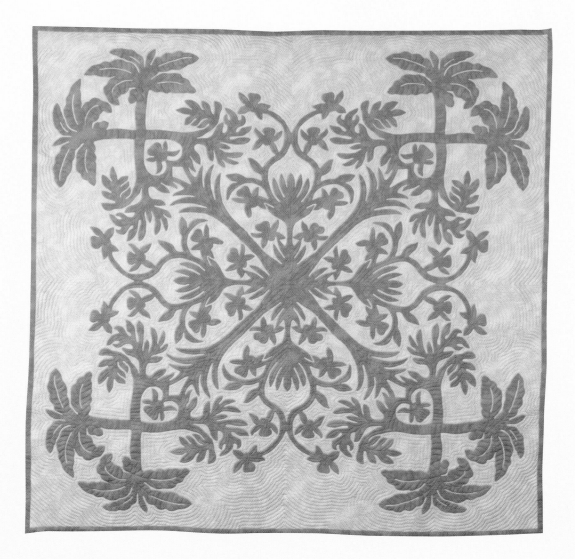

BREADFRUIT HAWAIIAN APPLIQUE

Date: 2005 **Maker:** Yoko Niizawa Honolulu, Hawaii **Size:** 112" x 112" **Owner:** Collection of Poakalani and Company, Honolulu

The Breadfruit is Hawaii's staple and there is a saying that if you make this design first you will not want for any of life's necessities. The center of this particular quilt is a vintage design circa 1920s from the Caroline Correa Vintage Collection and the Border Lei is a contemporary design by John Serrao.

their quilts in memory of loved ones who had passed on to the spiritual world and even in honor of grandchildren who had yet to be born. Quilt designs sometimes reflected major events on the islands. Every quilt had its purpose, and no quilt was made to just pass the time. It was believed that some quilt designs even came to the designer and quilter in their dreams.

The legacy of Hawaiian quilting and designing continues on the islands, and new designs are created every day. Quilting techniques are the same all over the world, but the style and design of the Hawaiian quilts are truly unique.

Morning Star Quilts

For centuries the symbol of the Morning Star has been an important cultural tradition for the northern plains Indians. In the Lakota culture, the morning star is used predominantly in ceremonies, mythology, and traditional art. Clothing, moccasins, and tepees were adorned with paintings and beadwork representing the Morning Star. The Akta Lakota website states that according to Lakota tradition, the star "represents the direction from which spirits travel to earth and is a link between the living and the dead… thus symbolizing immortality." When Lakota women began quilting, they adopted this design as their own.

The Morning Star design is similar to the Bethlehem Star and Lone Star patterns. While it most frequently appears as a large single star, it is sometimes surrounded by small stars, or set in a broken star setting. Color plays an important role in the quilt. Quilters often choose combinations of clear, bright colors; soft earth-tones; and patriotic colors, especially if the quilt is made for a military veteran.

In Lakota culture a Star quilt is one of the most valued gifts, made for marriages, naming ceremonies, and graduations. A star quilt is often draped on the casket at funerals.

*Warm Embrace: The Lakota
Star Quilt Cooperative Project*
The mission of Warm Embrace is to assist Indian leaders in their efforts to reduce the impact of debilitating poverty in their communities. It is a cooperative effort between the Mid-American Indian Fellowship and several Baptist Church congregations. The nonprofit organization began as the Warm Embrace Project, which collected warm winter clothing for the Cheyenne River Reservation in central South Dakota.

In 2005 they initiated the quilt project, which combines the talents of Cheyenne River and Warm Embrace Project leaders to provide support to native-owned businesses. The project collects fabric and equipment to assist Lakota women in creating star quilts and other craft projects, which will be sold through a new tribal tourism center in Bridger, South Dakota.

IMMIGRANTS FROM SOUTHEAST ASIA

While the Hmong have only lived in the United States for a few decades, their culture is an old one. The Hmong were settled in China before as early as 2700 BCE. They established a thriving population, but were in continuous conflict with the Chinese dynasties and became a nomadic people. In the 1820s the first Hmong migrated into Laos when they were hired as opium poppy workers. The French ruled Laos by the late 1800s, and the country became independent in

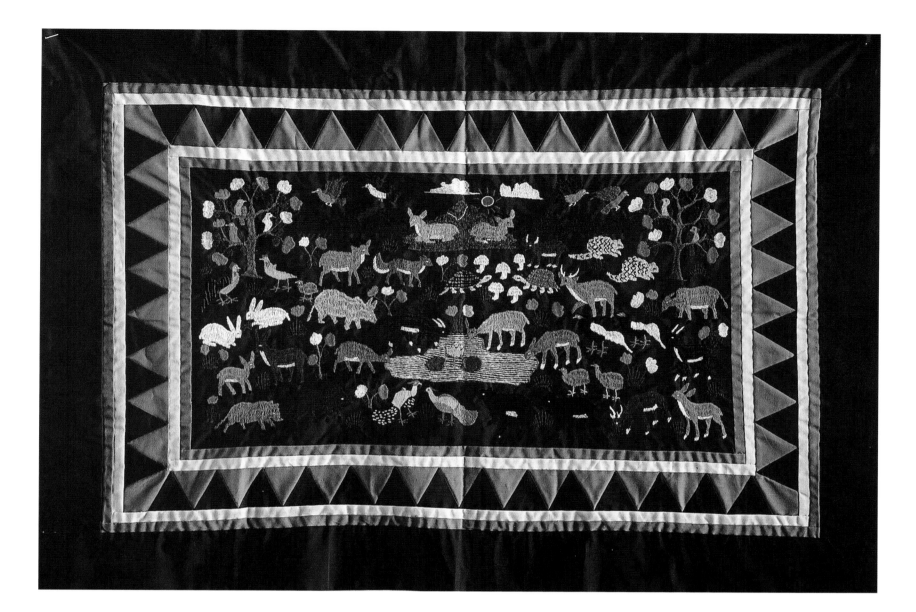

1949. A decade later, the Hmong became an important United States ally in the fight against Vietnamese Communists and in the conflict against the Laotian government. When the Vietnam War ended, Laos continued to persecute the Hmong. More than 100,000 Hmong were killed, and an additional 100,000 fled to Thailand, where they were settled in refugee camps. In the late 1970s, a few Hmong were evacuated to the United States, to protect these people from further persecution and possible annihilation, beginning several waves of immigration that continued into the early twenty-first century.

Pa'ndau

Pa'ndau, or flower cloth, is the traditional means by which Hmong women have recorded their histories and expressed themselves. Pa'ndau is a combination of appliqué and embroidery. Some Pa'ndau are embroidered with people, animals, and landscape, providing a visual

HMONG PA'NDAU

Date: ca. 1990 **Maker:** Unknown

Size: 18" x 24" **Owner:** Rose Werner, Dundas, Minnesota

Rose bought this Pa'ndau at an antique store in southern Minnesota. Hmong needlework is often sold through craft fairs or craft distributors, making it difficult to identify the maker.

Photo by Greg Winter and Lee Sandberg, Minneapolis, Minnesota

A newly finished Prayers and Squares quilt will soon be on its way to a young child. Quilts range from 45 to 50 inches wide and 55 to 60 inches long so that they are big enough to fit on a child's lap, but too small to get caught in a wheelchair or hospital bed.

device through which to present an oral history. Pa'ndau may also be appliquéd with traditional geometric designs. In the past two decades, Pa'ndau have become an important commodity for the Hmong. Traditional Pa'ndau is not quilted, but quilts are sometimes made that include Pa'ndau blocks. The appliqué skill has led to an unusual alliance between the Hmong women settled in Lancaster County, Pennsylvania, and the Amish in Lancaster County. When the Hmong settled in the county in the 1980s, a few Hmong women in search of paid employment approached local quilt retailers about the possibility of sewing for them. For the past decade, some Amish and Mennonite quiltmakers have collaborated with the Pennsylvania Hmong population and their families still in Thailand to produce Pa'ndau floral appliqué for the Amish-made quiltops, This merging of needlework styles produces unique quilts, neither truly Amish nor Hmong.[3] The work provides necessary income for the struggling Hmong, and appeals to consumers who like quilts with appliqué, a technique the Amish seldom use.

Spiritual Seekers

Quilters come from all religious and spiritual backgrounds. For many, quilting is the ultimate form of religion. Faith-based quilting projects can affirm the beliefs of those sharing the same religion, or create connections between seemingly unbridgeable groups.

The Prayer Quilt Ministry: It's All About the Prayers

Prayers and Squares, the Prayer Quilt Ministry grew out of a small quilting group at Hope United Methodist Church, Ranch Bernardo, California. In 1992, one member's two-year-old grandson was in a coma after heart surgery. A cheerful quilt was made and tied with heavy perle cotton. Members said silent prayers while making the quilt, and it became known as the prayer quilt. This quilt became an important part of the little boy's recovery.

Other parents asked for prayer quilts for their ill children and soon prayer quilts became one of the churches regular outreach ministries. Four years later, founding member Wendy Mathson moved and started a second Prayers and Squares chapter at her new church. These two chapters recruited members in other churches, and today there are 567 chapters in 43 states and six countries. Prayers and Squares is an interdenominational, nonprofit organization.

Prayer quilts are made by tying the layers with thick, cotton thread. A silent prayer is said for the recipient as each knot is tied. The purpose is to promote prayer through

the use of quilts. Recipients are young and old, facing a health care or personal crisis. When family and friends of the recipient request a quilt, the chapter tries to finish it within two weeks.

There are three "commandments" member chapters agree to follow. First, the ministry's purpose is to promote an active prayer life, so members should involve many participants. Second, members must recognize that because not all people are comfortable with prayer, they should give considerable thought as to whether a quilt is the appropriate gift for the proposed recipient. And finally, no form of payment is to be accepted for the quilts, as prayers are not a commodity. The Prayers and Squares motto is "It's not about the quilt; it's all about the prayers."

The Faith Quilts Project

The mission of the Faith Quilts Project is "To deepen interfaith and intercultural understanding by gathering together people of diverse faiths to share their deeply held beliefs through collaborative quiltmaking." Boston, Massachusetts, artist Clara Wainwright is the force behind Faith Quilts. On the project website, www.faithquilts.org, Clara writes, "After September 11, I became fascinated by the power of faith for both good and evil. I decided to explore different faiths

through the medium of quilts, which seems a positive gesture in such a polarized world." She organized Faith Quilts to work with artists and faith-based groups in the Greater Boston Area. Faith quilts are sponsored by the Public Conversations Project, a nonprofit organization that facilitates community conversations about difficult issues of race, poverty, and fear.

Faith Quilts was a five-part project. In the first component, collaborative quiltmaking, 38 quilt artists trained in collaborative quiltmaking and dialogue facilitation, worked with single- and multi-faith groups to make 57 quilts. Participants included Christians, Muslims, Jews, Unitarians, Wiccans, and Buddhists. The second part was a visual documentation of the project, conducted onsite during quiltmaking activities. The third part included a series of public events and workshops, which lead to part four, a month-long exhibition of the quilts, the first of which took place in April 2006 at the Cyclorama at the Boston Center for the Arts. The last component is the continued provision of resource materials to others wishing to start similar projects.

Gender

European textile producers were men, and men have always been quilters. In the nineteenth century textile

production became predominantly the sphere of women, so much of the history of male quilters is lost. We know from diaries and journals that men often helped create patterns and templates for quilting. There are many stories of little boys helping with their mothers quilt. Odin Roberts remembered sitting under the quilting frame in 1930s North Dakota. His job was to trim stray threads from the back of the quilt as his mother and aunts quilted. There are some nineteenth- and early twentieth-century quilts known to be made by men. The Henry Ford Museum in Dearborn, Michigan, has a quilt made by Herbert James Smith in 1918 from army uniform scraps. He was the army tailor at Fort Benning, Georgia, and included handmade pennants with the Blue Star Banner. But the strong division of male and female roles meant that most men were not expected to participate in sewing and quilting activities. In the twentieth century, an increasing number of men found quilting to be an excellent creative outlet, as well as a unique career choice.

Brian Dykhuizen—Quilting in the Abstract

A degree in art and elementary education launched Brian Dykhuizen's quilting career. He taught art in the Midwest for several years and then headed down a different career path. In 1997 he took a fabric-dyeing workshop. He needed to do something with all that fabric, so he began making bed quilts. Five years later he was making art quilts. Today his work travels from his Kalispell, Montana, studio to shows and galleries throughout the United States and England.

Brian is most inspired by color, and creates his quilts from whole-cloth hand-dyed fabrics. He starts projects with just one-yard of cotton and a selected color. He dyes cloth from a painter's perspective. On his website Brian writes, "I like to work with a whole cloth. I start by choosing a color that speaks to me, or a color I want to work with. Occasionally I have a picture or certain shapes in my mind's eye that I need to see on fabric, other times I just start applying the dye and let the colors take me on the journey. There seem to be so many rules and requirements in this life. Some days are calm, others are so chaotic I don't know which way to turn. I think that is why my work is abstract and somewhat random. That is why I love working with dye. Dyes have a mind of their own so I never really know how a particular piece will look until it is finished."

Quilting allows Brian to be a stay-at-home parent to three busy young children. While his children find his work interesting, they have yet to follow in his footsteps. He is

the only male member of the Flathead Quilt Guild, which makes him somewhat of a novelty. Brian also works part-time at the Quilt Gallery in Kalispell. Recently his work has appeared at the National Small Art Quilt Exhibition, the Birmingham, England, Festival of Quilts and the Quilts=Art=Quilts Exhibition at the Schweinfurth Memorial Art Center in Auburn, New York.

Scott Murkin—Taking a Different Path

Scott Murkin is a physician in Ashborough, North Carolina. He is also a prolific quilter, quilt judge, historian and teacher. Scott grew up in a sewing environment. His grandmother was a traditional quilter, and his aunts were fabric craftspeople. As his grandmother became older, and sewing was more difficult, she asked Scott to help her cut quilt patterns. Scott went to medical school, and quiltwork was left behind. In 1994 he wanted a handmade quilt for his small daughter. Since neither his wife nor mother sewed, Scott made the quilt himself, learning sewing and fabric construction techniques along the way.

Like Brian, Scott approaches his quilting from a design standpoint first. Once he settles on a design, he then figures out how best to construct it. His style is diverse and includes abstract quilts, three-dimensional fiber art, and more traditional designs. Understanding quilting history influences his work. In an interview, Scott explained that when he recently started a complex log-cabin design, his first concern was "whether I really had anything new to say in the log cabin format. Being intimate with both the classic and contemporary history of the log cabin quilt, I was able to honestly answer, yes, I did have something new to say, much as poets keep writing sonnets and musicians keep penning love songs."

Scott approaches his role as a minority quilter with humor and grace. As a man in a predominantly women's world, he gets noticed. This is exciting, but at the same time can be tedious as he answers the same questions repeatedly. Scott doesn't mind though as he notes "most people are simply genuinely interested in how someone went down a different path than most other guys…. There is a common language among quilters and the love of fabric is a strong bond that pretty readily overcomes any obstacles."[4]

Scott's work appears in museums and galleries across the country. Recently, his work "Joshua" toured as part of the Men of Biblical Proportion exhibit, an exhibit of quilts made by male quilt artists depicting a male figure from the Bible.

STRATA VI–CONSTRUCTION

Date: ca. 2006 **Maker:** Scott Murkin, Asheboro, North Carolina **Size:** 21" x 16" **Owner:** Scott Murkin

Scott's Strata series includes 22 quilts. He made Strata VI using the fabric he cut from Strata V as he squared up its blocks.

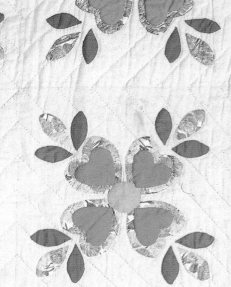
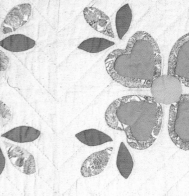
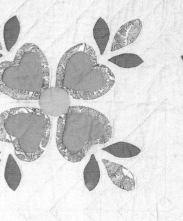
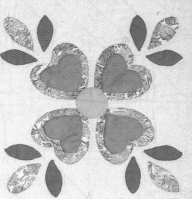
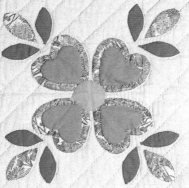
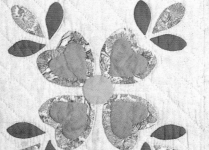

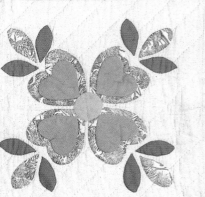

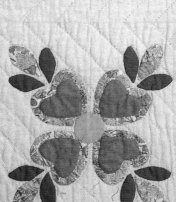
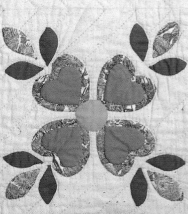
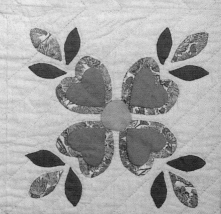

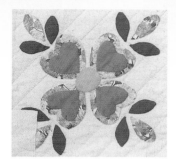

Quilting in Communities

We used to have quilting parties at least twice a year. One time we would meet at one house, and one time at another; you'd keep on that way until the quilt was finished….

Mrs. Mayme Reese, WPA interview, September 21, 1938[1]

The tradition of group quilting is as old as the tradition of quilting itself, but it gained popularity in the nineteenth century. A quilting circle or bee was an excellent way to get a quilt completed quickly. Often the hostess would have a quilt already pieced and on a quilt frame. Friends and neighbors would then help finish the quilt.

Mayme Reese, an African-American quilter from South Carolina, remembered, "If I was making the quilt, I'd set up the frame in my house and the other two or three ladies would come to my house and spend the day quilting….Maybe I'd have been sewing scraps together for a year until I got the cover all made." Quilting parties can be all-consuming and sometimes basic needs are overlooked. Mayme also noted, "Whenever we had [a] quilting party, the men-folks had to look out for themselves. They ate cold food if they came in hungry…if they fussed, we'd remind 'em 'bout keeping warm in the winter."[1]

APPLIQUÉ

Date: 1967 **Maker:** Helping Hands Quilters, Stillwater, Minnesota **Size:** 67" x 84" **Owner:** Washington County Historical Society Collection, Stillwater, Minnesota

The Helping Hands quilters began meeting in 1924. They gave this Ohio Rose quilt to the Historical Society at a tea in 1967.

Detail, Appliqué
Washington County Historical Society Collection, Stillwater, Minnesota

The Quilting Party was painted by Mary Lyde Hicks Williams, between 1890 and 1910. Mary was born in North Carolina in 1866, and lived on a plantation. Her paintings depict Southern life and people. Image used courtesy of North Carolina Museum of History

Quilters need communities, whether they are large, formal guilds, more informal circles of friends, or family gatherings. The quilter's community provides an opportunity for fellowship and for the exchange of new quilting information and local events. Within the community, the quilter is surrounded by people who appreciate the visual value of their work and also understand the personal motivation for quilting. For many, the quilting community provides lifelong support and friendship, something not always available outside the group.

QUILTING CIRCLES AND PARTIES

Quilting circles or bees are usually informal groups. They are not legally incorporated, but held together by the personalities and interests of the members. Some last for many years, others until members move away. A quilting bee can be ad hoc, put together to accomplish one quilt or a short series of projects.

Sometimes quilting circles are more formal. The Friendly Circle Club in southeast Ohio is one of the oldest continuous quilt clubs in the United States. The group of mothers started getting together to quilt in 1917. Eventually they developed rules for hosting meetings, limited the membership to 20, and took minutes of their meetings. Members take turns hosting the meeting. The club takes field trips, has block exchanges, and makes group quilts for quilt shows and charity.

However, a quilt circle is organized, the friendship and the support members give each other is the primary reason for the group's existence.

The Tuesday Morning Group

Kalispell, Montana, is the business and tourism center of northwest Montana. Located just 30 minutes from Glacier National Park and scenic Flathead Lake, it attracts thousands of visitors a year. It is also home to a thriving arts and quilting community.

The Tuesday Morning Group is a modern-day quilting circle with a dozen members, who also belong to the Flathead Valley Quilt Guild. The Group developed when a few guild members wanted time together outside the guild meeting to quilt and visit. Most members seemed to be available on Tuesday mornings, so the group informally named themselves after that day. The group's attendance varies, but a dozen women and one man make up the core group. Some members live full-time in the Flathead Valley, others live there seasonally. Many of the members have relocated there from outside the state, and have built lasting relationships through quilting together.

Meetings are very informal and quilting is the primary activity. Members take turns hosting meetings, but usually work on their own quilts. The Tuesday Morning Group quilters have diverse interests: some prefer traditional patchwork

Square dancing follows a quilting bee in Pie Town, New Mexico, ca. 1940. The quilt frame is hoisted to the ceiling to make room for the dancers. Photograph courtesy of the Library of Congress

Women in Scranton, Iowa, gather for quilting and conversation ca. 1940. The quilt will be donated to a needy family. Photograph courtesy of the Library of Congress

and appliqué styles, while others make modern art quilts. The goal is to provide personal support and friendship. While they are brought together by the love of quilting, they also support each other as friends, sharing the joys and sorrows in their lives.

QUILT GUILDS

The Rising Star Quilter's Guild of Lexington, Massachusetts, defines a quilt guild as "an organization that supports learning about and appreciation of quilts." Quilt guilds are incorporated organizations, with bylaws, officers, and membership dues. Modern guilds are loosely based on the European guild system, which supported and protected its members for economic purposes.

While most quilt guilds these days no longer need to protect their members from unfair business practices, there are distinct advantages to belonging to a guild.

Guilds are often able to schedule well-known speakers because they can guarantee a large audience and can afford the speaker's fees. Members are given preference if a limited number of people can attend. Guilds frequently have the resources to host quilt shows, some of which are limited to members only. Because most guilds are run by volunteers, there are many opportunities to get directly involved with the quilt world.

Guilds can be at the local, state, or national level. Some guilds limit their membership, while others are

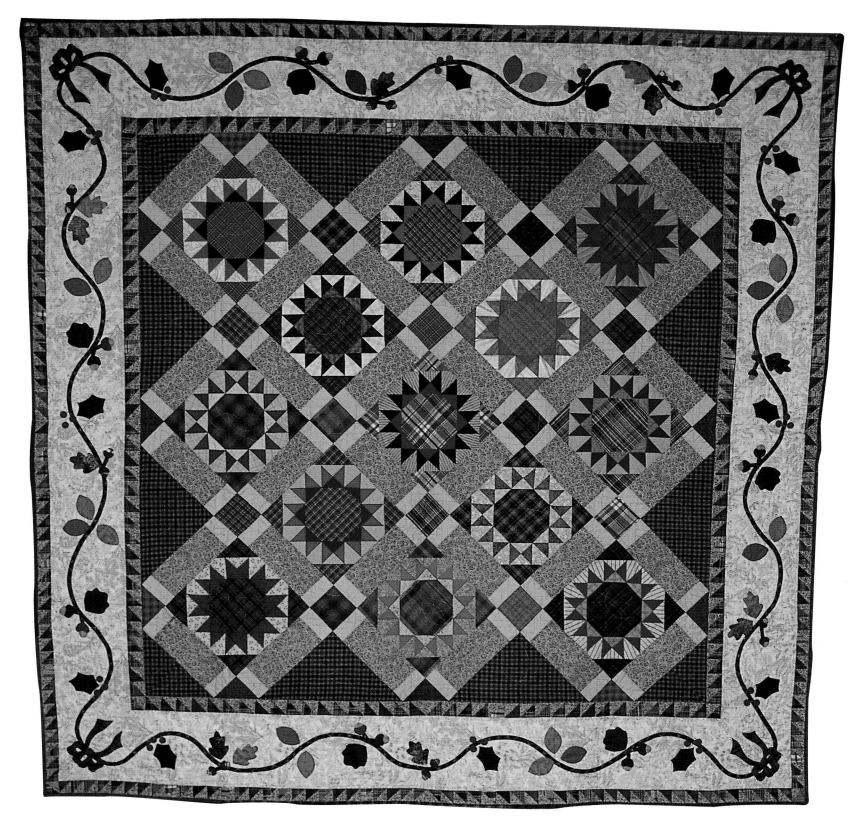

TRADITIONS IN PLAID

Date: 1995–96 **Maker:** Patricia Linder, Kila, Montana **Size:** 82" x 84" **Owner:** Patricia Linder

Some of members of the Tuesday Morning Group choose traditional pieced patterns for their quilts. Patricia selected plaids for this quilt. Plaids can be a challenging fabric to use in patchwork because they are difficult to match. Photo by Shelley Emslie

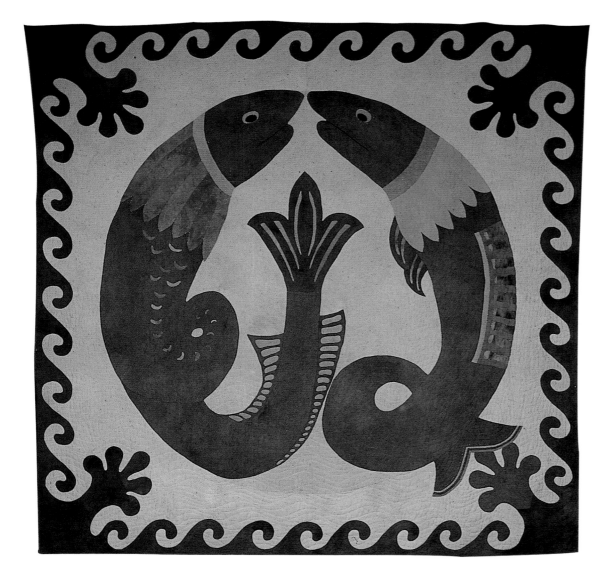

SILKENESE FIGHTING FISH

Date: 1998 Maker: Linda Dreyer, Whitefish, Montana Size: 77" x 75" Owner: Linda Dreyer

Linda is one of the art quilters who attends the Tuesday Morning Group. Her work is inspired by Asian designs and features her own hand-dyed fabrics. Photo by Shelley Emslie

sonal and can be a significant commitment. Many guilds encourage people to attend as visitors to see if the guild is the right place for them.

The Oldest State Quilt Guild

The textile tradition in Utah is strong. When Brigham Young led the members of the Mormon Church to Utah in the late 1840s, women brought their quilts with them. As they settled into their new homes in the desert, they created quilts to stay busy, provide comfort in a new and hostile environment, and to share with new migrants. For many years, the Mormons and the state of Utah operated as a self-contained unit within the larger United States. The Mormons even developed a separate textile industry. During the mid-nineteenth century, the Mormon community operated a Cotton Mission, a woolen mill, and experimented with a silk industry.

With such a rich textile history, it is not surprising that Utah may have the oldest incorporated statewide guild in the United States. In 1977, immediately after the national bicentennial, native Utahan Jean Christensen and her older sister Ruth Garbett gathered some friends together to form a quilt group. Jean had lived outside the state for some time and had recently returned. Jean and Ruth, who shared a family quilting tradition that had been passed down through many generations,

open to anyone with an interest in quilting. The mission of the Village Quilters of Loudon, Tennessee, is "to provide to quilters of all skill levels, from beginner to professional, the opportunity to meet, share ideas, and learn new techniques." Most guilds do have membership fees, which help pay for meeting space, guest speakers, and the newsletter. Membership in a guild may entitle the member to discounts at local quilt-related businesses. Some people belong to more than one guild. The decision to join a guild is per-

Bird's-Eye View: A Look at the Founding of the Minnesota Quilt Guild

by Helen Kelley

Readers of the Quilter's Newsletter Magazine *column "Loose Threads" know Helen Kelley as a perceptive essayist, whose writing sets the quiltmaking experience within the context of everyday life. Helen is also a quilt designer, lecturer, and recipient of numerous honors, including Minnesota Quilter of the Year and membership in the Quilter's Hall of Fame. She was the first president of the Minnesota Quilters in 1978. Her most recent books are* Every Quilt Tells a Story *and* Helen Kelley's Joy of Quilting.

Helen's essay reflects on the founding of the Minnesota Quilt Guild, which is one of the earliest state guilds in the country and its growth from 18 women grouped around one table to a statewide organization of more than a thousand members.

This morning started out much as any other day. I worked late last night, trying to make this little crib quilt that I am sewing on lie smoothly and gently, but nothing seemed to work. It hitched itself up at one corner. When I made the corners meet properly, the whole quilt sat crooked. I worked until I realized that I was picking at the little quilt so badly that I would most certainly eventually cut, mangle, or bruise it and that I had better "quit now" and wait to fix it when I was rested this morning.

During the night, I tossed and turned as triangles and miters fluttered through my brain, but with the dawn, I woke, knowing what I had done wrong and I was ready to set the little quilt right.

In the light of day, with a cup of coffee to jump-start me, I sat down to work. My sewing machine sits against the east wall of my workroom, right in front of a long window that looks out over my husband Bill's garden. The light was good. My mood was good. I knew that this was finally the time when my quilt would be good, too. As I stitched, a feeling of satisfaction settled over me. The day was bright and warm; a pleasant sort of moment and the world outside my workroom window held its breath as the heat of the day settled in.

I concentrated on my stitching. My eyes tracked the bobbing sewing machine needle carefully as it moved along the troublesome seam. I stopped and stretched my shoulders. I was so preoccupied that I almost missed the magic moment when it happened. In an effort to relax, I sighed deeply, lifted my eyes to the view across the windowsill and out into the garden where our tall canna lilies stand against our neighbor's fence. There in the still, silent sunlight, the fresh, new, scarlet flowers seemed to melt into an aura of red. Then, in that moment of quiet glory, a tiny movement caught my eye. There was a flutter, a blur

moving into that pool of red, and I realized that a hummingbird had discovered our cannas. It dipped and sipped and darted. Another bird appeared…and another. One at a time, these exquisite birds were coming to this splendid feast. I sat motionless, afraid to disturb this moment as the hummingbirds congregated.

The sun rose. It passed over the gable of the house and a shadow crept across the flowers. The crimson glow muted and the frenzy of the birds evaporated but the enchantment lingered. All day, the mystery of that gathering stayed with me.

* * *

I went back to my sewing machine. My mind still resonated with the wonder of it. There was something indefinable, fragile in the moment. I remembered the time when I was a part of such a gathering. In the early years of the 1970s, I quilted quietly in my workroom, feeling somewhat isolated and just a bit alone. Then, I began to meet other people, one here, one there, who had discovered quilting, too. Something drew us together into the realm of fabric stashes and rainbow colors and miracles and putting geometric shapes together to create lovely wonders. One by one, these knitters and embroiderers and dress-makers had somehow stumbled independently upon this amazing old craft of quilting. Each had individually devised her own sewing techniques, but the principles were the same, points intersecting perfectly, corners straight and square, and tops lying smooth and even. Each loved what she was doing; she was making magic.

These quilters, such as they were, came from a variety of backgrounds. Some had fallen heir to the craft, because they had memories of their grandmothers who had quilted. Some came to quilting from a fine arts background and they had discovered the remarkable tactile and dimensional possibilities of quilts for their artwork. The history buffs felt a strong tie with the women who quilted before them, quilters without the benefits of stores filled with an infinite variety of fabrics, 100-watt light bulbs, knife-edge scissors, rotary cutters, and computerized sewing machines. These new quilters felt a kinship with those quilters before them and they were deeply moved by those women who had vision, faith, and the persistence to have created rare beauty in their quilts without the benefit of space-age tools.

Many years ago when I was engaged to be married, having a wedding quilt seemed to me to be a traditional comfort and a marriage blessing. I felt I wanted a wedding quilt to be part of my life, too, but at that time, there were precious few written resources on quilting available and nobody to share this with. I studied an old quilt laid out in pristine loveliness on the bed in my mother's guest room and I devised my own techniques to put my quilt together.

Later, in the 1970s, when my oldest daughter was planning her own wedding, she, too, wanted to have a quilted blessing. Again, I improvised and invented and we made her a quilt, and while we were making that quilt, we met other quilters in libraries and fabric shops, and so… The Gathering began.

Eighteen quilt-lovers assembled, one day, around a large table in the family room of a nearby home. This casual, comfortable group of women had been meeting in a haphazard sort of way in a convenient room at a local YWCA. Usually, the plans for these affairs included some sort of workshop. The group had little structure and responsibility for each get-together fell on to whichever generous quilter happened to raise her hand to volunteer "for the next meeting." We were a loose organization and we were drifting without direction. It was obvious to us all that we needed a more formal structure.

The first order of the day was to define our situation. We had come together from odd corners of the greater Twin Cities metropolitan area because we liked each other, we loved quilting, and we were hungry to share what we had learned, but the vague nature of the group needed defining. We needed to know who each of us was and where we lived and how we could be contacted. We needed a better form of communication beyond casual phone calls and friendly chats in fabric stores.

One participant suggested that if we collected dues and maintained a bank account, "Somebody" could put together some sort of newsletter to be mailed out to let everybody know exactly when and where we were going to meet next. It would be a good idea, when we had a meeting, if "Somebody Else" could be responsible for filling the coffee pot. To keep all of us sorted out, "Somebody More" could keep a written record of what we were doing and who was there to do it. At that moment, as we sifted and sorted through our ideas, our "official" board began to take shape. A tax accountant offered to be the new treasurer and a librarian offered to be secretary and a quilter with journalism experience offered to see that a newsletter would be mailed out each month. I had limited journalistic and financial experience, but was fairly well-organized and quite bossy, so they made me president.

Like those hummingbirds that flocked to the canna flowers seeking the mystery in the red nectar, we watched as new quilters flocked to our Minnesota Quilter's Guild. Though the group had begun with merely 18 women, more quilters have found us and the membership has grown.

Now, the gathering includes beginning quilters and some who are impressively accomplished. Some members are oriented to contemporary techniques and designs while others lean more toward traditional skills. Some members are not even quilters, but are quilt appreciators. There is a sweetness that has come from working together and learning together. What is even more astonishing is that we are not alone. Guilds around the world have become gathering places for people who love quilts. Week by week, in homes, community halls, churches, and libraries, quilters gather to reflect and to refresh and to sustain and to applaud each other.

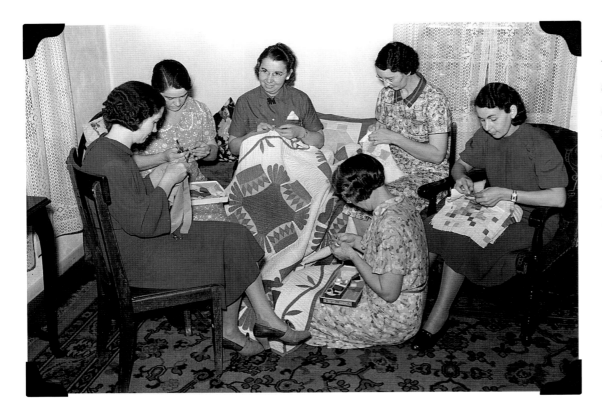

An adult home economics class in Tuggart Valley, West Virginia, ca. 1938. Library of Congress

The Utah State Guild has more than 70 charter chapters across the state. Guild members meet locally and participate in statewide events, including documenting historic quilts in the state through the Utah Quilt Project and participating in many charitable events. The Guild sponsors a quilt festival each September, and in 1996 they hosted a quilt show to celebrate the state's centennial. The group also hosted a larger, international quilt show in conjunction with the 2002 Olympic Games, which were held in Salt Lake City.

both had a strong interest in quilting history and Utah history. Jean began to research how to go about starting a statewide quilt guild. She found information on smaller guilds, but nothing about a statewide guild. She moved forward, setting the precedence for a new type of quilting organization.

Since the time of the early Mormon settlers, who brought swarms of bees with them, Utah has been called the Beehive State. The beehive represents "industry, perseverance, thrift, stability, and self-reliance, all virtues respected by the region's settlers." The Beehive appears in the center of the state's great seal and on the state flag. The beehive is also the logo for the Utah Quilt Guild. The Guild held a contest in 1980 to select a logo, and Maurine Smith submitted the beehive. It has been used ever since.

NATIONAL GROUPS

Many quilting groups serve a national audience. Some of these organizations are dedicated specifically to a quilting technique, such as the Crazy Quilt Society, based in Omaha, Nebraska. Two groups, the American Quilter's Society and National Quilting Association, Inc., serve a general quilting audience. Each offers unique programs and gives quilters an opportunity to communicate with quilters outside their local area.

American Quilter's Society

Say the name "Paducah" and many quilters immediately envision heaven on Earth. This is predominantly due to the work of the American Quilter's Society, established in Paducah, Kentucky, in 1984 by

Meredith and Bill Schroeder. In just 20 years, the Shroeders have created a thriving organization that has improved the economic base of the northern Kentucky city on the banks of the Ohio River. Paducah is also home to Hancock Fabric, famous in the quilt world for its huge selection and mail-order business.

The American Quilter's Society (AQS) provides a "forum for quilters of all skill levels to expand their horizons in quilt making, design, self-expression and quilt collecting." Toward this end, AQS offers a variety of programs and activities.

Perhaps the best-known program is the AQS Show and Contest. The show lasts four days in April, and thousands of people attend. Winners take home prizes in sums of up to $10,000. In August AQS sponsors the Expo, an exhibition of quilting, needlework, and sewing, in Nashville, Tennessee. AQS is a major publisher of quilting books, has a quarterly quilting magazine, and recently added the American Quilter television series, which airs on the Lifetime Network to its repertoire.

As an organization that understands the importance of preserving, collecting, and learning the history of quilts, AQS offers the Quilt Appraisal Education and Certification Program. This is a rigorous, multipart course designed to enhance the qualifications of those already appraising quilts for insur-

ance and retail purposes, and to develop a referral network of certified professionals. There are now more than eighty certified professionals in the United States and Canada. The Museum of the American Quilter's Society maintains a permanent collection of award-winning quilts from their shows, and displays new exhibitions from the museum's collection, as well as exhibits of contemporary and historical quilts from quilt collectors, quilt contests, and museums around the United States. Any quilter or quilt lover can join the AQS. Benefits include a one-year subscription to *American Quilter Magazine*, which features articles about current quilting practice and discounts on hundreds of books published by AQS.

National Quilting Association, Inc.

In 1970, a group of women from Washington, D.C., formed the National Quilting Association (NQA) with two major goals: to generate and sustain interest in making, collecting, and preserving quilts and to use quilting activities to support educational and philanthropic programs. The NQA membership is composed of individuals and local chapters in all 50 states and Washington, D.C.

NQA sponsors the annual National Quilting Day the third Saturday in March, an event that

grew out of Quilter's Day Out, a program by the Kentucky Heritage Quilt Society designed to celebrate the richness of Kentucky quilting traditions. NQA took this day to a national level in 1992, and it became a global celebration the following year. Members are encouraged to celebrate National Quilting Day by doing service projects such as making baby quilts for local hospitals, teaching quilting to newcomers, donating quilts to charity, or just spending time pursuing their favorite quilting activity. Quilt shops are encouraged to offer classes or host a service project.

The National Quilting Association sponsors two other programs that recognize the importance of excellence in today's quilting world. The Master Quilter's Guild awards the title of Master Quilter to women and men who exhibit the highest level of quiltmaking skill. Candidates submit a large quilt in any technique to a committee of five judges. Posthumous awards are not given, so each quilt must be exclusively the work of a living candidate. In 2006, 21 people held the title Master Quilter. NQA also offers a Teacher Certification Program. Applicants, who come from within the United States and many foreign countries, have experience teaching in quilt shops, community education programs, and private practice. Teachers are evaluated on their

own quiltmaking skills in piecing, appliqué, quilting, and quilt finishing. They must also submit a teaching resume and lesson plans.

THE ART QUILTING COMMUNITY

Social worlds are held together by organizations and innovative quilters are no exception. Several national and regional organizations provide support to professional art quilters.

Many people come to quilting as a natural outgrowth of participation in other arts. Studio Art Quilt Associates, Inc., (SAQA) a nonprofit organization that supports the growth of the art quilt field, defines art quilts as "a contemporary artwork exploring and expressing aesthetic concerns common to the whole range of visual arts: painting, printmaking, photography, graphic design, assemblage and sculpture, which retains, through materials or technique, a clear relationship to the folk art quilt from which it descends." SAQA publishes a quarterly journal and monthly newsletters, hosts conferences, and invites members to participate in juried shows. The group serves both the amateur and professional art quilter.

Artists grow and create best in the company of other artists. The Art Quilt Network, a 20-year-old organization founded by Nancy Crow, provides its 60 members with two retreats each year. Members

work noncompetitively and share ideas and professional information along with recent artwork.

ONLINE COMMUNITIES

Cyberspace communities instantaneously bring people together from around the world. Online quilters' communities provide a forum for members to share information and ask questions. While most posts stay on the topic of quilts (marked as QR for quilt-related or NQR for Non-quilt related), posts about family events and personal observations are often allowed. With the growing number of interesting communities and quilt-related blogs, it's a wonder that quilters still find time to quilt.

Quilt History List

Quilthistory.com is "the oldest and most respected vintage textile discussion group on the Internet." Members come from all walks of life and quilting backgrounds, including scholars, students, curators, appraisers, and anyone genuinely interested in the history of quilting as it is practiced today. Lively discussions are part of the draw, and information and opinions flow freely through the postings.

List moderator Kris Dreissen is owner of the Quilt Bug, an Esperence, New York, quilt shop. She maintains the list membership and ensures that everyone follows the rules, keeping non-quilt related discussions brief and maintaining respect-ful postings. Members are asked to donate a one-time fee of $15 to cover the cost of list maintenance. Members post their comments to an email server and can choose to receive emails as they are posted, or a daily digest of all emails posted over the previous 24 hours.

QuiltArt:
The Internet Mailing List
for Contemporary Quilters

While QHL focuses on the history of quilting, QuiltArt is dedicated to the contemporary art quilting. Started in 1995, QuiltArt is a an excellent resource for the experienced art quilter. In addition to the discussion forum, the site posts information on contests and career opportunities, a photo gallery of members' quilts, and a page where members can post their website links. Judy Smith of Washington, D.C., manages the list, which also asks for a $15 donation to cover costs.

From eighteenth-century hearth to twenty-first-century cyberspace, quilters have always and will continue to come together in community and fellowship. While we may have lost the intimacy of gathering in one spot, we have gained friendships worldwide. Whether we are sipping our coffee together in the sewing room, or at our laptops in a hotel room, we share the same news, the latest patterns, a bit of quilt history, and some gossip.

From eighteenth-century hearth to twenty-first century cyberspace, quilters have always, and will continue to come together in community and fellowship.

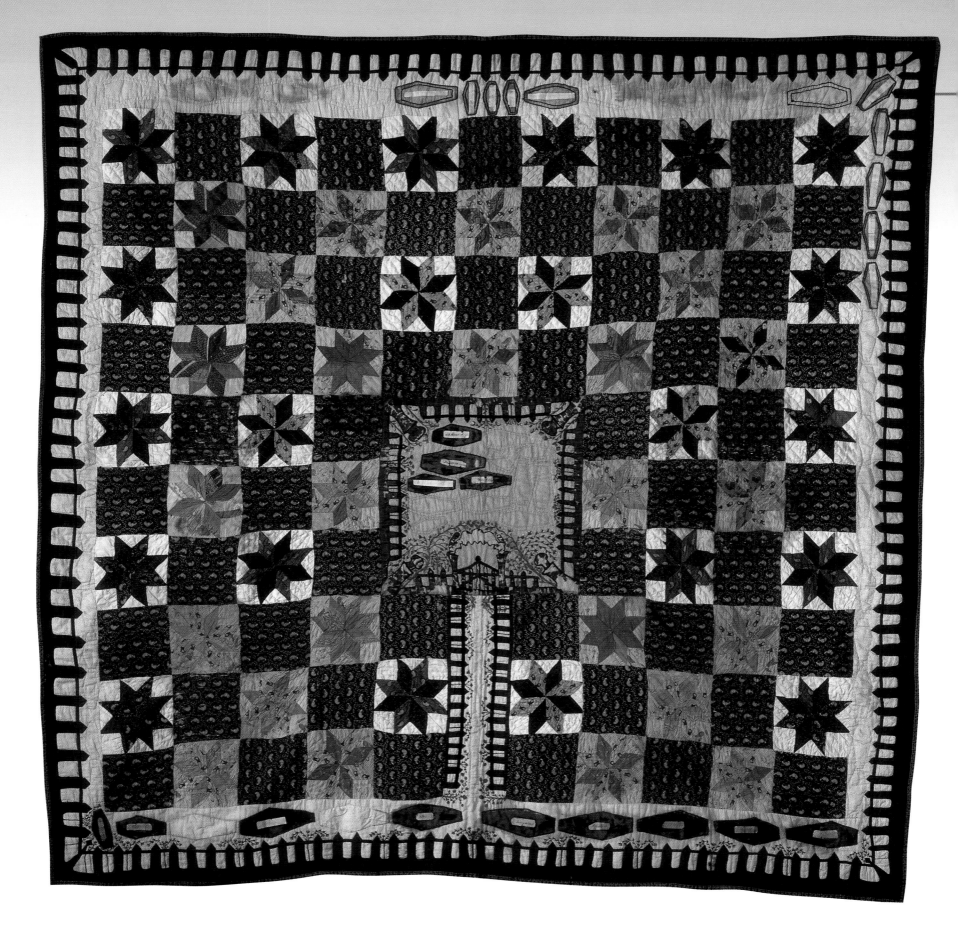

Quilting for Life and Death

We are changing the attitude of the American people by bringing them something beautiful. There is nothing beautiful about AIDS. It is a hideous disease....With The Quilt, we're able to touch people in a new way and open their hearts so that they no longer turn away from it, but rather understand the value of all those lost lives.

Cleve Jones, The Quilt: Stories from the Names Project, 1988

Quilts are first and foremost works of art, and all works of art carry an element of self-expression. For the quilter, their work is an opportunity to share a piece of themselves to tell a story and to help others. Some quilts are particularly expressive, they tell the stories of life and death. Our father dies, we put his favorite shirt in our fabric stash, it will be part of our next quilt. We find a lump in our breast, we buy pink fabric and make a quilt block for Quest for the Cure. We quilt our memories, our fears, and our hopes, then we share them with others in order to heal.

GRAVEYARD QUILT

Date: ca. 1843 **Maker:** Elizabeth Rosberry Mitchell **Size:** 85" x 81" **Owner:** Collection of the Kentucky Historical Society Museum

While Elizabeth's quilt is unusual, the experience of losing children was common throughout the United States in the nineteenth century. Her selection of subdued hues reflects the colors appropriate for mourning in the nineteenth century.

*Detail, Graveyard Quilt
Collection of the Kentucky Historical
Society Museum*

QUILTING GRIEF

When we suffer, we take refuge in safe places. That may be family and friends, it may be a particular house or park, or it may be a familiar activity. Quilters have always used quilting as an outlet for their grief, and to speed the healing process. The process of quilting is comforting. In the simple acts of ironing fabric, cutting a pattern, and taking a few stitches, the quilters keep their hands busy, and allow their mind to rest. Quilting is an ideal art form for expressing grief. Many quilts contain scraps of fabric from the clothing of loved ones. Using clothing in a quilt also gives the quilter an opportunity to share the stories of their loved one with others.

After eight-year-old Mabel Swartz died in 1895, near the small town of Coesse, Indiana, her mother, Rachel, turned her grief into a quilt. Little Mabel wore aprons to keep her two dresses clean, blue and green plaids for weekdays, and brilliant red for Sundays. Rachel used the aprons to create pieced Autumn Leaf blocks, set with white sashing and borders. In 1909 Rachel had another baby girl, Naomi. Rachel gave the quilt to Naomi, along with stories of Naomi's older sister, Mabel.[1]

Victorian-era mourning customs were often elaborate, influenced by the precedent set by Queen Victoria when her husband, Prince Albert, died in 1861. During this time Americans were greatly enamored of all things English, and following rigid societal rules may have provided comfort during the Civil War, when most families, North and South, had someone to mourn. Many women chose to publicly mourn their loss for a full year or more, wearing exclusively black clothing and black jewelry. During the latter part of the nineteenth century, women adopted the custom of making mourning jewelry and wreaths from the hair of the deceased, often braided with the hair of their living relatives and friends.

When crazy quilts became popular in the late nineteenth century, women discovered a new medium with which to memorialize their dead loved ones. Many late nineteenth-century crazy quilts contained memorial blocks. In the collection of New York's Metropolitan Museum of Art is a crazy quilt made around 1877 by Tamar Horton Harris North, of North Landing, Indiana. It is approximately 50 inches square and it contains nine crazy blocks of silk, velvet, and cotton fabrics. The center block is embroidered with the name "Grace," the quiltmaker's 20-year-old daughter who died in 1877. The other blocks are heavily embroidered, and include common mourning symbols such as calla lilies, an angel, an urn, and several crosses.

Quilting as part of the grieving process fell out of favor during the

mid-twentieth century, when quilt-making in general declined. As quilting gained popularity in the 1960s, however, people naturally rediscovered the healing properties of quilting. Twenty-first-century fabric photo technologies make it possible to include images in quilt blocks, personalizing quilts with the faces of our loved ones.

Quilters also quilt to heal from other monumental losses in life including divorce and serious illness. These quilts may graphically represent the loss through the use of photos, artifacts, and descriptive blocks. Or the quilts may not refer to the specific loss at all, but instead provide a means to occupy the maker's hands and give creative relief while the mind heals.

The Graveyard Quilt

Because grief is a lifelong process, some quilts, such as the Kentucky Graveyard Quilt, were made over a long period of time, or many years after the loss. This striking quilt, made by Elizabeth Roseberry Mitchell, is housed at the Kentucky Historical Society and is perhaps one of the saddest quilts in a museum collection.

By 1843 Elizabeth had lived in Pennsylvania, Ohio, and Kentucky. Two of her children died young, John Vanetta as an infant in 1836, and 19-year-old Matthias in 1843. She lived in Kentucky, but both of her sons had been buried in Ohio.

Today, this can be a spur-of-the-moment afternoon drive, but in 1843 poor roads and impassable waterways made it a journey of several days.

Children's lives were often cut short in the mid-nineteenth century. Disease, poor nutrition, and inadequate health care meant most women lost at least one child before that child reached adulthood. In 1843, at the time of Mitchell's son's death, the cult of mourning of the Victorian era had not yet reached its height, but women often used their needlework skills to artistically record their grief.

Elizabeth's quilt is an eloquent testimony to the fragility of life. She designed a center block to represent the family's graveyard. Four coffins are appliquéd on to the graveyard. Two of those coffins carry the names of Elizabeth's dead sons. The graveyard is surrounded by plain and patchwork starred blocks. There are two borders. The inner border contains appliquéd coffins of 21 other family members, who were apparently still living when the quilt was made. It appears that Elizabeth intended to relocate each coffin to the graveyard when that person died. The border is faded where two of the coffins once were sewn before they were removed and resewn in the center graveyard. The outer border represents the picket fence often found around graveyards of the time period.

Why would Elizabeth make this kind of quilt? In family tradition, the

Detail, center block of Elisabeth Rosberry Mitchell's Graveyard Quilt, showing the coffins of her two sons and two other family members. Collection of the Kentucky Historical Society Museum

quilt was started after she visited her sons' graves in Ohio. Perhaps the visit reminded her of a maternal emptiness, and making a quilt kept her mind and her hands busy. Perhaps she was following the same motivations as genealogists today, creating a record to be passed down through generations. While some today may find it to be a morbid quilt, perhaps Elizabeth simply found it comforting.

Passage Quilts: Grief and Transition Through Improvisational Quiltmaking

Sherri Wood, quilt artist from Durham, North Carolina, helps her students create fabric memories using clothing from their deceased family members. She calls the result "Passage Quilts," as the process helps the maker mark their own progress through the steps of grief. Sherri's students use no rulers or templates, but start with the shape of the clothing to maintain a sense of the original owner. From this foundation, students design either a functional or artistic quilt. Sherri, who has a master's degree of Theological Studies and an MFA in Sculpture, began making improvisational quilts as part of her own spiritual practice in 1993. On her website, www.passagequilts.com, she describes the Passage Quilt as "a healing journey through the process of grief and transformation resulting in a new orientation to loss."

For many of Sherri's students, cutting into the clothing is the hardest

REPENT QUILT

Date: ca. 2004 **Maker:** Sherri Wood, Durham, North Carolina, and others
Size: 96" x 72" **Owner:** Sherri Wood

Sherri was inspired by the Graveyard Quilt to make this prayer banner in memory of military personnel killed in the Persian Gulf. Each coffin represents a death, and are arranged to form the word "Repent." It is a community-based project and includes work by many of Sherri's students.

GEORGIA MARIE WOOD (1917–2003)

Date: 2004 **Maker:** Sherri Wood, Durham, North Carolina **Owner:** Sherri Wood

Sherri made this quilt from her grandmother Georgia Marie Wood's housecoats, Sunday dresses, and golf shirts. The quilt is designed to retain the shape of the original clothing, giving it a three-dimensional appearance. The quilt was a gift for her father, Georgia's son.

part of quiltmaking. She encourages them to look at the creation of the quilt as a five -step process, both artistically and psychologically. From the first step of selecting materials, which is part of telling the story, to the final psychologically consoling and transforming step of actually using the quilt, Sherri gives her students a reason to continue, and encourages a positive view of the future.

QUILTING TO COMFORT OR FIND CURES

Few things in life are more frightening than being diagnosed with a life-threatening illness. The seriously ill suffer from pain, sometimes shame, and the knowledge that they may not recover. Those with loved ones who have a major illness also suffer. Long days spent caring for a family member or friend lead to exhaus-

tion. Missed workdays and expensive treatments cause financial distress. The ill and their caretakers need all the support they can get. Activist quilters participate in many projects to raise funds and provide comfort to those suffering from modern illnesses.

AIDS Quilt Projects: Quilting Compassion

Acquired Immunodeficiency Syndrome (AIDS) is one of the most devastating and least understood illnesses of our time. AIDS was identified as a disease when the first AIDS patient was hospitalized in June 1981, and another in January 1982. By 1985 the Center for Disease Control had identified 10,000 cases, and 4,942 deaths. San Francisco alone had lost more than 1,000 citizens. There was no known cure and doctors knew little about what caused AIDS. The public often was misinformed about the disease and patients and their families suffered prejudice and shame.

The NAMES Project Foundation

Into this situation stepped gay rights activist Cleve Jones. In 1978 he helped organize an annual candle-light march in honor of Mayor George Moscone and gay San Francisco City Supervisor Harvey Milk who were assassinated in November of that year during a

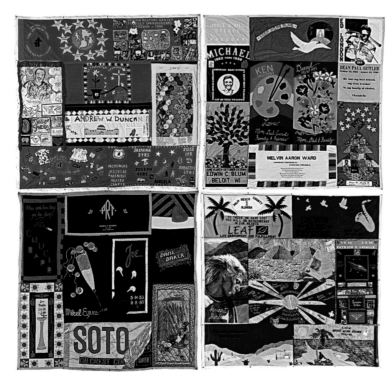

Four blocks from the AIDS Memorial Quilt provide insight into the lives of AIDS Victims. Each block is numbered to help viewers locate it when the quilt is on exhibition. Clockwise from top left, Block #4637, Block #5319, Block #5034 and Block #1522.
Courtesy of the Names Project Foundation, Photo by Paul Margolies, 2004

political confrontation with another city supervisor. Jones had served as an intern in Milk's office a couple of years before the assassination. During the 1985 march, Jones asked marchers to carry cards with the names of the 1,000 San Franciscans who had died from AIDS since its discovery in 1981. The activists created a memorial by taping the cards to a wall. Jones made a quilt panel in memory of his close friend Marvin Feldman. In 1987 Jones and Mike Smith co-founded the Names Project Foundation to create a quilt in memory of AIDS victims. This publicly exhibited quilt would increase AIDS awareness, raise funds, and aim to reduce the stigma and misinformation regarding AIDS.

The first AIDS Memorial Quilt, sometimes called The Quilt, was exhibited on the National Mall in October 1987. The quilt, which was as large as a football field and contained 1,920 panels, toured the country in 1988, and by October it was four times larger. The entire quilt has been exhibited five times, in 1987, 1988, 1989, 1992, and 1996. In 1989 the quilt was nominated for the Nobel Peace Prize. By 2006 it had become the world's largest community art project. Today the quilt, which contains approximately 46,000 panels, weighs 54 tons, covers 175 basketball courts, and, if laid end-to-end, would extend more than 52 miles, is too large for any one venue. But

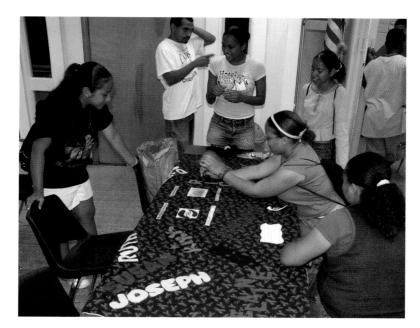

Students learn about AIDS and health care while making memory quilts at Anna's Workshop in Rhode Island. Relatives of AIDS victims request to have a panel made and provide the Workshop with details of the victim's life.

groups of the quilt's panels tour the country annually. Fifteen million people have seen the quilt, and according to the AIDS Memorial Quilt website, it has raised more than $3,250,000 for AIDS services.

The quilt continues to grow through new panel donations. Anyone can make a panel, and there is never a cost to the panel maker. Panels are sewn together in groups of eight related panels, creating a 12-foot-square block. Panels contain not only the names of AIDS victims, but sometimes three-dimensional remembrances, including jewelry, hair, toys, and clothing. Nearly 20 percent of all U.S. citizens who have died from AIDS are named on the quilt.

Anna's Workshop: An AIDS Quilt Rhode Island Project

AIDS Quilt Rhode Island was originally affiliated with the Names Project Foundation and is now an

independent, nonprofit organization. One of its primary programs, Anna's Workshop, is an innovative, educational program for teenagers that combines the art of quilting with learning more about the AIDS crisis. Ann Antoni was a dedicated volunteer with AIDS Quilt Rhode Island and created the workshop to "help young people understand the Quilt, learn basic information about AIDS, and develop compassion for PLWAs (People Living With AIDS)." (Source: AIDS Rhode Island Website)

For more than ten years, AIDS Quilt Rhode Island has worked with school and youth group programs to create panels. Anna's Workshop began in 1999 when Channel One, a youth empowerment program, asked Ann and Beth Milham to conduct a panel-making workshop for their summer youth camp as part of an HIV prevention component. A lasting relationship sprung from one workshop, and the Rhode Island Project now conducts workshops with many other groups. The Cranston Career and Technical School hosts workshops for their health career students. Students at St. George's School, a college prep boarding school in Middletown, make panels as part of their Martin Luther King Day project. Young Heroes, a middle school Americorps program of City Year, Rhode Island, hosted a statewide workshop in 2000, where 100 students made a total of 19 panels in one day.

Panels are usually requested by a person's family members, friends, or coworkers. Sometimes panels are requested by an AIDS service organization such as Matthew 25, which requested a panel devoted to clients of Serenity House, a former residence for people living with AIDS. Workshop participants learn about the quilt project and then are given materials and biographical information they need to create a commemorative panel about an individual who has died from AIDS. During the workshops, students also receive age-appropriate instruction about AIDS prevention. All panels are publicly dedicated at either the International AIDS Candlelight Memorial in the spring, or at the World AIDS Day commemoration held each December. By combining the panel project with health-care information, Anna's Workshop advances AIDS awareness and compassion and may save lives.

Cancer: Quilting for Survival

The very word "cancer" causes alarm. Cancer seems to strike out of nowhere, and cuts across social, ethnic, and economic boundaries. Almost every family in the United States has lost a loved one to cancer. In 2007 the American Cancer Society estimates that there will be 1,444,920 new cases of cancer, and

559,650 people will die from cancer. There are many forms of cancer, but the most common for both men and women are lung, colon, and rectum cancer. The most common cancer for men is prostate cancer, and for women is breast cancer. Quilters nationwide are on the front line of the fight for knowledge, funding, and ultimately a cure.

Quilt Pink

There are more than 200,000 new cases of breast cancer reported in the United States each year. Breast cancer is the most frequent form of cancer among women, and the second leading cancer-related cause of death for women. According to the American Cancer Society, through early detection and improved treatment the five-year survival rate for all stages of breast cancer is now 88 percent. While 99 percent of victims are women, a small but significant number, about 1,600 per year, are men. Quilt Pink is one of the numerous projects that support breast cancer survivors and further information in the field.

American Patchwork and Quilting magazine started the Quilt Pink program to raise funds for the Susan G. Komen Breast Cancer Foundation. Quilt Pink works with quilt shops nationwide to host a one-day event in September. Quilters visit a participating shop to create a white and pink quilt block in mem-

ory of a particular individual or just to show support for the cause. The shops then assemble the blocks into quilts, which are sent to the magazine to be auctioned online in the spring. The proceeds from the quilt sales are presented to the Komen Foundation during October's Breast Cancer Awareness Month. More than a thousand shops, representing all 50 states and Washington, D.C., participated in the first Quilt Pink, held on September 30, 2006.

Quest for a Cure

Northcott/Monarch in Lyndhurst, New Jersey, creates the Quest for A Cure line of quilting fabrics. These fabrics are sold through quilt shops nationwide. For each yard sold, Northcott donates a portion of the proceeds to breast cancer research.

Northcott also has a three-stage initiative to support breast cancer victims. The company is working with THE Quilt, a Canadian breast cancer support program, and the Y-ME Foundation in United States to raise funds for the direct support of breast cancer patients. The first stage is the Quest for a Cure Block Challenge. Quilters design blocks from a specific Quest for a Cure line. The second stage takes place the last weekend in March, when quilt shops host a 30-hour Quilt Marathon. Participants work around the clock, sewing the chal-

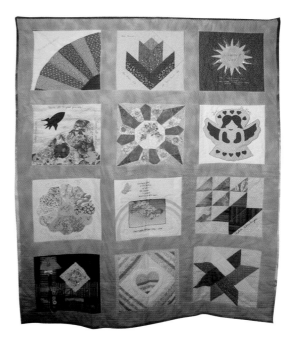

OVARIAN CANCER SURVIVOR'S QUILT

Date: ca. 1999 **Maker:** Ovarian Cancer National Alliance **Size:** 48" x 60"
Owner: Ovarian Cancer National Alliance

This is the fifth of the five original Cancer Survivor's Quilts. One of the blocks contains words of encouragement: Today is your day, you are off to great places, you are off and away!

lenge blocks together, and completing quilts. The final phase is the auctioning of these quilts.

Ovarian Cancer Quilt Project

Ovarian cancer is one of the least understood cancers. The symptoms of the disease are subtle, and unlike breast and cervical cancer, there is no accurate screening test. Yet, one in 55 women will contract ovarian cancer and a large percentage will not survive five years. Women have few options by the time they are diagnosed and often feel isolated.

The Ovarian Cancer Survivor's Quilt Project intends to change that. Ovarian cancer survivor and quilter Shirlee Mohiuddin created the project, which is sponsored by the Ovarian Cancer National Alliance and modeled on the NAMES project. Squares are made by patients or in memory of those lost to the disease. Health-care professionals, volunteers, and cancer survivors use the quilts as a dramatic backdrop to speak about the disease. The five completed quilts are also available for exhibition around the country. Alliance staff members also provide support and information to those who would like to create a similar quilt for their state or community. Quilts have been made by the Minnesota Ovarian Cancer Alliance and St. Louis Ovarian Cancer Awareness among others.

Quilt 4 Cancer

Frank Halden lost his wife, Hallie-Jo Collins, to lung cancer in 2003.

Hallie-Jo was a lifelong quilter, and Frank shared her hobby. Quilting became an important outlet for his grief. Frank is definitely not alone. Lung cancer is the most common form of cancer in the United States, with 175,000 people contracting the disease each year, 85 percent of whom die within five years. It is also one of the few cancers that can be prevented through lifestyle changes. Hallie-Jo was a lifelong smoker. As Frank quilted through his grief, he realized this hobby could save lives.

In 2005 Frank launched the nonprofit Quilt4Cancer.org. He uses the website to auction an annual memorial quilt of his own creation and to exhibit other memorial quilts available for auction. Interested parties may purchase raffle tickets for $25 each. The first quilt, a Snail's Trail pattern in rainbow colors made by Frank, was auctioned in April 2006. Frank manages the raffles exclusively through the Internet. Tickets are purchased through a secure server, and the winning entry is selected through a random number generated by the server. Managing the charity online keeps administrative costs down and ensures that more money goes directly to programs, such as the Norris Cotton Cancer Center in Lebanon, New Hampshire.

SEPTEMBER MOON POSTCARD QUILT
Date: ca. 2006 **Maker:** Virginia A. Spiegel,
Illinois **Owner:** Unknown

*September Moon, one of Virginia's original
designs, is one of the tiny quilts raising large
amounts of money for cancer programs. Artists
around the world now donate quilts for the
auctions.* Photograph by Virginia Spiegel

Fiberart for a Cause

Virginia Spiegel's family connection to cancer is noteworthy. Her father is a colon cancer survivor and her sister is chair of the Relay for Life, a fundraising program of the American Cancer Society, in Forest Lake, Minnesota. So it is natural that Virginia is also involved with the American Cancer Society. Since April 2005 she has voluntarily coordinated the Fiberart for a Cause program, creating postcard-sized quilts for sale and auction. The project started when Virginia made a few of the quilts, hoping to sell them online and donate the proceeds to the American Cancer Society. Soon she was making and selling the postcards full-time. A friend, textile artist Karen Stiehl Osborn, offered to donate some postcards in memory of her own father. In less than a year, she was joined by fiber artists worldwide, including many members of the online group QuiltArt. In just two years, Fiberart for a Cause raised $120,000. Because the fundraiser is managed by volunteers, quilters donate the art, and the International Quilt Festival donates booth and auction space, 100 percent of the proceeds go directly to the American Cancer Society.

Quilters are redefining traditional approaches to life and death issues through their art, whether that art is produced for remembrance, awareness, or to raise money. Making the quilts provides quilters with a way to take control of a situation, at a time when they are feeling as if everything is out of their hands. The benefits of these projects will last for generations.

Alzheimer's Art Quilt Initiative

by Ami Simms

Ami Simms learned to quilt in the 1970s, while working on her undergraduate thesis about the Old Order Amish in northern Indiana. She is a quilt designer, international quilting teacher, and author of many books, including How Not to Make A Prizewinning Quilt, Invisible Appliqué, *and* Creating Scrapbook Quilts. *In 2006 Ami started the Alzheimer's Art Quilt Initiative, which works to increase awareness about Alzheimer's disease and to raise funds for Alzheimer's research.*

Ami's essay describes her experience with her mother's Alzheimer's disease, the motivation behind the Alzheimer's Art Quilt Initiative. She also discusses the role of the Initiative in battling the devastating disease.

My mother has Alzheimer's disease. She lived with my husband and me for nearly four and a half years, and for much of that time she kept busy by sewing quilt tops. Rather than sew rows of same-sized patches, she rotary cut odd shapes and puzzled them together. I palmed them off on unsuspecting quilters at my lectures and workshops to fix, finish, and then donate to their favorite charities. It was a win-win situation. Mom had something meaningful to do, and several hundred charity quilts were donated by kind-hearted quilters who didn't mind Mom's odd color combinations, weird constructions techniques, or mismatched seams.

As Mom's Alzheimer's progressed, her patchwork got stranger. There were more pleats and fewer seams that actually caught both pieces of fabric. A steam roller was about the only thing that would get them to lie flat, and I ran out of takers. She continued to sew because it was something she could still do. I didn't want to tell her otherwise. Everyone needs to feel their life has purpose.

I continued to make a BIG FUSS over her "quilts." We both did the Happy Dance every time she finished one, and I tucked them away to finish "later." (The 20-gallon tote is now full to the top!)

Finally, the part of Mom's brain that remembered how to piece her odd-shaped patchwork faltered. She couldn't remember how to puzzle the pieces together. I suggested we go to 6-inch squares she could sew in rows, and then join the rows to make the quilt tops. In the transition, I became custodian of her rotary cutter and cutter of the squares.

Learning to patch this "new" way was an excruciatingly difficult concept for her to grasp. It took hours and hours to teach her to sew pairs, then to join the pairs to make the rows. She kept forgetting how to count to eight. Diagrams didn't help, nor did the sample rows we sewed together. She looked at a row with six blocks and a row with eight blocks and thought they were the same length.

Still, she was determined. She had to hang on to every thought with both hands, yet she wanted so much to help by making charity quilts. How do you say "no" to that? So, she sewed and I cut 6-inch patches—thousands of patches. None of what she sewed was usable. Too many puckers, pleats, and holes. But, she was on a mission. And I was going nuts!

Something had to change. It was then that I remembered I had several spools of YLI Wash-A-Way water soluble basting thread. We added borders to three of her quilt tops, and then without her knowing I wound all her bobbins with Wash-A-Way thread. After she went to bed at night I soaked her patchwork in the washing machine. With a quick spin and a few minutes in the dryer, I was able pick out the regular thread. My friend Judy and I ironed the squares and gave them back to her the next day to sew, mixed in with freshly cut patches.

Every other day I would show her one of the three "finished" quilt tops to her and tell what a good job she was doing. She never caught on.

About the time I learned it was quicker to cut up new fabric than soak, dry, and press the old, Mom was accidentally unthreading the machine with every other seam. I don't know what she was doing to that poor machine, but even Steve became proficient at re-threading her Bernina. Mom had completely forgotten how. One afternoon I found the machine tipped on its front. She was staring at the top of the spindle trying to thread it.

My mother is just one of 4.5 million Americans who have Alzheimer's disease. There are countless wives, husbands, sons, and daughters who suffer right along with them, as victims of this disease lose their life skills one by one. It is like watching death in slow motion, mourning what was.

My mother is approaching the one-year anniversary of moving to an Alzheimer's care unit. She lives with 17 other people she does not know. Her brain has lost its ability to store the memories of who they are, even though she shares meals and activities with them daily. She still knows me, but it takes longer and longer for her to register my face and voice as those of her only child. Most basic tasks are difficult; sewing is out of the question.

Mom's struggle with Alzheimer's was the motivation for the Alzheimer's Art Quilt Initiative (AAQI). I wanted to turn the anger and sorrow I felt into something positive. The AAQI is a grassroots, Internet-based effort to raise awareness and to fund research. All profit is donated to Alzheimer's research. The AAQI is accomplishing its goals with two concurrent programs.

Alzheimer's: Forgetting Piece By Piece

The first is a nationwide quilt exhibit called "Alzheimer's: Forgetting Piece By Piece." It contains 52 quilts, each interpreting Alzheimer's in some way. More

than 60,000 people have seen the exhibit since its premier in August 2006 in Nashville and it is my hope that half a million people will see it as it crisscrosses the United States until July 2009.

The work of 54 quilt artists from 30 states, plus one artist from New Zealand is represented in the exhibit. The artists, many internationally renowned, offer poignant interpretations of the Alzheimer's experience in fiber. Themes include gritty illustrations of the anger, frustration, and stress of care-giving; imaginings of an existence stripped of memory and learning; beautiful tributes to loved ones taken by Alzheimer's; and anticipation of a future cure. They are quilts of heartbreak and hope. Each artist statement is paired with a fact about Alzheimer's.

A CD has been created with photographs of all the quilts in the exhibit narrated by the artists. All profit from the sale of the CD ($15) goes to Alzheimer's research.

Priority: Alzheimer's Quilts

The second is a monthly Internet auction of "Priority: Alzheimer's Quilts" so named for the urgent need for research dollars and the requirement that these quilts must fit into a cardboard USPS priority mailer. They are small works of fiber art no larger than 9 inches by 12 inches, auctioned during the first 10 days of each month at www.AlzQuilts.org. Bids have ranged from $15 to $250. Some Priority: Alzheimer's Quilts are sold out right. Selling these very small quilts has raised more than $30,000 for Alzheimer's research since January 2006. They are donated by quilters all over the country. Each quilt successfully sold in 2006 or 2007 enters its maker into a drawing for a Bernina sewing machine.

Recently, the Alzheimer's Art Quilt Initiative was invited to sell Priority: Alzheimer's Quilts at the International Quilt Festival in Houston. In just four and a half days, supporters of the AAQI purchased 340 quilts for a total of $16,990.

To donate or bid on monthly Priority: Alzheimer's Quilt auctions, to purchase the CD of the traveling exhibit, or to find out more information about the Alzheimer's Art Quilt Initiative, visit www.AlzQuilts.org.

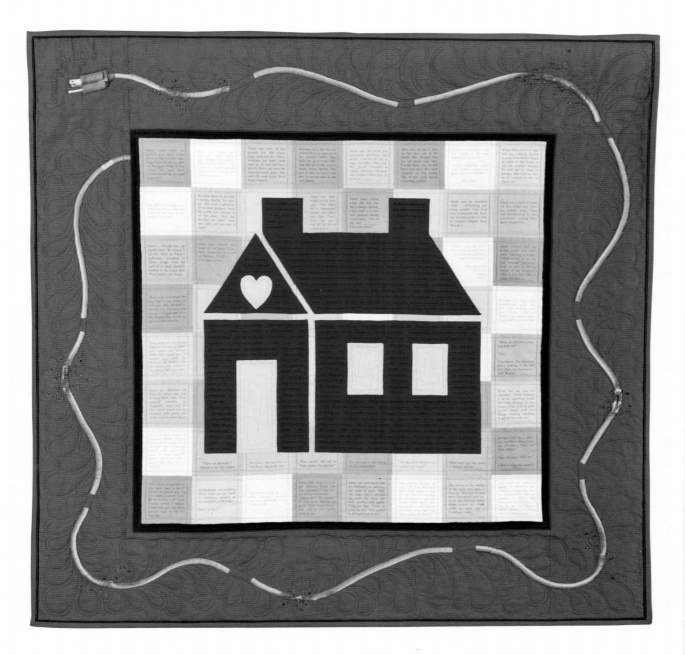

UNDERLYING CURRENT

Date: ca. 2005 **Maker:** Ami Simms, Flint, Michigan **Owner:** Alzhiemer's Art Quilt Initiative

Ami's quilt uses the image of disrupted electrical current to describe the experiences of Alzhiemer's patients. The quilt is part of the exhibit that has appeared at the AQS 2006 Quilt Exhibition in Nashville, the Pennsylvania National Quilt Extravaganza in Harrisburg, and quilt guild shows in California and Texas.

Quilts As Gifts

I remember one spring…there was a lot of the girls that had got engaged and we did nothin' but make quilts for 'em. I was an awful quick sewer, so, of course I was always one of the first to be asked. We would think we'd got everybody quilt up, when some mornin' there'd be a knock at the front door…I declare sometimes I'd be so fair worn out the mere thought of doin' another quilt would make me feel jest like droppin'.

Ella Bartlett, WPA interview, December 19, 1938[1]

WEDDING ALBUM

Date: ca. 1864 **Maker:** Mary Nevius Potter and friends, Pottersville, Maryland
Size: 86" x 86" **Owner:** The Newark Museum/Art Resource, New York; collection of the Newark Museum, Newark, New Jersey

Mary used detailed appliqué, a technique usually reserved for "best" quilts. The patterns are reminiscent of the Baltimore Album quilts popular a decade earlier.

*Detail of Appliquéd block
Mary Nevius Potter's Wedding Album Quilt.*
Courtesy of the Newark Museum/Art Resource, NY; Collection of the Newark Museum, Newark, New Jersey

The quilter puts the last stitch into the binding just in time for gift-wrapping. She may be late for that wedding, but the quilt is done, and perfect. Quilts make great gifts, everyone knows that. The challenge for today's quilter is to keep up with the many requests for gift quilts. Some quilters manage to find time to make quilts for every occasion. Most have to settle on specific occasions, such as weddings, births, or anniversaries. Some quilters prefer to give "non-occasion" quilts, a surprise gift for someone special.

Quilts as gifts are a centuries-old tradition. The famous Tristam hangings, described in the first chapter, are believed to have been a wedding gift to an Italian couple around 1395. Quilts were expensive presents and were

given and received predominantly by the wealthy. In the United States the earliest gift quilts were also wedding quilts. By the 1820s, wedding quilts became a common gift as fabric became readily available and people had a greater amount of leisure time. The Friendship quilt or Signature quilt was usually a gift, and many Album quilts were also intended as gifts. By the mid-nineteenth century, most brides expected to bring quilts with them into their marriages as part of their doweries. Some of the quilts were made by the bride; others were gifts from friends and family members. Quilts made specifically for babies were rare until the early 1800s, due to the high infant mortality rate. With the amount of work that goes into creating a quilt, time was better spent on large quilts. By the mid-nineteenth century, mortality rates among children had dropped, so crib quilt gifts became more common. In some communities and families it was also common for the female relatives and friends of a young man to make him a quilt when he reached adulthood, especially if he was leaving the community. And, of course, sometimes quilts were given for no reason, other than affection for the recipient.

How do today's quilters decide who should receive the gift of a quilt? This is a difficult decision, as our desire to give quilt gifts far exceeds the amount of time we have available to make them. Most quilters want to be sure the recipient will truly appreciate the gift. Some only give quilts for major life events such as graduations or weddings of family and friends. Others limit their quilt-giving to certain family members, for example making one for each grandchild. A few lucky quilters seem to have enough time and energy to give quilts to everyone they know, and for every reason. Whatever "rules" they select, giving a quilt is giving a piece of oneself and is one of the most personal decisions a quilter can make.

WEDDING AND ANNIVERSARY QUILTS

Weddings and quilts are inextricably linked. Nineteenth-century novels and histories quote the number of quilts needed to start a household: often 10, 12, or 13. Most of these quilts were meant for general use, but at least one would be a "best" quilt, used only for company or special occasions. Since other quilts in the household were often used to the point of being threadbare, it is these "best" quilts that often survive with stories intact.

According to Dr. Tina Brewster Wray, curator of collections at the White River Valley Museum in Auburn, Washington, before 1870 a wedding dowry had to include a Bride's Quilt, stitched with hearts.

A Bride's quilt, or bridal quilt, was a "best" quilt, generally made after the young woman was engaged. Unlike her everyday quilts, which were usually pieced, the bridal quilt was often appliquéd or whole cloth, which allowed her to exhibit her best quilting skills. Before the Civil War heart-shaped quilting was seldom used on quilts other than bridal quilts. There is much folklore surrounding the use of hearts— some stories hold that if hearts are used for an unmarried girl's everyday quilt, she will never marry. A romantic story, for perhaps a practical custom; intricate heart shapes require more time to quilt, so they weren't a sensible decoration for an everyday quilt.

Documentation abounds regarding quilting bees to finish wedding quilts. In many oral histories, interviewees reminisce about gathering to quilt, and it is still the custom in a few quilt guilds, religious communities, and families to present a newly married couple with a quilt made by family and friends.

Wedding Album Quilt

In 1864 the United States of America and the Confederate States of America were in the final desperate battles of the Civil War. About the same time Mary Nevius Potter, of Pottersville, New Jersey, and friends made this beautiful Wedding Album quilt for Mary's wedding. The quilt contains 36 blocks, each made by a different woman. Thirty-five of the blocks feature hearts, flowers, and other designs expressing good wishes for a happy marriage. The 36th block prominently placed just above and left of center includes an American flag. Flags are often used in quilts as a sign of patriotism during periods of war. The use of the flag indicates that Mary's sympathies lie with the Union troops. Whether Mary had a family member serving in the Union Army, or was caught up in a wave of patriotism is not known. This quilt is an example of how women of the time expressed their political beliefs through everyday activities such as quilting.

There are many other stories of nineteenth-century group-made wedding quilts. One story discovered by the Wisconsin Quilt History Project involved a wedding quilt given to Sevina Kraus Harms in 1870. Sevina's mother, Eva Frank Kraus, was an immigrant from Germany, who raised eight children in southwest Wisconsin, four girls and four boys. Eva designed the Folk Animals and Flowers wedding quilt, and asked each of her sons to draw the animals that would surround the flower pots. Sevina's quilt contains appliquéd horses, birds, and foxes, all designed by her brothers.[2]

The custom of getting together to make a large number of quilts for

a newly married couple has all but disappeared. Fewer people have the sewing skills or the time, and family and friends are often scattered across the country. If a couple is lucky enough to receive a wedding quilt, it is usually through the work of one or two dedicated quilters.

Denali's Northern Lights

Joan Hodgeboom, the owner of The Quilt Gallery in Kalispell, Montana, makes many wedding quilts for her nieces and nephews. When her daughter, Jodi, announced her engagement to Bill, Joan started working on a very special wedding quilt. Jodi and Bill live on the edge of Denali National Park, Alaska, and Jodi works for the Denali Foundation, an organization that provides education and preservation support to the natural environment. Joan wanted to create a wedding quilt that would reflect the couple's home and challenge her quilting skills.

Joan has always liked quilt patterns with peaks and has a collection of old patterns. Using the Whig's Defeat pattern, she designed their wedding quilt with colors to represent the Northern Lights phenomena, sometimes seen in both Kalispell and Denali. She combined three separate patterns to achieve the right arcs for the peaks. Joan used paper and curved-seam piecing, appliqué, and machine quilting to complete the quilt. Jodi and Bill will have to decide whether to hang their quilt in the new home Bill is building, or use it as a bed covering. In the part of Alaska where they live, winter temperatures often dip to 35 degrees below zero Fahrenheit.

The Hale Family Anniversary Quilt

Long marriages provide another occasion to celebrate with a quilt. While no one knows when the first wedding anniversary quilt was made, by the late twentieth century they

HALE FAMILY ANNIVERSARY QUILT
Date: 1976 **Maker:** Terry Grimlie, Roosevelt, Utah **Size:** 94" x 92" **Owner:** Terry Grimlie

Terry used 108-inch wide tricot for both the top and backing of this quilt. Quilting the fabric was challenging, as the tricot stretches under both machine and hand quilting. Photo by Shelley Emslie

were a popular way to acknowledge a 25th, 40th, or 50th anniversary.

The Hale family quilt is an example of this growing trend. It also contains tricot, a fabric rarely used in quilting today, but that had a short-lived popularity in the early 1970s.

Terry Grimlie comes from a family of quilters. Her great-great grandmother, two great-grandmothers, and one grandmother were all quilters who lived in Wayne, Nebraska, during the early and mid-twentieth century. Their many quilts reflected the patterns popular of the times: scrappy Ocean Waves during the 1930s, feed sack Flower Baskets in the early 1940s, and Colonial Girls in the 1960s. While the family stayed in Nebraska, Terry's life took her to Utah, Oklahoma, and finally Montana, but no matter where she lived, she always stayed in touch with her quilting roots.

When Terry was living in Roosevelt, Utah, her grandmother and grandfather reached their 50th wedding anniversary. Lydia Irene Vonasek married Clifford Jefferson Hale in 1926. Terry and her friends made Lydia and Cliff an anniversary quilt.

The whole cloth quilt features a

Baby quilts were often made in anticipation of an oldest child's birth, and then passed down through the family.

Sego Lily quilting pattern. The Sego Lily is the Utah state flower, the state in which Terry was living at the time. The names of the couple and their wedding date are quilted in the center of the quilt. What is truly unique about the quilt is that it is made from two layers of 108-inch-wide tricot with a polyester batting. Terry remembers that in 1976 when tricot and other knits were readily available and affordable, it was a preferred fabric for home whole cloth quilting purposes. These fabrics also came in long widths, which meant the quilter could make a whole cloth quilt without piecing strips. By the 1980s, quilters advocated a return to 100 percent cotton, which now also comes in long widths.

CHILDREN'S QUILTS

The earliest quilts made specifically for children generally appear in the nineteenth century, although the DAR Museum in Washington, D.C., has a white, whole cloth crib quilt made in 1792 and attributed to June Hoffman Kiersted of Rheinbeck, New York. Quilt historians believe the appearance of children's quilts reflect a change in attitude toward children and recognition of childhood as a separate stage of life. Prior to the nineteenth century, children were dressed as babies through the toddler years then they were often looked upon as mini-

adults, who were to dress in adult styles and complete adult chores. The large families and short life spans prevalent during the early 1800s contributed to the belief that childhood was a stage through which children were to pass quickly.

By the mid-nineteenth century, these attitudes changed. Children on the average were living longer and healthier lives due to improved healthcare and living conditions. Childhood, therefore, lasted longer, and children required clothing, toys, and bedding suitable for that life stage.

Baby quilts were often made in anticipation of an oldest child's birth, and then passed down through the family. In the nineteenth century, a baby quilt differed from other quilts primarily in size. These baby quilts are made in patterns traditional for the time period, but designed in smaller sizes of between 41 and 45 inches on a side. Although patchwork will always be a popular child's quilt choice, by the twentieth century childhood-related patterns appear, including many variations of Sunbonnet children, embroidered nursery rhyme patterns, and appliquéd children's toy patterns. In the late twentieth century, fabrics and patterns designed specifically for baby quilts became readily available. The baby quilt is a very popular first quilt because of its small size, but remains a favorite of

WHOLE CLOTH CRADLE QUILT

Date: ca. 1854 **Maker:** Mary Frances Degge, Petersburg, Illinois **Size:** 41" x 47"
Owner: Collection of the Illinois State Museum, Springfield, Illinois

The quilt's central urn design was popular in decorative arts of the first half of the nine-teenth century, and can be found in paintings, furniture, and other textiles of the time period.

experienced quilters, too. Lola Bee of Jackson County, West Virginia, made a one-patch baby quilt for the birth of her son John Augustus Bell in 1887. John's family owned the Buffalo Store Company, a dry goods store near Marshall, West Virginia. John perished in the 1918 world-wide flu epidemic, leaving behind a son and daughter. Lola raised the daughter, Maxine, and gave her the preserved baby quilt.

In 1942, members of the Berkeley, California, Sewing Club made a baby quilt for member Margaret Wynkoop Atthowe. Because Margaret's family worked in the shipping industry, each member made a blue-and-white sailboat block from a 1936 *Kansas City Star* pattern. Margaret gave birth to a girl, whom she named Margaret, and the sailboat quilt remained the only group-made quilt in the sewing club's 49 year history.[3]

BOY'S EMBROIDERED QUILT

Date: 1924–1935 **Maker:** Emilie Ann Arnold Clarke, Detroit, Michigan **Size:** 74" x 86"

Owner: Courtesy of Michigan Traditional Arts Program Research Project

Emilie made these two quilts for her children. Emilie received an M.D. from the University of Michigan in 1922, and a Ph.D. from Wayne State University in 1937. She worked as a doctor for the Michigan Department of Health and the Red Cross.

Whole Cloth Cradle Quilt

Early children's quilts were smaller versions of quilt patterns used for bed-sized quilts. The Whole Cloth Cradle quilt was made in 1854 for Mary Frances Degge, Jr. Fanny, as she was known, was the third child and second daughter of John and Mary Degge. John was a harness maker in Petersburg, Illinois. He drew the quilt top's design, which includes a central urn filled with flowers and surrounded by swags of fern leaves. Mary expertly quilted the design, using just 11 stitches to the inch. Fanny's older sister, who was born in 1850, did not survive childhood. Perhaps this intricate quilt was also a prayer for good health for their new baby girl.

Clarke Children's Quilts

In the 1920s and 1930s, Emilie Ann Arnold Clarke was a busy woman. The Detroit, Michigan, woman had two young children, Harriet and

GIRL'S EMBROIDERED QUILT

Date: 1924–1935 **Maker:** Emilie Ann Arnold
Clarke, Detroit, Michigan **Size:** 69" x 82"
Owner: Courtesy of Michigan Traditional
Arts Program Research Project

George. She had a mother-in-law who was a prolific quilter and who wanted her daughter-in-law to quilt with her. This was difficult, because Emilie was also a medical student who eventually became a physician with the Michigan State Public Health Department. Despite her busy schedule, Harriet found time to quilt. Two of her quilts were for her two children. From a distance they appear identical, two embroidered quilts, 30 blocks, set with navy blue sashing. Emilie, however, used two different sets of patterns, predominantly farm and exotic animals for George's quilt and flowers and dolls for Harriet's quilt. Harriet remembers her mother, grandmothers, and aunt quilting on a frame in their home's attic. In 1986, Dr. Harriet Clarke and her brother, George, donated 45 quilts with templates, patterns, and notes to the Michigan State University Museum.

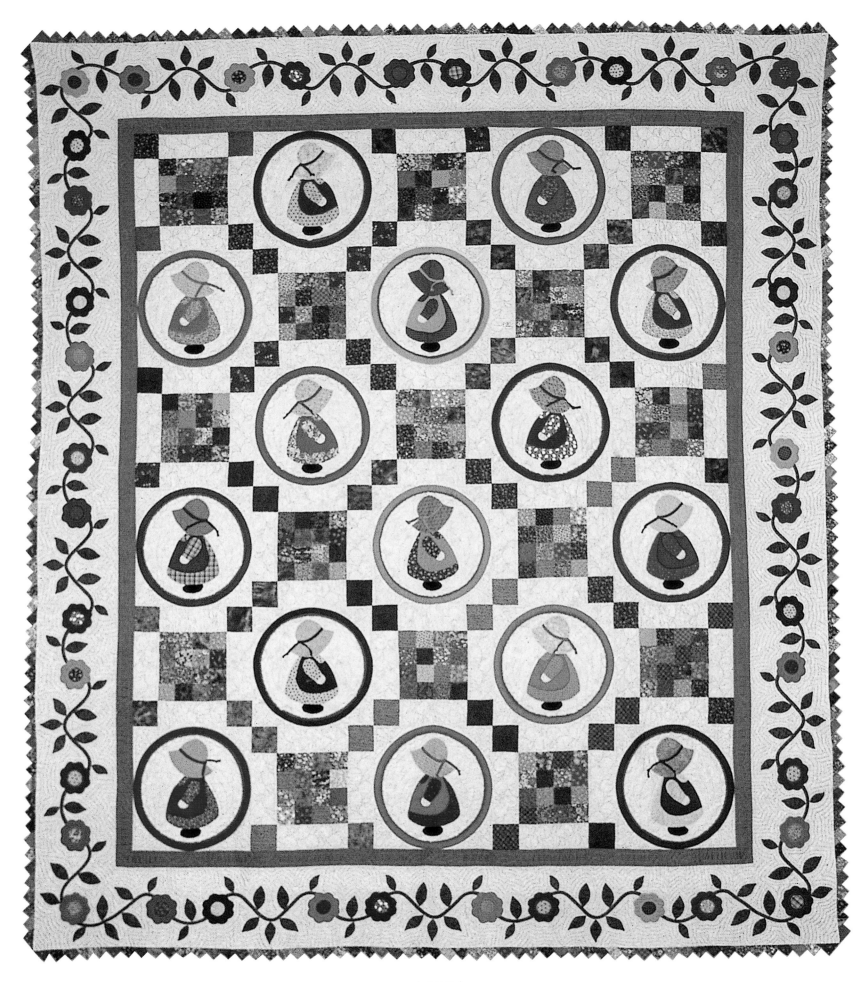

QUILTS FOR OTHER GIFTS

There are many other reasons to give a quilt gift. Other life passages, graduation, moving, and retirement are opportunities to share. In the mid-nineteenth century it was not uncommon for a young man's female relatives and friends to make a quilt that would symbolize the passage from boy to adult. Mrs. C. S. Conover, of New York City, made such a quilt for her grandson in 1855. Using silk, satin, and cotton fabrics, some of which date to her own childhood in the late 1700s, she made a colorful quilt of small, complex blocks. The quilt itself, now in the collection of the Newark Museum in New Jersey, is still in excellent condition, indicating that Mrs. Conover's grandson seldom used it.

Another quilt made for a young man is the Joseph Colesworthy Quilt at the Maine State Museum. This Friendship quilt includes pieced and appliquéd blocks, signed by female family and friends, presumably the makers of the blocks. The quilt was made in 1857, the year that Joseph turned 22. The quilt also includes a double block United States flag, foreshadowing Joseph's military service during the Civil War. Today, memory quilts made of T-shirts and other clothing and decorated with photos and signatures of friends are often given as gifts to mark a life passage.

Mary Duncan Pattison, a Minnesota teacher who emigrated from Scotland in the mid-nineteenth century, used a quilt to give the gift of literacy to her grandchildren. Wanting to teach her grandchildren the alphabet before they entered school, she used the pages of a linen book as the blocks in a brightly colored Brick Wall quilt.[4]

Robert Ernest Dorr of Creighton, Nebraska, received a Nine Block Crazy quilt from his mother, Alice, for his 12th birthday in 1899. Robert did not have many years to enjoy his quilt, as he died in a silver mine accident as a young adult. Robert's older sister Sarah Mae inherited the quilt.[5]

There doesn't have to be a special occasion to give a quilt. Many quilters make a quilt for a friend simply because that friend admired the pattern or fabric. Jimmie Ann McClean, of Kalispell, Montana, made a Sunbonnet Sue quilt in 2003 for her adult daughter, Bonnie. Jimmie chose a Sunbonnet pattern that had been used in a quilt made by Jimmie's mother and placed it in a garden setting because Bonnie and Jimmie's mother shared a love of gardening.

The gift of a quilt should be cherished for its style, color, and workmanship. Within each quilt rests a part of the quilter.

SUNBONNETS FOR BONNIE

Date: ca. 2003 **Maker:** Jimmie Ann McLean, Kalispell, Montana **Size:** 86" x 102" **Owner:** Jimmie Ann McLean

Jimmie Ann's quilt is a modern update of an early twentieth century favorite design. Jimmie Ann is a member of the Kalispell Tuesday Morning Group. Photo by Shelley Emslie

Chapter 9

Quilts on Display

Among the quilts the esthetic quality is so high that it would be foolishly arbitrary to single out particular examples. For connoisseurs, the show will confirm what they already know—that this is one medium in which the American folk imagination excelled. For newcomers to the material, the show will be a stunning revelation.

Hilton Kramer, "Art: Quilts Find a Place at the Whitney," *New York Times*, July 3, 1971

FLOWER BASKET PETIT POINT
Date: 1943 **Maker:** Grace McCance Snyder, Nebraska **Size:** 92" x 94" **Owner:** Nebraska State Historical Society

Petit point is a common needlepoint technique. This one-stitch flower basket design adapts well to a one-patch quilt design. This quilt took the purple ribbon at the Nebraska State Fair in 1943.

Detail, Flower Basket Petit Point
Photograph courtesy of the Nebraska State Historical Society

T

wo women, their heads together, stand before a quilt. "I wonder where she got the pattern," one whispers. The other leans forward, a little too close. A woman in white gloves steps in and asks them if they'd like to see the back of the quilt. They laugh a little sheepishly and nod. The quilt show is underway.

Quilters have displayed their work for centuries, from the first funeral hangings in the tenth century to last week's quilt show. In the United States, quilts were part of the needlework exhibits in local fairs by the mid-nineteenth century, and by the 1930s, quilting was important enough to warrant its own exhibition area in the largest fairs, including the 1933 World's Fair. In the twentieth century, quilters began organizing their own

fairs, and the quilt show was born. Through most of the twentieth century, the shows featured the best of traditional quiltmaking. But just as the country "modernized" after World War II, so did quiltmaking. By the 1970s a radical group of quilters were making art quilts, meant for walls not for beds. Not welcome at established shows, they started their own show at a little barn in southern Ohio. Happily for today's quilter, art and traditional quilting have found common ground in the desire to display quilts, and some of each appears at most modern shows.

WORLD'S FAIRS

In the United States, quilting and fairs are inextricably linked. Nearly every fair, whether it's a local, county, state, or national fair, has an exhibition area and awards for quilts, and quilters are often asked to demonstrate their technique for fair-goers. The relationship began during the United States' centennial in 1876 and continued with the support of homemaker's groups and county extension offices. Today, most local, county, and state fairs award premiums and cash prizes for high-quality quilt projects. Two World's Fairs, both held in Chicago, Illinois, are notable for their advancement of the quilt field. The 1893 Columbian Exposition was the first national fair to have a separate

building showcasing the work of women, and the 1933 Century of Progress was the impetus for the largest quilt contests held to date. Record crowds attended both fairs, introducing the art of quilting to many new audiences.

Columbian Exposition

The World's Columbian Exposition celebrated the 400th anniversary of Christopher Columbus's voyage to North America. By 1893 the United States had risen to become a world power, despite internal growing pains, a national depression, and an increasing dissatisfaction among the nation's workers. Many of the pavilions at the fair were a showcase of the country's strengths while others provided an idealistic view of the world's cultures. This was the largest fair held in the world to date and required the creation of a virtual city along the Lake Michigan shoreline. Twenty-seven million people attended the fair during its six-month run, a boom for a fledgling tourism economy in the heavily industrial Chicago.

Famous landscape architect Frederick Law Olmsted transformed Jackson Park, a dark, marshy, neglected area, into a community of 200 classical Beaux Arts-styled buildings. The fairgrounds became known as the White City, for the white, alabaster-like finish on the buildings. Visitors strolled pathways between pavilions, rested

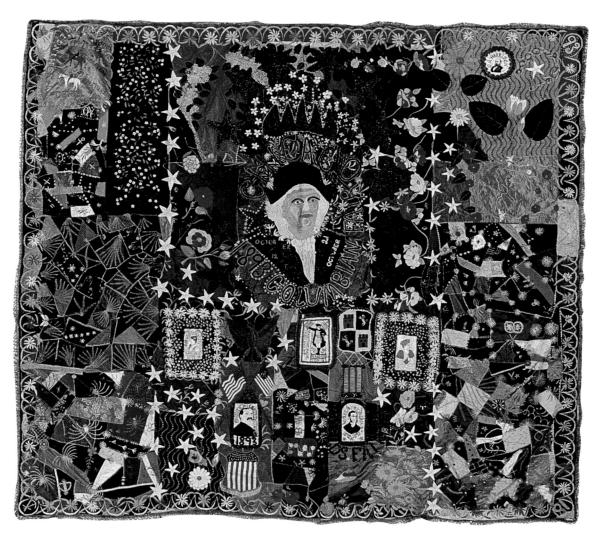

in shaded parks, and visited a lagoon, complete with a full-sized scale replica of Columbus's ship, the *Santa Maria*. This was the first fair to have a separate amusement area, which included the first Ferris wheel, a 250-foot tall monstrosity, with 36 cars, each carrying 60 people. Many new foods were introduced at this fair, including Juicy Fruit gum, Aunt Jemima pancake mix, and Shredded Wheat.

The Columbian Exposition was an important event for women. As at the Centennial Exhibition in Philadelphia, a separate building was designed for the Women's Department, displaying the domestic activities, inventions, and artwork of women. Notably, though, it was the first time that a World's Fair building was designed by a woman. Sophia G. Hayden, a graduate of the Massachusetts Institute of Technology, won a women's-only national contest with her proposed design for the building—a 400-foot by 200-foot structure in the style of the Italian Renaissance. The Women's Building included exhibit halls, parlors, meeting rooms, a library, and administrative offices.

Hubert Howe Bancroft describes the Women's Building in *The Book of the Fair*: "In the eastern portion of the north wing are the exhibits of the United States, or as announced over the entrance, an exposition of the applied arts of America. Here, nearly every state in the republic displays its most artistic needlework, its costumes, ceramic wares, mosaics, and other specimens of industry, largely contributed by societies of national repute."

Prizes were awarded for exhibitions related to women's industry. Instead of being exhibited together, quilts were featured within the context of a larger state exhibit. The 136 exhibited quilts represented the work of community groups and individuals in designs such as the Crazy Quilt, which became popular after the 1876 Centennial Exhibition in Philadelphia, and pictorial representations of Columbus's voyage.

Contemporary accounts of the fair mention a quilt made from Mrs. Henry Quincy's petticoats in the Massachusetts exhibit. Mrs. Quincy was an ancestor of John Quincy Adams, president from 1825–1826, so these petticoats were well over 150 years old. The same account mentions a silk, banner-like quilt in the North Dakota exhibit, made by the children at Day School No. 1, Standing Rock Indian Agency. The Illinois State Museum owns a Crazy Quilt made for the fair. This quilt features a center block that depicts the bust of Christopher Columbus. Eliza H. Bell, wife of Alexander Graham Bell, was a prolific quilter, and reportedly made a quilt for the fair.

Quilts were exhibited in other buildings of the fair as well. Kyra Hicks has uncovered the story behind one quilt, exhibited in the Agricultural Building. Martha Erskine Ricks was born into slavery in Tennessee around 1817. In 1830 her father purchased his family's freedom, and the entire family emigrated to Liberia, Africa, where Martha became an accomplished quilter. Martha, who had always wanted to meet Queen Victoria, designed the Coffee Tree Quilt as a gift to the queen. The coffee tree is a native Liberian plant, and coffee was an important cash crop. When Martha did finally meet Queen Victoria in 1892, she gave her the quilt. The next year the quilt appeared at the Columbian Exposition as part of the Liberian agricultural exhibit.

Century of Progress Fair

Forty years later in 1933, Chicago hosted another world's fair, the Century of Progress Fair, which commemorated Chicago's 100th anniversary and showcased the technological advances during the first part of the twentieth century. The fair was located near Lake Michigan, on the

site now occupied by Meigs Field. The exhibits were housed in sleek, art deco-design buildings, which were bathed in electric light after dark. Visitors could see exhibits featuring medical advances, such as infant incubators for premature babies, and the latest in automotive technology. The modern House of Tomorrow and the Hall of Science showed visitors the future, while a full-scale replica of Fort Dearborn, from which the city of Chicago grew, reminded visitors of the past.

The fair was a welcomed diversion from everyday life at a time

This needlecase was one of the many souvenirs available to visitors at the 1933 Chicago Century of Progress Fair.

The Century of Progress Quilt Contest brought entries from all over the United States. The $1,000 grand prize encouraged experienced quilters to submit their finest work, and persuaded many nonquilters to learn a new skill. Many women submitted their very first quilt, hoping to win the prize that would ease family financial woes during the Depression.

when the country was mired in the Great Depression. By 1933 the number of people without jobs or homes had hit an all-time high, with 12,830,000 people or 24 percent of the population without jobs. Forty percent of people aged 16–24 were neither in school nor employed. Recently elected President Franklin Roosevelt implemented the first federal works projects, creating jobs for the unemployed. The Civilian Conservation Corp (CCC) provided young men with jobs in forestry and flood control projects. Many state and national parks throughout the country developed their hiking trail systems during this time through CCC projects. The Works Progress Administration (WPA) was one of the largest projects with more than eight million participants. The WPA constructed highways, airports, and public buildings. Artists were hired to paint murals in many of these buildings. The WPA also hired writers and researchers to study the folk life of the United States, resulting in a massive archive of information about cultural practices in states from New York to California, which is still used by historians today.

Quilting experienced a resurgence during the Depression out of necessity. Many of the quilts were "make-do" quilts, using scraps from worn out household textiles. Their primary purpose was to keep warm, but quilters did the best they could to create attractive coverings with the resources at hand. Quilters rarely had the opportunity to make "best" quilts, showing off their needle skills and design expertise.

The Century of Progress Fair gave quilters a forum in which to showcase their skills. One fair contest created great excitement among the nation's quilters. Sears, Roebuck and Company sponsored the Century of Progress Quilt Contest, in which quilters were to create an original design based on the fair's theme. Twenty-seven thousand quilts were entered, featuring community stories.

Abbie Elizabeth Hanson Diener of Milwaukee, Wisconsin, submitted a Crazy quilt with patches from four generations of family members and friends living in the communities of Neenah and Milwaukee. Each patch includes an embroidered signature along with embroidered buildings, flowers, animals, and people. Buildings were a popular design on the quilts, especially the buildings of Fort Dearborn, and the fair itself, which had been pictured in brochures advertising the fair.[1]

Traditional patchwork designs abounded in appliqué and piecework, especially complex patterns like the Rising Sun and New York Beauty. The rules did not exclude submitting quilts made from kits, which were popular in the 1930s, so many submissions were actually designed by Marie Webster and

The Sears project was the first of many corporate-sponsored quilting contests. In 1992, Land's End and Good Housekeeping magazine sponsored the All-American Quilt Challenge. Winners were selected from all 50 states, and their quilts are now displayed on the Library of Congress's American Memory website.

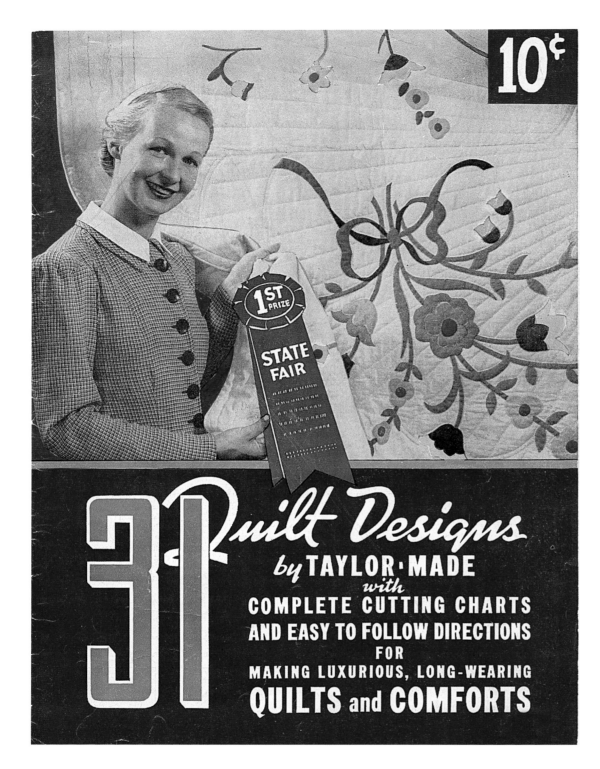

which is equivalent to about $15,000 in 2007. This money could pay for nearly a third of the cost of a small home during the 1930s. An additional $200 would be awarded if the final selection featured the theme of the fair: A Century of Progress. To enter, women brought their quilts to the local Sears store, or sent them to one of ten mail order offices. Judges then selected the quilts that would move on to ten regional contests. Judging was based on creativity, color selection, pattern design, and technical expertise. Three winners from each region were selected. Winning quilts at the regional level went to the national contest. Despite the large number of entries and the many innovative quilts that represented the theme of change and technology, the grand prize winner was a very traditional trapunto Star of the Bluegrass, ostensibly made by Margaret Rogers Caden of Lexington, Kentucky. Several contestants appealed the contest, and it was discovered that while Margaret may have designed the quilt, the piecing and quilting was done by three other women, who occasionally did other quilt work for her. The winning quilt was given to Eleanor Roosevelt and has since been lost. Pictures of the 30 finalist quilts were published in the 1934 Sears Catalog, and patterns were sold with some of these designs.

Pattern manufacturers marketed their products to a new generation of quilters in the mid-twentieth century. Taylor-Made used the image of a first-prize ribbon to give the purchaser confidence in the product's quality.

Ruby McKim. Quilts also featured famous Americans: Presidents such as George Washington and Abraham Lincoln, scientist Thomas Edison, and aviation hero Charles Lindbergh.

Quilters across the nation competed for the grand prize of $1,000,

THE QUILT SHOW

Quilts were exhibited at local, state, and regional fairs beginning in the nineteenth century. During the 1930s, when more women returned to sewing and quiltmaking to save money, regional and national quilt shows developed. One of the earliest was at the Eastern States Exposition in West Springfield, Massachusetts. The exposition was started in 1919, and by 1930 included an impressive women's building, which included a quilt show. The exposition drew more than just New England quilts; in 1936 Josephine Craig of Emporia, Kansas, took first prize with her Garden Medallion Quilt. In 1938 Macy's Department Store in New York City hosted their second quilt

IN GOD, LIBERTY AND FREEDOM WE TRUST

Date: ca. 1986 **Maker:** Shirley Barrett, Lakeside Montana **Size:** 72" x 72" **Owner:** Shirley Barrett

Shirley made this quilt to commemorate the Statue of Liberty centennial. Quilts were solicited from all 50 states for an exhibit in New York, and Shirley's quilt was one of those selected.
Photo by Shelley Emslie

show. These quilts were for sale for prices ranging from $19.98 to $64.54.

The quilt show as we know it today is a product of the late twentieth-century quilt revival. These shows are often hosted by local and state guilds, and usually the work of volunteers, who put in long hours planning the shows, and even longer hours implementing them. The Minnesota Quilt Guild claims to have the largest all-volunteer show in the country. This show is held every June, hosting as many as 600 quilts, 100 vendors, dozens of classes, and drawing visitors from across the country. Nationally, hundreds of shows are held each year, so many that magazines like *Quilter's Newsletter Monthly* devote several pages each month to listing them. Top prizes range from a few hundred dollars at the smaller shows to $20,000 at the American Quilter's Society Show in Paducah. Exceptional quilts may be entered in and win prizes at several shows. For a select few quilters, show prizes are an important source of income.

Air Show by Jonathan Shannon

Jonathan Shannon learned to quilt in 1989. Three years later, he made Air Show, which received the Best of Show award at the 1993 American Quilter's Society Show in Paducah, Kentucky. Jonathan was the first male quilter to win this award. Air

Show was inspired by Jonathan's interest in 1930s airplanes. He also wanted to create a quilt that held wide public appeal, particularly for men, whose interests he felt were neglected within the quilt world. Jonathan's prize for this quilt was $15,000, which he donated to the Museum of the American Quilter's Society to create the Shannon-Ross Scholarship. This fund provides grants to serious quilt students to pay for classes at the museum.

Jonathan has won England's National Patchwork Championship with his 1994 quilt Amigos Muertos. He is a certified judge for the National Quilting Association and has judged shows in the United States and abroad.

Flower Basket Petit Point by Grace McCance Snyder

Grace McCance Snyder learned to quilt as a young girl in 1880s Nebraska. She continued to quilt while raising four children on a ranch in the western Nebraska Sandhills, and by the mid-nineteenth century had received numerous first-place ribbons at the Nebraska State Fair. Her 1943 quilt Flower Basket Petit Point was designed using a China pattern from the Salem (Ohio) China Company. The quilt contains 85,875 pieces, 5,400 yards of thread and it took her 16 months to finish. After the quilt was finished Grace contacted the

1902 ★ A CENTURY OF SERVICE ★ 2002

A CENTURY OF SERVICE

Date: 2002 **Makers:** Staff and volunteers
of the Pacific Northwest Office of the Bureau
of Reclamation **Size:** 18" x 6" **Owner:** United
States Bureau of Reclamation

*Created to honor the Bureau of Reclamation's
one-hundredth birthday, this quilt combines
traditional patchwork with more contemporary
appliqué. The quilt is displayed at the Pacific
Northwest Regional Office in Boise, Idaho.*

China Company to be sure she had-
n't violated their copyright on the
pattern. The company sent her a
complete set of the China in
acknowledgement of her work. The
quilt won the Purple Sweepstakes
Ribbon at the Nebraska State Fair
in 1944. Grace was inducted into
the Quilter's Hall of Fame in 1980,
and her autobiography, *No Time on
My Hands,* as told to her daughter
Nellie Snyder Yost, was published
in 1991.

THE RISE
OF THE ART QUILT

Exhibit at the Whitney:
Teaching the Public
to View Quilts as Art

In July 1971, America's view of
quilts was changed forever by one
exhibition. The Whitney Museum of

American Art opened the exhibition
Abstract Design in American Quilts
curated by collectors Jonathan
Holstein and Gail Van der Hoof. The
exhibit featured more than 50
quilts, selected not for their ability
to provide warmth, but instead for
artistic merit. Crazy quilts, Log
Cabins, Star patterns, and simple
Nine Patches showcased how quilts
could be viewed as works of art,
using color, design, and materials.

For a sophisticated New York
audience, this exhibit was revolu-
tionary. Although it was not the
first quilt exhibit in the country, it
was the first to be held at a high-
profile art museum. Reviews of the
exhibit appeared in the *New York
Times*, reaching an even larger
audience. Following the exhibit's
run in New York, Abstract Designs
in American Quilts toured the coun-

try, bringing the idea of the quilt as art to thousands of Americans.

This exhibit is often viewed as the beginning of both the art quilt movement and the late twentieth-century quilting renaissance. It was certainly a very public display, which, when combined with a renewed interest in handcraft of all kinds and a new generation of Americans seeking a means of self-expression, influenced the course of quilting and art into the twenty-first century.

Quilt National: Creating Space for the Art Quilt

In the 1970s, quilt shows only accepted entries that reflected time-honored quilting traditions. Innovative quilters could only exhibit their work at some fiber arts shows and occasionally a fine arts venue, where their work was rarely recognized as "quilts." In 1979, fiber artists Francoise Barnes, Nancy Crow, and Virginia Randles worked to change this. These southern Ohio artists had been working with fabric for several years, creating layered and stitched designs intended for walls as opposed to beds. The three coordinated with artists preserving a dairy barn near Athens, Ohio, to mount the first Quilt National, providing emerging quilt artists the necessary space to make a bold statement about the significance of their work.

The artist response to Quilt National was significant. Nearly 200 artists submitted 390 pieces. The show included 56 of these quilts, representing 43 artists.[2] The first Quilt National was a success, and the Dairy Barn continues to be a primary vehicle for art quilt exhibition. The Quilt National competition is held in odd-numbered years and draws well over a thousand entries from the United States and abroad. The artists submit slides of their work, which are reviewed by a team of three judges. Artists' names are withheld from the judges, to ensure that each quilt is judged on its own merit, not the judges' knowledge of the artist. Selected quilts become part of the Quilt National Exhibition, which is shown first at the Dairy Barn before traveling to museums and other quilt shows throughout the world.

Quilt National requires that entries represent traditional quilts in form. According to the Quilt National website: "Work must be predominantly fiber and be composed of at least two full and distinct layers that are held together with stitches." Artists take creative approaches to this construction, experimenting with size, shape, fabrics, and color. The blend of tradition and innovation encourages artistic growth while maintaining the heritage of the quilt.

DRESS QUILT
Date: ca. 2004 **Maker:** Susan Shapira, Anchorage, Alaska **Size:** 31.25"x 61.5"
Owner: Alaska State Museum, Anchorage, grant from the Rasmuson Foundation

Susan has been a quilt artist since 1985. Her inspiration comes from nature, art, literature, prayer, and ethnic textiles. She includes cultural objects in her work such as beads, shells, and bells. The Dress Quilt was featured in her 2004 solo show at the Alaska State Museum.

Art Quilts in Perspective

by Hilary Morrow Fletcher

Hilary Morrow Fletcher was the Quilt National project director from 1982 until her death in August 2006 of melanoma. She was a tireless advocate of art quilts, a quilt collector, and board member of Studio Art Quilt Associates. Hilary came to Quilt National as the exhibition entered into preparations for its third biennial exhibition and was instrumental in molding it into one of the world's leading art quilt juried exhibitions. She was also a lecturer and writer.

This essay, written several years before her death, looks at the development of the art quilt movement, and its place in the greater world of both art and quilting.

When scientists study the evolution of a species, they often examine selected samples of a population and note the changes that occur over the passage of time. I believe that the size, diversity, and longevity of the Quilt National universe makes it an appropriate population to study. By viewing the works in the 11 Quilt Nationals, we see the introduction and development of trends that not only characterize the art quilt of the '90s but are likely harbingers of the art quilts that we'll see in the next millennium.

Today's art quilt hasn't developed in a vacuum. Under the influences of history, technology, and the creative environment, art quilts have evolved to form a diverse body of work. These quilts represent the interaction of natural, social and personal history with a multitude of materials and techniques and an endless depth of energy and imagination.

Before Quilt National, the word "quilt" nearly always referred to a particular kind of bed cover—a fabric sandwich. The layers were held together with thousands of tiny handmade stitches that complemented the design of the pieced or appliquéd top layer. When displayed on a bed, some of the quilt's surface was hidden, which meant that there was little point in creating a single, overall image. The quiltmaker's focus, therefore, tended to be on small-scale motifs that could be appreciated regardless of how much—or how little—of the surface could be seen.

Then, in the 1970s, something happened that forever changed the nature of the quilt. Formally trained artists discovered an excitement in the exploration of repetitive patterns and in the technique of combining small bits of this and that. They took a new look at the humble, quilted bed cover and began to view layered and stitched fabric as an attractive alternative to traditional art media. They saw endless possibilities in the colors and visual textures of cloth. They saw the stitched line as another source of design. And, perhaps most important, they escaped the tyranny of the quiltmaker's rules. They may not have known what a quilt should be, but they certainly knew what a quilt could be.

The result of this creative energy was a small body of work intended for walls rather than beds. It's not surprising that quilt show organizers and traditional quilt-

makers felt threatened by these so-called artist-quiltmakers. Some of this work bore little apparent relationship to the warm, familiar creations people expected to see. "These objects aren't quilts!" the viewers announced. "They're art!"

At the same time, tools and technologies were being developed that had the potential to create previously impossible effects. The new generation of sewing machines, color xerography, and readily available fabric paint and dyes presented challenges to which this new breed of quiltmaker responded with gusto.

Nancy Halpern once noted that she and "her kind" were considered mavericks in their quilt guilds. We are fortunate that the pioneers of the art quilt movement were not deterred by the disapproval of their early creations and that they courageously worked to produce quilts that differed from the familiar and accepted norms. They also encouraged others, by example, to begin creating highly personal and unique works.

Undoubtedly, one of the most significant trends in the development of this art form is the use of surface design techniques—techniques that alter the color, pattern, and/or texture of the cloth. While generations of early quiltmakers selected fabrics on the basis of color or pattern, innovative quiltmakers were not content to limit themselves to the fabrics available in their local quilt shops. They wanted something other than a few solid colors and lots of calicoes, and they explored and employed a variety of techniques to create exactly what they needed.

By looking at works from all of the Quilt National exhibitions, we realize that today's quilts merge continuing traditions with new ones. Generations of quiltmakers, including contemporary artists, have taken advantage of differing visual textures of cloth. They have voiced concern for social and personal issues. Added to these traditions are the relatively recent trends of using surface design techniques, of using materials and techniques that weren't available to earlier quiltmakers, of creating works for walls that may not be rectangular and may not even be solid, of manipulating the surface with something other than hand created stitches, and of producing images that may or may not be beautiful.

Fewer and fewer of today's innovative quilts are updated interpretations of classic quilt formats. The subject matter of the quilt, be it a personal memory or an artist's statement about a political or social issue, appears to be increasingly important. Today's artists view their quilts as a means of expressing their creative energies in ways that are simply not possible with other materials. They are expanding and adding to the rich vocabulary of the heritage quiltmaker and they are transforming color and texture into dynamic patterns that provide new visual experiences.

There is no question that the art form has been enhanced by thousands of quiltmakers making personal journeys through explorations of color, shape, and line. I feel quite confident that through the continued creative efforts of the world's quiltmakers, the art quilt as we know it, will continue to evolve and enrich the lives of an ever widening circle of appreciative viewers.

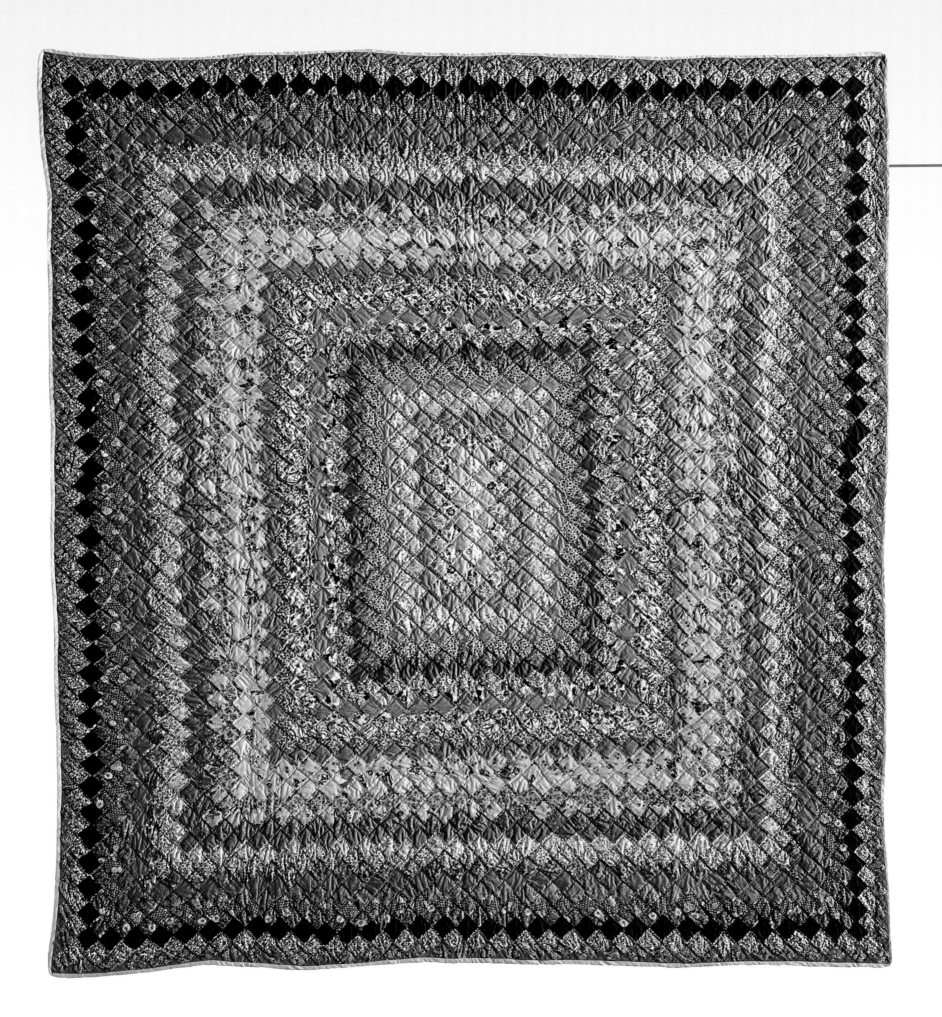

Chapter 10

Quilting as Business

To eke out their slender income both women make quilts. When they furnish all the materials and do all the work, which includes the quilting, they collect three dollars a quilt. But a detailed enumeration proves that the material alone costs two dollars and a half. "But sometimes we make more. My niece who was married last month wanted us to quilt her the design called the "Wedding Ring"; so she furnished us all the material and ordered two quilts at $1.50 a piece. We generally make two quilts a week. It takes a day and a half to quilt each one," concluded Mrs. Colbox. She displayed two quilts they were making. They were, indeed, quite colorful and gay. "I used my quilt money to buy shoes and cotton cloth for two dresses," summoned up Mrs. Colbox. Said Mrs. Farlow, "I haven't had a new dress in ten years."[1]

Anna Win Stevens, Federal Writer's Project, December 16, 1938, Asheville, NC

In the 1930s, Mrs. Farlow and her daughter Mrs. Colbox spent long hours bent over a needle, handpiecing a unique quilt. For each quilt, they made barely more than the cost of the materials, yet this was a major part of their household money. Professional quilters in the nineteenth and early twentieth centuries were poorly paid and had few materials to work with. That has changed. Quilting in the twenty-first century is big business. According to the 2006 Quilting in America ™ survey, there are more than 27 million quilters in the United States, and nearly one in six households participate in quilting activities. The average quilter spends $172.29 a year, making quilting a $3.3 billion industry.

BOSTON COMMONS

Date: ca. 1950 **Maker:** Nellie Martin, Pennsylvania **Owner:** Betsy Marvin, Minneapolis, Minnesota

Nellie made the quilt top for her daughter Helen's wedding. Helen was a teacher in Las Vegas, Nevada. Nellie only made quilt tops, so Helen sent the top out to be quilted by an unknown quilter. Photograph by Greg Winter and Lee Sandberg, Minneapolis, Minnesota

Detail, Boston Commons
Photograph by Greg Winter and Lee Sandberg, Minneapolis, Minnesota

MORNING GLORY, MARIE WEBSTER

Date: ca. 1912 **Maker:** Unknown

Size: 81"x 89" **Owner:** Rose Werner,
Dundas, Minnesota

*Morning Glory was one of Marie Webster's
earliest designs. Her kits quickly became a
preferred way to do appliqué quilting.*
Photograph by Greg Winter and Lee Sandberg,
Minneapolis, Minnesota

PIONEERS IN THE BUSINESS OF QUILTING

Quilting has been a business for more than 200 years. The earliest quilters-for-hire were seamstresses, who also made clothing and other family textiles. It was a low-paying job, but women could take piece-work home and work while they watched their children. Many women in the nineteenth century earned additional family income or completely supported themselves in this manner.

Elizabeth Keckley, a slave in St. Louis during the 1840s, not only provided income for her own family, but also supported her owner's family with her needle. Eventually she was able to raise $1,200 to purchase freedom for herself and her son. Elizabeth went on to become the dressmaker to Mary Todd Lincoln, publish a book about her life, and is best known as the maker of the Mary Todd Lincoln Quilt, which contains documented scraps of fabrics from Mary's time in the White House.[2]

In the twentieth century, some women specialized in quilting tops made by others. Sisters Elsie Noble Ball and Mary Ball Jay of Fairfield, Iowa, quilted 135 tops between 1935 and 1970. They kept meticulous notes about each quilt, its owner, the cost of thread, materials used, and dates of the quilting. The winning entry in the Sears Century of Progress Quilt Contest was only partially the work of entrant, Margaret Caden. Margaret contracted with at least three Kentucky quilters to produce the top, do the quilting, and complete the stuffed work designs.

Marie Webster is the first true quilting entrepreneur of the twentieth century, and is credited with the early twentieth-century quilt revival. Marie grew up in Indiana

in the 1860s and learned needle-work from her mother, who was a professional seamstress. Needlework was a lifelong passion for Marie, and she began designing her own quilts when she was in her 50s. She published her first quilting pattern in the *Ladies Home Journal* in 1911, and in two years was publishing her own pattern catalog. Marie's floral appliqués in pastels on light backgrounds were like a breath of fresh air after several decades of Crazy quilts and dark-colored patchwork. By 1915 she had authored her first book on American quilting, *Quilts, Their Story and How to Make Them.*

Throughout the 1920s, Marie's Practical Patchwork Company provided quilting patterns, kits, and partially completed quilt tops to an eager audience. While Marie no longer designed new patterns after the 1930s, her granddaughter Rosalind Webster Perry has reproduced Marie's original book and two volumes of original patterns using the same company name. Marie's home in Marion, Indiana, is the site of the Quilter's Hall of Fame, an organization that Marie herself was inducted into in 1991.

QUILTING COOPERATIVES

The availability and affordability of the automobile in the 1920s spurred the building of roads across the country, and improved roads

Marie Webster had this formal photo taken about 1905. Ten years later she and her kits would be known nationwide. Photo courtesy of Rosemary Webster Perry

brought tourism into previously isolated communities. Tourists were introduced to the arts and crafts of these areas, and returned to their homes with samples of regional painting, woodworking, and quilting. When friends and family members saw these new works, they wanted their own, creating an increased demand for regional art. A new industry was born.

One way to accommodate both tourist and artist was to create a craft cooperative. The cooperative accommodates the tourist by providing a convenient shopping experience for local crafts. It supports artists by providing an outlet for their work, marketing and sales support, and some means of handling the "business" side of art. In the 1930s and 1940s, loosely organized craft cooperatives developed along commonly traveled roads,

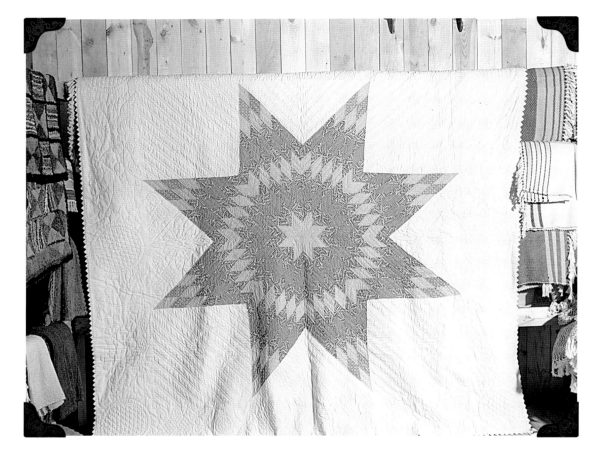

This handmade quilt was sold at a Virginia craft co-op on U.S. Highway No. 1, 20 miles north of Fredericksburg, Virginia, in 1941. Craft cooperatives helped local artists market their work to a large audience. Library of Congress

particularly in Appalachia to sell mountain-made crafts and in the Southwest to sell Indian art. Over time some of these cooperatives disappeared, while others grew and became more professionally organized.

In the 1960s, the Kennedy and Johnson presidential administrations launched the War on Poverty, a campaign to improve economic conditions, particularly in rural areas. As a means to that end, Volunteers In Service to America (VISTA) was created in 1965. VISTA was similar to the Peace Corps, except volunteers worked with community organizations in the United States to address the issues of poverty. One of the methods VISTA employed was the creation of cooperative work programs.

James Thiebeault, a VISTA volunteer from Massachusetts, was sent to West Virginia to look at air and water pollution levels in 1970. As he met with residents, he met many women who quilted enough to provide sufficient family income. Struck by the affordability of the quilts, and the high construction standards the women maintained, James coordinated the organization of a quilting business cooperative based in Malden, West Virginia, which became Cabin Creek Quilts.

Over time the cooperative grew and prospered, and in 1991 they purchased the historic Hale House in Malden, which became a retail shop, training center, and administrative headquarters. The cooperative

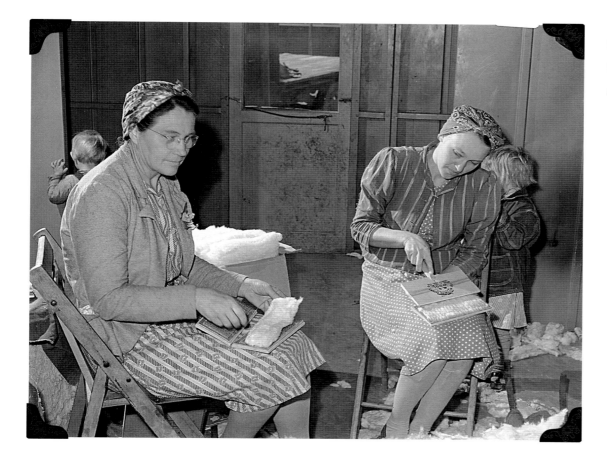

Women at a farm worker's community in Woodville, California, card surplus cotton to be used for quilts, ca. 1942. Library of Congress

became a nonprofit organization; the governing board consists of cooperative members, who make decisions based on the best interests of the quilters. Maintaining a rural quilt cooperative is not easy; members have to balance their quilt work with the requirements of home and farm. The introduction of inexpensive, imported American-style quilts from China has hurt the industry, so Cabin Creek emphasizes the heritage of West Virginia quilts and quilters, and their reputation for quality construction.

MACHINE QUILTING

As mentioned previously, women have long generated income by quilting the quilt tops made by others. Throughout much of the twentieth century the tops were often handquilted, partly due to tradition, but also because the sewing machine technology available for the home market was not adequate to easily quilt large projects.

This changed in the 1980s, when Fred Nolting began marketing the Longarm Quilting Machine, designed for bed-sized quilts, from twin to king. Other companies, including APQS and Gammill, also developed longarm machines. The new machines were affordable, relatively easy to use, and could fit in a quilter's spare bedroom or basement. With a little practice, a quilter could now quilt a full-sized quilt in less than a day.

Quilting Technology

Technology refers to the use of tools and methods in the manufacturing process. Therefore, the first person to use a bone needle was making use of technology. Hand cranked and treadle sewing machines were a technological improvement over the needle, and when an electric motor was added in the late nineteenth century, home sewing production dramatically increased. Technology use in quilting has always been controversial. Despite the invention of the home sewing machine in the 1840s, at the time quilters in the United States were creating uniquely American designs, quilting is still thought of as a handcraft. Some quilters and quilt collectors feel that a quilt must be handpieced, or at least handquilted to truly qualify as a quilt. Many quilt shows did not accept machine-quilted entries well into the 1980s. In 1989 Caryl Bryer Fallert won Best of Show at the American Quilter's Society Show with Corona II, the first machine-quilted work to win this award.

Today's home quilter thinks in terms of computer technology. Computerized sewing machines, with programmable, perfect stitching have been available since the late 1980s. Quilt design software such as Electric Quilt, QuiltSoft, and 123 Quilt allow aspiring designers to create quilt designs, and include libraries of thousands of blocks, quilt styles, and fabrics. With these software packages quilters can design and store a virtual quilt, change the size and create images in multiple color combinations and print templates, rotary cutting instructions, and paper-piece foundation patterns. A laptop computer lets researchers access quilt photos from websites such as the Quilt Index, connect to quilt study listservs such as Quilt History List, and download free quilting patterns at Poakalani and Company.

The future of quilting technology will be determined by the future of technology as a whole. But technology should always be used to enhance the quilting experience, and not replace it with a virtual process.

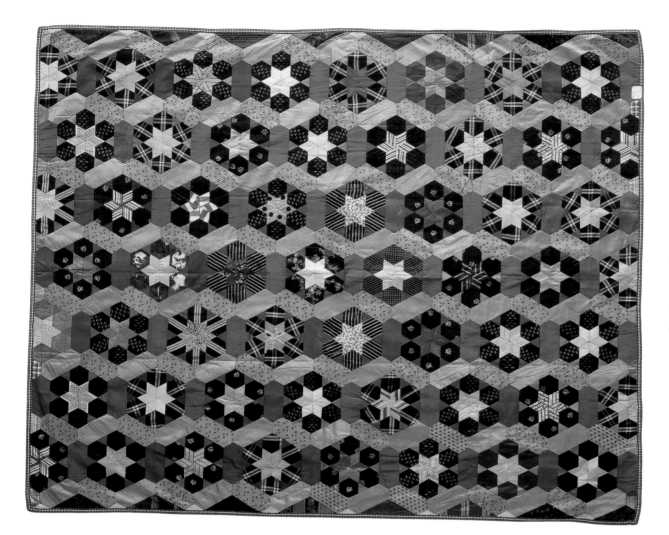

HEXAGON STAR
Date: ca. 1885
Maker: Mrs. H.D. Morse
Size: 60" x 72"
Owner: Stevens County
Historical Society

*Fabric manufacturers offer a wide
variety of reproduction nineteenth
century fabrics for today's quilters.
They find inspiration from antique
quilts in museums and private
collections.*

The longarm quilting machine opened up new business opportunities. Longarm quilters could finish their own quilts much faster, leaving time to work on someone else's quilt. The growing number of quilters in the last part of the twentieth century meant a growing number of tops that needed quilting. A longarm quilting business could be managed from home, ideal for women and men trying to juggle careers and families.

In the 1990s, the number of longarm quilters continued to grow, and longarm machines became a staple exhibit at quilt shows. As the machines improved new options became available, including stitch-length regulators, ergonomic advancements, new patterns, and design features. The first computerized programs for longarm machines merged new technology with traditional quilt designs, but were most effective when used by quilters with significant computer experience. The new computer programs are more user-friendly and offer thousands of pattern options, but some quilters still prefer the control of using the hand-guided machine.

QUILT SHOPS

Quilting shops are predominantly a result of the late twentieth century quilting revival, and the growth of specialty retail shops in the 1970s and 1980s. In the nineteenth century and through most of the twentieth century, quilting materials were purchased either through mail-order catalogs or at dry goods, department stores, and general fabric stores. The inventory of items available specifically for the quilter was small—a few fabrics, patterns, books, and notions—not a sufficient amount to make an independent store economically viable.

As quilting became more popular and quilters craved 100 percent cotton fabrics, the industry responded by producing fabrics, notions, books, and patterns designed specifically for the quilt market. In the 1970s and early 1980s, women had smaller families than previous generations, and strong career ambitions. Those who had put their careers on hold while their children were small were returning to the workplace in large numbers and many were interested in becoming business owners. The quilt shop seemed a natural niche for creative, business-savvy women.

Serving the Quilter

A full-service quilt shop does more than just sell fabric. Most offer a wide range of classes for both beginner and accomplished quilter, providing technical and creative support to their customers. Many also now offer machine quilting services, either at their store or with a contracted quilter. The quilt shop provides a social network for its customers, and the employees are expected to be knowledgeable and helpful. With thousands of fabrics on the market, no one shop can carry them all. Most shops have a shared clientele of dedicated quilters.

Recognizing that shared clientele, shops work together to appeal

HMONG APPLIQUÉ PANEL

Date: ca. 2000 **Maker:** Unknown

Size: 22" x 22" **Owner:** Rose Werner, Dundas, Minnesota

In addition to P'andau embroidery, Hmong textiles also include geometric ribbon-style appliqué. This panel consists of a top and backing and does not include batting. Photo by Greg Winter and Lee Sandberg, Minneapolis, Minnesota

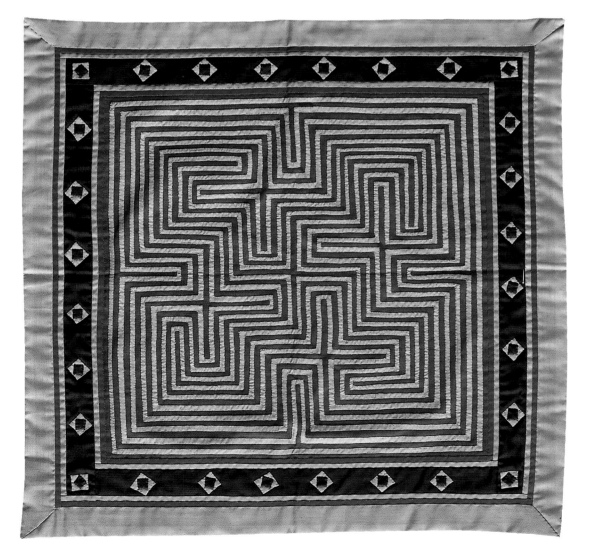

Quilting Tours Abroad

United States quilters are fascinated by quilts and fabrics of other countries. To satisfy this curiosity, quilters can go on a number of international tours. California quilt appraiser Deborah Roberts hosts a quilter's tour of France, which includes visits to historical museums such as the Textile Museum in Lyon, and Les Olivades Factory, a working textile printing factory in Tarascon. Quilters can tour England and Wales with Chere Brodsky, a New Hampshire quilt designer, collector, and owner of Country Heritage Tours. This tour includes the Welsh Wool production industry and admission to the UK Festival of Quilts. Other tour providers offer travel to the Tokyo International Great Quilt Festival, which attracts more than 500,000 each year; African Safaris to meet with African quilter's guilds; and tours of Australia and New Zealand quilt shops.

to as many quilters as possible. As a means to that end, store owners invented the Quilt Shop Hop. A Shop Hop is often held over a long weekend in a particular region, and store owners plan special activities, classes, and sales. Many shop hops advertise a special pattern or kit that can only be completed by picking up one component at each participating store. Quilters are willing to travel long distances to attend a Shop Hop. Many shops participating in a hop are separated by only a few of miles, while others are hours away. Quilters attending the First Annual Great Alaska Quilt Shop Hop, held in December 2006, drove hundreds of miles to visit all 13 stores that participated. The Circle of Friends Montana Quilt Shop Hop claims to be the largest shop hop in the United States. Now in its fifth year, the hop includes 46 shops. The hop takes place in late April and early May. Hop organizers have divided the state into seven regional circles. Shoppers that visit all stores in a circle are eligible for that circle's first prize. For each circle completed, shoppers are registered for the grand prize, which in 2007 is a top-of-the-line Janome sewing machine.

The Latest and Greatest

Fortunately for today's busy quilt shop owner there is help finding new products. Quilts, Inc., is a Houston-based company that sponsors International Quilt Market, a trade show for the quilting industry that only those working in the quilting business can attend. Two shows are held each year, the fall

BACK TO THE 30s SUNBONNETS

Date: ca. 2000 **Maker:** Barbara Chilton,
Kalispell, Montana **Size:** 54" x 66"

Owner: Barbara Chilton

*Barbara used popular 1930s reproduction
fabrics to make this retro-style quilt. In the late
twentieth century, quilters began to choose
reproduction fabrics over modern fabrics for
their traditional patterns.* Photo by Shelley Emslie

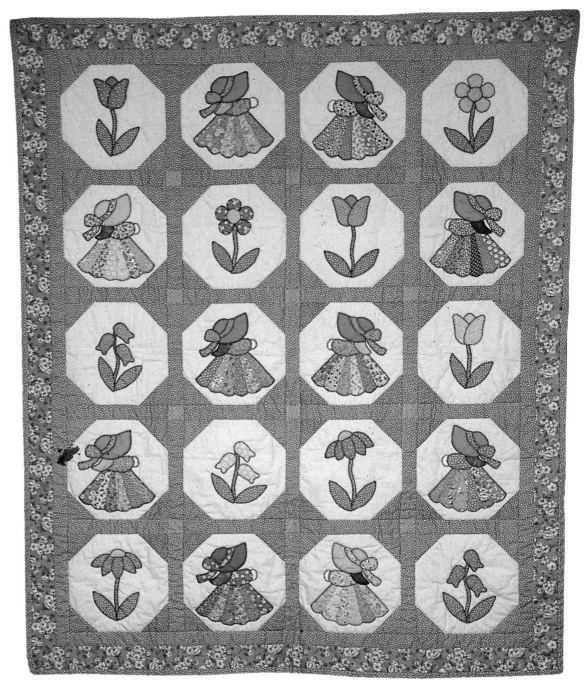

show is always in Houston, while the spring show rotates among venues around the country. Thousands of vendors present their product lines and help shop owners select those best for their shop. Quilts, Inc., also helps shop owners by co-sponsoring the triennial Quilting in America survey, which measures the time and money quilters commit to their hobby.

Wholesale distributors such as Minneapolis-based Rubenstein and Ziff are a one-stop resource for owners of small shops who wish to purchase smaller amounts from many suppliers, or for those shops located far from manufacturers. All major

fabric manufacturers have regional representatives who work with both wholesale marketers and shop owners. Windham Fabrics, based in New Jersey, has 22 representatives serving all 50 states and Puerto Rico.

Quilt Shows

Once confined to fairs and local quilt groups, quilt shows have become not only an opportunity to exhibit one's quilting skills—they're also big business. Quilt shows bring tourism dollars into a community and award monetary prizes to winners in numerous categories. Best of Show awards range from a few hundred dollars in the smaller shows, to $20,000 at the American Quilter's Society Show in Paducah.

Show entries must follow a set of rules established by the show committee, which consists of guild members. Rules govern the size of quilts, how long ago the quilt may be completed, who is eligible, and the distribution of prizes. Quilts are submitted for judging in a series of categories. The 2007 Minnesota Quilters Show catalog lists 12 categories, including individual and group entries in traditional and nontraditional (art) categories, such as size of quilt and quilting technique. Only four nonjudged categories are listed: quilt, clothing, 3-D, and children's entries.

Quilts shows also give attendees an opportunity to take classes and do some shopping. One of the most popular attractions at any show is the merchant's mall. The merchant's mall grew out of the proliferation of quilting materials in the 1980s. The mall is the place to buy the latest fabrics, books, and gadgets, often at a show discount. Vendors at the larger shows represent local and national quilt shops, sewing and quilting machine dealers, and book and notions retailers. Many retailers count on show income for a significant portion of their annual sales.

The Moravian Sewing Circle in Lititz, Pennsylvania, provided quilting services to raise money for their church, ca. 1942. They quilted for one cent per yard of thread. Library of Congress

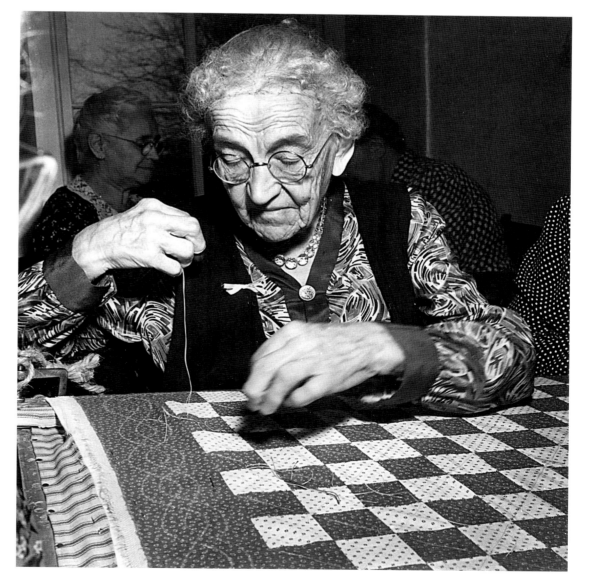

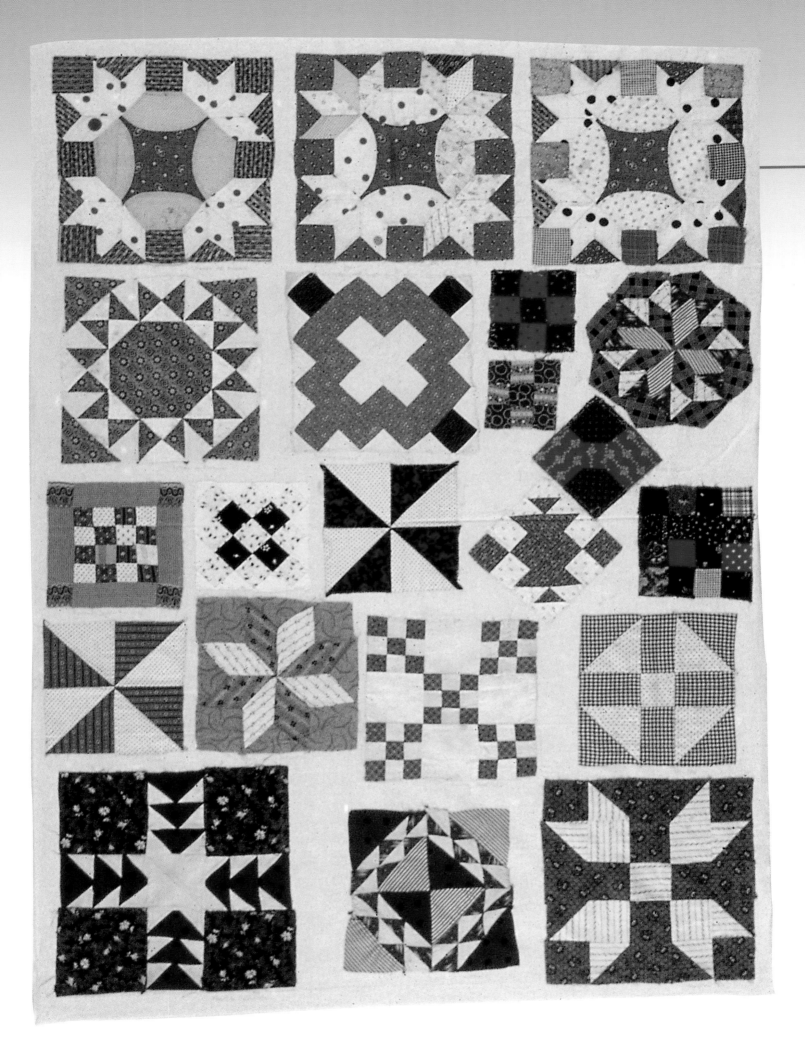

Sharing the Knowledge of Quilting

I've been quilting since I was old enough to sew. My mother always done that. And I was a nosey little old girl, and I always stood in the way. Every scrap she drop, why, I'd pick it up and sew. I kept sewing until I got where I could make a good block, and she put it in her quilt as encouragement.

Cloaner Smith, *Traditional Quiltmaking in Louisiana*

Knowledge must be shared, or it will be lost. For centuries traditional crafts were part of daily life and were passed down through families or learned by apprenticeship. Mothers gave their daughters small projects to fit their tiny hands, perhaps a handkerchief to hem. Poorly sewn seams would be ripped out and resewn until perfect. In this way little girls practiced the stitches they would later need to produce the family's clothing. And, through the first part of the nineteenth century, knowledge of quilting was shared in this same way. Children might be given a few patches to piece or they sat next to their mothers at the quilting frame, watching the stitches, perhaps they were given the task of cutting threads.

As literacy rates increased and printed material became more widely circulated, quilting knowledge was also passed on through books and mag-

Mary Barton created study panels to teach future generations about quilt history. She stitched blocks from old quilts, usually quilts that had been damaged, to cotton muslin. Many of the panels include her handwritten notes about the subject. Courtesy of the State Historical Society of Iowa, Mary Barton Collection

Detail, panel block from Mary Barton Collection
State Historical Society of Iowa

azines. Many nineteenth-century women anxiously awaited the arrival of *Godey's Lady's Book*, *Modern Priscilla*, or the *Delineator* to see the latest needlework designs. Patterns from these magazines might be passed from quilter to quilter for years. Advances in communication technology provide new means of sharing knowledge. At the same time, busy schedules have reduced the time available to work together. Quilters today have many choices. They can read a book, go on a quilt retreat, or sign-up for an online class. Quilters must use the technology to their advantage and continue to seek new networks to share what they know about their craft.

QUILTING PATTERNS IN NEWSPAPERS AND MAGAZINES

Patterns for quilts first appeared in the United States in the 1830s. In 1835 *Godey's Lady's Book*, a popular woman's fashion magazine, published the first quilt pattern, the Honeycomb, a hexagonal piece of patchwork. Other fashion magazines followed suit, including *Peterson's Magazine* and the *Delineator*. *Good Housekeeping* and *Ladies' Home Journal* included patterns and mail-order ads for kits and patterns. These magazines also published patterns for other types of needlework, and by the end of the century patterns had become a common section in most magazines.

Magazines provide patterns for beginning and experienced quilters. Prior to the proliferation of quilt shops in the late twentieth century, magazines and catalogs were the primary source of quilting supplies.

In the twentieth century, quilt patterns could be found in the women's section of many newspapers. Perhaps the best-known patterns today are those published by the *Kansas City Star*. Ruby McKim Studios provided patterns for the *Star* from 1929 through 1931, and later patterns were also designed by readers, the Home Art Studio in Des Moines, Iowa, and Graphic Enterprises, in New York, under the name Laura Wheeler. More than 1,000 patterns appeared in the pages of the *Star*, beginning in 1928 and ending in 1961. Still popular with quilters, the patterns recently have been reproduced in a ten-volume series and are available as software for the Quilt-Pro system.

Other magazines and papers offered quilt pattern columns. Florence LaGanke designed the Nancy Page Quilt Club patterns, which appeared in newspapers, including the *Detroit News* and the *Oregonian*, the newspaper in Portland, Oregon, during the 1930s. The *Chicago Tribune*'s Loretta Leitner Rising wrote under the name Nancy Cabot. Recently, Merikay Waldvogel has written about the life of Gladys Sanders, who became Patty Shannon, women's editor of the *Kentucky Farmer's Home Journal*. The *Journal* offered patterns, and sponsored quilt block contests in the 1930s and 1940s.

Quilter's Newsletter Magazine *is one of the earliest magazines designed for quilters. This 1978 issue features new patterns, information on techniques, and advertisements from quilt-related businesses.*

In September 1969, Bonnie Leman started *Quilter's Newsletter Magazine*, a magazine devoted solely to quiltmaking. The early issues were black and white, published from Bonnie's home. The magazine complemented her other business, Heritage Plastics, which produced plastic quilting templates. Within ten years, *Quilter's Newsletter Magazine* became a full-color, national publication and is now the longest running quilting publication in the United States. As part of Primedia Magazines, its sister publications include *Quiltmaker, Quick Quilts*, and *McCall's Quilting*. Today's quilter can choose from a wide variety of magazines, all featuring wonderful patterns and great quilting tips.

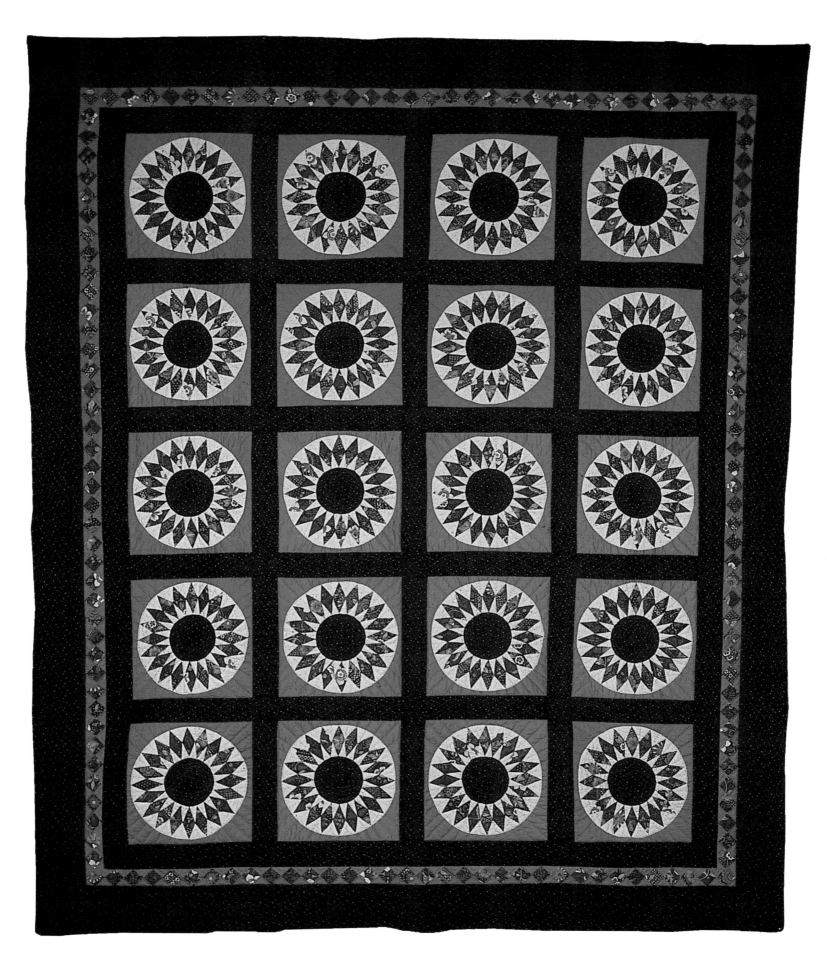

TELEVISION QUILTING

Quilting became a television phenomenon in the late twentieth century. Series such as *Lap Quilting with Georgia Bonesteel* and *Quilting* with host Penny McMorris aired on public television stations nationwide in the early 1980s. Television became a preferred medium for revival quilters Marianne Fons, Liz Porter, Eleanor Burns, Kaye Wood, and Nancy Zieman. It was also an excellent way for the busy quilter to see firsthand quilting news. During one, half-hour program, quilters could see how to make a new pattern and meet the rising stars of quilting.

As cable TV options expanded in the 1990s, so did the number of new quilting shows. Home and Garden TV and the DIY network offered a wide range of arts and craft–related shows, including the popular *Simply Quilts* hosted by the equally popular television host Alex Anderson.

In 2005 Georgia Bonesteel partnered with her son Paul to produce the documentary *The Great American Quilt Revival*, a film that tells the story of American quilting since the 1970s and features many of the stars of late twentieth century quilting, including Cuesta Benberry, Barbara Brackman, Jonathan Holstein, and Jean Ray Laury. Released by American Public Television, the documentary has appeared on television stations around the country and received awards at local and regional film festivals.

QUILTERS ON RETREAT

Sometimes quilters just want to get away from it all, the pandemonium of work, irritation of housekeeping, and the interruptions of everyday life and commitments. In the 1990s quilter's retreats became a popular way to find uninterrupted quilting time. Going to a unique location with a great teacher and dedicated quilting friends is now a much-anticipated annual event for many quilters.

The Quilter's Workshop

If you drive 50 miles east of Flagstaff, Arizona, you'll come to the small town of Winslow. Located on historic Route 66, along the edge of the Painted Desert, Winslow calls itself "the City of 10,000 Friendly Faces." One of those faces is Eloise DeSpain, owner of the Quilter's Workshop. She is a third-generation Arizonan and a retired arts and humanities professor who now manages this unique retreat center.[1]

In defining herself, Eloise says, "I love quilting, I love quilting history and I am living a life devoted to quilting. ...[N]othing stops my heart and makes it sing more than seeing a historic quilt that has been made with the greatest of skill and care."

She is the founder, president, and historian of the local quilt guild and teaches a block-of-the-month club. Each block features an aspect of the factors that have shaped the course of women's live since the industrial revolution.

SUNBURST

Date: 1998 **Maker:** Shirley Barrett, Lakeside, Montana **Size:** 82" x 98"
Owner: Shirley Barrett

Shirley was experimenting with blue color ways when she made this quilt. The Sun Burst design is one of the oldest patchwork patterns. Photograph by Shelley Emslie, Big Fork, Montana

Sharing Quilting via Television
by Alex Anderson

Host of television's popular quilt show, Simply Quilts, *Alex Anderson is also a widely sought after quilting teacher, author of more than a dozen books, including* Start Quilting with Alex Anderson. *She now co-hosts the web-based program* The Quilt Show *with quilter and musician Ricky Tims. In this essay Alex talks about her experiences with sharing quilting knowledge through television, and the potential the Internet holds for teaching quilters.*

Ever since I first picked up a thimble nearly 30 years ago, quilting has been a lifestyle for me. My passion and love for this craft hasn't diminished over time, but only grown stronger.

I decided to begin teaching very early in my quilting career, at local recreation centers and my church. Soon into my newfound "career," I found myself teaching at local quilt shops. These opportunities offered compensation to fund my obsession while allowing me to remain a stay-at-home mom. The extra money—to purchase fabric, of course!—was a bonus, but the *best* part was helping others discover the joy, excitement, and community of quilting.

Then, as now, quilting in the San Francisco Bay area was a dynamic and growing entity. Well-known teachers crisscrossed the country sharing their expertise with local guilds and quilt shops. The "Quilting Renaissance" had reached an all-time fever pitch. Publishing companies devoted solely to producing quilting titles launched and grew by leaps and bounds. Quilting shows cropped up on public television, and quilters couldn't seem to get enough. And I made it my personal goal to share my passion with a wider audience.

After many of my quilts appeared in other people's books, C&T Publishing offered me a contract to publish my own book in 1992. Then in 1994 while teaching at a Southern California quilt show, HGTV approached me about hosting *Simply Quilts*, a new, nationally televised cable TV show. Frankly, *that* wasn't in my game plan, and I was hesitant to entertain the idea. My husband gently pushed me toward the possibility.

Simply Quilts filled a niche in the world of quilting that no one could have predicted. To this day, when I'm asked to describe the best part of hosting *Simply Quilts*, the answer is easy: "To share my passion with those I might never meet otherwise." Commercial television offered an unparalleled level of communication, not only in the United States, but also internationally. With this exposure came responsibility, and maintaining an appropriate balance has been a constant challenge. The show was a tool to introduce people to quilting, but it also carried the obligation to continue to grow the active quilter.

As host, my job was to guide guests through each show while complying with network guidelines and restrictions. Some guests came with television experience, but most were novices to the medium, and naturally nervous about facing a camera. Having experienced similar terror during the first season of *Simply Quilts*, I vowed not only to impart information to the viewer, but also—along with the *Simply Quilts* team—to make the experience pleasurable for my guest.

As HGTV grew, they too were defining themselves as a network. In time, the guidelines of programming became clearer, and it was often a dance to satisfy both quilters and the network. Fortunately the network saw the value of the show, and it was fun being part of the "journey."

Television had the power to attract those who did not quilt. Spouses gained a better understanding of their partners' passion, and those lucky enough to possess a family heirloom learned more about its value and care. We in the industry were able to celebrate not only the "famous quilters," but also those who simply enjoyed giving the craft a personal spin. My own understanding and appreciation of our community deepened. Although I knew all along that quilters are by nature both generous and kind, to see it firsthand and on a regular basis has been an incredible honor.

During the 11 years (and 493 episodes!) that *Simply Quilts* aired, quilting continued to grow at a breathtaking pace. The Internet and other forms of instant communication have connected us in previously unimagined ways. International friendships have flourished, resulting in an exciting exchange of ideas. The entire quilting community, not just those fortunate enough to enjoy large quilt shows, benefits from global experience and inspiration.

As *Simply Quilts* moved toward its inevitable conclusion, pod casting became a fun next step for me. Communicating entirely through the spoken word, without the support of visual images, presents an interesting challenge … and a wonderful opportunity. I've discovered a new, more intimate connection with fellow quilters. Without network directives, I could behave in a more authentic fashion. Those who listen to the *Quilt Connection* (www.alexandersonquilts.com) comment that they feel they are getting to know the real me—and in fact they are!

The Internet continues to offer new opportunities, such as bringing unrestricted, online television to our global community. *The Quilt Show with Alex and Ricky* (www.thequiltshow.com) celebrates quilting techniques, personalities, trends, and philanthropic efforts. This Internet-based TV show and the World Wide Quilting Community is geared to enhance quilting in a fresh, unscripted fashion, recognizing that quilting is more than a hobby—it's a lifestyle.

My personal mission statement is to educate, inspire, and grow today's quilting community. It is my privilege and good fortune to have pursued this goal in many different ways. I love our community and could not imagine my life without quilting. Fortunately, I will never have to!

Eloise restored an 1885 home with 10-foot ceilings and wooden floors and added a tile floor great room with sinks to accommodate a preparation area and extensive art library and art supplies. The retreat center has a two-bedroom guest house, and Eloise lives on-site in a small cottage behind the center. Her students come for a four- to five-day quilting workshop and to go hiking and canoeing in the mountains around Winslow.

She teaches all her students traditional hand piecing and quilting. For her own quilts she uses a quilting frame that is more than150 years old. She also restores quilts, paying special attention to the quilt's integrity and history. She does not restore every quilt brought to her, but helps her clients understand how restoration may compromise the integrity of some quilts, so the client can make the best decision for their particular quilt.

Quilts and fabrics from Terry Thompson Clothier's collection are the basis for many of her classes. (www.terrythompson.com) Photo by Deb Rowden

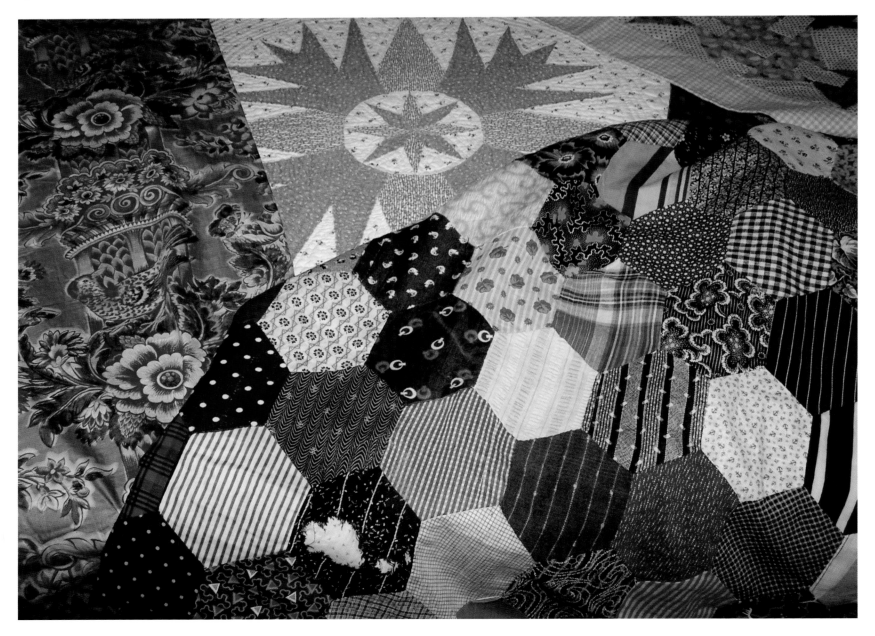

Fabricamp participants examine historic quilts. Terry's program emphasizes the role quilts play in American history. (www.terrythompson.com)
Photo by Deb Rowden

FabriCamp

Terry Thompson Clothier wears many hats. She is a quilt artist, pattern and fabric designer, teacher, writer, and historian. Her books and patterns represent the history of women and quilting from the eighteenth through the early twentieth century. She was one of the members of the Kansas Quilt Project, and one of the authors of *Kansas Quilts and Quilters*. Her experiences on her grandparent's farm in Peace Creek, Kansas furnished the background for her popular book *Quilts and Stories From the Peace Creek Homestead*. She is also a designer for Moda fabrics, most recently the Lewis and Clark line.

Terry teaches FabriCamp, a hands-on retreat for shop owners, quilt collectors, dealers, and appraisers. Participants attend three- and four-day retreats to learn quilt dating and study actual fabrics used in quilts from the late 1700s through the mid-1900s. Terry believes that women's history and the history of quilting are entwined, so she uses stories and journal entries about historical women in her classes. She suggests that students use the quilting techniques of the time period to become immersed in the era. Terry holds retreats at her Lawrence, Kansas, studio, and sometimes includes field trips to see other area textile collectors.

BACK TO SCHOOL — CLASSES FOR QUILTERS

Quilters know the best way to learn new techniques and to make new friends is to attend a quilt class. Many of today's avid quilters would never have learned to quilt if someone hadn't taken them to a class.

In the 1960s and 1970s, most classes were offered through school district's community education programs or county extension offices. Today, quilter's take classes at shops, quilt shows, and online. Quilting instructors taught the basics of quilt design, including template construction, handpiecing, and handquilting. Few quilting fabrics were available so new students frequently chose muslin, a few calico prints, and some colored solids. The end project was often a small sampler quilt of nineteenth-century patterns, which gave students a chance to practice pieced square, triangles, and diamonds. Few advanced classes were taught, as it was assumed that once a quilter knew the basic techniques they need no further instruction.

This changed in the late 1980s, when a large number of fabrics became available and quilt shops began to open around the country. Shop owners discovered that offering classes was an excellent way to build a clientele and sell the new fabrics. But experienced quilters would not attend beginning quilting classes. To meet the need, quilt shop owners began to offer classes based on a specific pattern, often a wall hanging, table runner, or item of clothing. Quilters could come for just one or two sessions, and leave with a nearly completed project. This appealed to seasoned quilters, and gave beginning quilters a reason to keep quilting. These days, quilting classes are the life blood for many shop owners.

In the last part of the twentieth century, quilters began using techniques from other art disciplines. Experienced quilters requested classes in painting, fabric dyeing, embroidery, and machine quilting taught by experts in the field. To remain competitive, shops with the means to do so offered classes by nationally recognized quilt artists. Lucky students have taken classes in crazy quilting from Judith Baker Montano, machine quilting from Diane Gaudynski, and fabric painting from Velda Newman.

The classes offered at modern quilt shows and shops are incredibly diverse. Quadrille Quilting in New Haven, Connecticut, has repeat requests for the Delectable Mountains class, a nineteenth-century pattern that has gained popularity. Tennessee Quilts in Jonesborough, Tennessee, offers quilted postcard classes, a quilt form you can send in the mail. Quilters at the Road to California show can make a cell phone holder

or learn how to paint thread with their sewing machine.

RAISING THE NEXT GENERATION OF QUILTERS

For an art form to continue, it must be passed on to the next generation. Traditionally a mother or grandmother teaches her children or grandchild to quilt and sew. In the twenty-first century, many children no longer learn that way. Mom may not know how to sew, and Grandma lives three states away. Or Grandma may not sew either. School home economics programs, which in the mid-twentieth century taught predominantly cooking and sewing, now teach a wide variety of family and consumer activities and have less time to devote to sewing.

In order to fill this void, some shops and community education programs offer beginning quilting classes for children. Boys and girls ages 9 through 14 learn basic sewing skills while making simple quilts and pillows. Common first patterns are four- and nine-patch blocks. A few educational quilting programs for children, such as the School House Project in New Jersey, and Florida's Eduquilters, are so large, they encompass an entire state.

The School House Project: State Quilt Guild of New Jersey

The State Quilt Guild of New Jersey encourages a new generation of quilters through the School House Project. Members of the guild hope to nurture an appreciation for quilting among third- and fourth-grade New Jersey schoolchildren, "emphasizing the creative, mathematical, and historical significance of quilts and quilting." Melanie Normann, one of the founders of the New Jersey guild, came up with the idea of a trunk in 2001. Diana Condit, a quilter and former teacher, volunteered to chair the project. They received a quilt from Dorothy Gruber, made for a challenge based on the children's book *A Quiltmaker's Gift*, which teaches children the art of giving through the tale of a selfish king and generous quiltmaker. This quilt

Sewing quilts in Gees Bend, Alabama, ca. 1937. Library of Congress

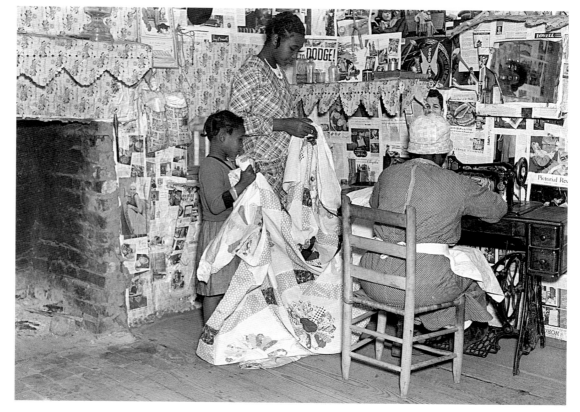

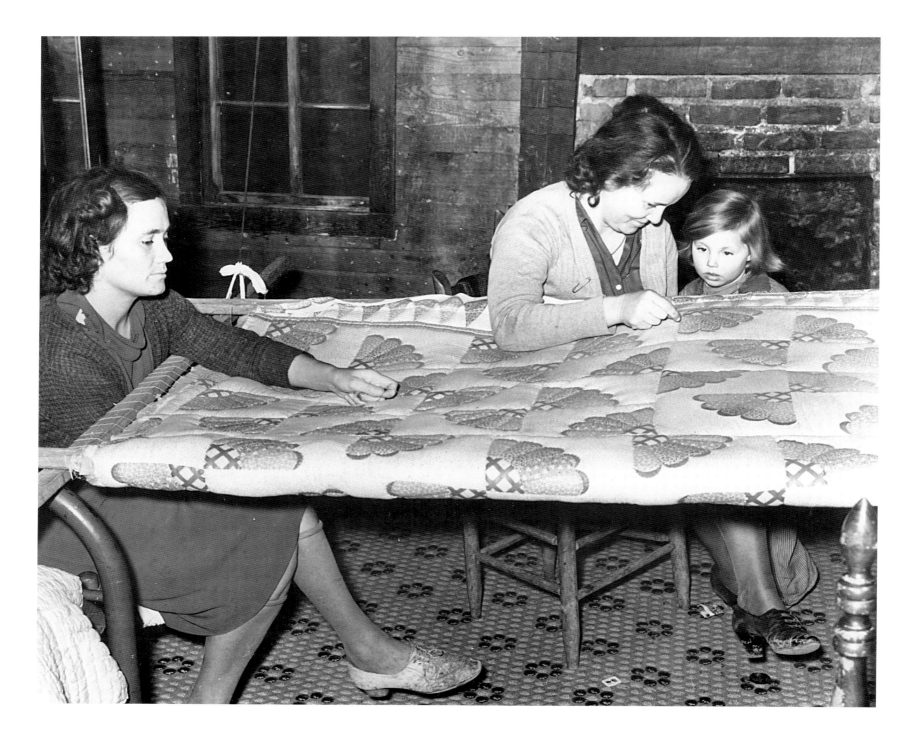

Young girls learn to quilt by watching their mothers at the quilt frame. This photograph was taken at a sharecropper's home near Pace, Mississippi in 1939. Library of Congress

became the inspiration for the trunk, which is truly a quiltmaker's gift to the students of New Jersey.

Each participating school receives a trunk filled with materials and instructions to get started. The trunk includes a quilt top prominently featuring the school house block, more than two dozen blocks with storyboards explaining each block, copies of popular quilting story books, a curriculum guide, historical information about quilts and quilting practices, quilting folklore, mathematical worksheets, original quilt blocks, and all the materials children need to create their own quilt designs.

The School House Project trunk travels throughout the state, spending two weeks at each contracted school. The project has been a great hit with kids ranging from second through fifth grade, and participation is high enough that the guild is planning to produce a second trunk so that one trunk can be available in the northern part of the state and one in the southern part.

Eduquilters.org

Eduquilters is a Florida-based, non-profit organization dedicated to sharing the knowledge and love of quilting with children in the state. Working with Brevard Public Schools, quilters teach a variety of programs from one-day talks about the art and history of quilting, to multiple-day sessions where students make quilts for charity or personal use.

Read All About It

Peruse a quilter's sewing room bookshelf. Pattern books such as Kaffe Fassett's *Kaleidoscope Quilts* share a shelf with Harriet Hargrave's *Heirloom Machine Quilting*. On the coffee table are quilt histories, perhaps *The Quilts of Gee's Bend* and *Minnesota Quilts*. Jennifer Chiaverini's *Round Robin* and Sandra Dallas's *Alice's Tulips*, fictional stories about quilters, are on the nightstand. Quilting has become so popular that quilters want to read about

it in their free time . . . when they're not quilting, that is. And there are plenty of books to choose from in all genres, including nonfiction, memoir, and fiction. Since 1976, there has been an explosion of quilting books on the market. Retailing giants like Amazon.com list more than 8,000 titles under quilting patterns and history.

In 1915, Marie Webster, inventor of the kit quilt, wrote *Quilts: Their Story and How to Make Them*, the first history of American quilting published, it was also one of the first books to look specifically at the history of women's work. Marie was already a successful pattern designer and writer, and her new book sold well. It was reviewed in 24 publications, including the *New York Times* and the *Chicago Tribune*. It was re-released in 1990, with a biography of Marie by her granddaughter Rosalind Webster Perry. In 1929, Ruth Finley published *Old Patchwork Quilts and the Women Who Made Them*. Finley was a newspaper woman and an early feminist. Her book looked at quilts from a folk art point of view. In the 1940s, Carrie Hall published her book, *The Romance of the Patchwork Quilt*. The focal point of Carrie's book was images of 884 traditional quilt blocks made by her as part of her quilt study. In the 1970s, Patsy and Myron Orlofsky published *Quilts in America*, a survey looking at 300

Although the quilt is one of the most familiar and necessary articles in our households, its story is yet to be told. In spite of its universal use and intimate connection with our lives, its past is a mystery which—at the most—can be only partially unraveled.[2]

Marie Webster, *Quilts: Their Story and How to Make Them*, 1915

years of quilting history, including tools, dyes, and fabrics. In the 1980s, the amount of research on quilting increased dramatically. Beginning with Kentucky, quilters in many states began state quilt projects to document quilts made in their states. By 1981, the state quilt projects began to publish their findings. By the time Rod Kiracofe's book *The American Quilt* was published in 1993, many state projects were also publishing their own books, depicting regional variations in quilting design. The history of quilting in the United States could no longer be confined to just one volume. The body of quilt history literature continues to grow and remains popular as today's quilters explore connections between their lives and work and that of previous generations.

But quilters wanted more than just a history of their craft; they were hungry for more patterns, both new and old. The pattern book market boomed as publishing companies such as That Patchwork Place, C&T Publishing, and the American Quilter's Society based their businesses on providing quality books to an eager and growing readership. Published patterns range from Maggie Malone's *1,000 Great Quilt Blocks*, featuring traditional patterns to Sharon Pederson's *Reversible Quilts* which shows quilters how to make quilts that look great on both front and the back.

Several new genres of quilt writing have emerged in the past two decades. Quilting memoirs and essays such as Helen Kelley's *Every Quilt Tells a Story* merge thoughts on quiltmaking with stories of real-life events, the chronicles that make up the lives of many quilters. Quilting anthologies such as *This Old Quilt* mix traditional quilt lore, fictional writing, and memoir in short story formats, perfect for the quilter needing an inspirational pick-me-up. A growing number of fictional quilters amaze, amuse, and comfort us, including Earlene Fowler's mystery-solving Benni Harper, Jennifer Chivarini's close-knit Elm Creek Quilters, and Sandra Dallas's heroines Queenie Bean and Alice Bullock. These genres, mixing the trials and rewards of everyday life with the love of quilting, provide a deep sense of community to quilters throughout the country and around the world.

Quilting is a social art that needs to be passed down to the next generation in order to survive. While in the past quilting was taught through personal interaction with a parent or grandparent, modern families often live great distances from each other, making that nearly impossible. The quilting community has filled the void with classes, books, and programs that have pushed the art of quilting far beyond what our ancestors could have ever imagined.

Vintage quilt patterns are a popular collectible item with quilters. They are found at yard sales, antique stores, and local libraries. Vintage patterns are a great source for learning traditional quilting techniques.

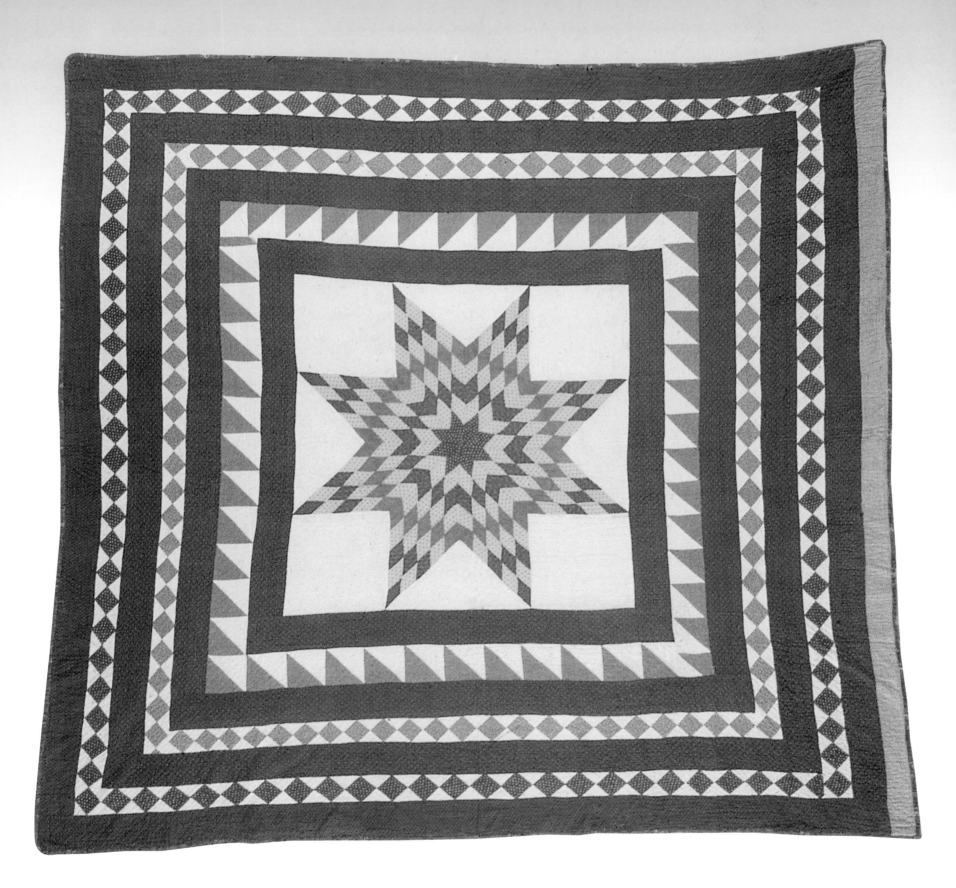

AN ENCYCLOPEDIA
of CLASSIC QUILT STYLES

One reason quilts hold such high appeal is the wide variety of styles and techniques used in quilting. From the simple patchwork designs popular during the Great Depression to the modern art quilts of today, quilters can pick and choose the style and technique that best suits their abilities, interests, and the tastes of the person for whom they are making the quilt. Some quilters use the same technique, and perhaps the same pattern, throughout their quilting life. Others leap-frog from one style to another, never repeating themselves and always trying something new. In the past century, the sophisticated array of fabrics and tools on the market encourage quilters to expand their horizons.

Since the quilter's world is so expansive, it isn't possible to present every style and pattern used in the United States. Instead, this encyclopedia of quilt styles aims to document some of the more common styles used in this country over the past 250 years. The encyclopedia is organized alphabetically by quilt style. Within each style section is a historical overview, a sample of common quilt patterns, and descriptions of some specific quilts.

Appliqué

Appliqué is used in many types of needlework, including quilting. The word is derived from the French word for "applied." Appliqué designs are made by stitching small pieces of cloth on to a larger cloth. By adding layers on top of the base pieces, quilters can make complex and realistic designs. Appliqué is the perfect style for those who enjoy handsewing, as the designs require detailed stitching. It is a very practical and accurate way to make pictures,

GLITTER STAR

Date: ca. 1860–1880 Maker: Unknown, from Wisconsin Size: 85" x 88.5"
Owner: Mary Barton Collection, State Historical Society of Iowa

This quilt is handpieced and handquilted. It contains no batting. The Glitter Star pattern appears to be an original design by the maker.

flowers, and animals. Appliqué's roots reach back to ancient Egyptian and Chinese textiles of the ninth century that included floral motifs in appliqué. In American quilting, appliqué has evolved from the *broderie perse* style popular in the late eighteenth century to the intricate nineteenth-century album quilts, to the new, fusible no-sew techniques used on modern quilts.

In the first decade of the twenty-first century, quilters use a broad range of appliqué techniques, including handsewn, machine sewn, reverse appliqué, and fusible products. Appliqué remains a popular style today. The Appliqué Society, an organization founded in 1997 to foster an appreciation of appliqué in quilting, has 79 chapters in 33 states. Expect to see many new appliqué quilts during the next century.

TRADITIONAL APPLIQUÉ STYLES

Medallion Appliqué

Medallion-style quilts include a dominant central design (the medallion) framed with a border of smaller designs. The medallion design is an excellent way to showcase appliqué skills as it gives the quilter an opportunity to create an intricate and large central motif, which can then be surrounded by smaller appliquéd designs, or sometimes pieced blocks. The designs in the medallion quilts of the late eighteenth and early nineteenth centuries were generally made from chintz cut-outs, a technique sometimes referred to as *broderie perse*. A French term that means Persian embroidery, *broderie perse,* seems to have come into use in the early eighteenth century. Quilters from the nineteenth century usually described these quilts as chintz appliqué. The chintz fabrics were imported from England between 1815 (the end of the War of 1812) and 1840, when American textile mills began to flourish.

By the mid-1800s, the central design consisted of elaborate appliqué flora with border designs that might repeat the central design, introduce a new appliqué element, or contain a series of pieced blocks.

The popularity of the medallion continues to this day. Many of the kit quilts of the 1920s and 1930s use the style to set off a highly detailed floral or geometric design, which is then surrounded by smaller, similar design elements. Medallion settings are also popular block-of-the-month patterns, giving quilters guidance to create large quilts over a 6- to 12-month period.

The Garden Medallion
Quilts of Emporia, Kansas
When Ruth Finley published *Old Patchwork Quilts and the Women Who Made Them* in 1920, she

EAGLE APPLIQUÉ
BOUND SUMMER SPREAD
Date: 1848 **Maker:** Helen Gilchrist Ferris, Hills Grove, Illinois **Size:** 93" x 97"
Owner: Collection of the Illinois State Museum

Helen attended a young ladies school in New York in the mid-1840s and probably made this spread at the school. It contains no batting.

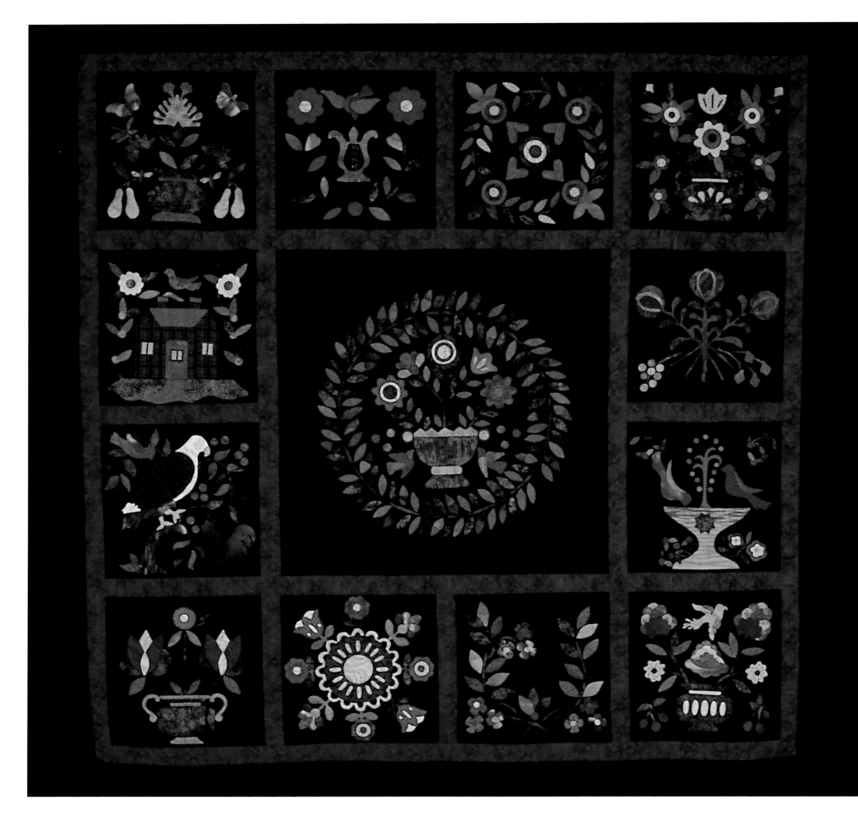

FOLK ART MEDALLION

Date: 2005 **Maker:** Patricia Linder, Kalispell, Montana **Size:** 84" x 87" **Owner:** Patricia Linder

The blocks are adapted from Elly Sienkiewicz, Susan McKelvey, and antique Baltimore Bride designs. This quilt won Best of Show at the Northwest Montana Fair in 2005. Photo by Shelley Emslie, Big Fork, Montana

described the appliquéd garden medallion as the "acme of the branch of art." In Emporia, Kansas, during the 1920s and 1930s, quilt-making was a highly competitive activity, and quilters designed garden medallion quilts to showcase their appliqué expertise. One of these quilts is the Garden made by Josephine Hunter Craig in 1933. An 1857 quilt in Ruth Finley's book inspired the pattern, and Josephine received some help with the quilting from her friends Elizabeth Goering and Maud Leatherberry. Not just a Kansas phenomenon, the quilt won first prize at the 1936 Eastern States Exposition in Springfield, Massachusetts, one of the first national quilt contests.[1]

Album Appliqué Quilts

The Album Appliqué quilt, like the medallion quilt, attained popularity in the mid-nineteenth century. This quilt style was an extension of the tradition of the autograph album, which was common in upper-class homes during the early 1800s. In an album quilt, each block usually features an individual design and rarely do the blocks repeat, therefore the album quilt is part of the sampler quilt tradition. The blocks from earlier quilts might be constructed from chintz cut-outs, while later quilts have highly detailed appliquéd designs. Some album quilts might be constructed by one

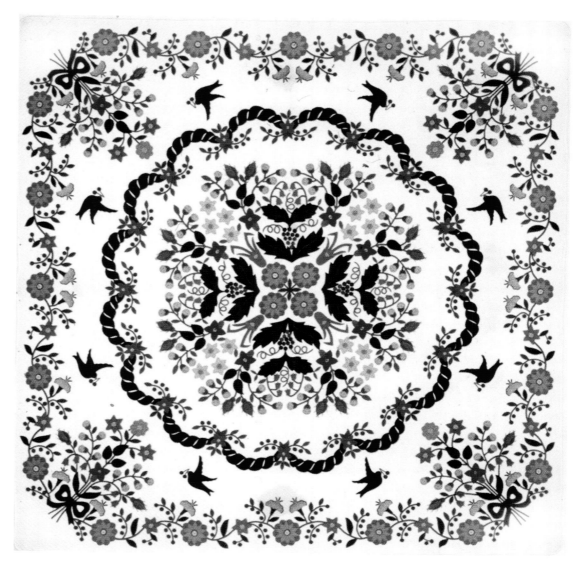

individual, but more likely are the work of friends, making them part of the friendship or memory quilt tradition. Block makers often signed their names on their block in ink or embroidery. Often these quilts were made as gifts for weddings or other celebrations. Families that owned album quilts almost always considered them "best" quilts for use only during special occasions, so surviving examples usually show very little wear.

THE GARDEN

Date: 1933 **Maker:** Josephine Hunter Craig, Emporia, Kansas **Owner:** Kansas State Historical Society

Josephine was a farm wife in the Emporia area. This same quilt also took first place at the Kansas Free Fair in Topeka and the Kansas State Fair in Hutchinson.

Baltimore Album Quilts

During the 1840s, in the area around Baltimore, Maryland, the album quilt reached a height of popularity not seen anywhere else in the country. Several factors combined to make this possible. Baltimore was an active seaport, making materials and artistic influence readily available. It was also a relatively wealthy community, meaning the ladies of Baltimore had both the leisure time and the financial means to create highly artistic quilts. And the United States was a new country, with ambition and strength, both of which are reflected in the pattern choices for the quilts.

The album quilt craze dominated quiltmaking in Baltimore for more than a decade, from the early 1840s until the mid-1850s. By the late 1850s, however, when the country was on the verge of Civil War, the album trend was dying, as time and money were committed to other activities. But the patterns were never lost and appeared from time to time in other quilt styles. With the quilting revival of the late nineteenth century, new generations of quilters discovered appliqué, and, with the help of designers such as Elly Sienkiewicz, an internationally recognized expert on the Baltimore Album quilt and author of the *Baltimore Beauty* book series, learned to create patterns in the album style. Today, the Baltimore Appliqué Society helps preserve and promote the appliqué techniques of historic Baltimore women.

One of the interesting features of Baltimore Album Quilts is that they include both English and German influences, the two different communities that had settled Baltimore by the mid-nineteenth century. English influence is reflected in the use of chintz appliqué and in the embroidered details. Other block designs have the appearance of scherenschnitte, the paper-cutting tradition of southern Germany. Baltimore Album quilts also use two colors popular in the German folk art tradition: red and green. Many Baltimore Album quilts have similar block designs, as just a few local designers created the patterns. Some designers have been identified, such as Mary Simon, whose designs feature floral wreaths, red baskets, and blue bows. Other designers remain anonymous. The designs of Designer II are characterized by three-dimensional padded flowers, and the quilts of Designer III feature realistic flowers and animals that have been outlined in overcast embroidery.

ALBUM QUILT

Date: ca. 1845–1855 **Maker:** Unknown, Baltimore, Maryland **Size:** 105" x 106"
Owner: International Quilt Study Center, University of Nebraska–Lincoln 1997.007.0320

In addition to the intricate appliqué blocks, this quilt also includes several inked drawings.
This quilt was made when the Baltimore Album quilt had reached its height of popularity.

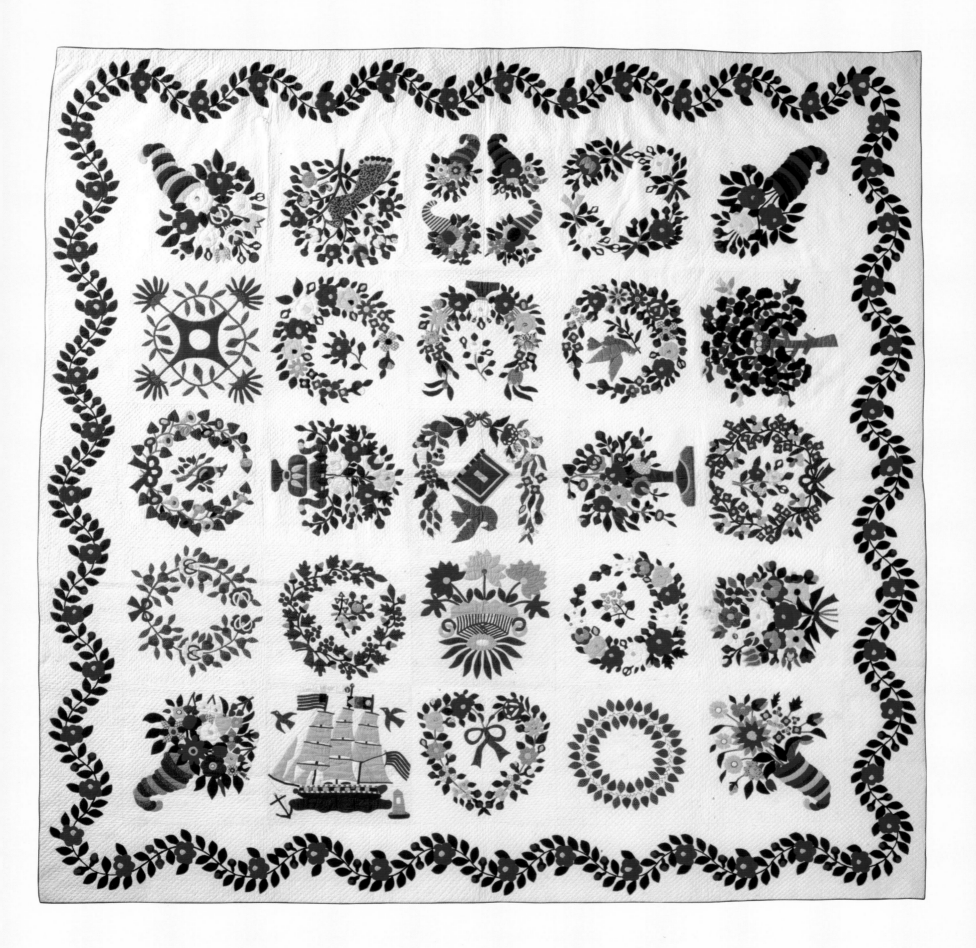

The Popularity of Red and Green Appliqué

Red and green was a popular color combination for quilts of the mid-nineteenth century for many reasons. Red and green dyes were readily available during that time, although not always stable in the long term. An increase in German immigration in the 1840s and 1850s brought the traditions of our modern Christmas celebrations, including the combination of red and green. Red and green fabrics commonly appear in Baltimore Album quilts because the area had a large German population. The two colors were also in favor during the early part of the Victorian era. And red and green lend themselves well to the reproduction of roses and other favorite flowers that quilters like to include in their work.

PEONY AND BUD

Date: 1856 **Maker:** Elizabeth Wells Perisho, Paris, Illinois
Size: 98" x 101"
Owner: Collection of the Illinois State Museum

Elizabeth was just sixteen years old when she made this quilt. The family tradition is that it was her favorite quilt, and therefore she used it very little.

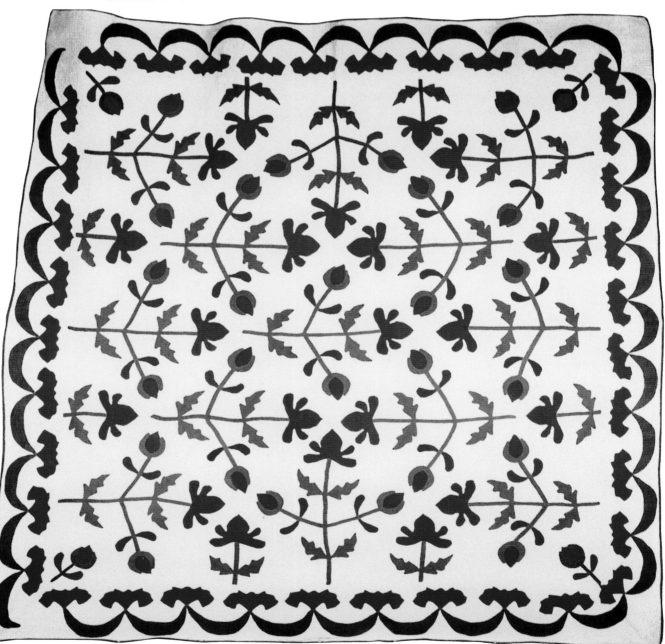

Tulip patterns were the most frequently documented appliqué pattern in the North Carolina state quilt project, despite the fact they are predominantly a northern United States flower.

TULIPS

Date: ca. 1870 **Maker:** Carolyn Brockmeier Engleman, Greenwood, Illinois **Size:** 77" x 77" **Owner:** Collection of the Illinois State Museum

Tulips were a popular design in the nineteenth century. Carolyn immigrated from Prussia in 1864. She made this quilt shortly after her marriage to Casson Engleman in Madison County, Illinois.

The most common red and green appliqué appears on a white- or cream-colored background. Red and green appliqué quilts were often considered "best" quilts, which may be one reason so many seem to have survived. And, since red and green quilts made today are traditionally winter holiday quilts, many more may survive through the next century.

A Garden of Roses

Roses, which commonly appear in ancient Egyptian and Greek stories and in Christian and Islamic texts, are a symbol of youth, beauty, and love. England's Tudor King Henry VII adopted the rose as a symbol to unite England in the late 1400s. Cultivating roses is a challenging venture, requiring much love, patience, and attention. With this tradition, it is no wonder why roses have also become a popular appliqué pattern, as creating exquisite appliqué requires love for fabric and design, patience, and attention to detail.

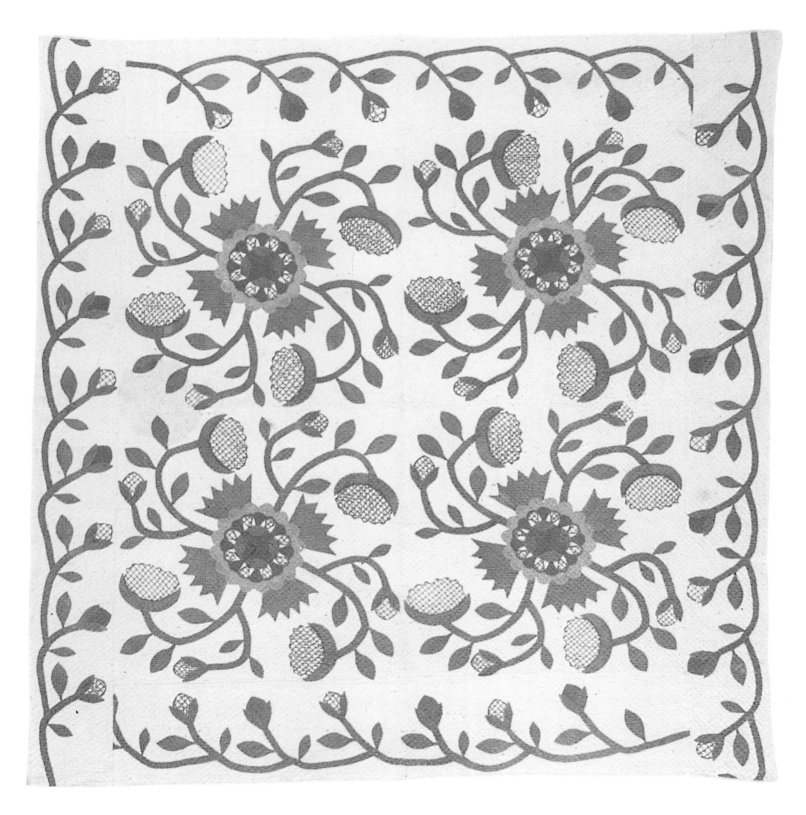

DEMOCRATIC ROSE

Date: ca. 1860 **Maker:** Unknown. **Size:** 72" x 75" **Owner:** Mary Barton Collection, State
Historical Society of Iowa

*This quilt is hand appliquéd and machine quilted. Machine quilting is unusual in mid-nineteenth
century quilts, and it is possible that the quilting was done at later time than the top.*

OHIO ROSE

Date: ca. 1920 **Maker:** Unknown, from Pennsylvania **Size:** 82" x 82" **Owner:** Stella Rubin Antiques, Potomac, Maryland

The Ohio Rose is set in a popular wreath style. This is one of several rose patterns named for states. Photo by Steve Goldberg

HAWAIIAN APPLIQUÉ: A FUSION STYLE

Hawaiian appliqué is a fusion art style that combines traditional textile forms of the Hawaiian Islands with the quilting traditions brought by Euro-American settlers. The whole cloth appliqué design produced on the islands is similar to the paper-folded designs of German scherenschnitte. Traditional designs are usually floral, while newer designs include animals. Hawaiian appliqué typically includes echo quilting around the central design.

Traditions and Superstitions in Hawaiian Quilting

by Cissy Serrao

Quilts have always been part of my upbringing. Both of my parents came from quilting families. In every place we went and every home we visited, someone was always working on a quilt. Because of this upbringing, I've learned many traditions about Hawaiian quilts. I would like to share a few of them with you here.

Never Sit on a Hawaiian Quilt. When the quilts were displayed on the beds they were admired, talked about, and even softly touched, but you never, ever sat on the quilt. If you were tired you carefully lifted up the edge of the quilt so you could sit or you folded the quilt before lying down. The quilt was treated with the utmost respect. It was not until I finished my first quilt that I understood why. Many hours were spent making a quilt and in Hawaii most quilts were made by only one person. Hawaiians believed that the quilt embodied the quiltmaker's spirit. In showing respect for the quilt, you are also showing respect for the maker.

I finished my own quilt after many, many, many, long hours and my first thought when displaying the quilt was, "If anyone sits on the quilt I will personally strangle them." How's that for keeping the tradition running in my family?

Quilts were labeled with the name of the design of the quilt and also with the name of the person who made it. I can remember going to a family's home and they would show us their quilts and say, "Oh that's Aunty Lei's Plumeria Quilt" or "That's Cousin Nani's Kahili Quilt." The quiltmaker's name was always associated with the quilt.

I remember going to family gatherings and seeing all the quilts elegantly displayed on the beds in every room and the wall hangings graciously hung throughout the home. The quilts always added a special flavor to the gathering.

It was not until I was older that I finally asked my mom why the quilts were always part of the family parties. She explained to me that each of the quilts we owned were made by a special family member or friend and that the quilts were given with love. She said during the family gatherings the quilts are displayed so that when people look at the quilt they not only admire the quilt but they always remember the person who made it. I was told that quilts, like pictures, are another form of remembrance. My mom told me that one day when I'm long gone from this world and my quilt is displayed in someone's home, I too will be remembered.

SUNBONNET SUE AND SIMILAR APPLIQUÉ QUILTS

The Sunbonnet Sue patterns developed from the tradition of children's book illustrations created by British illustrator Kate Greenaway in the late 1800s. Greenaway was a contemporary of Randolph Caldecott, for whom the American Library Association's Caldecott Medal for best picture book is named. Greenaway and Caldecott were

SUNBONNET SUE

Date: ca. 1920–1940 **Maker:** Unknown

Size: 60" x 84" **Owner:** International Quilt Study Center, University of Nebraska–Lincoln 1997.007.0256

Many different sewing techniques have been used to create Sunbonnet Sue. The Sues in this quilt are machine appliquéd.

among the first artists to create illustrations specifically for children's books. Greenaway's illustrations depicted children at play, often in profile, with faces obscured by large bonnets. Kate Greenaway designs became popular embroidery patterns and eventually made their way to appliquéd quilts.

In 1900, American Bertha Corbett Melcher published a book called *The Sunbonnet Babies*. Her illustrations were used to decorate household items, such as china, and became the basis for what is commonly known as Sunbonnet Sue. Sunbonnet Sue, her brother Overall Sam, and many relatives, including the Colonial Lady, were most frequently used in the first part of the twentieth century. They experienced a revival in the 1970s and

1980s, when quilters used both traditional patterns and fabrics as well as modern fabrics with new variations on the pattern, sometimes placing Sue in political and social settings, such as running for political office and mountain climbing. Sunbonnet Sue Quilts are great examples of folk-style appliqué.

PIECED AND APPLIQUÉD PATTERNS

Some patterns feature a pieced element that is appliquéd to the background fabric. One common design is the Dresden Plate, also known as China Aster, which consists of a pieced wheel that is commonly appliquéd to a slightly larger background fabric, then placed in a traditional block setting to make a bed-sized quilt. These patterns are

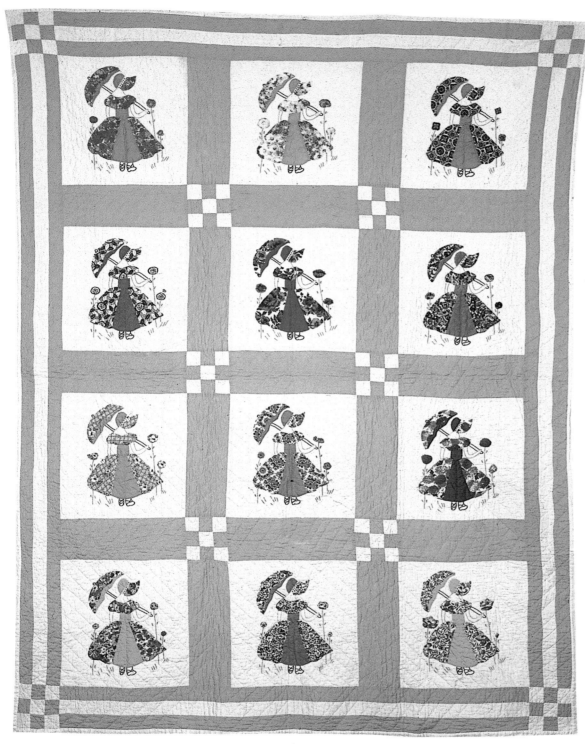

COLONIAL GIRLS

Date: ca. 1960 **Maker:** Lydia Vonasek Hale, Wayne, Nebraska **Size:** 71" x 94" **Owner:** Terry Grimlie, granddaughter of maker

Lydia made this quilt with women from her Farm Extension Club in Wayne, Nebraska. Colonial patterns and dolls were popular in the early 1960s. Photo by Shelley Emslie, Big Fork, Montana

Lydia Hale used this paper pattern to make cardboard templates for the Colonial Girls Quilt. She recorded fabric and cutting information on the templates. Photo by Shelley Emslie, Big Fork, Montana

VASE OF FLOWERS MEDALLION

Date: 1809 **Maker:** Unknown, from Georgia
Size: 82" x 79" **Owner:** Panhandle-Plains
Historical Museum, Canyon, Texas

This reverse appliqué quilt was a twenty-first birthday present for Carter Braxton Harrison. It was made from cotton produced on his family's Georgia plantation. The quilt migrated to Texas with the Harrison family later in the nineteenth century.

excellent ways to use up scraps and were particularly popular during the Great Depression.

REVERSE APPLIQUÉ

Since the first decades of the nineteenth century, reverse appliqué has been used by the Kuna Indians of Panama to create decorative clothing known as Molas. The reverse appliqué technique also appears in American appliquéd quilts as early as 1807, becoming more common in the mid-nineteenth century, although never reaching the popularity of other forms of appliqué. The process involves placing the background fabric over the accent fabric, then cutting out the background fabric, turning it under and stitching it to the accent fabric to create a pattern that is the "reverse" of the traditional appliqué patch. With the introduction of new books and classes that teach this technique, reverse appliqué has gained popularity during the first part of the twenty-first century.

Recent Trends in Appliqué

Stained Glass Technique

Quilters are always searching for new influences for quilting. In the late twentieth century, some quilters turned to architecture for inspiration, especially those churches, schools, and homes decorated with stained glass windows during the Art Noveau and Arts and Crafts movement. The stained glass window style translated

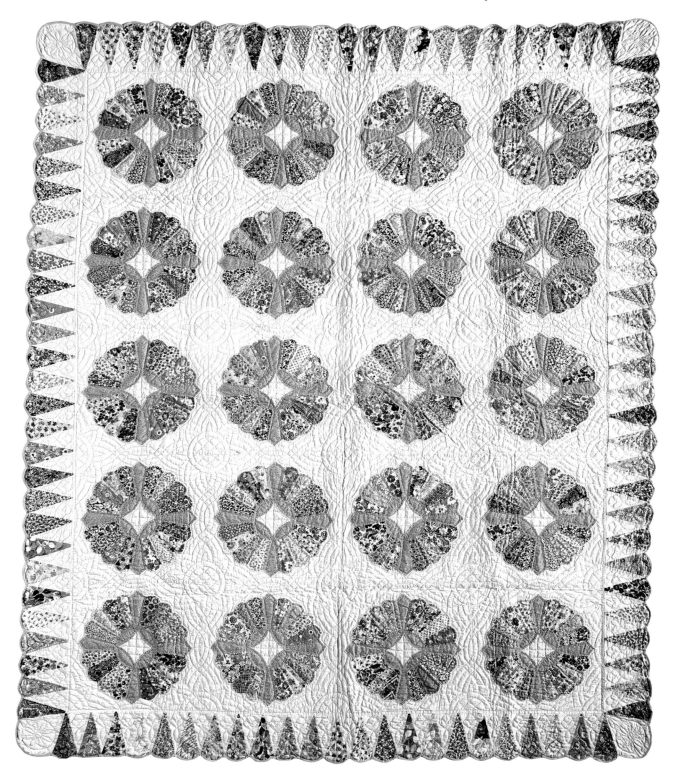

DRESDEN PLATE

Date: ca. 1930–1940
Maker: Unknown **Size:** 77" x 95"
Owner: Patricia Cox, Edina, Minnesota

This Dresden Plate Quilt has an ice cream border. Patricia purchased it because it reminded her of a quilt her grandmother gave her in the 1950s.

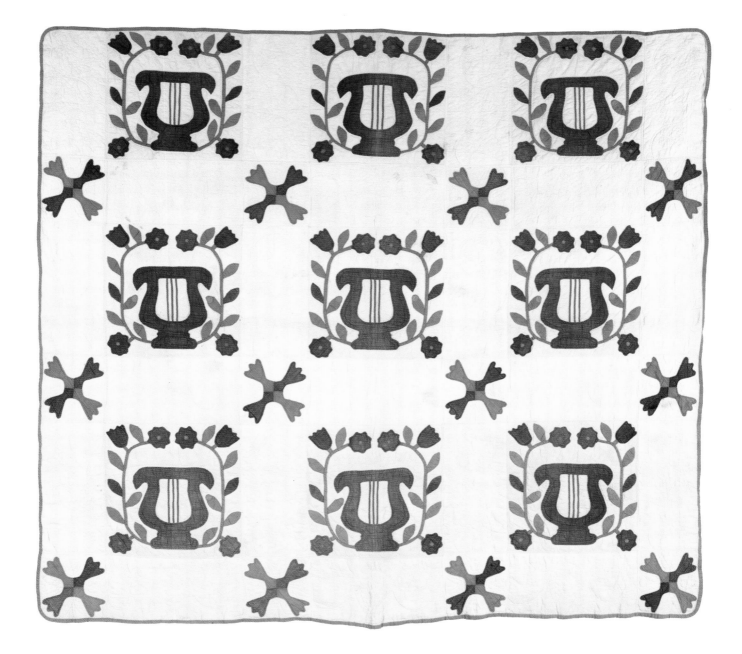

LYRE PATTERN QUILT

Maker: Elizabeth Manning, of Arkadelphia, Clark County, Arkansas, 1850–1875

Owner: Collection of the Historic Arkansas Museum, Little Rock, Arkansas

This quilt contains both appliquéd and pieced elements. The lyre design, which is symbolic of musical ability, is popular in Europe.

well to appliqué patterns, where a black background fabric or black bias fabric outlined the colorful pattern, just as the leading in stained glass windows frames the glass.

Fusible Appliqué

For the quilter who needs a faster appliqué technique, or is looking for an easy way to create multiple layers of appliqué, the fusible products introduced in the late 1990s make all things possible. Essentially a thin layer of adhesive attached to a paper backing, fusible products are applied to the appliqué piece by using a warm iron, then the appliqué piece is ironed in place on the quilt top. Quilters use various techniques to enhance the quilt, including decorative top stitching, fabric paints, and metallic threads.

Appliqué quilts continue to be popular in the twenty-first century. It is still the best technique to create realistic designs in fabric. All techniques can be completed through either hand or machine stitching, and many quilts today contain elements of both. The wide range of accent materials now available, including fabric paints, decorative threads, laces and trims, as well as new sewing machines with built-in appliqué stitches, encourage quilters to explore new territory while making a traditional design.

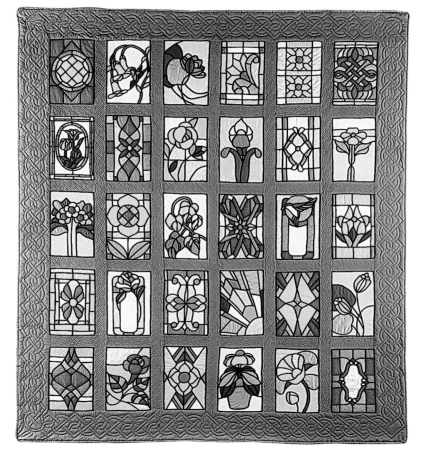

STAINED GLASS WINDOWS

Date: ca. 1986 **Maker:** Nadene Zowada, Buffalo, Wyoming
Size: 98" x 112" **Owner:** Collection of the Museum of
the American Quilters Society (MAQS), Paducah, Kentucky

This quilt uses colors popular in the Prairie Style Architecture of Frank Lloyd Wright. The quilt won a Purchase Award at the 1986 American Quilter's Society of Show.

Art Quilts

People who make quilts identify themselves first as "quilters," signifying solidarity. We are brought together by the act of quilting, and we are drawn to others who identify themselves as quilters. Through quilting we have created a social world. We understand ourselves and others through this world.

Subsequently, many quilters will identify themselves as either "traditional" or "art" quilters, creating distinctive roles in the social world of quilting. Art plays a role in all types of quilting. Color and fabric combine to make a unique, useful item that can be called a work of art. But some quilts are intentionally designed as works of art. They may be functional as quilts, but the primary emphasis is on form, material, and technique. During the late twentieth century emerging and diverging interests in fiber arts required that quilters alter their definition of "quilt" and "quilter," sometimes with reluctance.

TRADITIONAL QUILTING VS. INNOVATIVE QUILTING

People who define themselves as "traditional" quilters create quilts using patterns based on long-standing popular designs. Color and fabric choices may reflect a particular time period in history, regional preferences, or recommendations by a pattern designer. Some traditional quilters prefer hand sewing, but most, in their desire to create more quilts, make use of available technology to speed up the process. They use a rotary cutter to quickly cut block patches and a sewing machine to piece the blocks together. More traditional quilters are using sewing machines to quilt batting, backing, and top together in order to finish more quilts. While there is a wide variation in use of technology in traditional quilting, to the traditional quilter a quilt has a particular use: as a bed covering, table runner, or wall decoration. The purpose of the traditional quilt is to invoke warmth, comfort, and continuity.

The purpose of the art quilt is to communicate an idea, challenge aesthetic traditions, or experiment with materials. Art quilts are sometimes referred to as "innovative" quilts, meaning they include elements outside the realm of traditional quilting. Art quilters, who often have academic training in one or more fine arts, such as painting or sculpture, view the quilt as an extension of the fiber arts, making it acceptable to use techniques applied in any of these, including weaving, embroidery, painting,

dyeing, beading, or knitting. They often design their own quilt blocks, use free form designs, and incorporate personal objects such as jewelry, clothing, and medals into their work. They experiment with bold color combinations, and often make quilt-related art, including but not limited to vases, clothing, books, and jewelry.

Art Quilt Styles

Art quilt techniques fall into the same general categories as traditional quilts: pieced, appliqué, or whole cloth. It is the design content and use of the quilt that makes it an art quilt. General design categories include pictorial quilts, abstract, wearable art, and three-dimensional quilting.

Pictorial Quilts

Pictorial quilts have distinct design elements that include figures of people, buildings, plants, animals, alphabets, words, and letters. The work is intended to convey a concrete idea to the viewer. Some pictorial quilts tell a story, while others capture a snapshot in time. Many of the quilts made for Ami Simm's Alzheimer Art Quilt Initiative use both of these approaches. Quilted postcards often use pictorial figures on a miniature scale.

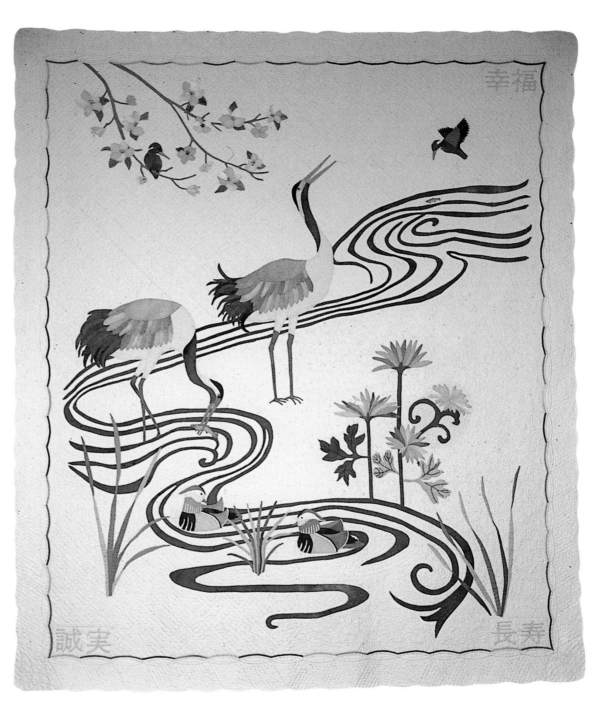

JAPANESE WATER BIRDS

Date: 2002 **Maker:** Linda Dreyer, Whitefish, Montana **Size:** 67" x 80" **Owner:** Linda Dreyer, Whitefish, Montana

Linda used all plant-based dyes for this quilt. She included the Kanji symbols for fidelity, longevity, and happiness. The quilt won an honorable mention at the 2003 International Quilter's Association Show in Houston. Photo by Shelley Emslie, Big Fork, Montana

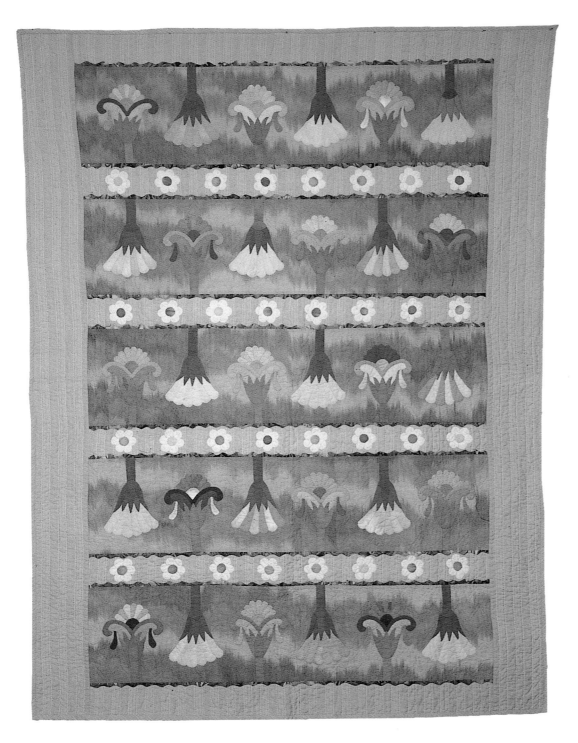

PHAROAH'S LOTUS PONDS

Date: 2006 **Maker:** Linda Dreyer, Whitefish, Montana **Size:** 52" x 70.5" **Owner:** Linda Dreyer

This is a transition quilt for Linda as she began to use commercially produced fabric dye. The lotus flower is a symbol of spiritual rebirth. Photo by Shelley Emslie, Big Fork, Montana

Linda F. Dreyer,
Whitefish, Montana

Linda uses appliqué and hand-dyed fabrics to create stories. Her current work is inspired by the designs of Egypt and Asia. Her quilts have been pictured in *Quilter's Newsletter Magazine*, and she has won several awards including honorable mention for large-scale appliqué at the Houston International Quilt Festival. In the early part of her quilting career, Linda used only plant-based dyes in her fabrics, but some of the dyes were not stable and faded too rapidly. Linda now also uses chemical-based dyes to achieve the color results she desires.

Abstract

Abstract quilts have conceptual design elements: unexpected angles, blurred boundaries, or a sense of motion. Abstract designs may also tell a story, but the viewer needs to use their imagination to see it and often requires prompting from the artist. Brian Dykhuizen paints fabrics with abstract designs, then quilts design elements within the fabrics. Nancy Crow often creates quilts with blocks having strong geometric designs: circles, squares, and rectangular strips, in powerful, contrasting colors.

Heather Fox, West Virginia

Heather Fox is a young, formally trained artist with a degree in Fine Arts and Interior Design from West Virginia University. She is a juried artist at the West Virginia state-sponsored Tamarack: Best of West Virginia Center in Beckley, and her quilts hang in the West Virginia Cultural Center in Charleston.

Heather is a self-taught quilter whose work combines traditional

METAMORPHOSIS

Date: 2006 **Maker:** Brian Dykuizen,
Kalispell, Montana **Size:** 33.25" x 44"
Owner: Brian Dykuizen

*After painting the fabric with thickened
dye, Brian cut the cloth apart. He then
reassembled it using fabric strips and
fusible web.*

IT'S ALL RELATIVE.

Date: 2006 **Maker:** Heather Fox, Rainelle,
West Virginia **Size:** 42" x 33"
Owner: Heather Fox

*This quilt is part of Heather's series of quilts
based on the bargello needlepoint technique.
The bargello series experiments with color and
shape.* Photo by William Gudmundsson

handstitching with art quilt style. As
she describes it, "I took to quilting
like a fish to water." Heather finds
inspiration for her art quilts through
the natural world and her own imag-
ination. Currently, she is working on
a Bargello series of small art quilts,
using the zigzag needlework pattern
popular in needlepoint as the basis
for the quilts' patches. She is excited
to be part of the relatively new art
quilt revolution, and strives to learn
more about its history while prepar-
ing for her part in its future.

Wearable Art

For centuries people quilted clothing to provide warmth and protection. Late twentieth-century quilters elevated quilted clothing to a high art status, created specifically for its appeal in the fashion world.

Susan Deal

Susan's sewing career has taken her from 4-H shows as a child, to the Bernina and Fairfield Fashion Shows. She uses traditional quilt designs as the basis for her garments, adding unique designs and brilliant color to create award-winning clothing. Her work has appeared at the New England Quilt Museum, the AQS Designed to Wear show, three Bernina shows, and nine Fairfield shows. In addi-tion, her clothing has graced the pages of books published by AQS and many magazines including *Quilter's Newsletter Magazine* and *American Quilters*. Susan lives in Arizona, but teaches at the Houston International Quilt Festival, the National Quilting Association Shows, and for guilds in the Southwest and California.

J. Michelle Watts

The land and culture of the southwestern United States is New Mexico artist Michelle Watt's greatest source of inspiration. Her quilts, wearable art, and patterns include designs found in regional architecture, nature, and art. She pieces, quilts, and appliqués her work almost exclusively by machine,

THE DANCE ELECTRIC

Date: ca. 2000 **Maker:** Susan Deal, Prescott, Arizona **Owner:** Susan Deal

This design is made of half-square triangles. Light and dark triangles are sewn at different angles to create a three-dimensional effect. Photo by Tom Henderson Studio, San Diego, California

WHEN AUTUMN LEAVES START TO FALL

Date: ca. 2000 **Maker:** Susan Deal Prescott, Arizona **Owner:** Susan Deal

Susan used the maple leaf block as the basis for the vest and swing coat. The blocks are turned in four opposite directions to achieve the design. Photo by Tom Henderson Studio, San Diego, California

ANCIENT HANDS TOUCH MY SOUL

Date: ca. 2005 **Maker:** J. Michelle Watts, Roswell, New Mexico **Owner:** J. Michelle Watts

This coat, which was included in the 2005 Bernina Fashion Show, Inspiration, was inspired by designs from the ancient people of New Mexico. Photo by Kim Coffman and courtesy of Quilts, Inc.

This detail of Ancient Hands Touch My Soul shows Michelle's machine quilting and embroidery work. Photo by Kim Coffman and courtesy of Quilts, Inc.

combining strong design elements and rich color choices. She has been quilting for more than 20 years, and is a charter member of the Pecos Valley Quilters in Roswell, New Mexico. The author of *Quilts of the Southwest*, published by the American Quilters Society in 2005, Michelle teaches quilting throughout the United States.

Three-Dimensional Quilting

For some quilters, quilts are not two-dimensional objects. In the past decade, due to changes in artistic tastes and the new interfacing and shaping materials available to the quilting market, more art quilters add three-dimensional characteristics, such as layered and stuffed fabrics, to their quilts. Some artists create quilted sculptures. The popularity of creating bowls and boxes from quilting fabrics brought three-dimensional quilting out of the art studio and into the mainstream. The boxes and bowls have become popular gifts, often serving as part of the gift-wrapping.

Susan Else

When California art quilter Susan Else finishes a piece it is anything but ordinary. Multicolored, small three-dimensional people, animals, and furniture stand on the surface of her quilts. Of her work, Susan states, "I treat cloth not as a flat surface but as a wild, flexible skin for three-dimensional forms. Making sculpture from fabric presents unique challenges and creative possibilities—and it makes me approach sculptural problems with an unusual

BINGO

Date: 2004 **Maker:** Susan Else

Size: 20" h x 31" w x 21" d **Owner:** Susan Else

Six fabric friends play a favorite game. Susan includes details such as bingo markers and soda cans to make the setting more realistic.

WORK IN PROGRESS

Date: 2006 **Maker:** Susan Else, Santa Cruz, California **Size:** 30" h x 20" w x 20" d
Owner: Susan Else

A mixed media fabric sculpture stitches herself together in Susan's delightful work. Susan uses handpainted and hand-dyed cloth for the surface design, and batting, foam and armature wire to achieve the three-dimensional effect.

SPUN GOLD

Date: ca. 2005 **Maker:** Scott Murkin, Asheboro, North Carolina **Owner:** Scott Murkin

Scott used galvanized steel wire in the binding of this sculpture, which helps it retain its shape, or allows him to "remodel" it.

slant. I use cloth to create an alternate universe, and the resulting work is full of contradictions: It is whimsical, edgy, mundane, surreal, and engaging—all at once."

Susan is a member of Studio Art Quilts Associates, a national non-profit organization dedicated to promoting the art quilt and professional support to art quilters. Her work was juried into Quilt National 2005, Tactile Architecture 2003–04, and she has won awards at the Pacific International Quilt Show. She also has a series of solo exhibitions throughout California and the southwestern United States.[2]

Crazy Quilts

Phe Crazy quilt is a product of the excesses and indulgences of the late nineteenth century. As the country recovered from the trauma of the Civil War, a huge disparity developed between classes, large numbers of immigrants came to the United States, industry boomed, and luxury fabrics such as silks and velvets became more readily available. The leisure class had the time and resources to devote to creating intricate needlework.

CRAZY QUILT

Date: ca. 1903 **Maker:** Rosalind Ducept Bruce, Turtle Mountains, North Dakota
Size: 63.5" x 75.5" **Owner:** State Historical Society of North Dakota

The embroidery work in Rosalind's quilt reflects her Chippewa-Metis heritage; it is reminiscent of beadwork floral patterns used by the Chippewa. She also included plants and animals native to the Turtle Mountains.

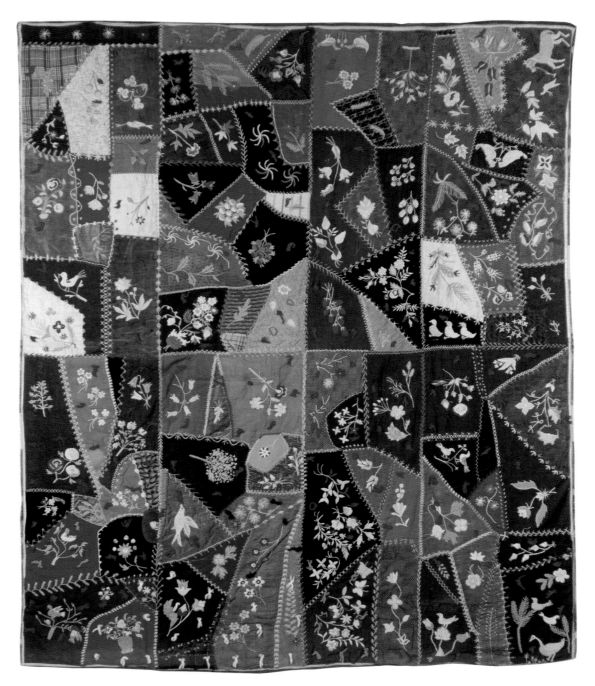

The impetus for the Crazy quilt was the 1876 Centennial Exhibition in Philadelphia, Pennsylvania, an exhibit that ran for six months, and had more than 8 million visitors. One of the crowning glories of the fair was the Japanese Pavilion, where attendees could see for the first time the arts and culture of this mysterious country. During much of the eighteenth and nineteenth centuries, Japan had been in an isolationist state, discouraging travel and contact with countries outside of Asia. American artists quickly incorporated elements of Japanese style and design into their work, and quilters were no exception. The seemingly random pieced style of the Crazy quilt replicated the crazed or broken glaze on Japanese porcelains, and the richly colored fabrics echoed the colors common to Japanese art.

Over the next 20 years, thousands of Crazy quilts were made, merging talents for piecing with embroidery. By 1884, magazines published embroidery designs specifically for Crazy quilts, and quiltmakers began to incorporate personal items into their quilts: ribbons, hair ornaments, and special occasion fabrics, velvet, silks, and satins. As the Crazy quilt declined in popularity toward the end of the century, those still created became less ornate. Many Crazy "quilts" were not intended to be used as bed coverings, but were made simply for decoration as throws and piano covers. Crazy quilts were also designed as commemorative quilts, such as the Illinois Columbian Exposition quilt, and as mourning quilts to remember dead loved ones by using scraps of their clothing. This trend signaled a shift in the purpose of quiltmaking. Quilts were no longer made out of necessity, as a way to keep warm during cold winters. Quilts were beginning to find acceptance as an artform.

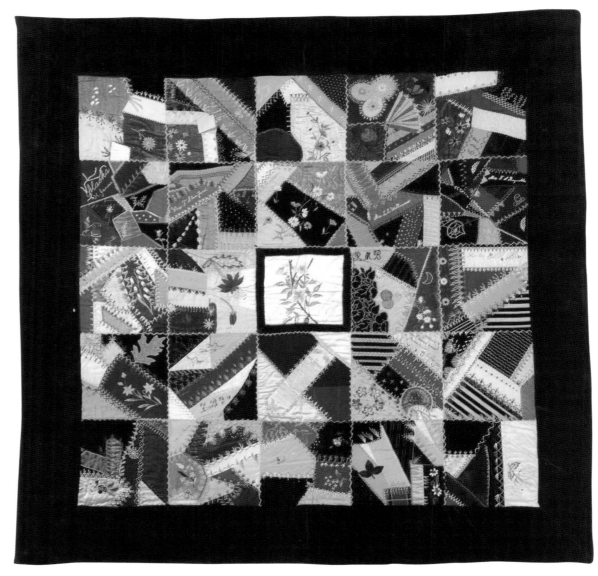

LAFEYETTE DAWSON CRAZY QUILT
Date: 1888 **Maker:** The Ladies of Sitka, Alaska
Size 72" x 72" **Owner:** Alaska State Museum, Juneau

The Ladies of Sitka Alaska presented this quilt to District Court Judge Lafayette Dawson when he left Sitka. Twenty-one women signed the blocks. The crazy squares set around an embroidered flower block are reminiscent of the medallion-style quilts of the early 1800s.

Victorian Culture and Decorative Art

The Victorian era, associated with the reign of England's Queen Victoria, began in the United States in the early 1840s, and ended shortly after the queen's death in 1901.

Much is written about this era and its excesses—increasingly large homes, impractical clothing such as the mid-century hoop skirts, and elaborate rules of courtship. Even in its own time period, "high" Victorian culture received ridicule. In 1873, Mark Twain published *The Guilded Age,* a novel that exposed the separation of rich and poor, the title itself indicating that the appearance of wealth and proper social behavior was only on the surface. At its best, the Victorian era brought new technology such as the steam engine and telephone; ideas, including emancipation and woman suffrage, money, and people to the rapidly growing United States. At its worst, it was a time of great divide: between North and South, rural areas and urban, immigrant and citizen. It saw the end of slavery for African Americans, and the beginning of subjugation for Native Americans. By the end of the period, the United States had become a major world power. The nation had grown from 25 states, predominantly east of the Mississippi, to 45 states spanning the breadth of the continent. Great Britain was no longer the primary influence on the United States.

From the Victorian era emerged three major decorative arts traditions: Victorian Design, Aestheticism, and the Arts and Crafts movement. Victorian Design was based on creating "clutter" and points of interest in rooms. It was under the influence of Victorian Design that the term "conversation piece" developed, and rooms where decorated around items that provided visitors with a topic of conversation. Wealthy families collected such curios during trips overseas and displayed them as a sign of their wealth and gentility. Odd items, such as wreaths made of hair, rocks and fossils, and unusual ceramics decorated households. Aestheticism, essentially art for the sake of art, became a significant influence on design and décor in the 1870s. The classical designs of Rome, Greece, and Japan dominated the Aesthetic movement. The United States had established a trade relationship with Japan in the 1850s, which encouraged the flow of Japanese arts to the country. Japanese influences in design are exhibited in the used of fans, symmetry, and embroidery.

In the last quarter of the nineteenth century, the Arts and Crafts movement, championed by William Morris, a leading English designer of wallpaper, fabric, and furniture, became a significant influence on design. The Arts and Crafts movement, which emphasized the role of the craftsperson in society and equated traditional crafts with fine art, was a reaction against the mass-produced

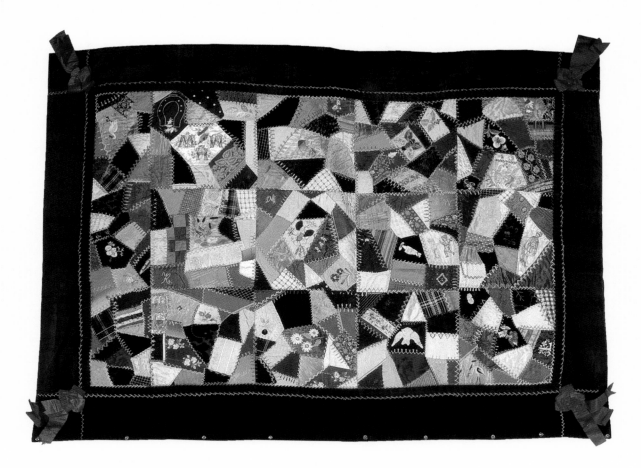

CRAZY QUILT THROW

Date: 1884 **Maker:** Agnes Kirkpatrick Terrell, Clayton, Illinois **Size:** 45" x 63" **Owner:** Illinois State Museum

Agnes probably made this throw for her ten-year-old daughter, Ada. The red satin ribbons, and purple silk backing create a particularly colorful quilt.

goods of the Industrial Era. Textile design, woodworking, and stained glass all experienced a renaissance during the Arts and Crafts movement.

The Crazy quilts from this time period exhibit all three design styles, Victorian, Aestheticism, and Arts and Crafts. The Victorian style is represented through the cluttered appearance of blocks, using many random patches of fabric and mementoes such as pieces of clothing or ribbons from events. The Aesthetic style is evident in the Japanese elements that were used in the quilts, including fans and intricate embroidery. Finally, the Crazy quilt embodied the very foundation of the Arts and Craft movement. The Crazy quilt elevated a traditional craft, creating quilts for use as bedding, to a high art form.

CRAZY QUILT

Date: ca. 1890 **Maker:** Laura Gibbon, Iowa
Size: 45" x 76" **Owner:** Katie Burton,
Brainerd, Minnesota

*This quilt was probably intended as a piano
cover or other decorative throw. Katie Burton
is the great-granddaughter of Laura Gibbon.*
Photo by Greg Winter and Lee Sandberg,
Minneapolis, MN

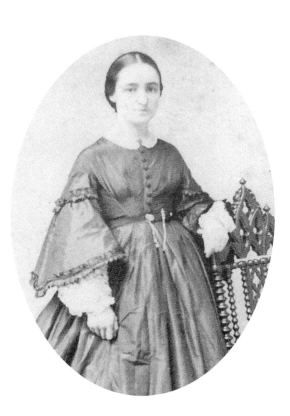

Quiltmaker Laura Gibbon

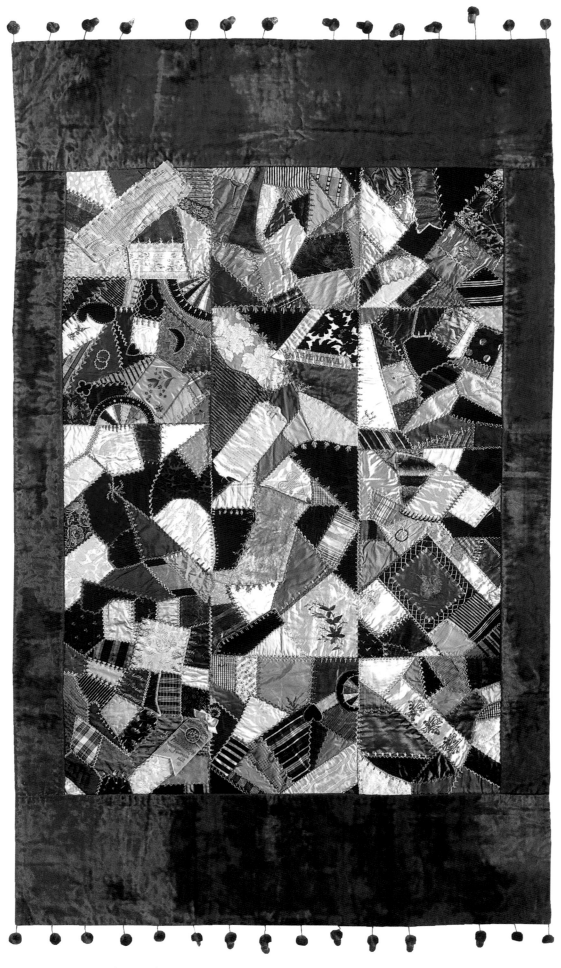

THE LAURA GIBBON QUILT

Often the story behind a quilt and its maker is lost. Other times, as with the Laura Gibbon quilt, the stories survive, becoming a part of popular culture. Laura Gibbon's life became the basis of the 2002 novel *Through the Canebrake*, by William McCollough, an adventure story set during the Civil War.

Laura was born in Kentucky in 1837. In 1844, after her father, a newspaper publisher, was murdered, her family moved to Iowa. She married in September 1861, and her surgeon husband immediately joined the Union Army. He was captured behind enemy lines in the summer of 1862. Courageously, Laura, who had joined him in Vicksburg, went into the camp under a flag of truce and arranged the exchange of prisoners. Laura continued alongside her husband until his discharge in 1864.

Laura and her husband were active members of the Society of the Army of the Tennessee, a Civil War veteran's group. They attended many of the banquets and were acquainted with General Ulysses S. Grant.

Laura's quilt was actually intended as a piano cover. In addition to pieces of special clothing, she has included the ribbons from these banquets, the menu from her daughter's 1884 wedding reception, and a fringed border.

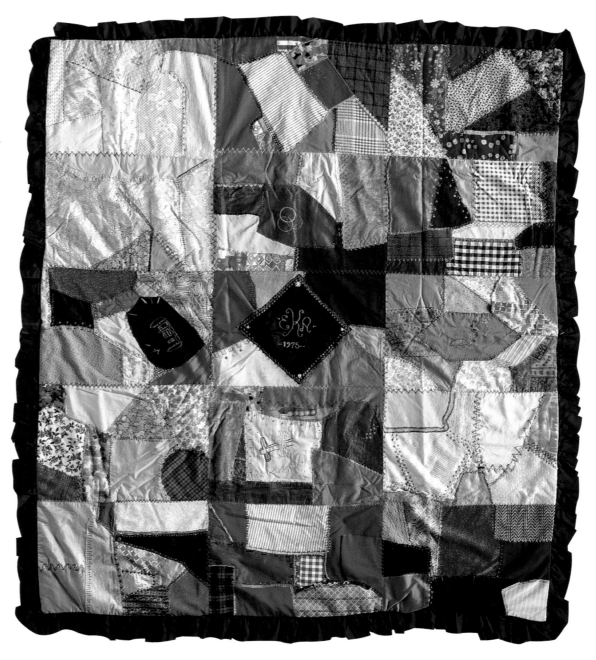

MODERN CRAZY QUILT

Date: ca. 1970–1975 **Maker:** Betsy Marvin, Minneapolis, Minnesota **Size:** 50" x 50"
Owner: Betsy Marvin

Betsy used scraps from her mother's sewing room floor to make this quilt one summer when she was in high school. Many of the scraps were polyester or rayon fabrics.
Photo by Greg Winter and Lee Sandberg, Minneapolis, Minnesota

Embroidered Quilts

Embroidery is a sophisticated needleart that was considered part of a young women's education in the eighteenth and nineteenth centuries. Girls made embroidered samplers featuring numbers, the alphabet, flowers, and animals to practice stitches and display their talent. Embroidery was also used as a way to keep young hands busy and out of trouble.

Embroidery first appears in American quilts in the late eighteenth century, and was used to embellish the album and signature quilts of the nineteenth century. The 1876 Centennial Exhibition, credited as the inspiration for the Crazy quilt mania, also featured exhibits of "Art Needlework," where decorative embroidery was used to embellish common household items, such as bed and table linens, accent pillows, and clothing. In the next decade, embroidery became the needle art of choice.

Patterns appeared in magazines of the 1880s, and by 1889, the Ladies Art Company had printed one of the first catalogs for mail-order patterns. A variety of pattern-marking techniques were used at the time. Pattern designs were perforated so they could be stamped or pounced through the perforations onto the fabric. Iron-on transfers became available in the 1870s, although the user had to position transfers carefully so the design didn't bleed or smear around the edges. Linens stamped for embroidery were available in 1884, and some manufacturers made stamped quilt blocks after the turn of the century.

Embroidered quilts reached their zenith in the last part of the nineteenth century and first part of the twentieth century, when entire quilt tops contained nothing but embroidery stitches.

REDWORK

Redwork is perhaps one of the most recognized of all embroidered quilts, featuring striking designs made from deep-red embroidery thread on a white background. While most redwork quilts date from the last decade of the 1800s through the first quarter of the 1900s, the style remained in use throughout the twentieth century. Since the 1990s redwork has experienced a revival, finding a new generation of devotees.

Patterns are pictorial, often including animals and people inspired by nursery rhymes and literature. Redwork patterns are also often commemorative, including famous people and places. Redwork stamped squares, marketed specifically for the 1901 Pan American Exposition in Buffalo,

REDWORK

Date: ca. 1890 **Maker:**
Unknown, Pennsylvania
origin **Size:** 72" x 72"
Owner: Stella Rubin
Antiques, Potomac, Maryland

*Redwork embroidery became
popular in the nineteenth and
twentieth centuries, following
the introduction of Turkey Red
floss in 1829. This particular
quilt includes unusual motifs
and appears to have been
made for a young bachelor.*
Photo by Steve Goldberg

New York, and other fairs, became known as "penny squares" because they were sold for a penny each.

QUILTS WITH A CHILDREN'S THEME

Embroidered quilts were often made for children. The rise in popularity of embroidered quilts in the late nineteenth and early twentieth centuries coincided with the development of crib-sized or baby quilts. Embroidery was often used on children's clothing of the late nineteenth century, and it was natural for it to be used for baby quilts.

Well-known designers such as Ruby McKim created embroidery patterns specifically for children's quilts. McKim's Quaddy Quiltie series includes woodland and water animals dressed in human clothing. Dolls and toys, nursery rhymes and Sunbonnet Sue, farm animals and pets, all were favorites with mothers and grandmothers who were creating a keepsake for a much-loved child. Many children's quilts were used up before the child reached adulthood. Others appear at auctions and antique stores, having long been separated from the original owners. A few treasured quilts remain in families, or are donated to museums, as is the case with Emilie Clark's quilts. Her children donated their quilts to Michigan State University, where they can be viewed on the Quilt Index website.

FARM ANIMALS QUILT

Date: Top: 1930s, quilted ca. 2000
Maker: Frances Mary Smith, Ontario, California, and Bonnie Coston, Kalispell, Montana **Size:** 57.5" x 57.5"
Owner: Bonnie Coston

Frances Smith embroidered the squares during the Depression, and her daughter, Bonnie, finished the quilting 70 years later. Photo by Shelley Emslie, Big Fork, Montana

EMBROIDERED KEWPIE DOLLS

Date: ca. 1930 **Maker:** Unknown, from Pennsylvania **Size:** 74" x 82" **Owner:** Stella Rubin Antiques, Potomac, Maryland

This quilt combines unusual Kewpie Doll blocks with more common Sunbonnet Sue blocks. It is a very colorful quilt, which is unique for this style of embroidery. Photo by Steve Goldberg

CROSS STITCH ALBUM QUILT

Date: ca. 1930–1950 **Maker:** Unknown, from Pennsylvania **Size** 54" x 82" **Owner:** International Quilt Study Center, University of Nebraska–Lincoln 1997.007.0946

Made from reproduction cross-stitched linen samplers, this quilt is in the Colonial Revival Style tradition, which was popular in needlework during the first part of the twentieth century.

STATE QUILT BLOCKS

In the first part of the twentieth century, the United States consisted of 48 states and the territories of Alaska and Hawaii. Designer Ruby McKim created a set of state flower embroidery patterns in the 1930s. These and related designs were often used on quilts from the 1930s. In the 1960s and 1970s the designs were revived and appeared on dish towels, pillows, and occasionally quilts from that era. Today's patterns include state birds, natural wonders, and state seals.

CROSS-STITCH QUILTS

The cross-stitch is the simplest of all embroidery techniques, using just two stitches used to form an "X." Cross-stitch elements often appear in embroidered quilts. In the mid-twentieth century, kit manufacturers offered full-sized, stamped, cross-stitch quilts, which were popular with middle-class housewives, who had the time and money to spend on them. These kits were sold through needlework catalogs such as Herrschnerrs and Lee Wards, and also at local stores, including Woolworths, JCPenney, and Sears. Cross-stitch designs were completed in either one-color thread or multicolor, and two common styles emerged—the center medallion and individual blocks. Blocks were often sold in kits of six, and could be joined to make the size quilt of the maker's choice. Patterns were also published in women's magazines, and a few intrepid quilters created their own cross-stitch designs, based on patchwork blocks, illustrations, or, in at least one case, reproduction colonial samplers.

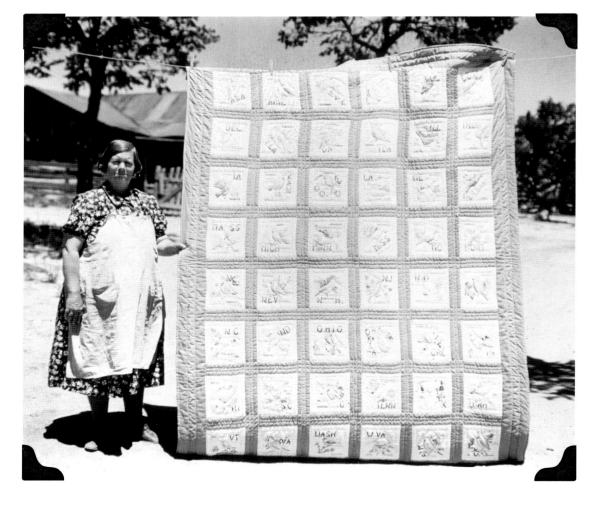

Mrs. Bill Staggs, Pie Town, New Mexico, displays her state block quilt, ca. 1939. She and her husband were area farmers. Library of Congress

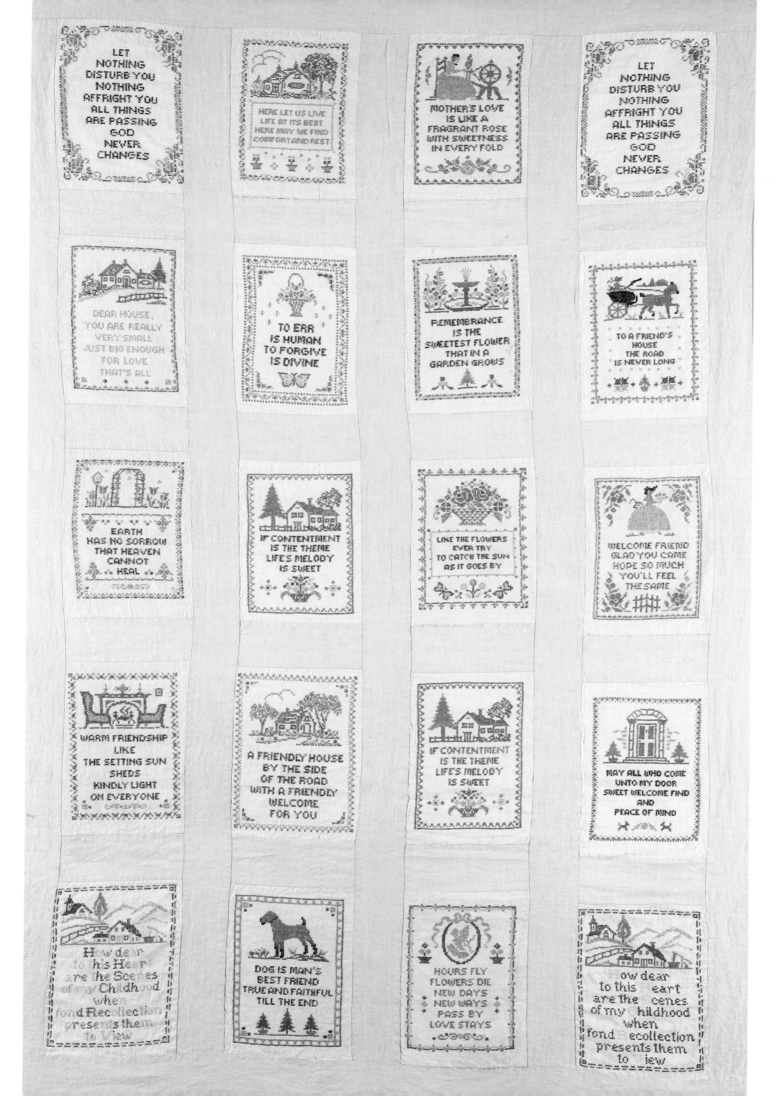

Kit Quilts

The simplest way to make a new quilt is to buy a kit that includes the necessary instructions and materials. Kits are great for those who wish to try a new technique or are uncertain about their ability to match colors and fabrics. Kitting quilts is good business for quilt shops and designers, giving them a way to pitch the latest styles and unique fabrics to customers.

Quilt kits are a product of the twentieth century, evolving along with other needlework kits. The first simple kits were sold in the 1910s, but Marie

DAISY CHAIN, MARY McELWAIN KIT

Date: 1938 **Maker:** Ruth Augustyn, Wisconsin
Size: 73.5" x 91" **Owner:** International Quilt Study Center, University of Nebraska–Lincoln 1997.007.0389

Mary McElwain opened her quilt shop in Walworth, Wisconsin, after her husband closed the family jewelry business. In addition to stocking fabrics, threads, and Marie Webster kits, she also designed her own kits.

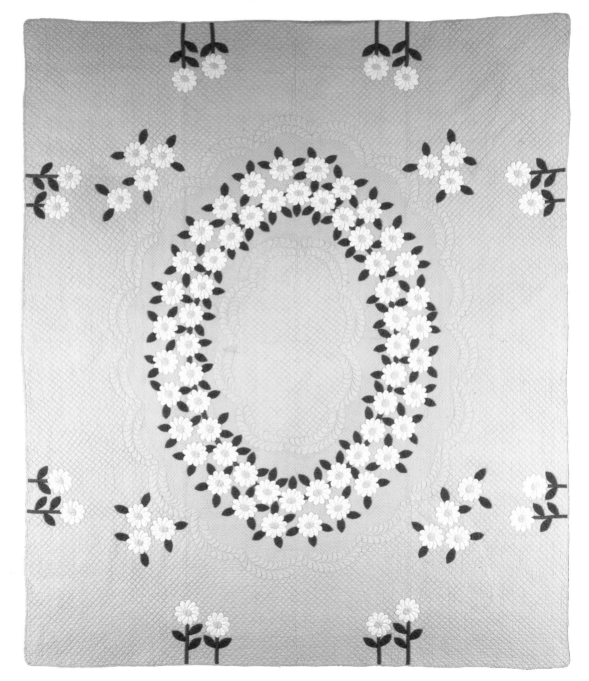

Webster is credited with building the retail of quilt kits into a business in the 1920s. She and other designers, including Anne Orr, Ruby McKim, and Mary McElwain, kitted and sold their original patterns. By the mid-1920s, needlework distributors sold kits through mail-order catalogs. At its peak in the mid-twentieth century, more than 100 companies sold quilting kits through mail-order. Well-known names included Bucilla, Lee Wards, and Herrshners. Today's quilters like to collect the old catalogs.

Kit quilts represent the popular styles of the time period, so kits from the 1920s emphasize appliqué and embroidery, while kits from the 1960s feature cross-stitch. The Lone Star pattern is a common pieced kit, popular from the 1940s through the 1980s.

There was a brief lull in the kit industry during the last part of the twentieth century, when new quilters

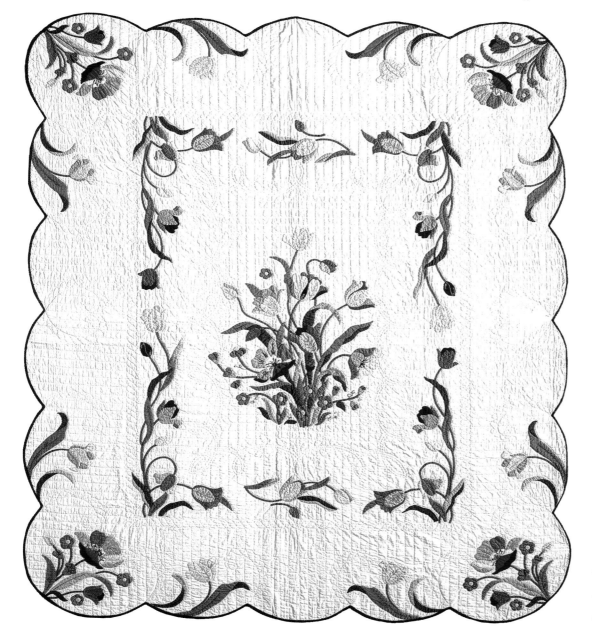

TULIP TIME, PROGRESS COMPANY KIT
Date: ca. 1954 **Maker:** Unknown **Size** 76" x 87"
Owner: Rose Werner, Dundas, Minnesota

Progress appliqué kits were offered in several different colorways. The tulip kit was also available in purple. Photo by Greg Winter and Lee Sandberg, Minneapolis, Minnesota

4-H QUILT, RUBY McKIM PATTERN

Date: ca. 1935 **Maker:** Unknown **Size:** 70" x 79" **Owner:** Rose Werner, Dundas, Minnesota

This quilt is made from a Ruby McKim design. The quilting in the green blocks is the 4-H symbol representing head, heart, hands, and health. Photo by Greg Winter and Lee Sandberg, Minneapolis, Minnesota

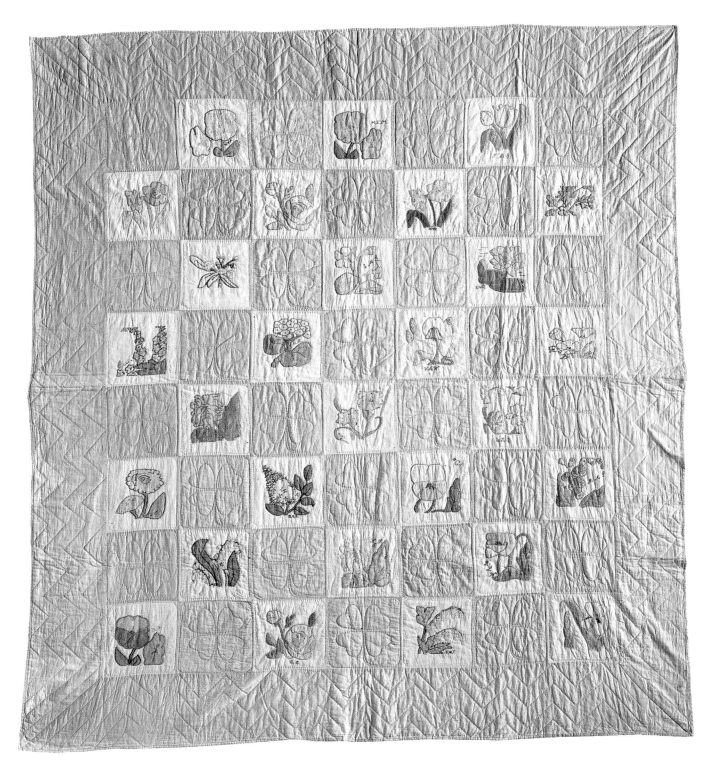

preferred to select their own patterns and fabrics, and for a short time kits had a reputation as "hobby" projects that were not for the serious quilter. In the past decade, however, both pattern and fabric companies and individual shop owners have re-introduced kits. Kits are an affordable and excellent way to learn a new technique. Because kits contain all instructions and all materials except batting, quilters are more likely to finish the project.

Friendship and Memory Quilts

Quilts provide a tangible and comforting way to share the memories of friendship, especially if the recipient will be traveling far from home, whether by 1840s wagon train or twenty-first–century jet.

Friendship or memory quilts can be made from any pattern or combination of fabrics—the one requirement is that the quilt evoke strong memories of family and friends. In the mid-nineteenth century, the appliquéd album quilt was often used as a Friendship quilt, particularly in the Mid-Atlantic states and New England, where the album quilt was most popular. In quilts of the 1840s, pieced patchwork blocks were designed to hold signatures, while quilts of today may contain photographs of loved ones, places visited, and favorite pets. Friendship and Memory quilts may be made by one person, or they may be the work of many. Sometimes the quilts are abstract or symbolic expressions of memories, vivid or obscured by time, such as many of the quilts from the Alzheimer's Quilt Initiative. Others are concrete representations, and include specific names, dates, and images of events.

A detail of the Honeycomb Friendship Quilt shows the signature block. Each block is 7.5 inches on the diagonal.

Signature Quilts

Signature quilts rose to popularity in the 1830s and 1840s, when the Northeastern and Mid-Atlantic states were becoming more urban and industrialized and the Southern and Midwestern states had established stable agricultural economies. European-American explorers were familiar with the terrain and peoples of the continent's western regions, and settlers from the United States and abroad began to settle in areas west of the Mississippi. Signature quilts were the perfect keepsake for families or individuals before their journey.

Signature quilts were also popular gifts for young brides. A bride's friends might each make and sign a

HONEYCOMB FRIENDSHIP QUILT

Date: 1848 **Maker:** Unknown, from Northeastern United States **Size:** 54.5" x 77.5" **Owner:** Mary Barton Collection, State Historical Society of Iowa

While the maker is unknown, the signatures in this quilt represent ladies from Vermont, New Hampshire, and Massachusetts. Many of the names appear to be from the same family.

CHIMNEY SWEEP/CHRISTIAN CROSS WITH FLYING GEESE BORDER

Date: ca. 1861 **Maker:** Unknown, from Chatsworth, Illinois **Size:** 74" x 85.5" **Owner:** Mary Barton Collection, State Historical Society of Iowa

The Chimney Sweep or Christian Cross pattern was very commonly used for signature and album quilts in the mid-nineteenth century. The Flying Geese border was an unusual setting.

The Connecticut Quilt Search Project documented 129 signature quilts, more than four percent of the total quilts surveyed. Most were in album or chimney sweep patterns.
The Connecticut Quilt Search Project

block, often adding special wishes for a happy and long life.

Signature quilts are ideal fundraising quilts as well. A charity might have a quilt made and then sell space to those who wish to sign the quilt. The Red Cross quilts made during World War I are well-known examples, but signature quilts have also been used to raise money for political candidates, preservation efforts, and to combat poverty.

Exchanges
Another type of Friendship quilt may be created when quilters exchange blocks or fabrics with friends. In a block exchange, each quilter makes a number of the same block to trade with friends. Other

times, fabrics are exchanged, and each quilter makes his or her own quilt. In a round robin exchange, a quilt top started by one quilter is then passed among friends, each one adding their own blocks or border, resulting in a quilt different from the one the original quilter had in mind. Usually the original quilter keeps the quilt, but sometimes they are gifts to other people or donated to charity. Exchanges are started in many ways: through quilt guilds, among quilting friends or family members, and some are coordinated through the Internet. The Nifty Fifty Quilters coordinate their exchanges through their website. Each exchange has a hostess who coordinates participant activities and ensures that there is an exchanged block representing each of the 50 states. Some of the quilts are auctioned to provide funding for the Carol M. Balwin Breast Care Center in East Setauket, New York.

ROSY HUE OF CHRISTMAS

Date: 1997 **Maker:** Patricia Cox and friends
Size: 60" x 63" **Owner:** Patricia Cox, Edina, Minnesota

Patricia made the center block, then each of five friends added a border. Quilters were Gerry Smith, Susan K. Nelson, Marlyce Payne, Greta van Meeteren and Shelly Zhikowski. Photo by Greg Winter and Lee Sandberg, Minneapolis, Minnesota

WHAT WOULD JOAN JETT DO?

Maker: Tammy Hoganson, New Prague, Minnesota **Size:** 33" x 33" **Date:** 2006

Owner: Tammy Hoganson

Tammy made this T-shirt quilt with shirts she collected at rock concerts. She created a pieced sashing for the blocks to add visual interest. Photo by Greg Winter and Lee Sandberg, Minneapolis, Minnesota

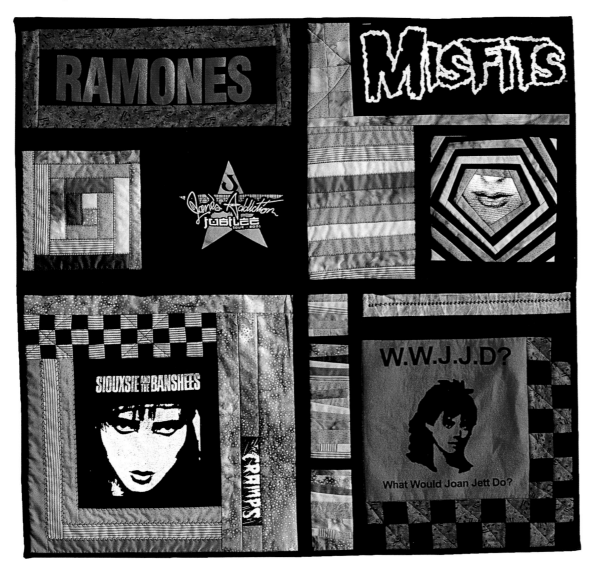

Memory Quilts

Memory quilts, often made by one quilter, are designed to evoke memories of a particular person or of an event in the maker's own past. Memory quilts are not a new phenomenon; album quilts in the 1840s, Crazy quilts in the 1880s and redwork in the 1900s often were used to depict memories of family, friends, events, and places. But the style has increased in popularity since the 1990s, due to improved photo-fabric technology and increased interest in scrapbooking. Today's memory quilt is the quilter's scrapbook, containing fabrics, photos, and mementos of the past. One of the newest designs, the T-shirt quilt, uses commemorative T-shirts cut into blocks. The T-shirt quilt has become a particularly popular quilt to make for graduations, using the T-shirts the graduate-to-be has collected throughout his or her high-school activities.

Photographs, which have become an important component in memory quilts, have been printed on fabrics for longer than you'd think. Photographs were first used in textile home furnishings around 1890 when a blue and white cyanotype was printed on to fabric squares, which were then made into pillows. Using a printing frame made of glass and household chemicals, homemakers could print fabric right in their own kitchens. Today's computers and high-quality printers allow quilters to print photographs directly on to fabric in full color, and without the mess.

Patchwork Quilts

I am piecing me a quilt, I have 12 stars done, nearly all the pieces were scraps that the neighbor girls have give to me, so just please send me a piece of one of your shirts and my aunties' a piece of one of their dresses to put in my quilt and I will send you a piece of my new dress.

Maggie Blair, six years old, Bentonville, Arkansas, Letter dated January 25, 1885

When the topic of American quilting comes up, the conversation always turns to patchwork, the use of geometrically pieced fabrics to create coverings. Quilters love appliqué, embroidery, and whole cloth quilts, but it is the patchwork quilt that captures the imagination and is often the style the new quilter learns first. Patchwork quilts evoke stories of ancestors struggling across the prairie, a weary mother sitting by a sick child's bed, or a war-time bride waiting for the return of her new husband. Although patchwork designs have been found across the world and date to as early as 980 BCE, American quilters have taken patchwork to a high art form. It is American quilters who began to create their quilts using block designs, adapting first designs brought from Europe, then creating thousands of original blocks that reflected American artistic tastes and fabrics, and named for American places, events, and ideas. By the mid-nineteenth century, American quilters were sharing these blocks within families, communities, and on the printed page, ensuring their continuance to future generations.

Those outside the quilt world fail to understand patchwork. Why would you take a piece of perfectly good cloth, cut it up, and then sew it together again? But the quilter understands the power of patchwork, the manipulation of shape and color, the combination of analytical and creative thinking.

Patchwork quilting came to the United States via England sometime during the eighteenth century. The earliest surviving English patchwork is a set of bed hangings and a quilt at Levens Hall, Cumbria, which dates from around 1708. The earliest examples of American patchwork appear in the late eighteenth century. While patchwork is often associated with needing to "make-do" with pre-used fabrics or scraps, it was also an opportunity for artistic expression, and new fabrics were sometimes used. Women had incorporated patchwork into their quilts for several decades when the Honeycomb pattern was printed in *Godey's Lady's Book* in January 1835, the first pattern in the United States to be published with a name. By

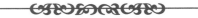

Patchwork: n. 1. Anything formed of irregular, incongruous, odd, or miscellaneous parts; jumble. 2. A quilt or other covering made of patches of cloth, etc. sewn together at their edges. 3. Any design or surface like this.

Webster's New World College Dictionary

Old Patterns Imbued with New Meanings

What's to be done with old patterns that have a long tradition of noble use and meaning, but have been co-opted and imbued with a newer, offensive meaning? One such pattern is the swastika, which is now known worldwide as the symbol of the Nazi Party and a reminder of the near-annihilation of Jewish people and other groups during World War II. Yet the design on which that Swastika was based has a tradition more than 3,000 years old and appears in the artwork of cultures worldwide, including ancient India, Ireland, Tibet, and parts of Native America. The word "swastika" is Sanskrit and means "to be good." Until the 1930s, the symbol represented life, growth, and friendship. In quilting, the swastika appears in the nineteenth century as a quilt pattern (with other names such as FlyFoot and Whirligig) and in late nineteenth-century fabrics. The makers of these quilts, who put so much effort into their creation, could never have imagined that one day the symbol they used on their quilts would be reviled and perhaps feared.

So what is the solution? Should these quilts be destroyed or hidden away? Should a quilter never make a new quilt using these patterns? There is no one correct answer to these questions. Quilters and quilt collectors need to go with their instinct and consider the following issues: Who is the intended recipient or viewer of the quilt? What are my own intentions and will I have an opportunity to explain why this quilt or pattern has been used or exhibited? Am I prepared to deal with misunderstandings that might arise? The responsibility rests with the individual.

SWASTIKA

Maker: Unknown **Date:** ca. 1920 **Size:** 73" x 87"

Owner: Rosie Werner, Dundas, Minnesota

This quilt was owned by a Northfield, Minnesota, antique dealer until the 1990s. She did not display it in her store because the symbol was associated with the German Nazi Party. Photo by Greg Winter and Lee Sandberg

STARS, HEXAGONS AND POLYGONS
Date: ca. 1860
Maker: Mrs. Carpenter, Vermont **Size:** 68.75" x 75"
Owner: Photograph courtesy of the Pocumtuck Valley Memorial Association, Memorial Hall Museum, Deerfield, Massachusetts

This quilt top is handpieced using approximately 82,000 diamond-shaped patches. The diamonds measure ¼ inch on each side.

mid-century, patchwork had become the predominant quilting method, and patterns had become more complex. There were many reasons for patchwork's popularity. Unlike whole cloth and appliqué, patchwork blocks could easily be made in small spaces or while traveling. Designs could be made with smaller amounts of cloth. Like today, some quilters found the planning and sewing of patchwork to be therapeutic, a few moments of peace in their busy world. Simple patchwork required less skill and time than appliqué, so beginners could start and finish a quilt quickly, important when many quilts were needed for warmth.

Patchwork quilts are made in many patterns, materials and sizes. Often patchwork quilts are not "best" quilts, but utility quilts that are meant to be used. Antique patchwork quilts often show higher levels of wear and tear than antique quilts of other styles for this very reason. Today's quilters make "best" quilts of both patchwork and appliqué.

The following pages describe common styles found in American patchwork. Since the realm of patchwork is so large, this is only an introduction. For more detailed information, refer to the bibliography.

Between 85 and 92 percent of the quilts documented in the majority of state quilt projects were predominantly patchwork.

Pattern Names

To my grand-daughter who now lives with me, Mary Devault, I give and bequeath…my quilted quilt of the pattern known and called "Rose of Sharon."

Elizabeth Range's Will, 1843, Jonesbourgh, Tennessee

When we see a quilt, we often ask the owner what pattern it is. This question is not always easy to answer, as many patchwork patterns have more than one name, and names come in and out of vogue over the years.

Pattern names come from many sources, including family tradition, local community culture, publications, and pattern designers. *Godey's Lady's Book* has the distinction of publishing the very first pattern in the United States with a name attached to it. The Honeycomb, or Hexagon first appeared in *Godey's* in January 1835. It was a simple, six-sided shape, not a new pattern by any means, but it carried the status of now having a name. The hexagon became the basis for many nineteenth- and twentieth-century quilts, including the popular Grandmother's Flower Garden. In the decades that followed, more patterns were named, some descriptive, some spiritual, and some imaginative.

Names have power. Consider the thought that goes into naming a child. We carefully ponder everything from family traditions, to community acceptance, to ensuring individuality. Quilt pattern names reflect the same level of contemplation. Consider the names given to one particular pattern with a basic four-patch design. It has negative names such as Robbing Peter to Pay Paul and Drunkards Path. Yet, the same pattern is also known as Wonder of the World. The name you choose for your quilt would depend on its intended use. You probably wouldn't call it Drunkard's Path if you were making it for a child's bedroom.

Quilt historians have put much effort into the study of pattern names. The most notable of these is Barbara Brackman, whose book *The Encyclopedia of Pieced Patterns,* contains more than 4,000 pieced blocks, divided by style and including the many names under which each has been published. Brackman spent more than 20 years compiling indexes, and this is the book that researchers turn to for pattern names. Understanding the complexity of names, Barbara includes this caveat in her preface. "I now realize that not every pattern has a name, there is no 'correct' name for any design, and that some of the names we take for granted as authentic nineteenth-century folklore actually have relatively short histories."

ROBBING PETER TO PAY PAUL

Date: ca. 1850 **Maker:** Unknown, Pennsylvania origin **Size:** 82" x 108"

Owner: Stella Rubin Antiques, Potomac, Maryland

This fine example of a Robbing Peter to Pay Paul quilt has a glazed chintz border and a backing that appears to be home-dyed. The lighter areas of the quilt are pieced in slightly different patterned fabrics. Photo by Steve Goldberg

Collector Mary Barton created visual aids for pattern study by sewing sample blocks together onto muslin sheets. This study aid for basket blocks includes nine different block patterns in a variety of fabrics. Photo Courtesy of Mary Barton Collection, State Historical Society of Iowa

BASKET QUILTS

Basket patterns are "realistic" patterns, meaning they are pieced as they actually appear. Baskets were an ordinary household item, but take on new status when pieced into a quilt. Both chintz appliquéd and album quilts in the 1840s contained basket blocks, and baskets appear in patchwork by the mid-1850s. In *The Encyclopedia of Pieced Patterns*, Barbara Brackman describes more than 120-pieced basket designs. Patchwork basket designs range from the very simple with just a few triangles, to the complex of 50 or more triangles.

The baskets may be empty or filled. Empty basket patterns usually have an appliquéd handle, although a few have pieced handles, and some basket patterns have no handle at all. The majority of basket patterns described by Brackman, however, feature baskets filled with appliquéd or pieced flowers, fruits, vegetables, or geometric shapes, usually diamonds or triangles. The baskets are often set on-point, but occasionally are set horizontally or vertically. Baskets quilts are popular reproduction quilts.

Two Baskets, Made 140 Years Apart

The two quilts here are virtually the same pattern, but made many generations apart and in different regions of the country. The older quilt, made in the 1860s, was bought by collector

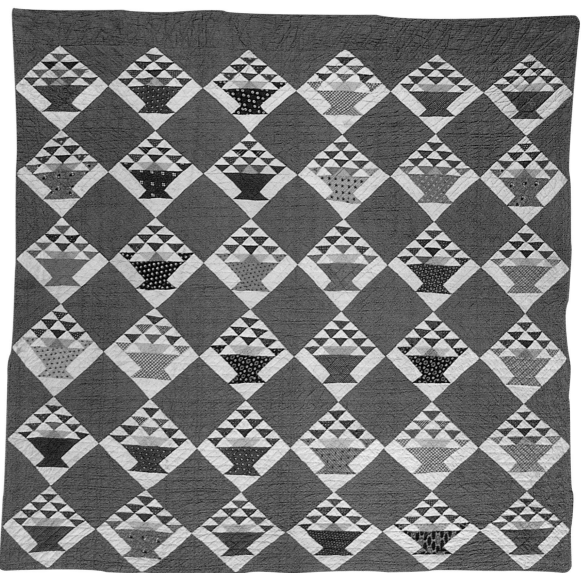

Mary Barton in 1975. Although the original maker of the quilt is unknown, it was probably made in Iowa. With the quilt was a note: "This quilt to go 2 ? The blocks was sewed by my sister Mattie in 1865 and were given for a wedding present of use. Some of my mother's Aunt Mary Stater's and myself dresses and all calico was 50 cents per yard civil war prices." A quilt of this size would have cost between $3.50 and $5.00 to make. Mary paid $77.75 for this quilt at a Des Moines, Iowa, auction.

BASKET QUILT

Date: ca. 1865 **Maker:** Unknown, from Iowa
Size: 72" X 75" **Owner:** Mary Barton Collection, State Historical Society of Iowa

This scrappy, triangle-pieced quilt, made in the 1860s, is similar to Brackman Pattern #704, which the Ladies Art Company called "Flower Basket" and Nancy Page referred to as "Betty's Basket."

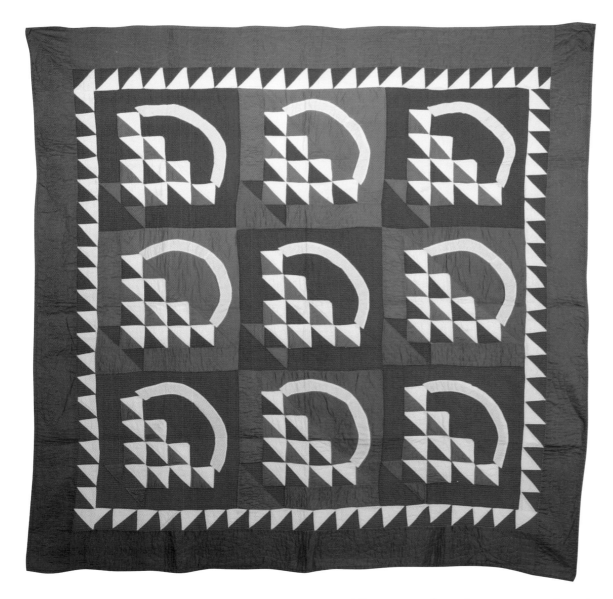

BASKETS QUILT

Date: ca. 1930 **Maker:** Unknown, from Pennsylvania **Size:** 72" x 72" **Owner:** Stella Rubin Antiques, Potomac, Maryland

The designer of this 1930s quilt framed her nine blocks within a sawtooth border. The handles are appliquéd. Photo by Steve Goldberg

OTHER REALISTIC PIECING STYLES

Quilters create blocks using other realistic patterns, including trees, flowers, buildings, people, and letters. Realistic blocks can be used to symbolize something personal to the maker. An unknown quilter in Almance County, North Carolina, pieced a North Carolina Lily quilt in 1855, perhaps not just to acknowledge her state, but to show sentiments toward the South in the turbulent years preceding the Civil War. Letter blocks may be used as a children's quilt to teach the alphabet. A Schoolhouse quilt makes a great gift for a teacher, and variations on the schoolhouse are often used today to make quilts given as housewarming gifts. Some realistic pieced patterns, particularly floral patterns, feature some appliqué. Barbara Brackman documents more than 100 other realistic patterns, and quilters are always designing new patterns to fit their needs.

CURVED PIECING

Curved patterns, such as the Double Wedding Ring, Fan blocks, and Sunburst patterns, are among the most challenging to piece. They range from simple, two-color patterns with just a few pieces, to complex, wheel-shaped designs including dozens of pieces and points to match. Curved pieces are present in a medallion quilt made in Randolph

The second quilt was completed in 2001, by Vivian Eby in Kalispell, Montana, from a pattern published in a national magazine using fabrics from the local quilt shop. Vivian calls the quilt "Friendship Baskets." It was made for her best friend, Pauline Thompson. Pauline died in 2004, and the quilt was given back to Vivian. Cotton quilting fabric in 2006 ranged in price from $7.50 to $9.50 per yard, making the cost of the top between $50 and $100, depending on quilt size.

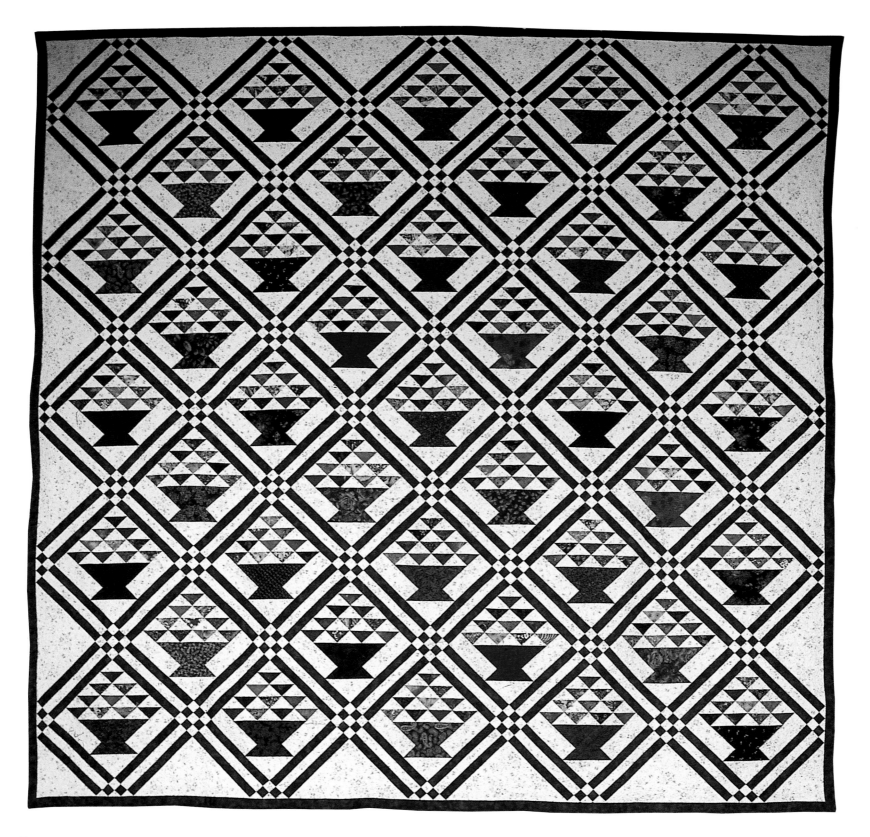

FRIENDSHIP BASKET

Date: ca. 2000 **Maker:** Vivian Eby, Kalispell, Montana **Size:** 91" x 93" **Owner:** Vivian Eby

Using a pattern from American Patchwork and Quilting, Vivian made this quilt to honor her best friend.
When her friend died, the quilt was returned to Vivian. Photo by Shelley Emslie, Big Fork, Montana

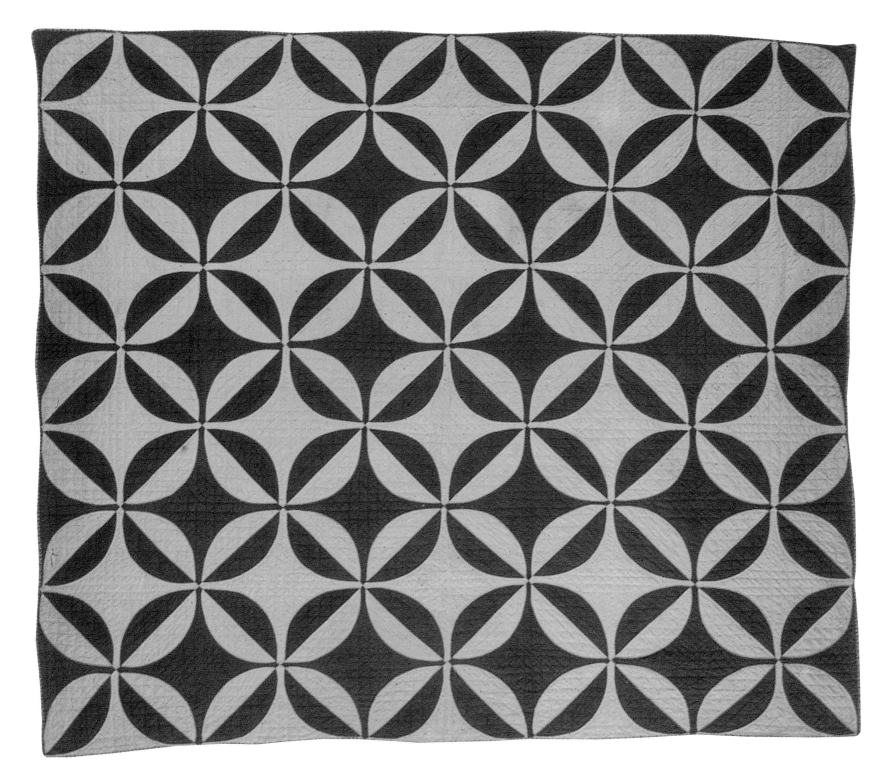

ROBBING PETER TO PAY PAUL

Date: ca. 1860 **Maker:** Unknown, from Iowa **Size:** 66" x 78.5" **Owner:** Mary Barton Collection, State Historical Society of Iowa

A common nineteenth-century curved pattern, Robbing Peter to Pay Paul is usually seen in just two or three colors, to create a visual sensation that the pieces of the pattern are being borrowed from each other.

County, North Carolina, around 1820 and in a Pennsylvania block-style quilt from the 1830s. But various curved-pieced patterns have been popular at different periods throughout the history of the quilt. In the 1840s and 1850s, wheel or compass patterns were commonly used, perhaps in homage to the national growth across the continent. The pattern Robbing Peter to Pay Paul, also known as Drunkard's Path, was common in the last quarter of the nineteenth century and a signature pattern of the Women's Christian Temperance Movement.

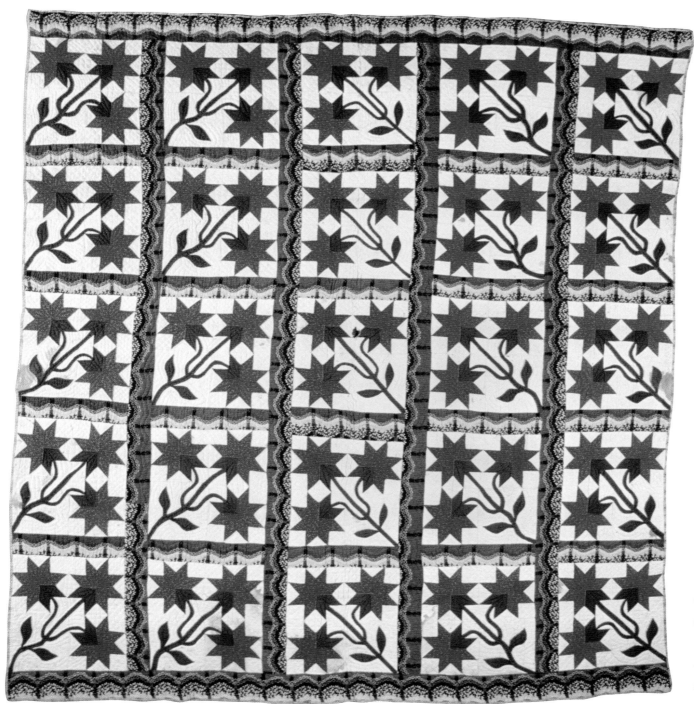

NORTH CAROLINA LILY

Date: ca. 1855

Maker: Margaret Graham Scott, Alamance County, North Carolina

Size: 83" x 85.5"

Owner: North Carolina Museum of History

The North Carolina Lily was popular in the southern states prior to the Civil War. Many variations of this design are found in quilts throughout the nineteenth century.

DOUBLE WEDDING RING

Date: ca. 1970 **Maker:** Unknown, from Pickens County, Alabama **Size:** 68.5" x 83"
Owner: International Quilt Study Center, University of Nebraska–Lincoln 2000.004.0001

This quilt was exhibited as part of the African-American quilt collection donated to the International Quilt Study Center by Robert and Helen Cargo. The red background is an unusual setting.

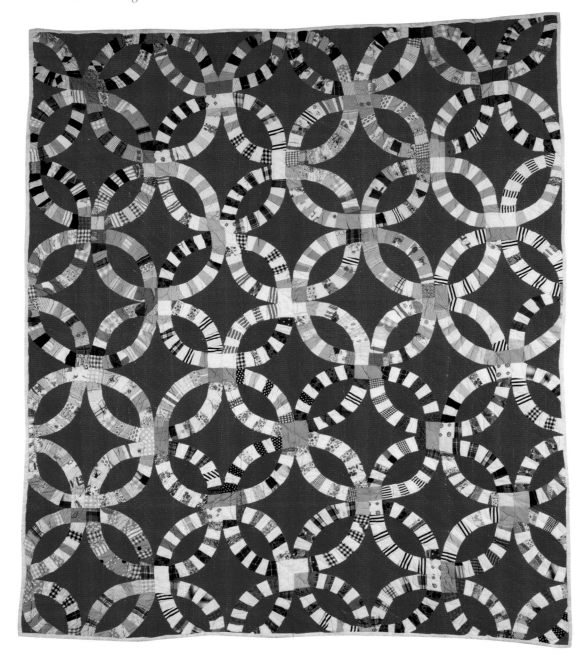

Fans patterns, either single fans or double fans, were common by the 1880s, appearing in Crazy quilts and in traditional block patchwork. The Double Wedding Ring was very popular in the 1930s. Curved piecing is either loved or hated by quilters today. The perfect, flat curve-pieced block is a challenge to create. New templates and improved sewing machine attachments have improved curve piecing for many quilters, and a few still use handpiecing to create the ultimate block.

The Double Wedding Ring

The Double Wedding Ring is predominantly a twentieth-century quilt, gaining popularity in the 1930s, although similar curved-pieced patterns were used in the mid-nineteenth century as well. One of the earliest examples is at the Shelburne Museum in Vermont, and dates from the second quarter of the nineteenth century. Double or interlocking ring designs have been used in European decorative arts since the fourth century AD, and can be seen in American decorative arts of the 1860s. The Double Wedding Ring quilt design appears to have evolved from these designs sometime in the early twentieth century. The pattern most commonly associated with the Depression Era, Double Wedding Ring quilts appeared in *Capper's Weekly*, a Kansas newspaper, on October 20, 1928. The ring components are usually pieced arcs, set into a light-colored background, but Double Wedding Ring quilts are also made with lighter colored arcs set into a dark background. Occasionally, Double Wedding Ring quilts are found that have single-fabric arcs, but these are extremely rare. As the

name implies, Double Wedding Ring quilts are often given as wedding or anniversary gifts and have long been considered "best" quilts that are often inherited by children and grandchildren of the original owners. Double Wedding Ring quilts and unfinished quilt tops are also found in antique stores.

Wheel Patterns

Wheel patterns usually include multiple design elements, including intricate point piecing. They all have a common design element—a center circle or circular-appearing patch with radiating points. Because of the detailed piecing this pattern requires, one wheel often makes up the entire quilt top. Wheel designs typically have names referring to the sun, compasses, kaleidoscopes, and flowers. The earliest wheel-style patterns appear in quilts by

WAGON WHEEL

Date: ca.1910–1930 **Maker:** Unknown, probably from Indiana **Size:** 44" x 35" **Owner:** International Quilt Study Center, University of Nebraska–Lincoln 2000.007.0062

This machine-pieced Amish crib quilt combines solid jewel toned cotton twill fabrics in an appealing Wagon Wheel Fan design.

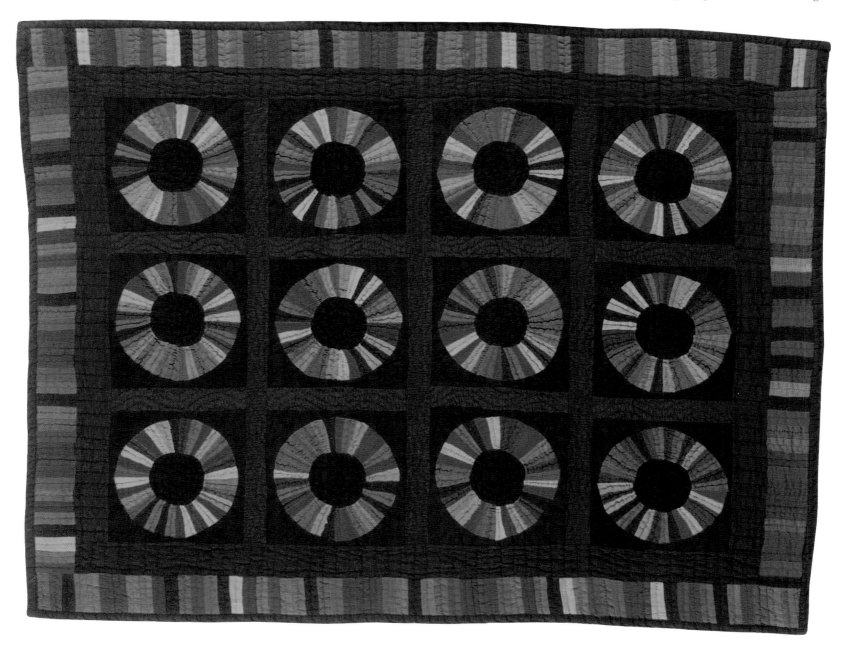

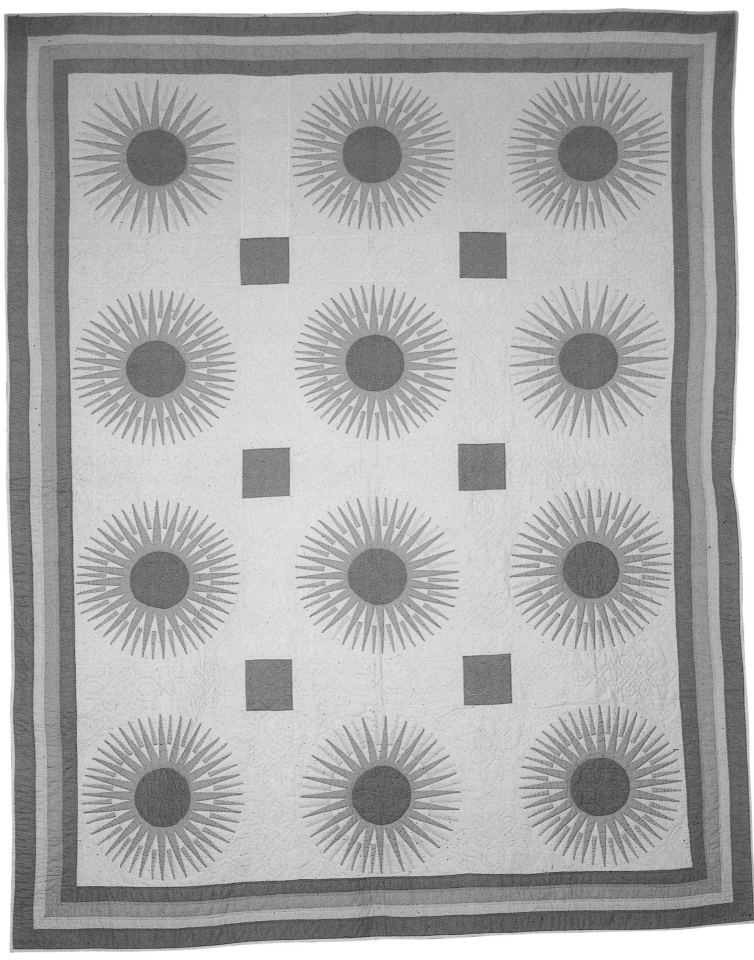

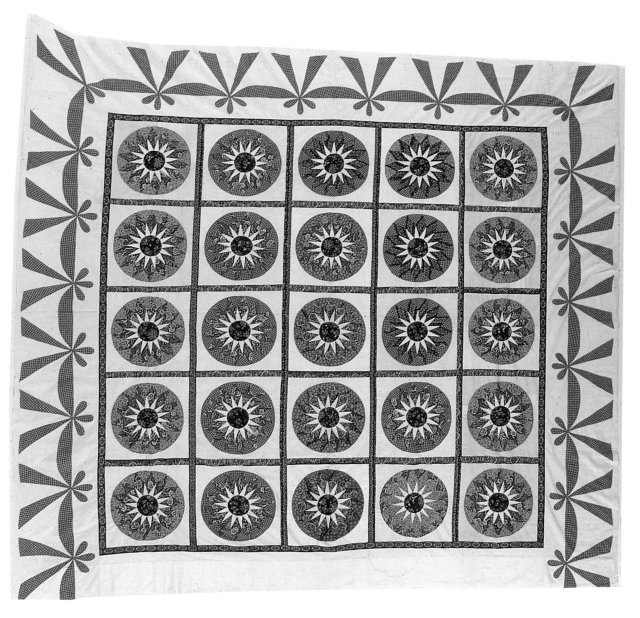

SUNBURST QUILT

Date: ca. 1930 **Maker:** Top pieced by Laura Smith, Ontario, California, quilted by Bonnie Coston, Kalispell, Montana **Size:** 71.5" x 92.5"

Owner: Bonnie Coston

This pattern with its 24 rays is similar to Brackman's block, #3493, which Nancy Cabot published as Sunburst and Home Art Studio called Tropical Sun. It has a larger center circle than other sunburst patterns. Photo by Shelley Emslie, Big Fork, Montana

1810, as a design element within a larger center medallion quilt. The Wheel of Fortune and Sunburst blocks are found in Oregon quilts from the 1850s, and both simple and complex Mariner's Compass quilts were made in New York from the 1840s through the 1880s. Barbara Brackman identifies nearly 300 wheel patterns, many of which were published in the 1930s and 1940s in columns from Nancy Cabot, *The Kansas City Star* and *Hearth and Home Magazine.* In the

1990s there was a resurgence of interest in the wheel designs, as the new generation of quilters, now comfortable with patchwork piecing, sought more complex designs.

DIAMONDS

Diamond-cut pieces are used to create one-patch blocks, in basket blocks, as stars, and in wreaths. The diamond shape is more difficult to piece than a square on-point because of its two acute angles and two obtuse angles. Blocks that

DINNER PLATE TOP WITH SWAG BORDER

Date: ca. 1850 **Maker:** Attributed to Catherine M. Bennett, Brooklyn, New York **Owner:** Mary Barton Collection, State Historical Society of Iowa

Catherine may have run short on fabric, as some of the block patches appear to be pieced together from matching scraps. The top remains unquilted.

DIAMOND RING QUILT

Date: ca. 1960 **Maker:** Lottie Tibbles Hale and Lydia Hale, Wayne, Nebraska
Size: 80" x 93" **Owner:** Terrie Grimlie, Kalispell, Montana

This wreath was pieced using 16 diamonds cut from different fabrics, then appliquéd to the quilt top. Lottie cut the diamonds and Lydia completed the quilt. Photo by Shelley Emslie, Big Fork, Montana

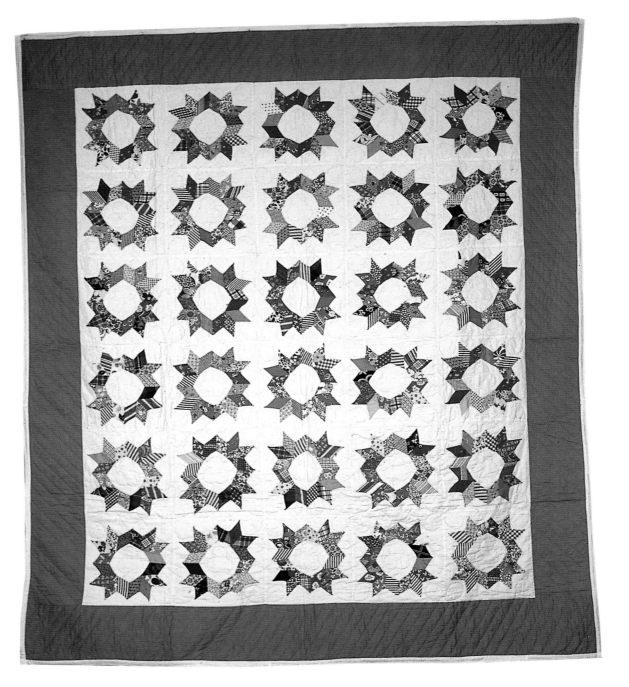

include diamonds may also require inset patches, which are more time-consuming and difficult to accurately piece. Diamond-shaped pieces often appeared in star quilts, particularly the Lone Star or Star of Bethlehem pattern, and wheel blocks as early as the 1830s. They were also used in single patch quilts, such as Mrs. Carpenter's quilt top from 1860s Massachusetts, baby block quilts, or in wreath designs such as the Hale Diamond Ring quilt made in Nebraska in the 1970s.

FOUR PATCH

The Four Patch pattern is among the simplest and most common quilt patterns. Its name indicates the grid layout, consisting of two equal-sized patches over two more equal-sized patches. The design within each patch may be a single block, or a more intricately pieced pattern, such as Windmill patterns, which may have four larger patches, each containing 24 or more smaller patches, for a total of more than 96 patches per block. Some Four Patch designs are asymmetrical, containing two smaller and two larger main patches. Simple Four Patch blocks are found in American quilts in the late eighteenth century, sometimes as blocks surround-

AMISH FOUR PATCH

Date: ca. 1984–1989 **Maker:** Leah Y. (Hostetler) Yoder, Mifflin County, PA
Size: 41" x 31" **Owner:** International Quilt Study Center, University of Nebraska–Lincoln 2003.010.0005

This Four Patch variation crib quilt made in dark, subtle hues was machine pieced using muslin fabrics. The quilting was done by hand.

FOUR PATCH CRIB QUILT

Date: ca. 1900 **Maker:** Unknown

Size: 37" x 37" **Owner:** Mary Barton

Collection, State Historical Society of Iowa

This is the Four Patch in its simplest form. The sashing is cut from a whole cloth fabric that gives the illusion of embroidered lace.

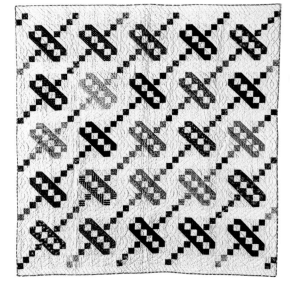

JACOB'S LADDER

Date: ca. 1840–1890 **Maker:** Unknown

Size: 71.25" x 76.5" **Owner:** Gail Bakkom, Minneapolis, Minnesota

There are many styles of Jacob's Ladder. This one uses a Four Patch block as its base. Photo by Greg Winter and Lee Sandberg, Minneapolis, MN

ing a center medallion. By the 1830s, many blocks had the Four Patch design as their base. Because the Four Patch design is relatively easy to piece, they were often used as beginner or teaching blocks, and are common in crib and doll quilts, particularly in the latter half of the nineteenth century. Sometimes the Four Patch is merged with another quilt style. The curve-pieced Drunkard's Path block is often in the Four Patch configuration.

LOG CABIN

The log cabin has both mythological and historical significance in United States history. Primitive log cabins were indeed built by pioneers in areas of the United States where trees were plentiful. Although the cabins were usually temporary structures until a more solid house could be built, they came to represent the rugged resourcefulness and independent spirit of the settlers of early America. William Henry Harrison used the theme of the log cabin in

the 1840 presidential election to show that he was a common man and not an aristocrat. Twenty years later, Abraham Lincoln also used the log cabin in his presidential bid. Some historians speculate that this may have increased the popularity of the quilt pattern in the decades after the Civil War.

The first documented Log Cabin quilt was made in 1865. The pattern became very popular in the late nineteenth century and into the twentieth century. It is a relatively simple pattern, including straight-pieced "logs" that surround a center square, which is sometimes referred to as the hearth. Tradition states that the hearth always be pieced in red to represent the fire burning, but in many quilts of the late nineteenth century, the center is any other color common during the time. Log Cabin blocks may be traditionally pieced or pieced upon a foundation fabric, and usually one side is built of lighter colored "logs" and the other side with darker "logs." Log Cabin quilts tend to be tied instead of quilted due to the thickness of the fabric layers, especially if they are foundation pieced. Quilters in the late twentieth century who had access to modern sewing machines, however, often choose to quilt the tops.

Perhaps the most fascinating aspect of the Log Cabin quilt is the different visual effect that can be created just by placing the same block in a different orientation to the other blocks. The variety of setting, the use of light and dark, and the different fabrics used can make the Log Cabin quilt either utilitarian or high art.

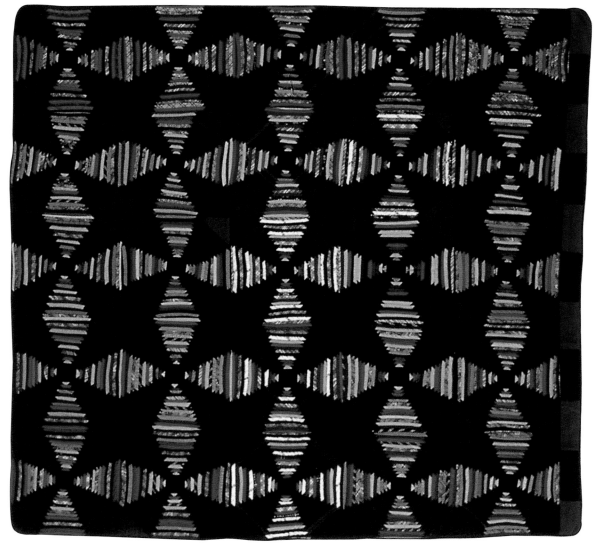

WINDMILL BLADE LOG CABIN QUILT

Date: ca. 1875 **Maker:** Unknown, from Iowa **Size:** 72.5" x 75" **Owner:** Mary Barton Collection, State Historical Society of Iowa

When Mary Barton bought this quilt, it had a note attached that said "Sina's kuilt. Mat (erial) bought in Sheldahl. Ma made when a girl." The maker bound the edges with black woven braid, which is still in good condition.

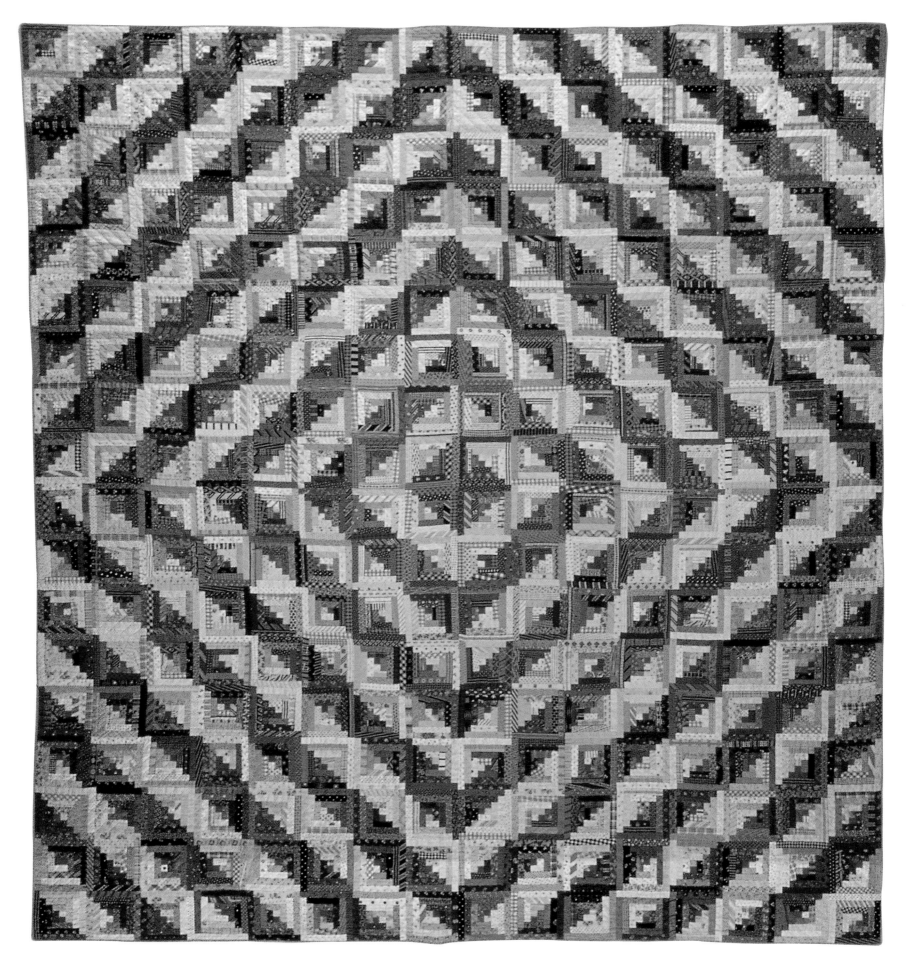

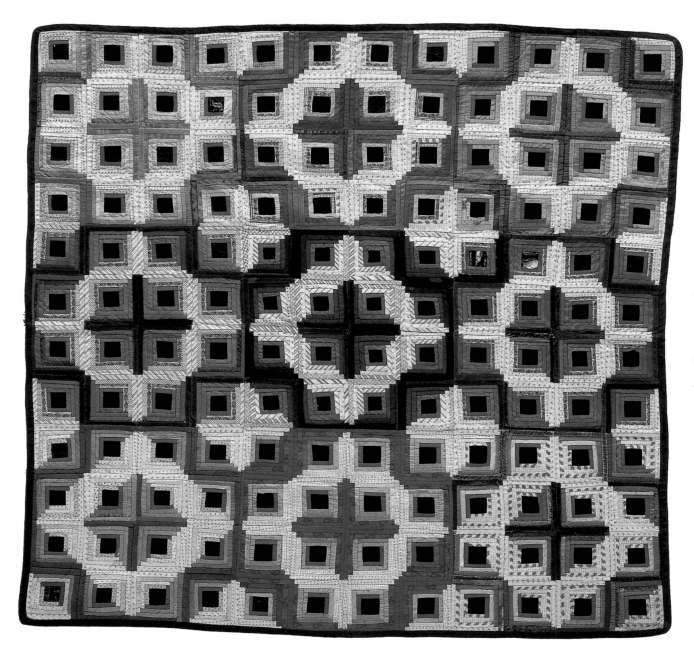

NINE PATCH

Like the Four Patch, the Nine Patch block in its most basic form is one of the simplest blocks to make and was often used as a teaching block. Ten-year-old Marie Morrisette won a prize for best patchwork quilt at the Fourth Union (Minnesota Fair) in 1857. The Nine Patch is also one of the earliest patchwork blocks recorded. The Connecticut Quilt Search Project documented a Nine Patch quilt from 1806.

The basic Nine Patch forms a grid, three patches by three patches square. But the Nine Patch block often appears in more complex variations, including uneven designs with larger center blocks and multiple pieces within each patch. Barbara Brackman describes more than 750 different designs for the Nine Patch block.

NINE PATCH VARIATION

Date: ca. 1850–1870 **Maker:** Unknown, probably from Vermont **Size:** 84" x 86"

Owner: International Quilt Study Center, University of Nebraska–Lincoln 1997.007.0199

This is a very complex nine-patch. The central blocks have flying geese borders, giving the quilt
the alternative name of Wild Goose Chase.

NINE PATCH VARIATION

Date: ca. 1890 **Maker:** Martha C. Wonsey
Size: 66" x 68" **Owner:** Michigan State
University Museum

*This simple nine-patch features five whole
cloth blocks alternating with four-patched
blocks. The 16 blocks are sashed with gingham.*

JACOB'S LADDER FOUR PATCH VERSION

Date: ca. 1875 **Maker:** Unknown **Size:** 80" x 88" **Owner:** Mary Barton Collection,
State Historical Society of Iowa

*Jacob's Ladder is also called Road to California and Railroad. This quilt top has accurate hand
piecing and appears to never have been washed.*

Two-Block Designs

In some quilts, two pattern blocks are combined to create a larger design, which has a unique name, separate from the blocks that make the design. The Double Irish chain is one example. One block is a 25-patch block, the other a plain block with a square pieced into each corner, similar to an unequal Nine Patch. The Irish Chain is one of the oldest quilt patterns, with examples from the eastern United States dated in the 1810s. The Irish Chain appears in single, double, and triple chain designs. The single chain has a Nine Patch

IRISH CHAIN QUILT

Date: ca. 1900–1910 **Maker:** Mary Lavinia Rhoden Stone, Sanderson, Florida

Size: 66" x 75" **Owner:** Collection of the Museum of Florida History, State Department of Florida

A five-by-five patch block alternating with a diamond in square block creates this Irish Chain quilt. Mary did the quilting by hand using a fan pattern.

block alternating with a plain block. The Triple Irish Chain uses a 49-patch block and corner-pieced plain block. Many of the two-block designs described by Barbara Brackman were published by twentieth-century pattern designers. Nancy Page published a design called Goose Creek, which combined a simple Nine Patch with a Diamond in Square block. A design named Monastary Windows using a Log Cabin block and a Four Patch is attributed to Nancy Cabot. In the 1990s, North Carolina designer and teacher Pepper Cory produced two books of patterns based on combining two or more separate blocks to create a distinctive quilt top.

HEXAGONS AND PAPER PIECING

The hexagon pattern originated in England during the 1700s and was brought to the United States by the late eighteenth century. The earliest surviving hexagon quilts are from the first quarter of the nineteenth century. It is a one-patch design. Hexagons are the basis of one of the most enduring patterns of the mid-twentieth century, the Grandmother's Flower Garden, which rose to popularity in the 1920s and 1930s. From the number of existing quilts, it appears that most quiltmakers tried some version of the design. Part of its popularity was design-based—the rings of hexagons making up the "flowers" combined with single ring of "path" made good use of the colors common during the twenties and thirties—oranges, mint-greens, and bubblegum-pinks. Also, this pattern could be made easily with scraps, which was important during the Depression. Hexagons were also used to create mosaic patterns. By decreasing the size of the hexagon and increasing the number of patches in their quilts, quilters could create rather complex, intricate mosaic patterns. Mosaic quilts might contain more than 60,000 patches.

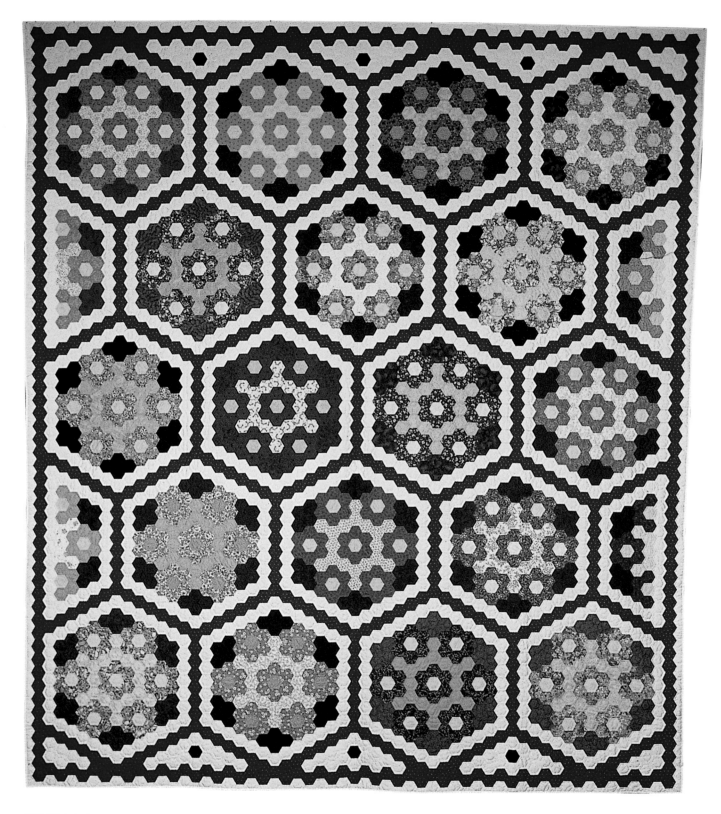

SEVEN SISTERS FLOWER GARDEN

Date: ca. 2004 **Maker:** Vivian Eby **Size:** 87" x 92" **Owner:** Vivian Eby, Kalispell, Montana

Vivian started this quilt in 1995, when she saw the pattern in a magazine. It is hand–pieced using the English paper piecing technique. Photo by Shelley Emslie, Big Fork, Montana

MOSAIC III

Date: 1941–45 **Maker:** Albert Small, Ottawa, Illinois **Size:** 84" x 98" **Owner:** Collection of the Illinois State Museum, Springfield, Illinois

Mosaic quilts were popular in the 1930s. Albert was a dynamite handler for a quarry in central Illinois. His wife challenged him to make a quilt when he teased her about the amount of time she spent quilting. Each of the 123,100 hexagons is a quarter of an inch wide.

GRANDMOTHER'S FLOWER GARDEN

Date: ca. 1930 **Maker:** Emmaline Myers, North Brookfied, New York **Size:** 76" x 100" **Owner:** Barbara Chilton, Kalispell, Montana, great-granddaughter of Emmaline

This is a popular setting for the hexagon patch. Fabrics are arranged by color and pattern to represent flower beds and paths. Emmaline used a combination of feed sacks and new fabrics. Photo by Shelley Emslie, Big Fork, Montana

Paper Piecing

The hexagon is generally made using a paper template. Catherine Springer's quilt featured in chapter two is made using this design. She used a cardboard template and then sewed each patch onto a pattern cut from newspaper. The hexagons were then attached to each other using tiny stitches—in this example between 50 and 60 stitches were used per hexagon. The papers remain inside the patches until the top is complete. Usually, the papers are then cut from the backside of the top, but occasionally a quilt is found with the papers intact. It is exacting work, but creates a perfect hexagon when done correctly.

SQUARE-IN-SQUARE

The square-in-square design features one square, often on-point, surrounded by a second square. The pattern may be very simple, an on-point square with a triangle pieced to each corner, forming the second square. Ocean Waves is a common complex example, with a center square, surrounded by multiple borders of sawtooth-pieced triangles. Square-in-Square patterns were sometimes used as signature blocks in friendship quilts in both the nineteenth and twentieth centuries. The large center square had plenty of room for embroidered or ink-signed names. The Amish Diamond in the Square quilt, a common pat-

OCEAN WAVES
Date: ca. 1920s **Maker:** Marrilla Hawley
Tibbles, Nebraska **Size:** 74" x 75"
Owner: Terry Grimlie

*Solid and plaid shirts make eye-catching fabrics
for this Ocean Waves quilt. Marilla pieced the
quilt on a treadle sewing machine.* Photo by
Shelley Emslie, Big Fork, Montana

tern of the Lancaster, Pennsylvania, Amish by the last quarter of the nineteenth century, is an entire quilt top designed as a square-in-square medallion.

STRIP QUILT

Strip or bar quilts gained popularity in the mid-nineteenth century. They were relatively simple to make. The earliest strip quilts were simply long, narrow strips of fabric sewn together and then quilted much in the same way as a whole cloth quilt.

In many strip quilts, pieced strips are alternated with whole cloth strips of similar width. This is a common setting for the Roman Stripe, whole cloth strips alternating with strips pieced in vertical bars and Flying Geese patterns, which alternate whole cloth with strips of triangular-pieced "geese." Amish and African-American quilters both make use of similar strip quilt designs. The Amish generally use solid-colored fabrics, while African-American quilters tend to

ROMAN STRIPE

Date: ca. 1875–1900 **Maker:** Hathaway Pickrell Hatfield, Illinois **Size:** 64" x 77"

Owner: Collection of the Illinois State Museum

Flannels and silks are the primary fabrics in this quilt. Red and black cording is sewn into the edge.

combine patterned and solid fabrics. Many of the Gee's Bend quilts are strip based. Strip quilts are generally finished with either a solid border or a pieced border reminiscent of the pieced strips.

SAMPLER QUILTS

The sampler quilt provides an opportunity for beginning quilters to practice a variety of block constructions and because many samplers include intricately pieced or very small blocks, gives more experienced quilters a chance to demonstrate their expertise. Before published patterns, samplers may have helped experienced quilters keep a record of their patterns. Usually a sampler quilt will contain any number of blocks, with few or no repeating designs. The smallest samplers might be just four blocks. Jane Stickle's 1863 quilt contains 225 different patterns. The sampler-style quilt dates to the early nineteenth century. Medallion quilts, common before 1830, often had bor-

SAMPLER QUILT

Date: 1900–1910
Maker: Unknown, from
Berks County, Pennsylvania
Owner: Schwenkenfelder
Library and Heritage Center,
Pennsylvania

*This brightly colored quilt
contains 29 blocks of
patterns popular in the
first part of the twentieth
century. Its backing is a
Log Cabin style "cheater
cloth," a popular fabric
around 1900.*

SAMPLER, OPPOSITE

Date: 1863 **Maker:** Jane A.
Blakely Stickle, Shaftsbury,
Vermont
Size: 80.25" x 80.25"
Owner: Collection of the
Bennington Museum #477

*Due to the release of the
book Dear Jane: the Two
Hundred Twenty-five
Patterns from the 1863
Jane A. Stickle Quilt by
Brenda M. Papadakis, this
quilt has become one of
the most famous sampler
quilts in the United States.
The book has influenced an
entire generation of quilters.*

ders containing a variety of pieced blocks. Album quilts, most popular in the 1840s, are appliquéd sampler quilts. A sampler quilt is usually made by one person, but occasionally are products of a block exchange in which each quilter makes a different style block. In the 1970s, the sampler quilt experienced a revival when the technique became a popular way to teach quilting. Common sampler blocks today include Nine Patch, Fan, Dresden Plate, Stars, and Baskets.

TAILOR'S SAMPLE QUILT

Date: ca. 1927 **Maker:** Espie Naomi Teague Williams, Maiden, North Carolina

Owner: North Carolina Museum of History

Essie used fabric samples from her husband Isaac's grocery and dry goods store to make this practical quilt. They are predominantly wool men's suiting samples. She tied it with blue yarn.

TUMBLING BLOCKS CHARM QUILT

Date: 1876 **Maker:** Unknown, Lancaster County, Pennsylvania **Size:** 86" x 87"

Owner: Stella Rubin Antiques, Potomac, Maryland

No two fabrics are alike in this quilt, which features a number of fabrics that are much older than the quilt itself. The tumbling blocks pattern is difficult to sew because it requires numerous inset blocks. Photo by Steve Goldberg.

Scrap Quilts

Quilters have made scrap quilts since the introduction of patchwork. The nature of patchwork allows artistic and practical use of the many scraps left over from clothing and cloth bags. During the Depression of the 1930s, the need to conserve financial and physical resources encouraged a renewed interest in quilting, and scrap quilts became the norm.

Scrap Charm Quilts

A charm quilt is a one-patch scrap quilt. The maker's goal is to create a large quilt top without using the same fabric twice. Charm quilts were particularly popular in the late nineteenth century, and these quilts often have a story to tell. The name "charm" may come from the tradition of making charm strings from buttons; a girl would try to collect 999 buttons, and the

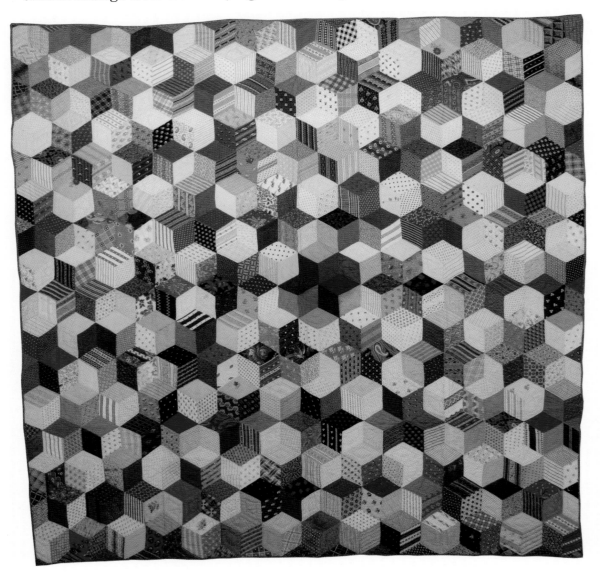

SPIDER WEB

Date: ca. 1917 **Maker:** Unknown

Size: 66" x 84" **Owner:** Mary Barton
Collection, State Historical Society of Iowa

*String quilts, such as this Spider Web, make
good use of scraps. The Spider Web uses
string-pieced patches to make a hexagon block.*

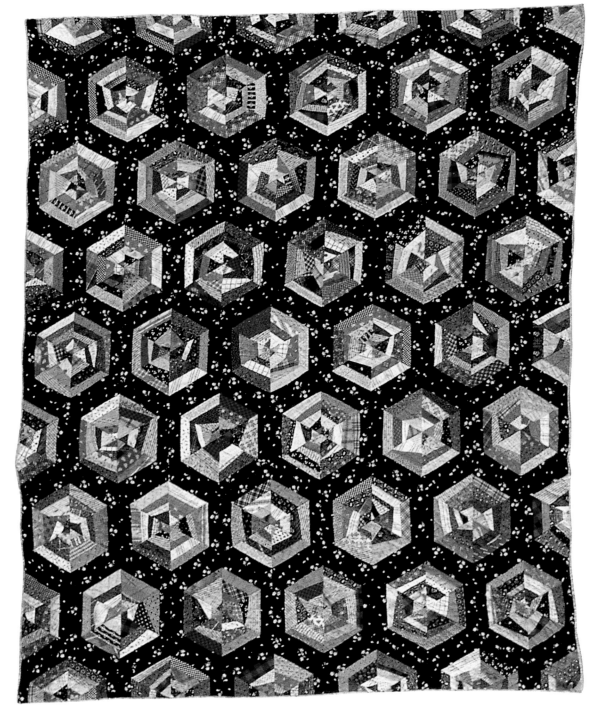

thousandth button would be given to her by her future husband. In some traditions, therefore, a girl would collect 999 fabric pieces for her Charm quilt, often from family and friends, and the final piece, the thousandth, would come from the man she would marry. Another tradition is that the quilt would contain just two matching pieces, inviting the viewer to find them. Whether these stories are true is uncertain, but the charm quilt is an example of the quilter's ingenuity. Charm quilts were popular during the last quarter of the nineteenth century and in the 1920s, during the first twentieth-century quilting revival.

String Quilts

The term "string quilt" refers to any number of quilt designs where the maker uses long, narrow strips of fabric to piece the triangles, squares, diamonds, and other shapes that make up quilt blocks. String quilt designs are typically found in quilts from 1890 to 1940. The strips, or strings, are sewn onto a foundation, which, during this time period was most commonly paper. The block pattern pieces are then cut from the resulting "cloth." Almost any block design can be made using the string-piece method, and it is a favorite among quilters who like to use up all of their scraps. Like other scrappy-style quilts, it was prevalent during the Depression, when little money was available to buy fabrics for quilts.

Postage Stamp Styles

Postage stamp quilts are scrap style quilts made from very small squares, often between 3/4 and 1 inch on each side, or about the size of a

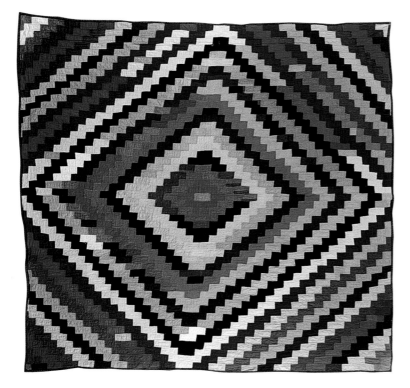

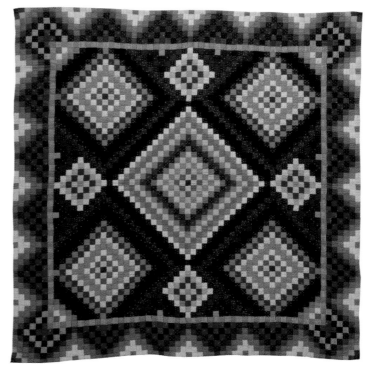

United States postage stamp. The earliest Postage Stamp quilts were made around the Civil War. They became more fashionable in the late nineteenth century and peaked in popularity in the 1920s. Like the hexagon mosaics, a postage stamp quilt may contain tens of thousands of pieces, and requires a significant amount of time to complete. The postage stamp style has few rules. They can be made with coordinated fabrics, or from fabric scraps. The setting can be random, or well planned. Trip Around the World is a common postage stamp style. Postage stamp pieces can also be used to replicate other quilt block styles, such as stars and Irish Chain. The style is easily adapted to Amish and Mennonite quilting patterns, and is common in Lancaster, Pennsylvania.

SPECIAL STYLES

This style refers to the use of materials or patterns that do not fit within the standard framework of established quilt styles and designs. Some of these quilts are regional designs, such as the Pine Burr, which is the state quilt of Alabama, or quilting fads such as Yo-Yo and Biscuit quilts. Regional designs may be passed from one generation to the next, while a fad is usually short-lived, but may experience periodic revivals.

Ribbons

Ribbons from prizes, political campaigns, or simply decorative hair ribbons are used in quilts. These quilts were particularly prevalent during the last quarter of the nineteenth century and first quarter of the twentieth century, when

SUNSHINE AND SHADOW POSTAGE STAMP

Date: ca. 1940 **Maker:** Edna Brontrager Helmuth, Arthur, Illinois **Size:** 77" x 90"
Owner: Collection of the Illinois State Museum, Springfield

Edna was an Amish quiltmaker from southern Illinois. She used the postage stamp block to make the traditional Amish Sunshine and Shadows quilt pattern.

TRIP AROUND THE WORLD OR PHILADELPHIA PAVEMENT

Date: ca. 1875–1900 **Maker:** Unknown, Pennsylvania **Size:** 73" x 76.5"
Owner: Courtesy of the Michigan Traditional Arts Program Research Collections

The maker of this quilt used 3,271 pieces just 1.25 inches wide to make a larger pattern. The quilter's name is unknown, but she is believed to have been Mennonite.

SILK RIBBON QUILT

Date: ca. 1920 **Maker:** Family of Frank Lessiter, Michigan **Size:** 41" x 64"

Owner: Courtesy of the Michigan Traditional Arts Program Research Collections

The grandfather of Frank Lessiter won the ribbons featured in this quilt for exhibiting short-horn cattle in the first part of the twentieth century. It is unknown who pieced them into a quilt.

YO-YO CHAIR COVER

Date: ca. 1930 **Maker:** Emmaline Meyers, New York **Size:** 31" x 47" **Owner:** Barbara Chilton, Kalispell, Montana

Yoyo patterns are technically not quilts, since they have no batting or backing. This chair cover includes feed sack fabrics. Photo by Shelley Emslie, Big Fork, Montana

genuine silk ribbons were awarded as prizes. Some ribbon quilts include only ribbons, pieced as one patches, while others, such as ribbon Crazy quilts, include other fabrics. Some quilters alternated the ribbons with pieced or plain blocks. Also popular during this time were Tobacco Premium quilts, which made use of the silk ribbons used to wrap cigars by the 1870s and cigarettes around 1900. The silk or sometimes cotton flannel wrappers featured pictures of flags, flowers, and birds, and quilters used them to make crib and bed-sized quilts.

Yo-Yos

The yo-yo, which was particularly popular in the 1930s and 1940s,

was an easy way to use up scraps and keep hands busy. Maureen Slattery Schebler of Davenport, Iowa was just five-years-old in 1942 when her mother taught her to make yo-yos using left over bridal fabric. Yo-yos, though often referred to as quilts, are not technically quilts because they lack batting and backing. Yo-yos are made by sewing a gathering stitch along the edge of a circle, then pulling the thread tight and knotting it. The yo-yos are then sewn together to create coverings for beds, pillows, or chairs. The interest in yo-yos waned after the 1940s, but patterns using yo-yos continue to appear in the twenty-first century.

Biscuit or Puff

Biscuits are made by sewing two pieces of fabric, right sides together, to form an envelope. The envelope is then turned right-side out and stuffed with batting, cotton fabrics, or, in the 1970s, sometimes pantyhose. The biscuits are then stitched together to form a larger quilt. The biscuit or puff quilt originated in the late nineteenth century as part of the Victorian interest in decorative textiles. Like Crazy quilts, they were often made with special occasion fabrics, such as silks and velvets. The patches may be random, or pieced into any style of block the quilter prefers, although less complex blocks such as four- and

nine-patches are easier to stuff. The Victorian-style puff was often made by pleating or gathering excess fabric on the quilt top block, which was cut larger than the quilt backing. This gathered fabric could be puffed up with batting. Many puff quilts are smaller than bed-sized quilts, and may have been used as decorative throws. The biscuit quilt also experienced renewed popularity during the late twentieth-century quilting revival, when the quilts were made using polyester fabrics popular in the 1970s. By the 1980s very few quilters made biscuit quilts as they sought more complex and useful patterns.

STAR QUILTS

Humans have always looked to the stars for inspiration and guidance, so it makes sense that star patterns abound in quilts. Barbara Brackman lists more than 300 patterns, and divides them into the following categories: Six-Pointed Stars, Eight-Pointed Stars, Feathered Stars, and Diamond Stars/45 degree angle. Sometimes quilters use a one-pieced star as an entire quilt top, medallion style.

Star patterns are among the oldest patchwork patterns and can be found as border or corner blocks in medallion-style quilts of the late eighteenth century. The eight-point

PUFF QUILT

Date: ca. 1900 **Maker:** Giltner Family, Albia, Iowa **Owner:** Marilyn Maddalena Withrow, Rogue River, Oregon

Marilyn's grandmother and great-grandmothers made this velvet puff quilt. The quilt contains gold braid, reportedly from the epaulets of a Civil War soldier.

LeMoyne Star is one of the earliest star blocks, in frequent use by the 1810s. By the 1840s, star patterns were commonly used in block-style quilts. During times when the United States was at war, there was an increase in the use of stars in quilts, particularly five-pointed pieced or appliquéd stars to symbolize the United States flag. Star patterns have remained a quilter's favorite, and are found in quilts from every part of the country and in every decade up through the present. At least one star pattern is associated with a particular group of people. The Lakota make Morning Star quilts based on the Lone Star design for graduations, weddings, and funerals.

Six-Pointed Stars

There are several styles of six-pointed star. One style consists of six diamonds that meet in the center. Background pieces are inset into the space between the diamonds to make a square or rectangular block. Six-pointed stars are also constructed with a center hexagon. Triangular patches are sewn to the sides of the hexagon, making the star. A third style is made by sewing the long sides of two triangles together, which

TAUBMAN QUILT

Date: 1930 **Maker:** Mrs. Edith Taubman, Oklahoma City **Owner:** Permanent Collection of the Sherwin Miller Museum of Jewish Art, Oklahoma City

Edith used a 1922 pattern called Texas Star as the basis for this quilt. The fabrics are cottons commonly found in the 1920s. Photo by David Halpern

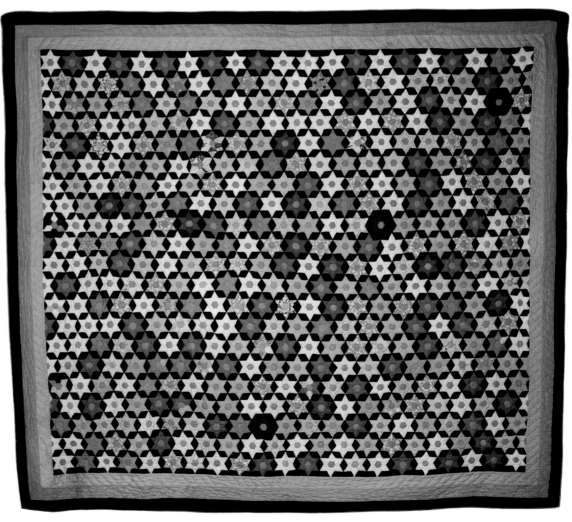

forms a diamond, then six of the diamonds are pieced together like the first style. Six-point stars carry names such as Texas Star, Star of the East, and Star of Diamonds. In 1930, Edith Taubman of Oklahoma City used a Texas Star to make a quilt for her grandson. Edith's family was Jewish, and she chose the pattern because it reminded her of the Star of David.

Eight-pointed Stars

Eight-pointed stars are often made of diamonds or triangles pieced together to form diamonds. The well-known LeMoyne, or Lemon, star is an eight-pointed diamond star. The Ohio Star, popular after the 1840s, also has eight points but is based on the Nine Patch design. Eight triangles radiate from a center square. The popularity of eight-pointed star quilts extends

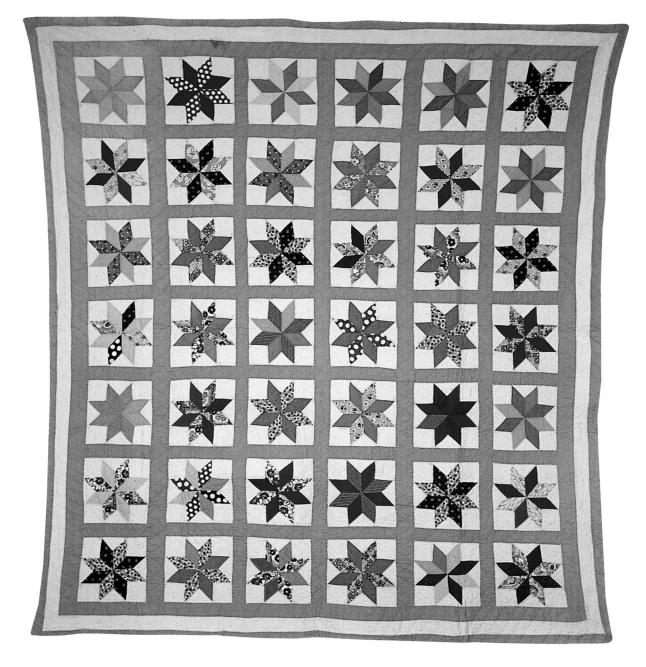

EIGHT-POINT STAR

Date: ca. 1950 **Maker:** Lottie Tibbles Hale, Wayne, Nebraska **Size:** 68" x 78"
Owner: Terry Grimlie, Kalispell, Montana

This pattern is also known as the LeMoyne Star. Lottie pieced the top, and it was quilted with the help of her friends. The fabrics are probably from the 1940s. Photo by Shelley Emslie, Big Fork, Montana

beyond their construction in fabric. The Trinity United Methodist Church in Houston, Texas has a stained glass window called the Ancestor Quilt. The window features an eight-pointed star quilt in the center, which visually ties together representations of children and adults and a map showing the migration of African Americans to Texas.

Feathered Stars

The basic feathered star pattern is based on the Nine Patch design. Feathered stars include a center block with plain corner patches and side patches made of one large triangle with a sawtooth border of small triangles or "feathers." Feathered Star patterns made their first appearance in the early nineteenth century and were common by the 1850s. They were made in both two-color and multicolor patterns. Feathered stars can be made as smaller, individual blocks, or in a medallion style.

FEATHERED STAR

Date: ca. 1900 **Maker:** Mrs. Goodman, Minnesota **Size:** 72" x 84"
Owner: Pipestone County Historical Society, Pipestone, Minnesota

The border pattern of this Feathered Star quilt includes the Carolina Lily and a Lemoyne Star. Photo by Greg Winter and Lee Sandberg, Minneapolis, Minnesota

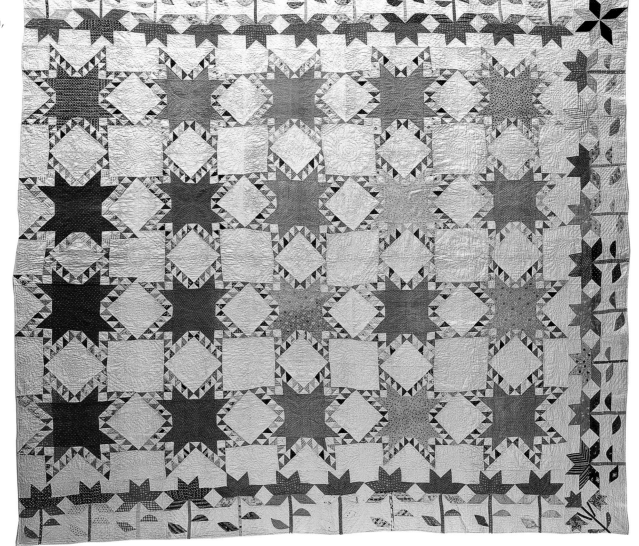

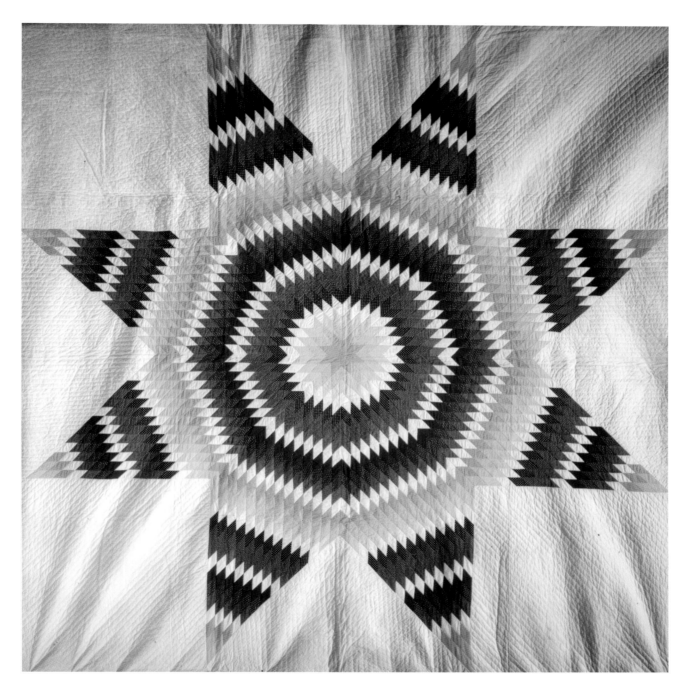

STAR OF BETHLEHEM

Date: ca. 1840

Maker: Abigail Adams, Shackford, New Hampshire

Owner: New Hampshire Historical Society

The Star of Bethlehem pattern is also known as the Lone Star. Abigail was born around 1818 she would have been in her 20s when she made this intricately pieced quilt.

Entire Quilt as Star

In some quilts, the center star medallion is so large that the entire quilt top appears to be one star. The most common example of this is the Star of Bethlehem, also known as the Lone Star and Morning Star. The Star of Bethlehem, which dates from the 1830s, is made by piecing together smaller diamonds into larger diamonds, eight of which are sewn together to make a large, eight-point star. In the 1840s, the pattern also came to be known as the Lone Star, giving a nod to Texas statehood in 1845. A variation of the Lone Star is the Broken Star or Blazing Star, in which the central star is bordered by partial eight-point stars. A regional star variation is

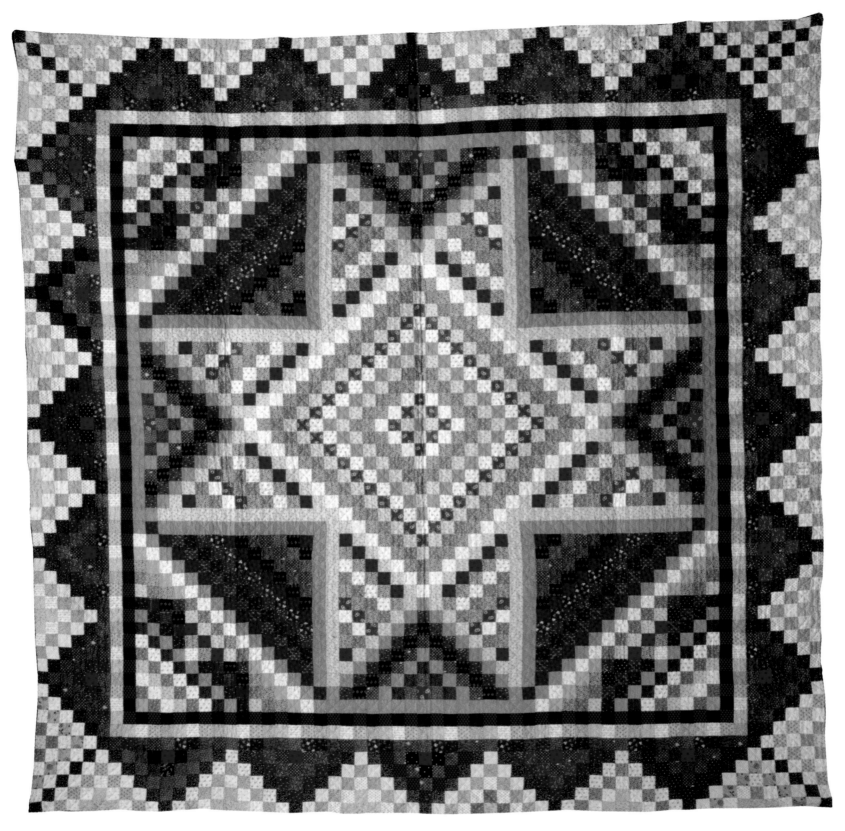

POSTAGE STAMP STAR

Date: ca. 1885 **Maker:** Unknown, attributed to Bowmansville, Lancaster Colorado, Pennsylvania **Size:** 80" x 82.5"

Owner: International Quilt Study Center, University of Nebraska–Lincoln 1997.007.0733

This eight-pointed star is sometimes called a Bowmansville Star because of its prevalence in the Bowmansville, Pennsylvania, area.

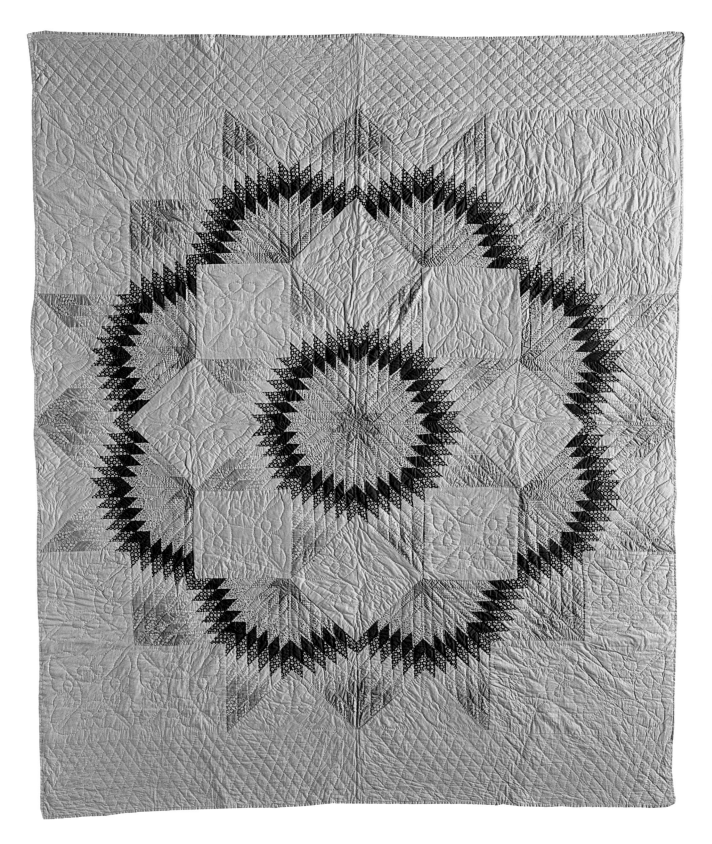

BLAZING STAR

Date: c. 1940 **Maker:** Pauline Ringwelski Copa, Little Falls, Minnesota **Size:** 73" x 91"

Owner: Jane Tillman Shaw, St. Joseph, Minnesota

This quilt style is also known as Broken Star. Pauline immigrated to the United States from Poland in the late nineteenth century, and raised her family in Minnesota. Photo by Greg Winter and Lee Sandberg, Minneapolis, Minnesota

the Postage Stamp Star, which is actually made from tiny squares pieced into a larger eight-point star. This style was especially popular in the area around Bowmansville, Pennsylvania, in the late nineteenth century, where the style was referred to as Bowmansville Stars.

Whole Cloth and Trapunto Quilts

CHINTZ WHOLE CLOTH QUILT

Date: ca. 1840 **Maker:** Unknown, from Massachusetts **Size:** 90" x 103.5"

Owner: The Bidwell House Museum, Monterey, Massachusetts

Not all whole cloth quilts are solid colors. This quilt is made of the same type of chintz fabric mid-nineteenth century quilters used for appliqué.

Whole cloth quilts, in which the fabric is one large piece or large strips of the same fabric, appeared in the United States in the eighteenth century, brought over by colonists from France and England. Though often thought of as "white" quilts, whole cloth quilts are also made from darker fabrics and printed fabrics. Earliest whole cloth quilts in Europe and the United States were chintz or wool, but, by the nineteenth century they were made from cotton and silk. The quilting is the primary focal point of the whole cloth quilt and they are generally considered "best" quilts, often given as gifts. In the mid-nineteenth century, many bridal keepsake chests included an intricately quilted white whole cloth quilt, which included hearts as a primary quilting motif. For other uses, quilting motifs included wreaths, vases, flowers, pineapples, eagles, contour, and straight-line quilting.

After the Civil War, fewer quilters made whole cloth quilts, possibly due to the scarcity of fabric and the wide variety of new quilt styles available to showcase a quilter's best work, such as the Crazy quilt and intricately pieced patchwork blocks. Whole cloth quilts became popular again during the Arts and Crafts Movement of the early twentieth century, when people were encouraged to adopt simple home decorating designs and give up the elaborate Victorian styles. During the late twentieth-century quilting revival, a new generation of quilters with new tools was drawn to the whole cloth design. While traditionally these quilts would be handquilted, allowing the quilter to show-off tiny, even stitches, today's quilter may quilt with a home or long-arm sewing machine.

Trapunto, also referred to as "stuffed work," is the practice of creating raised designs in the quilting. Like the whole cloth quilt, it has its origins in Europe, first in seventeenth-century Marseilles, France, and then in eighteenth-century England. The term originates from the Italian word, *trapungere*, which means "to embroider." The first evidence of trapunto in the United States appeared in the late eighteenth century.

In trapunto quilts, the tops are quilted onto a coarser material, through which cording, batting, or other materials can be inserted using

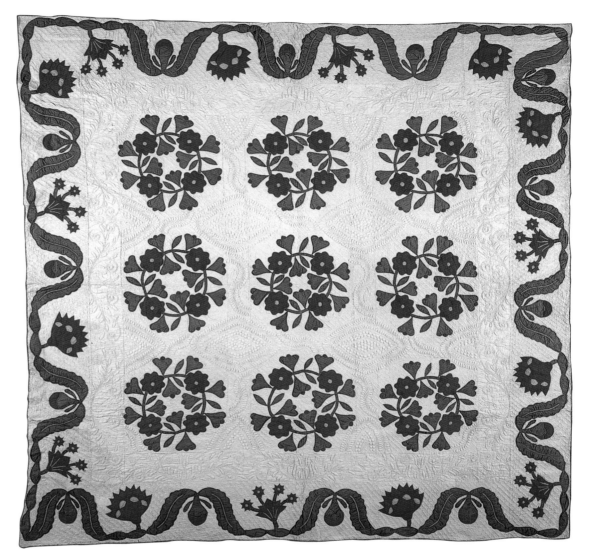

a needle or stylus. Often trapunto quilts are whole cloth quilts, but the technique is also used in pieced and appliquéd patterns. Because it is so time consuming and challenging, a trapunto quilt is likely to be the capstone of a quilter's experience.

Whole cloth quilts and trapunto lost their allure during most of the twentieth century, when scrap quilts, embroidered, and appliquéd quilts were favored. Since the 1990s, however, both techniques have found new advocates, and whole cloth and trapunto quilts appear frequently at quilt shows.

TRAPUNTO QUILT

Date: ca. 1850 **Maker:** Unknown
Owner: Stella Rubin Antiques, Potomac, Maryland

Trapunto or stuffed work is used to add dimension to this traditional red-and-green appliqué quilt. Trapunto quilts are usually considered "best" quilts. Photo by Steve Goldberg

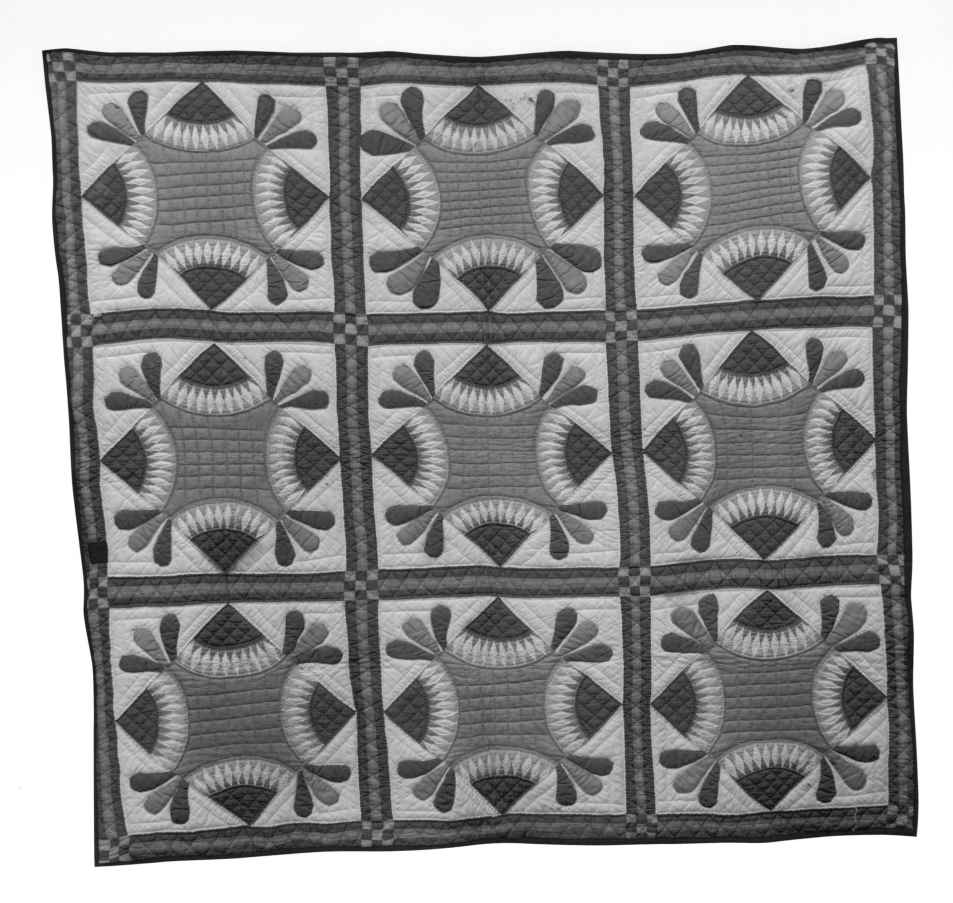

Quilts are more than just beautiful bed coverings or wall hangings. They are textile representations of our history. Within the stitches of every quilt, quiltmakers tell stories that provide insight into our political and social past. Sadly some of these historic quilts have been taken for granted, loved, used up, and even discarded with little thought of preserving the memories of the people, places, and events behind their making. Since the 1980s, dedicated volunteers and historians have made it a priority to ensure that the stories and quilts are preserved so that they may be cherished for generations to come.

COLLECTING QUILTS

The field of quilt studies owes a great debt to quilt collectors for many reasons. Collectors are dedicated to quilt preservation and their quilts have become the basis of significant museum collections. Most collectors are also quilt historians and their research provides new insights into the lives and the art of the quiltmakers. The personal interests and taste of each collector is reflected in the quilts they choose to collect.

How does one begin collecting quilts? Sometimes it's by accident, they may be given a quilt, inherit one, or simply buy one that they like in an antique store. Some collections are consciously started because the collector is particularly interested in quilts. Collectors may seek out very specific types of quilts, based on style, color, time period, maker, design, or the location in which the quilt was made. Some collections are eclectic and may

GRANDMOTHER'S ENGAGEMENT RING
Date: ca. 1880 **Maker:** Amadilla Lyons, Louisiana **Size:** 77" x 79" **Owner:** Anonymous

Amadilla made this quilt for one of her nephews, and the family only used it on Sundays. This quilt is one of the hundreds documented by the Louisiana Quilt Documentation Project. Courtesy of Susan Roach, Louisiana Quilt Documentation Project

change over time as the collector's personal tastes evolve.

In the past 25 years, collectors have been honored for doing their part to preserve the heritage of the quilt.

Private Collectors

America was introduced to the world of private quilt collectors when Jonathan Holstein and Gail Van der Hoof exhibited part of their collection in 1971 at the Whitney Museum. The exhibit not only "displayed quilts" but showed that quilts and quilt collections explored one or more themes. While Jonathan and Gail were by no means the first quilt collectors, they were the first to have their collection exhibited in such a high-profile location.

It would not be possible to list all the wonderful quilt collectors and collections in one volume, let alone a few pages. Some collectors of note include Eli Leon, whose collection of African-American improvisational quilts began touring the nation in 1998; Mary Schaefer, whose collection of quilts and ephemera is now housed at the Michigan State Museum; and Ardis and Robert James, whose diverse collection became the starting point for the International Quilt Study Center in Lincoln, Nebraska.

Mary Barton: Iowa Quilt Collector

"This notebook is meant to lead you into the research notebooks. I was working towards a someday book. Hopefully, my research will help you understand the quilting woman of the nineteenth century—her life style—the magazines she read (if she could read), her schooling, her household tasks, her travels, her possible employment—and of course if she was affected by emigration or migration." Notes to collection, Mary Barton, 1988

So begins Mary Pemble Barton's notebook to the curatorial staff at the State Historical Society of Iowa, which she penned upon donating parts of her collections to the society in 1988. The remainder of Mary's collection was donated in 1995.

Mary Pemble was born in 1917 and grew up in central Iowa. Like many girls from that era, she learned to sew at an early age, but Mary's sewing was exceptional. She won prizes for her work at the state fair. She attended Simpson College in her hometown of Indianola and graduated from Iowa State University with a degree in landscape architecture. Her work took an unusual turn for a woman at that time. During World War II both she and her husband worked for the Navy Department drafting air navigation maps. She "retired" in 1946 to raise a family.

Her quilt collection began by accident when she inherited some family quilts in 1949. Mary began to actively collect quilts and quilt memorabilia in the 1960s. In 1968

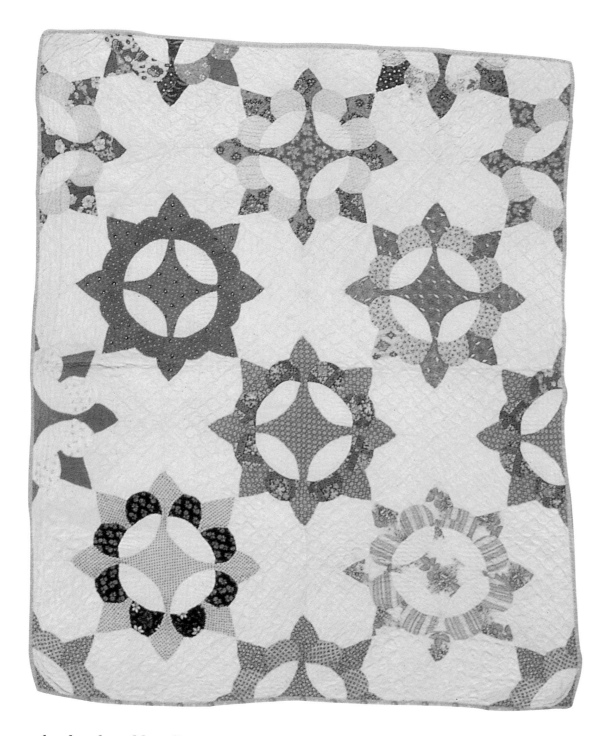

ROSE ALBUM

Date: ca. 1900–1910 **Maker:** Unknown
Size: 37" x 47.5" **Owner:** Mary Barton
Collection, State Historical Society of Iowa

Mary's collection spans the nineteenth and early twentieth centuries. This is one of the later quilts in the collection. The Rose Album pattern is an unusual design for the time period.

she developed her first presentation about quilts and presented it to the Faculty Women's Club at Iowa State University, where her husband worked. The same year Mary began to make her own heritage quilt, a remarkable appliquéd and pieced work that documented her family history. In her quilt notebook Mary wrote, "I spent 7 years making the Heritage quilt top and it was quilted by women of St. Petri Lutheran Church in Story City, Iowa. My Heritage quilt showed the gradual progression of one generation after another marrying and moving westward to Iowa." The quilt won an honorable mention at the National Bicentennial Quilt Exposition, held in Warren, Michigan, in August 1976.

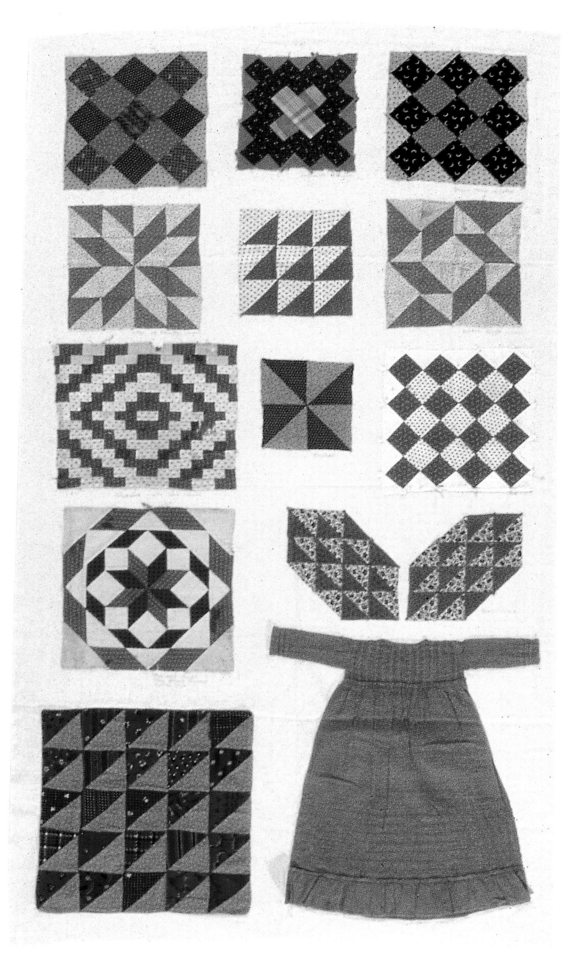

Mary created panels to study quilt fabrics and blocks. Her goal was to make connections between the manufacture of fabrics and their use in clothing and household textiles. In this panel, she included a child's dress made from the same fabric as some of the quilt blocks.
Photo courtesy of Mary Barton Collection, State Historical Society of Iowa

A woman ahead of her time, Mary kept a record of the quilt, including scraps of fabrics used and maps featuring the historical movement of her family from North Carolina to Iowa. In the 1980s, Mary became a well-known lecturer and quilt historian, and she was inducted into the Quilters Hall of Fame in 1984. During the late 1980s and 1990s, Mary began to donate her collection of quilts and quilt history to various organizations, including the State Historical Society of Iowa, Iowa State University, and Living History Farms, Des Moines, Iowa.

A researcher in the Mary Barton collection is first struck by its enormity. The textile collection includes not just hundreds of quilts, but examples of women's and children's clothing, quilt block study panels that Mary made, and many other household textiles. Mary made more than a hundred fabric study notebooks, most of which she divided by color or fabric type, each swatch accompanied by copious notes in her handwriting. Archival boxes overflow with quilt patterns, templates, nineteenth- and twentieth-century women's magazines, and more notes. Finally, Mary maintained and donated an extensive collection of quilting books, reflecting the types of published materials available during the early part of the quilting renaissance of the 1970s.

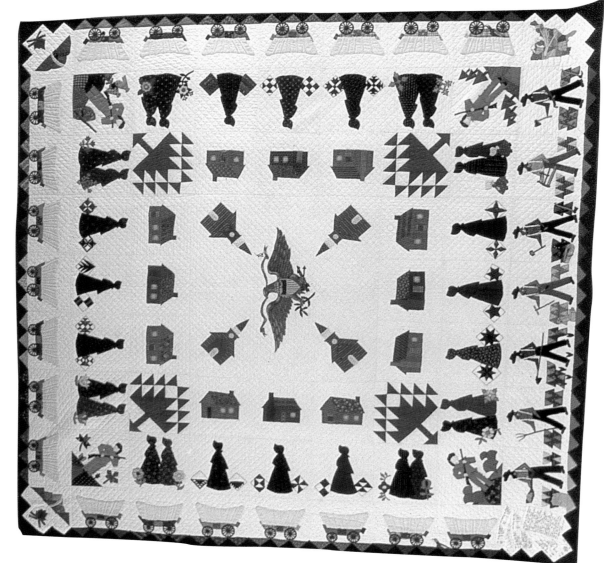

HERITAGE QUILT

Date: ca. 1970–1976 **Maker:** Top by Mary Barton, Ames, Iowa, quilting by Women of St. Petri Lutheran Church, Story City, Iowa **Owner:** Mary Barton Collection, State Historical Society of Iowa

It took Mary seven years to complete the top of this quilt, which was designed to show the migration of her family from Virginia to Iowa. She writes in her notebook: "Heritage Quilt at 1976 Bicentennial Quilt Show received a pink ribbon and lots of attention."

Collecting Depression-Era Scrap Quilts

by Patricia Cox

Patricia Cox is a quiltmaker, designer, and teacher. She is one of the founding members of the Minnesota Quilters in 1977 and chairperson of the Minnesota Quilt Project. Her books include Minnesota Quilts: Creating Connections with Our Past *and* American Quilt Classics. *She is also a quilt collector, and her collection spans the history of American quilting.*

In this essay, Patricia reflects on the experience of collecting quilts of the 1930s, an era that had personal significance for her because of family quilts. She talks about her personal and professional growth as collector, quilt historian, and quiltmaker.

When I began buying antique quilts in the 1970s and 1980s, those from the 1930s were readily available and affordable. Quilters of the 1970s quilt revival were still too close to those Depression years and the family members who made the quilts to want to purchase any from the era. The pastel color palette popular in the 1930s was not appealing or exciting in the eyes of these new quilters. The antique quilts they were interested in were the "old" ones from the nineteenth century. A couple of decades later, as the supply of nineteenth century quilts for sale dwindled, collectors began acquiring quilts from the early twentieth century. As a result, prices skyrocketed and 1930s quilts became more difficult to find.

The quilts from the 1930s were a reflection of times in which they were made. The stock market crash of 1929 and the ensuing economic depression affected the American people in many different ways. Women who liked to make quilts had to find the means to acquire fabric for little or no money. They recycled clothing, saved dress-making scraps, and bought cuttings from clothing factories. The companies making feed sacks realized that if they used printed fabrics to make their bags they opened up a whole new market for sales. Quilters used the feed sack material to make the tops and backings for their quilts, sometimes trading the sacks with other women to acquire enough of a certain color or pattern.

I began collecting quilts to use in my classes. I found that actual examples of quilts made a much greater impression than any picture, so I looked for examples of the most common designs. Sunbonnet Sue, Dresden Plate, Lone Star, Grandmother's Flower Garden, Grandmother's Fan, Double Wedding Ring—these quilts were my first priority. Many of the quilters in the 1930s made these patterns so examples were plentiful.

The Dresden Plate design was especially meaningful to me as my grandmother had given me a scrap Dresden Plate quilt with an ice cream cone border as a wedding present. I loved it and used it until it began to disintegrate. Along the

BUTTERFLIES

Date: ca. 1930–1940 **Maker:** Unknown and Patricia Cox **Size:** 80" x 80" **Owner:** Patricia Cox, Edina, Minnesota

Patricia purchased this Depression Era top and had it machine quilted. Photo by Greg Winter and Lee Sandberg, Minneapolis, Minnesota

way it became my mission to collect as many of this pattern that came my way. I still have not found one that is a close match to my beloved wedding gift.

Some of the quilts in my collection have been given to me as gifts because the owners could no longer care for them and wanted the quilts to have a good home. I purchased other quilts under the proviso that I not reveal their origin. Sometimes I had to buy a group of quilts in order to obtain the one I really wanted.

PANSY

Date: ca. 1930–1940

Maker: Unknown

Size: 76.5" X 93"

Owner: Patricia Cox, Edina, Minnesota

This quilt was made from a kit, possibly one published by the Progress Company. Patricia's collection includes kit and scrap quilts from the 1930s. Photo by Greg Winter and Lee Sandberg, Minneapolis, Minnesota

Teaching quilting and making quilts only made me more interested in collecting them. I wanted to find examples of as many of the different types of quilts produced in the 1930s as I could. I began to acquire appliqué kit quilts. These days there are collectors who specialize in appliqué kit quilts, but my early buys were hit or miss. Eventually I sought out examples of certain very popular patterns such as Pansies, Tree of Life, and Poppies.

Kit quilts were a direct response to the Arts and Crafts Movement of the early 1900s, which stressed a return to handmade traditional crafts. The manufacturers of kit quilts appealed to that sense of nostalgia by branding the kits with old-fashioned names such as Aunt Martha, Grandma Dexter, and Aunt Dinah, and using design elements invoking the past: colonial girls or quilt blocks from the nineteenth century. The kit package was less expensive than buying yardage for a quilt. Everything the quilter needed to complete the quilt was included and advertisers seduced beginners into believing they were capable of doing the work. The pieces and the background were marked, so all the quilter had to do was stitch and "Aunt Martha" was there to help if she ran into trouble. It is amazing that so many of these kit quilts were as well executed as they were, because many of the patterns were technically difficult.

As my knowledge of the history of quilting increased and deepened, I began to search for examples of quilts made from patterns by prominent designers, such as Marie Webster and Anne Orr. These quilts were harder to find and more

expensive. Stearns and Foster, a batting manufacturer, promoted their line of traditional designs as a way of keeping traditional patterns alive, and occasionally quilts made from Stearns and Foster patterns made their way to the marketplace. As the owners of quilts became more aware that what they had was, or could be valuable, prices inevitably started increasing.

For various reasons there were many unquilted tops left from the 1930s. A quiltmaker does not always like all the facets of the process. Some enjoy making the top but not doing the quilting. Some like to make pieced tops and others prefer appliquéd ones. It is rare for a quilter to enjoy all three techniques. In the 1930s, those who wanted to piece quilts but didn't like to finish them turned the quilting over to church groups. By finishing quilts, these groups made money for mission work or other church projects. In the 1930s, most quilts were still quilted by hand rather than by machine, so the process was time-consuming.

Finished quilts are generally more expensive than quilt tops, so many collectors purchase tops with the idea of finishing it themselves. In the quilt world, it's not uncommon to hear the refrain "when I retire I will quilt these tops." I myself knew that would never happen, as I have too many irons in the fire. The tops I've acquired have been quilted by others and I am deeply grateful to them. Quilting the tops has given them new life and they are functioning quilts that can be used instead of just decorating a shelf in the closet. The edges of an unfinished top can easily become damaged because the seam allowances are so narrow, so I have these tops quilted with borders, if necessary, and backings that are appropriate to the era of the top. If damage to the top has occurred, I have repairs made with vintage or reproduction fabrics.

Studying the history of quiltmaking, making quilts, and collecting antique ones has enriched my life in myriad ways. The empathy I feel for a long-dead quilter when I look at her work is something that I cannot adequately describe with words. Some may wonder why I would collect old quilts when one makes new ones. The answer is simple. When I see a beautiful antique quilt, I'm in awe of the maker's exquisite workmanship, knowing the difficulties she may have faced as she sewed the quilt. The new quilts are a legacy for the next generation and a tangible reminder of one's existence.

"Aunt Martha" was one of the popular pattern designers during and after the Depression. She also designed transfer patterns for embroidered linens.

Corporate Collections

Not all collectors are private individuals. Corporations have long been known for their art collections, which are often viewed as part of the corporation's assets. While most corporations do not have extensive quilt collections, a few visionaries understood the value quilts have in American history. One of the best known is the Esprit Collection of Amish Quilts, collected by Esprit company co-founder Doug Tompkins, originally housed and displayed in the clothing company's headquarters in San Francisco, where it was curated by quilt historian Julie Silber. In 2002 the collection was acquired by the Lancaster Quilt and Textile Museum in Lancaster, Pennsylvania. Some corporations collect quilts to document their own corporate history. Stearns Technical Textiles Company, based in Cincinnati, Ohio, is the original manufacturer of Mountain Mist batting, which first entered the marketplace in 1846. In the 1920s, Mountain Mist added quilt patterns to batting wrappers as part of a marketing campaign. The promise of free patterns encouraged quilters to purchase Mountain Mist batting rather than other brands. The specially designed patterns published by Mountain Mist influenced the quilting styles of the 1930s and 1940s. Stearns now has a corporate collection of more than 150 historical quilts made from these patterns.

Online Collections

Anyone with Internet access can view the Library of Congress exhibit Quilts and Quiltmaking in America part of the library's American Memory collection of written documents, sound recordings, photographs, films, prints, maps, and music that document the American experience. Quilts and Quiltmaking in

America provides access to the Blue Ridge Parkway Folklife Project Collection and the All-American Quilt Contest collection. Both of these collections belong to the American Folklife Center. The entire project includes 181 recorded interviews and 410 images of quilts and quiltmakers. The project's purpose is to set local quiltmaking traditions within the context of national trends, and bring the recorded stories of quiltmakers' lives to the general public.

The materials from the Blue Ridge Parkway Folklife Project provide an in-depth look at the lives of six female quilters living in the Blue Ridge Mountains of Virginia and North Carolina in 1978. The project was the work of Gerri Johnson, a folklorist documenting women's crafts for the American Folklife Center. Gerri and her colleagues documented the work of craftspeople whose art remained untouched by culture outside the region. Essentially, they were looking for an iconic, traditional quilter who made quilts from scraps, designed her own patterns, and followed the traditions of her foremothers. A chance encounter with North Carolina quiltmaker Carrie Severt led Gerri to a larger project, which documented a culture of traditional mountain quilters. During her research Gerri uncovered a rich and diverse quiltmaking practice, that reflected centuries-old traditions, yet was inspired by the current quilting revival.

Land's End and *Good Housekeeping Magazine* sponsored the All-American Quilt Contest in 1992, 1994, and 1996. This contest was reminiscent of the Century of Progress contest that Sears sponsored in 1933. Quilters submitted quilts in any style, appliqué, patchwork, or whole cloth, as long as they were original designs or interpretations of traditional patterns. National first, second, and third places winners were selected and each received prizes of $10,000, $3,000, and $2,000 respectively. First-place winners were selected from each state and the District of Columbia. The quilts reflected the entire range of style, from traditional to innovative, in every technique and color combination.

In 1994 and 1996, the contest had the theme "If Quilts Could Talk." Winners were required to write a short essay about the quilt and their inspiration for making it. A total of 13,100 quilts were entered in the three contests. In 1997, Land's End donated the archival collection, which consisted of manuscripts and images of all the quilts, to the American Folklife Center at the Library of Congress in Washington, D.C. The archive is accessible by appointment. Quilts and Quiltmakers in America features images of the 181 winning entries and essays by their makers.

Quilt collectors have advanced the

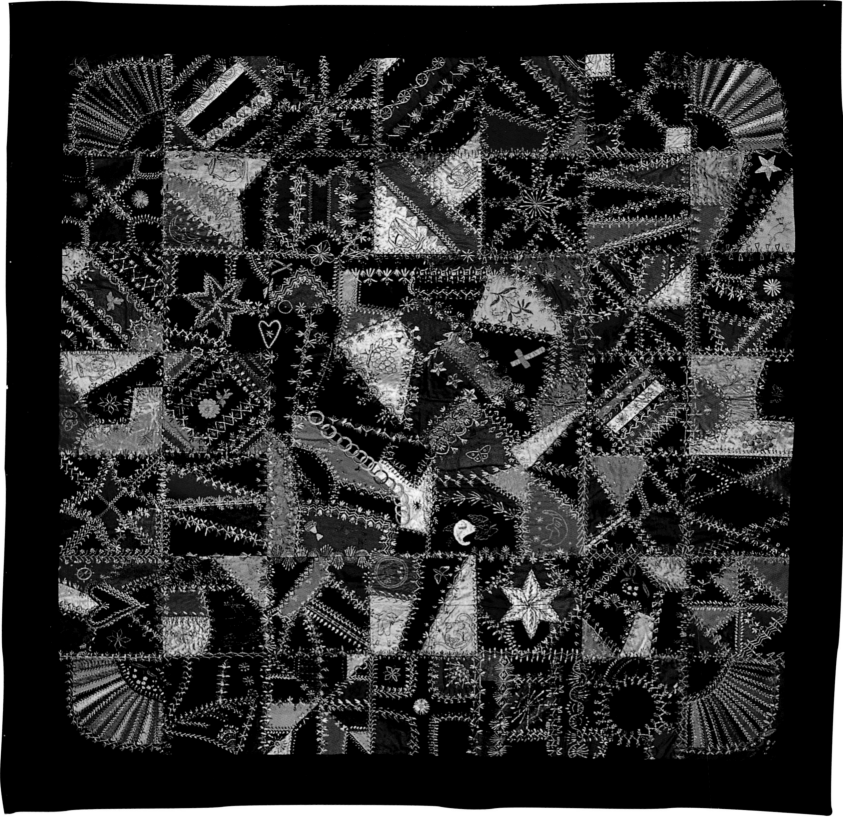

CRAZY QUILT

Date: ca. 1900 **Maker:** Ida Mae Brust, San Francisco, California **Size** 61" x 61" **Owner:** Shirley Barrett, Lakeside, Montana

When Ida Mae died in 1965, her granddaughter Debbie rescued this quilt from a pile of items left for donation.

Shirley Barrett admired the intricate embroidery and purchased it for her collection. Photo by Shelley Emslie, Big Fork, Montana

study of quilt history significantly by saving quilts that may have otherwise have been discarded or worn out. By tenaciously researching the backgrounds of both the individual quilts and quiltmakers, and the importance of the quilts within the context of local, regional, and national trends, collectors have provided a quilt study framework, which is now followed by quilt historians worldwide.

TAKING CARE OF QUILTS

Quilts have monetary value that extends beyond the cost of materials. But not all quilts have the same value. Variation in style, material, maker, age, and condition can change how much quilts are worth by thousands of dollars. A Sunbonnet Sue crib quilt from the Midwest in the 1940s may be appraised at $400, while a full-sized *broderie perse* spread from 1800s New England may appraise at more than $5,000, due to its age, rarity, size, and collectibility. That does not, however, make the *broderie perse* a more important quilt than the Sunbonnet Sue. Each has value within the historical continuum of quiltmaking in the United States. Having your quilts appraised by a professional quilt appraiser is an important step in caring for your quilts.

In determining a quilt's value, an appraiser looks at the position of the quilt within the current market, the style's current desirability among collectors, its rarity within the market, quality of construction, and known provenance. An appraiser will usually produce a written document with the estimated value of the quilt, which can be used in legal situations: if it is lost, stolen, or damaged, and also in property division circumstances such as divorce or estate settlements. And because markets change, the appraisal should reflect the current market value of the quilt, not what the owner paid for the quilt.

There are several types of appraisals. Although they differ in purpose, each should include a comprehensive written evaluation of the quilt and photographs. One of the most common is the insurance appraisal. This is a replacement value, what you would pay to acquire a similar quilt, should this quilt become lost or destroyed. This appraisal should be filed with insurance documents. A Fair Market Value appraisal is the amount this quilt would sell for in the current market, and this appraisal may be used to establish a price on a quilt about to be sold, or for estate valuation purposes. Fair Market Value may differ from the Insurance Value. If a quilt is to be donated, an appraiser can help establish a donation value, which may differ yet again. A donation value is used for tax purposes. For quilters who do not sell their quilts, the donation value is usually limited to the cost of mate-

Lost Quilt Come Home

In 1999, Maria Elkins, an Ohio quilter, shipped a quilt to a show in Omaha, Nebraska. Although she followed packaging instructions to the letter, the shipping information became separated from the package, and her quilt was lost. Maria started an active search for her quilt, which finally found its way home 53 days later. To cope with her own loss, and help other quilters, Maria started the Lost Quilt Come Home Page on the website www.lostquilt.com.

Every year quilters lose quilts in a number of ways. According to Lost Quilt the most common is theft from a vehicle, home, or quilt show. But quilts are also lost in shipping, during moves, due to natural disaster, or accidentally given or thrown away. In the past six years, Lost Quilt has featured several hundred quilts and helped reunite more than 50 quilts with their owners.

In addition to displaying photographs and descriptions of missing quilts, the Lost Quilt Page helps quilters in other ways. The site includes information on quilts that have been found, in hopes that the owners are checking the site. Maria also posts significant information on quilt care including documenting, photographing, appraising, displaying, and storing quilts.

⊱⊰

rials. Appraisals need to be updated to reflect changing market conditions, so quilts should be re-appraised every three to five years.

The American Quilter's Society, recognizing the importance of quilt appraisals and the varying qualifications of appraisers, sponsors a Quilt Appraiser Certification Program, conducted by well-known quilt historians Bobbie Aug and Gerald Roy. The certification program is a rigorous, multi-step process. The candidate must have experience appraising quilts, either with a mentor or on their own, and attend a series of appraising classes. They must understand the types of appraisals; know historical trends in quiltmaking; be able to identify fibers, patterns, and fabrics; and agree to abide by a stringent ethical code. Candidates are tested at the Annual American Quilter's Society Show each spring in Paducah. The test includes a written exam, an interview, and a hands-on appraisal. If the candidate passes, he or she is certified to appraise quilts for three years. There are approximately 100 AQS certified appraisers in the United States and Canada, and the AQS provides contact information for certified appraisers on their website. AQS appraisers are regulated

QUILT PATTERNS

by the Professional Association of Appraisers-Quilted Textiles.

STUDYING QUILTS

It is through the work of dedicated quilt historians, some academically trained, others self-taught, that we know as much as we know about quilts today. Propelled by their curiosity, interest in quilts and quiltmakers,

and the environment in which they are created, quilt historians are constantly seeking new information about the quilt to share with the quilting community through written materials, documentation projects, exhibitions, lectures, and workshops.

The first acknowledged quilt historian is Marie Webster, who published *Quilts: Their Story and How to*

A Meredith College archives class studies quilt blocks at the North Carolina Hall of History, Raleigh, ca. 1952. The interest in quilt study gained momentum throughout the second half of the twentieth century. Photo © North Carolina Museum of History

Fabric

The study of textiles is an important aspect of quilt research. In the past two decades quilt textile research has grown from an offshoot of general textile studies into a serious scholarly field of its own.

Understanding the type of fabrics used in a quilt can tell us much about the social, economic, and technological environment in which it was made. A chintz *broderie perse* quilt ca. 1700 will contain fabric imported from India or England, as chintz was not produced in America at that time. An intricate Baltimore Album quilt made in 1845 with all new fabric indicates that the quilt was created in an urban, wealthy environment, while a 1930s basic Four Patch made of used dresses and feed sacks likely originated in a poor, rural environment. Fiber, color, and design can also be used to determine the date of a quilt. A quilt containing rayon fabric cannot predate the 1930s, when rayon textiles were first introduced. Prussian blue cotton might indicate a quilt made sometime between 1830 and 1860. And quilts made with paisley printed cotton flannel were popular around 1900.

There are many great resources available that provide detailed information about the development of quilt-related textiles. *The American Quilt* by Rod Kiracofe contains an excellent historical overview of the textile production process in Europe and North America. Eileen Jahnke Trestain's book, *Dating Fabrics: A Color Guide 1800–1960,* and its sequel, which covers fabrics made between 1950 and 2000, is divided by historical time period and contains full-color photographs of hundreds of fabrics in each section. Barbara Brackman has written several useful books, including *Clues in the Calico,* which has become a classic guide to the identification and dating of quilts, and *America's Printed Fabrics 1776–1890,* which includes photos of fabrics and patterns for quilts to make from historical reproduction fabric.

❧

Make Them, the first quilt history book, in 1915. Her work was followed by other significant books about the history of American quilting from Ruth Finley, Carrie Hall, Myron and Patsy Orlofsky, and Rod Kiracofe.

In the 1970s and 1980s, new voices joined the quilter's chorus. Cuesta Benberry and Gladys-Marie Fry offered new perspectives on the history of African-American quilting. Barbara Brackman published the now-famous *Encyclopedia of Quilt Patterns,* the first major work on quilt patterns and names. Mary Bywater Cross introduced us to the quilts of the Oregon Trail, documenting the quilts of the pioneers. Elly

Sienkiewicz rejuvenated appliqué through her research about Baltimore Album quilts. Laurel Horton taught use of historical method, looking at inventories, documents, diaries, and oral histories in quilt research. These people were joined by many more women and men who sought to open our eyes, hearts, and souls to the diversity of American quilting.

The State Quilt Projects

Of all the contributions to quilting history in the twentieth century, the greatest has been made by more than 100 state and regional quilt projects conducted since 1980. Organized and conducted by volunteers, the state quilts projects have changed the way we conduct quilt research. Thousands of volunteers gave up their weekends and evenings to hold quilt documentations. People brought quilts from attics, closets, drawers, and beds to be documented and registered for use by future historians. Some projects were short-term in nature, others continue to the present. In an article "Affairs of State" published in the November 2004 issue of *Quilter's Newsletter Magazine*, Shelly Zegart, quilt historian and co-founder of the Kentucky Quilt Project, estimates that by 2004 there were more than 2,000 Quilt Days held nationwide, and more than 200,000 quilts documented. The products of this research include exhibits, more than 40 books, dozens of magazine articles, and yards of archival documents. The opportunities to make quilt-related connections to economics, migration patterns, national events, art history, and many other areas of study, are limitless.

Setting the Quilt Standard: The Kentucky Quilt Project, Inc.

The Kentucky Quilt Project, Inc., was founded in 1981 by quilt historian Shelly Zegart and others interested in preserving Kentucky quilt history. It was the first project designed to survey the diversity of quilting in one state. The two-year project set the standards for the management of a large-scale documentation project, and soon other states followed suit. One of the innovative methods used by the project was the Quilt Day. In order to survey as many quilts as possible, documenters needed to go to the quilts, not wait for the quilts to come to them. Twelve locations were selected statewide in such a way that quilt owners would have to drive no more than an hour to reach a documentation site. The Quilt Day was an event, bringing together owner and researcher to document quilts and stories. Volunteers maintained meticulous records using a one-page documentation form that would be the basis of future quilt documentation projects. Volunteers gathered oral histories from the owners. In the end, 1,000 quilts were registered.

In 1983 the Kentucky Quilt

Project created an exhibit featuring 44 of the documented quilts, which presented the breadth of Kentucky quilting in the nineteenth century. It is the only state project exhibit to travel through the Smithsonian Institution Traveling Exhibition Service. The book, *Kentucky Quilts: 1800–1900,* published in 1982, described the project and included spectacular photos of exhibited quilts. The Kentucky Quilt Project set a standard for later quilt projects; many quilt lovers strived to create an exhibit and book of their state's documented quilts.

Documenting Living Traditions: Museum of International Folk Art Survey

As Kentucky was finishing its documentation project, dozens of other projects were just beginning. Some projects were statewide, while others focused on smaller communities. In 1985, the Museum of International Folk Art in Santa Fe, New Mexico, began a survey of living, traditional quiltmakers. The project intended to build on a 1977 study conducted by Patricia Cooper and Norma Bradley Buferd, which examined southwest quilting practices.

Pennsylvania quilt historian Jeannette Lasansky and New Mexico native Nora Pickens did the research, speaking to more than 200 quilters who identified them-selves as traditional quiltmakers that had learned their craft from family or friends, not through formal training. Lasansky and Pickens narrowed down this group to just 23 women who best represented the traditional quiltmaker in the southwest and conducted in-depth taped interviews.

While this project was small in number of participants, the information gleaned about individual quiltmakers exceeded that of many other projects. Lasansky and Pickens were able to document regional quilt designs. The historical data told the story of Anglo-American and Hispanic women, many of whom moved to New Mexico from other southwestern states with parents or husbands looking for economic opportunity. Their quilts serve as documents of the hardship these women endured during the 1930s and 1940s, and because this was a time when the southwest was relatively isolated from the rest of the country, their work is free of outside influences.

Making a Web Entrance: The Louisiana Quilt Documentation Project

The Louisiana Quilt Documentation Project has the most comprehensive online presence of any single project. In 2001, the Louisiana Regional Folklife Program at Louisiana Tech University developed a searchable

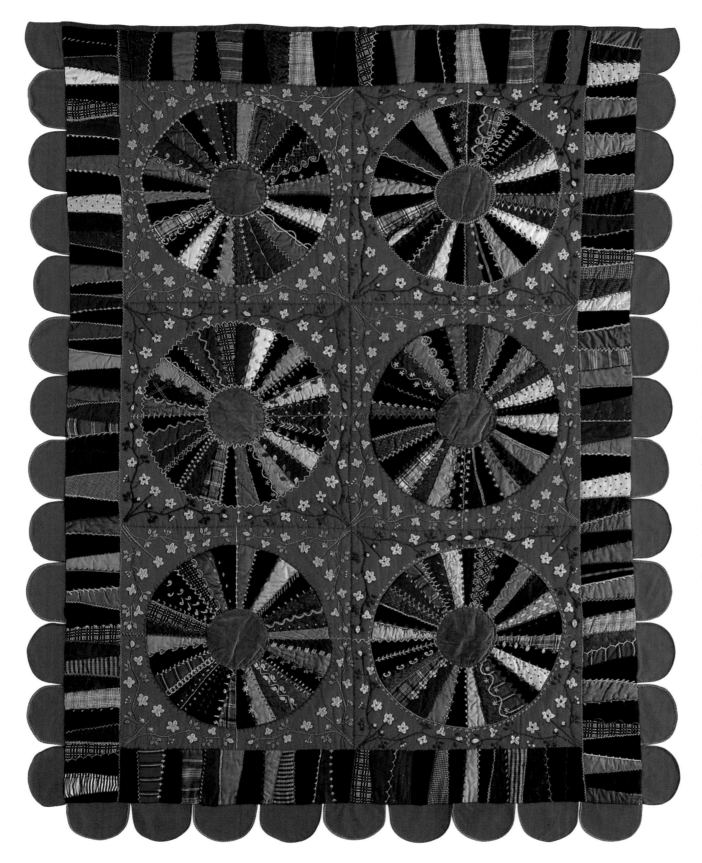

WHEEL

Date: ca. 1890–1910
Maker: Unknown
Size: 69" x 89"
Owner: Beverly Tesch

The owner purchased this colorful quilt, which was documented during the Minnesota Quilt Project, through an antique dealer in southern Minnesota. The quilt is enhanced with a virtual encyclopedia of embroidery stitches in crewel thread. A border of wedges and large scallops in red wool frame the quilt. It is backed with cotton sateen. The utilitarian fabrics of wool and rayon come alive in this quilt. The maker also included silk and velvet, harkening back to the height of the crazy quilt era.

THE TULIP QUILT

Date: ca. 1860 Maker: Mary Crowley
English, Lisbon, Louisiana Size: 81" x 82"
Owner: Anonymous

*This quilt is handpieced and handquilted.
The backing may be pieced from flour or
feed sacks.* Photo courtesy of Susan Roach,
the Louisiana Quilt Documentation Project

database of Louisiana quilts. These quilts represented those documented in the 1987–1990 Louisiana Quilt Project, which researched quilts from 1987 through 1990, concentrating first on the Shreveport region, and expanding south across the state, and the 1997 Masur Museum project, which documented quilts in the Monroe area. The database added those documented by the university from 2001 through the present, representing the northwest and northeast portions of the state, as well as the area around New Orleans, with the goal of documenting quilts in the remaining areas of the state. Although the original quilt project documented quilts up to 1946, the university project documents quilts up to the present day.

The current Louisiana Quilt Project is directed by Dr. Susan Roach, a folklorist whose dissertation presented women's quiltmaking practices in northern Louisiana. During her research, Dr. Roach examined quilting activities and the role quiltmaking plays in the cultural fabric of northern Louisiana communities. The original Louisiana Quilt Project, coordinated by Judy Godfrey and Sandra Todaro, also focused on the northern Louisiana region. Since 2001, the projects have expanded to document the entire state.

The project website is a wealth of information on quilting history and practice, scholarly articles on

quilting communities, online exhibitions, and advice for documenting quilts. The highlight of the site is the quilt database, presenting pictures and information for more than 2,100 documented quilts. Site visitors can search by keyword, quiltmaker, Brackman ID number (the pattern number Barbara Brackman uses in the *Encyclopedia of Pieced Patterns*), location, or interviewer, and results can be narrowed by date of the quilt. Hurricane Katrina and other disasters remind us of both the fragility of life and the vulnerability of historical documentation. The online database is an important advance in preserving cultural information.

American Quilt Study Group

In 1980, Sally Garoutte invited a few women to her Mill Valley, California, home to talk about studying quilts. From this assembly the American Quilt Study Group (AQSG) was formed, with the purpose of preserving the story of American quiltmaking. In 2006, AQSG, located at the University of Nebraska at Lincoln, now boasts more than a thousand members in the United States and beyond.

AQSG sponsors a wide variety of research activities. The group sponsors an annual quilt research seminar that draws hundreds of attendees held at sites throughout the country. AQSG maintains more

than 5,500 research items in a collection at the University of Nebraska, Lincoln library, and offers three scholarships for quilt study and seminar attendance.

Many quilters know the AQSG best through its publications program. The Technical Guide Series offers five booklets written by outstanding scholars in the field of quilt studies and covers topics related to quiltmaker research, quilt dating and documentation, oral history, and physical quilt care. AQSG publishes *Blanket Statements,* a quarterly newsletter featuring a mixture of scholarly research and current events in quilt study.

AQSG's *Uncoverings* is the primary publication, and a staple in quilt research. Published annually, *Uncoverings* presents cutting-edge research in quilt history. Scholars review submissions in the quilt history field and select articles based on academic merit and advancement to the field of quilt research. AQSG takes the submission process seriously, and offers a mentoring program to first-time writers. Potential writers are paired with experienced AQSG writers, who guide them through the paper preparation process.

The American Quilt Study Group is the model for many local, state, and regional study groups in the United States and abroad.

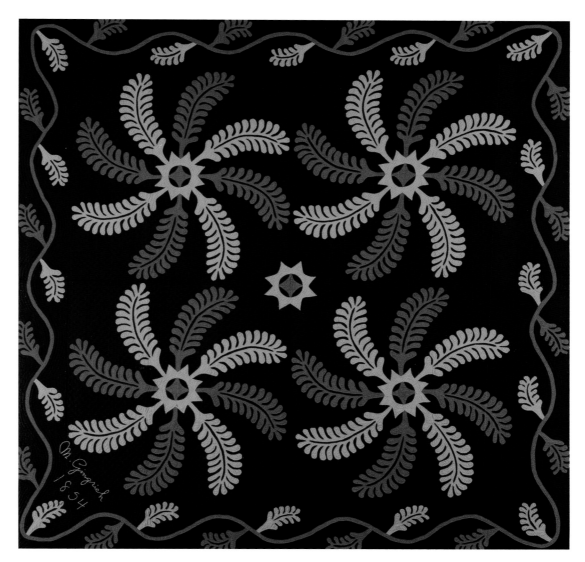

International Quilt Study Center

The University of Nebraska at Lincoln is also home to the International Quilt Study Center (IQSC), which houses one of the premier quilt collections in the United States, perhaps in the world.

A donation of 950 quilts from Nebraska natives Ardis and Robert James formed the beginning collection in 1997. The Jameses were impressed by the quality of quilt research conducted by the Nebraska

PRINCESS FEATHER

Date: ca. 1854 **Maker:** M. Gingrich, Dauphin County, Pennsylvania

Size: 84.5" x 86" **Owner:** International Quilt Study Center, University of Nebraska–Lincoln 1997.007.0774

This reverse appliquéd quilt is part of the 1,000-plus quilts donated to the International Quilt Study Center by Ardis and Robert James. This donation formed the nucleus of the center's collections.

Quilt Project, and the subsequent publication, *Nebraska Quilts and Quiltmakers*, which won the 1993 Frost Prize for Distinguished Scholarship in American Crafts, sponsored by the Smithsonian Exhibition. The university was a logical repository because it had a textile history graduate program, and agreed to take the entire collection.

The IQSC now holds more than 2,300 quilts from 17 countries. Primary collections include the Jonathan Holstein quilts shown at the Whitney Museum in 1971, Robert and Helen Cargo's collection of African-American quilts, the Sara Miller collection of midwestern Amish crib quilts, the Kathryn Berenson collection of French quilts, and the Linda and Dr. John Carlson Four Block Quilt. The collection also holds works by many of the country's contemporary quilters including Nancy Crow, Jean Ray Laury, and Faith Ringgold. The center develops exhibits that travel both in the United States and internationally, and it hosts a biennial symposium. In May 2006, the IQSC broke ground for a new, 37,000-square-foot facility, which will open in 2008. The new facility will have three exhibition galleries and state-of-the-art storage facilities.

ISQC is part of the university's Department of Textiles, Clothing, and Design. The department offers a unique graduate program: a Master of Arts in Textile History with a Quilt Studies Emphasis, the only degree of its kind. Students have the option of distance or on-site study, which makes the degree available to working professionals and full-time students. Students study textiles in the context of gender, class, ethnicity, political, religious, and technological issues.

The Alliance for American Quilts

In 1993, Shelly Zegart, Eunice Ray, Karey Bresenhan, and Nancy O'Bryant formed the Alliance for American Quilts. Shelly and Eunice were members of the Kentucky Quilt Project, and Karey and Nancy were corporate officers of Quilts, Inc., who were also associated with the Texas Quilt Search. The Alliance is a nonprofit organization with a three-part mission: "To further the recognition of quilts; to preserve the history of quilts and quiltmakers; and to establish the Center for the Quilt, a place that actively communicates with people about quilts and their meaning." (Source: Alliance for American Quilts) The Alliance works to bring together diverse participants in quilt study and quiltmaking under a shared vision that respects quilts as both art and artifact, and quilts and quiltmakers as keepers of stories. The 25-member board reflects the diversity of the quilting community, including folklorists, quilt scholars, quiltmakers, and quilt industry representatives.

To accomplish its mission, the Alliance has developed several innovative programs, including Boxes Under the Bed, Quilters' SOS—Saving Our Stories, and Quilt Treasures.

The Boxes Under the Bed program is the first of its kind, designed to reach local researchers and train them in the art and science of quilt preservation. Its name comes from the common experience of finding boxes of quilts and quilting related items stashed under beds, or other out-of-the way locations. Researchers are taught how to recognize quilt-related items, inventory their "boxes," and place the items in context with other quilting history. The program, which was introduced in 1996 at the Houston International Quilt Festival, has spawned several local and regional projects, as well as a national project coordinated by the Michigan State University Museum. The Alliance also provides information and an inventory form on their website for individuals who are fortunate enough to discover a collection of quilting ephemera.

Quilters' SOS is an oral history project started in 1999 designed to capture quiltmakers' stories in their own voices. Interviewers conduct a 45-minute conversation with their subject, using a quilt chosen by the interviewee as the basis for the discussion. Individuals and quilt guilds are able to undertake the projects using a manual designed by the Alliance. Interviews are transcribed and posted on the Alliance website with photographs of the makers and their quilts.

The third project, Quilt Treasures, acknowledges the importance of the late twentieth century quilt revival by interviewing some of the notable individuals who had the greatest impact on the movement. The interviews are taped and mini-documentaries are available on the website. Eleven portraits are currently available.

FOLK ART APPLIQUÉ

Date: ca. 1914 **Maker:** Catherine Weber, Morenci, Michigan **Size:** 62.5" x 65"
Owner: Michigan Traditional Arts Program Research Collections

Catherine was 90 years old when she made this quilt, which is now in the collection of the Michigan State University Museum at East Lansing, Michigan. This is one of several thousand quilts that can be researched via the Quilt Index.

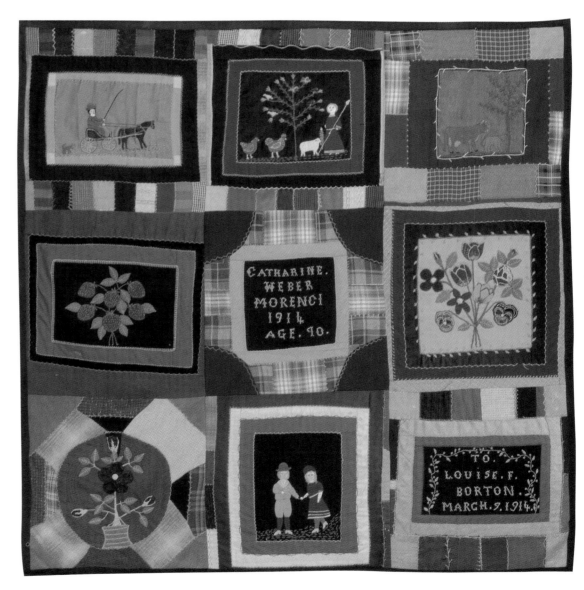

Quilt Index

The Alliance collaborates with other organizations to ensure that quilt history is made available to researchers and the public. One of these collaborations is the Quilt Index, a fully searchable database of quilts from documentation projects, libraries, and museums. The Index is managed by the Michigan State University Museum and MATRIX: The Center for Humane Arts, Letters, and Social Sciences Online. The project is funded by donations and grants, including the National Endowment for the Humanities and the Institute of Museum and Library Services.

Currently, the Quilt Index includes images and information from more than 1,000 privately and publicly held quilts. The initial project included quilts from the Michigan Quilt Project, Kentucky Quilt Project, Illinois Quilt Research Project, and Quilts of Tennessee. A comprehensive list of quilt fields was developed to ensure that comparable information is included for each quilt. Information collected describes the physical attributes of the quilt and significant background information on the quiltmaker. Quilts can be searched by collection, time period, styles or techniques, quilt function, and location in which the quilt was made. Other projects and museums will participate as funds become available. The Quilt Index hopes to present quilts from all 56 state and regional quilt projects, as well as quilts from other museums.

Quilt information is managed in partnership with staff members from each contributing organization. Copyright and privacy have been an important issue as the project evolved since images are available through the uncontrolled access of the Internet. All rights remain with the quilt owner or maker, and personal contact information is not available.

In addition to the searchable database, the Quilt Index features online quilt exhibitions created by guest curators and information on developing a quilt documentation form for use in documenting individual quilts. The form includes sections to record physical descriptions about the quilt and information about the quiltmaker. The form can be designed for use at documentation days, or by the individual who wants to document their own quilts. In the future, the Alliance plans to include bibliographies of secondary materials and aids for finding primary archival quilting materials on the Quilt Index.

PRESERVING AND EXHIBITING QUILTS

Museums provide visitors with an opportunity to become immersed in an environment, surrounded by the remnants of people and their stories. Most art and historical museums have one or more quilts in

their collections, which they exhibit with great pride. Those museums with significant quilt collections occasionally create and host exhibits and programs related to quilting. In the United States, a few museums are devoted exclusively to the art and history of quilts and quiltmakers. Though scattered across the country, they have one goal in common: to preserve and celebrate American quilting traditions.

Regional and National Quilt Museums

The United States is fortunate to have several museums devoted exclusively to the collection, care, and study of quilts from their state, region, or across the nation. These museums maintain active exhibition schedules, offer programs in textile history and production, and maintain research facilities.

San Jose Museum of Quilts and Textiles: The First of Its Kind

Just six years after Jonathan Holstein's groundbreaking quilt exhibit at the Whitney Museum and one year after the nation's bicentennial, a time often cited as the beginning of the quiltmaking revival, the Santa Clara Valley Quilt Association founded the San Jose Quilt Museum. It was the first museum in the United States to exclusively focus on quilts and the role of quiltmaking in the United States. The museum pro-

vided a much-needed exhibition venue for the new generation of fiber artists, whose work often had been ignored in traditional art museums. The opening of the museum also represented the new role of women in the history of society, brought to fruition as a direct result of the feminist movement of the 1960s and 1970s.

In 1986 the museum became a separate nonprofit entity, with a board of directors representing the San Jose community. A modest facility provided room for exhibitions and collections. In 2003, the museum partnered with the San Jose Redevelopment Agency and a group of private investors to create a new facility in downtown San Jose. They renovated a historic building and created three new galleries, library and educational spaces, and improved museum storage. The new facility

Visitors enjoy a new quilt exhibit at the San Jose Museum of Quilts and Textiles. The museum offers changing exhibitions throughout the year, featuring the works of local and nationally known quilters. Photo courtesy of San Jose Museum of Quilts and Textiles

opened in September 2005, with four times the space of the old building. The first exhibit, Traditions in Transition, paid homage to the museum's permanent collections and the past, present, and future of textile production.

LaConner Quilt Museum

Drive 70 miles north of Seattle, Washington, and you will come to the LaConner, a town founded in the 1880s that is situated just a few miles from the Canadian border and in the Skagit Valley. Successful Pacific Northwest merchants settled in the valley, building mansions for their homes, and George and Louisa Gaches built one such mansion here in 1891. After years as a home, hospital, and apartment building, the house was nearly destroyed by fire. Fortunately, it was restored with help from the Federal Historical Preservation Fund, and in 1997 the LaConner Quilt Museum opened in part of the building. In 2005, the museum purchased the building and expanded its exhibits to fill three floors.

The LaConner Museum honors the history of the Gaches Mansion through a strategic allotment of space. The first floor is decorated in the mode of the Victorian era, and the museum uses that space to exhibit quilts from the late nineteenth century. The second floor contains the main exhibition gallery, where the museum hosts regional, national, and international quilt shows. On the third floor, there's a quilt frame where local quilters can handquilt their latest creations.

Latimer Quilt and Textile Center

Tillamook, Oregon, is a small town along Highway 101, the major highway connecting towns along the Pacific Coast. In 1991 The Latimer Quilt and Textile Center opened in the town's restored historic Maple Leaf School. The vision of resident Clara Fairfield, the center's mission is to preserve the diversity of fiber arts in western Oregon, particularly the arts of quilting and weaving.

Each room in the former school is dedicated to one of the fiber arts. The museum's quilt room offers exhibits of historic and contemporary quilts and provides space for quilting classes. Volunteers offer information on quilts and quilting techniques and will baste and tie quilts as a fundraising project.

The museum's permanent collections hold quilts from the mid-nineteenth century to the present. Recently the museum has turned its collecting focus to items produced from Indigo-dyed fabrics. Because indigo dyes are used in both cotton and wool they appear in quilts and handwoven coverlets, both prominent elements in the museum's collection. By focusing on the collection of indigo textiles, the museum is able to draw a connection between its two main components.

New England Quilt Museum

The Industrial Revolution of the 1800s developed rapidly in New England, and Lowell, Massachusetts, became the center of the nation's textile industry. Today the Lowell National Historic Park, Mill Girls Exhibit, and Boote Cotton Mills interpret the history of the mills and the people who worked in them, while the American Museum of Textile History interprets the movement from home-based textile production to factory.

This textile-rich environment is an ideal setting for the New England Quilt Museum, which opened in 1987, making it the second oldest quilt museum in the United States. The museum collection grew slowly until 1991, when Gail Binney donated 33 antique quilts from her collection and that of her father, Crayola heir Edwin Binney III. The Museum's permanent collection now includes more than 150 quilts and tops from the eighteenth century to the present.

The New England Quilt Museum is located in downtown Lowell, Massachusetts. The museum collects and exhibits both historical and contemporary quilts. Photo by Ken Burris

Each year the museum presents regional and national exhibits featuring both contemporary and historic quilts. The museum is also active in community projects, including a partnership with Girls, Inc., to teach sewing skills to girls ages seven through twelve. The Lowell Quilt Festival, which draws entries nationally and internationally, is held each year to benefit the museum.

Rocky Mountain Quilt Museum

Golden, Colorado, resident and quilt collector Eugenia Mitchell wanted to share her collection with the community. In 1982, she and several others incorporated a museum, but it wasn't until 1990 that the Rocky Mountain Quilt Museum officially opened in downtown Golden. One hundred quilts from Eugenia's collection made up the bulk of the one-room museum. When it first opened its doors, the Rocky Mountain Quilt Museum was only the third quilt history museum in the United States.

From these humble beginnings the museum grew quickly. Today, its collections include 300 quilts representing traditional to contemporary designs. Visitors can view 10 shows each year, featuring more than 250 quilts. On Sundays, visitors can attend gallery talks by quilt historians and quilt artists. In 2006, the museum started the Youth Quilting Bee, an exclusive program for boys and girls ages nine and up. The Bee is limited to eight members, who learn quilting and sewing skills while making quilts for charity.

Virginia Quilt Museum

The Warren-Sipe House, Harrisonburg, Virginia, has a rich and romantic history. The house was built in 1856 as a wedding present for Edward Warren and Virginia Magruder. Edward served the Confederacy as a member of the Virginia Infantry during the Civil War and was killed in 1864 in the Battle of the Wilderness. Some claim that his ghost still visits the house, appearing on the center hall staircase. George Sipe, member of the Virginia House of Delegates, purchased the home in 1864 and enlarged it, adding Victorian architectural details. During the twentieth century, the house served as a recreation center, temporary courthouse and jail, and housed the local historical society. In 1995, it became the Virginia Quilt Museum.

The permanent collection holds more than 150 quilts, dating from 1810 to the present. The museum also collects the artifacts of the quilting, including letters, diaries, and clothing, which are frequently exhibited with the quilts to set a historical context for the quilt's creation. The museum also has a significant collection of sewing machines, and, to honor the original homeowner, a Civil War room. The

lower level of the museum is a hands-on children's room, designed as the interior of a log cabin. The room includes a reading corner filled with children's quilt stories and full-sized quilts donated especially for the children's use.

In 2000, the Virginia General Assembly recognized the importance of the museum's work by designating it the official quilt museum of the commonwealth.

Museum of the American Quilter's Society

As founders of the American Quilter's Society, Bill and Meredith Schroeder acquired a significant number of quilts. Some were purchased from well-known quiltmakers. The Schroeders also owned quilts from the American Quilter's Society Annual Show, which were purchased by the AQS as part of the prize awarded to the quilter. Wishing to

Visitors come to the Virginia Quilt Museum in Harrisonburg to see the extensive quilt and Civil War collections.

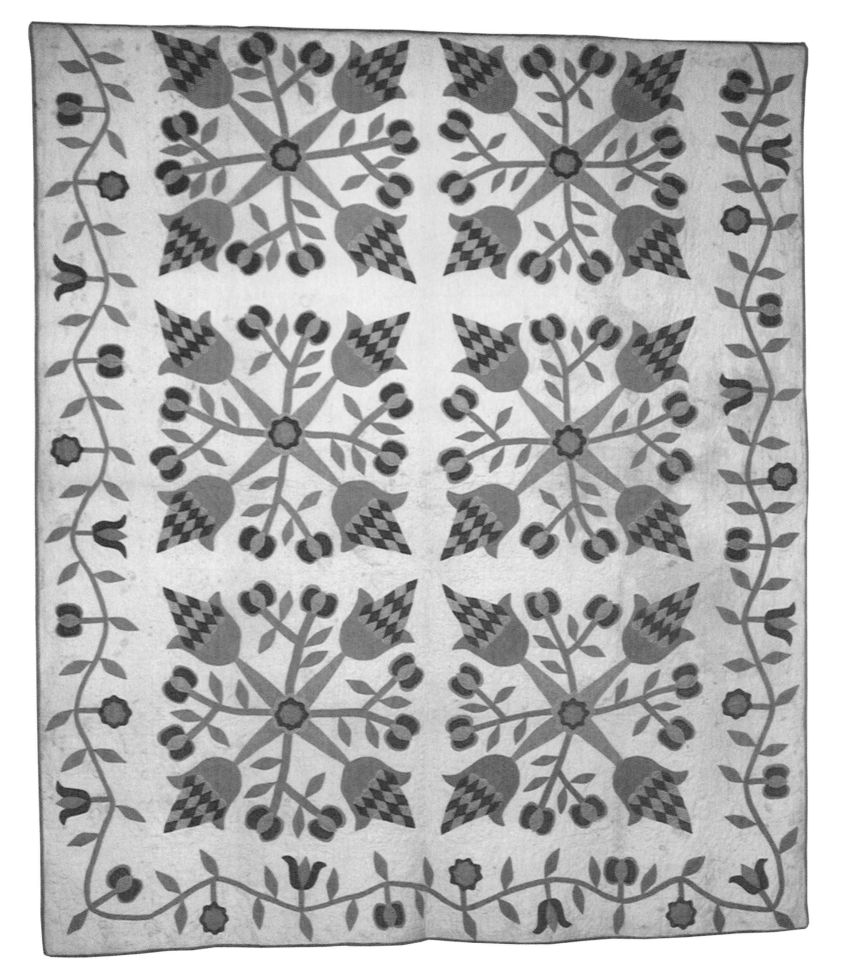

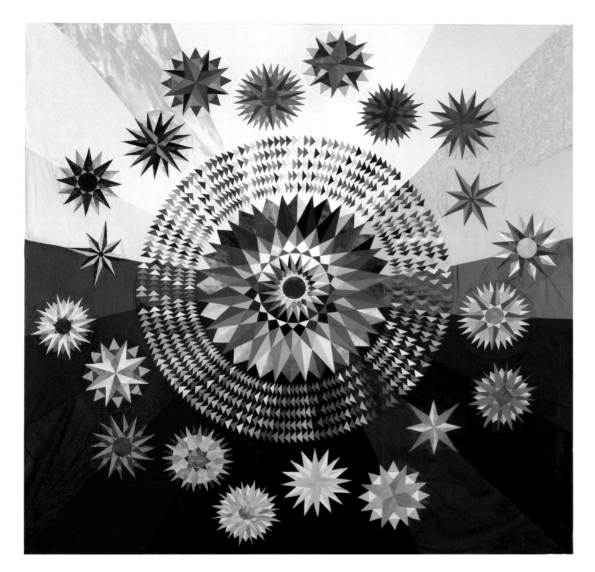

MARINER'S COMPASS DONOR RECOGNITION QUILT
Date: 2006 **Maker:** Luella Doss and Moey Anderson, Wisconsin **Size:** 130" x 130"
Owner: Wisconsin Museum of Quilts and Fiber Arts

Luella and Moey Anderson received permission from Judy Mathieson to adapt her Mariner's Compass Quilt, one of the 100 best quilts of the century, to make this striking donor recognition quilt. Photograph by Douglas Edmund

share these quilts with the public, the Schroeders helped found the Museum of the American Quilter's Society in downtown Paducah, Kentucky. A $2.2 million facility opened in 1991, featuring 85 quilts loaned by the founders.

The MAQS museum is a centerpiece of Paducah, a community that strongly supports artists and artistic businesses. The museum now owns more than 200 quilts. The Founder's Collection is the core of the artifact holdings. These quilts represent the many styles of the quilting revival.

Exhibits feature quilts from the permanent collection, and changing exhibits showcase both contemporary and antique quilts. The museum offers an ambitious roster of workshops annually, taught by well-known quilters.

Quilter's Hall of Fame

Quilt historian and appraiser Hazel Carter founded the Quilter's Hall of Fame in 1979, at the beginning of the late twentieth century quilting revival. The purpose was to honor and celebrate individuals who have

CROSSED TULIPS AND POMEGRANATE
Date: ca. 1860 **Maker:** Attributed to the Kerr or Borden family, Augusta County, Virginia
Size: 80" x 96" **Owner:** Virginia Quilt Museum, Harrisonburg, Virginia

Harrisonburg jeweler James McHone donated this quilt to the museum in 2004. Tulip quilts are among the most frequently documented quilt patterns in the state documentation projects.

made significant contributions to the quilting field. Six individuals were inducted that year: Jonathan Holstein and Gail Van der Hoof, collectors and the organizers of the 1971 Whitney Museum exhibition; William Dunton, the collector who popularized the Baltimore Album quilt; Ruth Ebright Finley, collector and author of *Old Patchwork Quilts and the Women Who Made Them;* Lenice Ingram Bacon, quilter and author of *American Patchwork Quilts;* and quilter/author Margaret Ickis. The Hall of Fame now includes more than 35 honorees. Each summer new members are inducted at a celebration featuring workshops, lectures, and book-signings by previous honorees.

At the 2004 celebration, the Hall of Fame opened its permanent headquarters in Marion, Indiana. The building features a museum and archives dedicated to the preservation of quilting history. Appropriately, the site is the home where Marie Webster produced her quilts and managed her pattern business. In 1991, Marie's granddaughter, Rosalind Webster Perry, offered to donate the house, which had been condemned, to the Hall of Fame. Over a 13-year period, with the help of many volunteers, the house was restored and is now a jewel in the city of Marion. The house was placed on the National Register of Historic Places in 1992, and the National Park Service declared it a National Historic Landmark. This is the only national landmark in the country that recognizes the achievements of a quiltmaker.

Amish Quilt Museums

Three museums in the United States feature predominantly Amish quilts. All are located in areas settled by the Amish: Kalona, Iowa, settled in 1846, and Lancaster and Intercourse, Pennsylvania, settled in the 1720s. The museums collect and exhibit both historic and contemporary Amish quilts.

Kalona Quilt and Textile Museum

Kalona in southeast Iowa was founded by three Old Order Amish families in 1846, the same year that Iowa became a state. Today, it is the largest Amish and Mennonite settlement west of the Mississippi and has earned the nickname "Quilt Capitol of Iowa." Stores in the historic downtown carry antique and new traditionally made Amish quilts, and each April the Kalona Quilt Show draws thousands of people from around the world.

The Kalona Quilt and Textile Museum is located on the grounds of the Kalona Historical Village, a museum interpreting the culture of the Iowa Amish. The centerpiece of the permanent collection are collector Marilyn Woodin's 30 Amish quilts, spanning the mid-nineteenth to mid-twentieth century.

Lancaster Quilt and Textile Museum

During the 1970s, Doug Thompson, a founder of the Esprit clothing corporation, started collecting Amish quilts for the company. This collection became well-known in the quilt community as the Esprit collection. It has the reputation as one of the best collections of authentic Amish quilts in the country. In 2002, the collection found a new home at the Heritage Center of Lancaster County, in Lancaster, Pennsylvania.

The Heritage Center already owned a significant quilt and textile collection, so in 2004 the center opened a second facility, the Lancaster Quilt and Textile Museum. The Amish Quilt Collection is the centerpiece of the museum's exhibitions and is augmented with exhibits featuring other textiles and quilts from southwest Pennsylvania. The museum offers a variety of programs for children and adults, quilters and nonquilters. They also collaborate with the Pennsylvania School of Art and Design to offer a Certificate in Folk Art Studies.

The People's Place
Quilt Museum

Phyllis Good is the owner of the Old Country Store in Intercourse, Pennsylvania, a center for Amish and Mennonite culture in Pennsylvania. The People's Place Museum occupies the second floor of the store. Phyllis and her husband, Merle, have feature exhibits of pre-1940s Amish and Mennonite quilts. Phyllis is also the publisher of Good Books, a line of books featuring Amish culture, quilting, and cooking.

Museums in Progress

The success of several state quilt projects has directly led to the founding of two museums, one in Wisconsin and one in Georgia. Both museums are works in progress; The Wisconsin Museum of Quilts has a permanent location, and is building a larger facility. The Georgia Quilt Museum, which is still looking for a permanent location, presents its exhibitions at museum and arts facilities around the state.

Wisconsin Museum of
Quilts and Fiber Arts

Cedarburg, Wisconsin, is home to the Hoffman Boeker Farmstead, the site of a pristine collection of 1860s farm buildings. The farmstead is the location of the Wisconsin Museum of Quilts and Fiber Arts, an interesting marriage of quilting history and historic architectural preservation.

Around 2001, the farm owners decided to sell the property, which included the original stone house, barn, wagon shed, and other outbuildings. But the owners were interested in more than money—they wanted to sell the property to some-

one who would maintain the historic integrity of the buildings. In today's environment of development and subdivision, it was difficult to find the right buyer. Fortunately, the Wisconsin Quilt History Project was at the same time searching for a museum site dedicated to preserving the state's quilting heritage. A sale was made, and in 2005 the interim museum opened in the farmhouse. In addition to hosting quilt-related exhibits and programs, the museum encourages responsible historic preservation through a series of events.

The Wisconsin Quilt Project is involved in a multi-million dollar project to create a permanent state quilt museum in the farmstead's barn. Fundraising efforts include a remarkable Mariner's Compass Fundraising Quilt, on which donors can have their name inscribed. The 130-inch square quilt will hang at the main entrance of the new museum.

Georgia Quilt Museum

Creating a quilt museum is one part inspiration and nine parts hard work. The Georgia Quilt Council began exploring the possibility of creating a Georgia Quilt Museum in 1999. The next year it seemed like the project was doomed when the Executive Committee Report voted to discontinue the project. But dedicated quilters can always find ways to raise money; these quilters saved the project.

Although the Georgia Quilt Museum is still seeking a permanent location, they do have an active exhibition program. In 2005, Georgia Quilt Museum sponsored the challenge Not Your Grandmother's Quilt. Georgia Quilt Council members were invited to create quilts less than 24 inches square that incorporated a modern twist on a traditional pattern. Dozens were received, and the exhibit toured the state from October 2005 through March 2007. In 2007, the museum challenged entrants to make a small Crazy quilt. The challenges serve a dual purpose: to showcase the work of Georgia quilters and to generate awareness and financial donations for a permanent museum. Quilts from both challenges have been donated to the museum for its collections.

In the past 50 years, quilt study has emerged as a recognized research field. The work of self-taught and academically trained historians has documented ideas we've often suspected about quilting, cleared up long-held myths, and identified new aspects of the relationships between art, economics, and domestic work. The field is poised to grow in the twenty-first century, as universities add textile study degree programs and researchers continue to exhibit and publish their works.

DANE COUNTY BICENTENNIAL QUILT

Date: 1976 **Maker:** Citizens of Dane County, Wisconsin **Size:** 108" x 108" **Owner:** Dane County Area Agency on Aging, Madison, Wisconsin

Among the scenes of Dane County depicted on the quilt are the first grist mill in the county, the first United Church of the Brethren in the state, and the Dane County Seal, which recognizes the organization of the county nine years before Wisconsin became a state.

END NOTES

Part 1

Chapter 1
 1. Berenson, *Quilts of Provence*, 39

Chapter 2
 1. Allen and Tuckhorn, *A Maryland Album*, 68
 2. Covington, *Gathered in Time*, 10
 3. Laury, *Ho For California!*, 49
 4. Cross, *Treasures in the Trunk*, 68
 5. Laury, 43
 6. Cross, 18
 7. Dallas, *The Quilt that Walked to Golden*, 6

Chapter 3
 1 *The Scarlet*, January 10, 2002
 2. Chronicles of Oklahoma, 472
 3. *Ibid*, 474
 4. Goldman and Weibusch, *Quilts of Indiana*

Chapter 5
 1. Fry, *Stitched From the Soul*, 8
 2. Fry, *Stitched From the Soul*, 1
 3. McCalls.com April 23, 2006
 4. Murkin, Scott, email December 2006

Chapter 6
 1. Reese, Mayme, WPA interview, September 21, 1938

Chapter 7
 1. Minnesota Quilt Project, *Minnesota Quilts*, 66

Chapter 8
 2. Kort, Ellen, *Wisconsin Quilts*, 62
 3. Valentine, Fawn, *West Virginia Quilts and Quiltmakers*, 185
 4. Laury, *Ho for California*, 143
 5. Minnesota Quilt Project, *Minnesota Quilts*, 55
 6. Crews and Nagle, *Nebraska Quilts & Quiltmakers*, 156

Chapter 9
 1. Kort, Ellen, *Wisconsin Quilts*, 150
 2. Bob Shaw, *The Art Quilt*, 14.

Chapter 10
 1. Farlow, Mrs. Albert, WPA interview, December 16, 1938
 2. *Quilter's World*, March 2002, www.quilters-world.com

Chapter 11
 2. DeSpain, Eloise, email correspondance, December 7, 2006
 3. Webster, *Quilts: Their Story and How to Make Them*, XXI

Part 2

 1. Finley, Ruth, *Patchwork Quilts*, 123
 2. Susan Else, www.susanelse.com
 3. Ramsey and Waldvogel, *Quilts of Tennessee*, 9
 4. Brackman, *Encyclopedia of Pieced Quilt Patterns*, 4
 5. Arkansas Quilters Guild, *Arkansas Quilts*

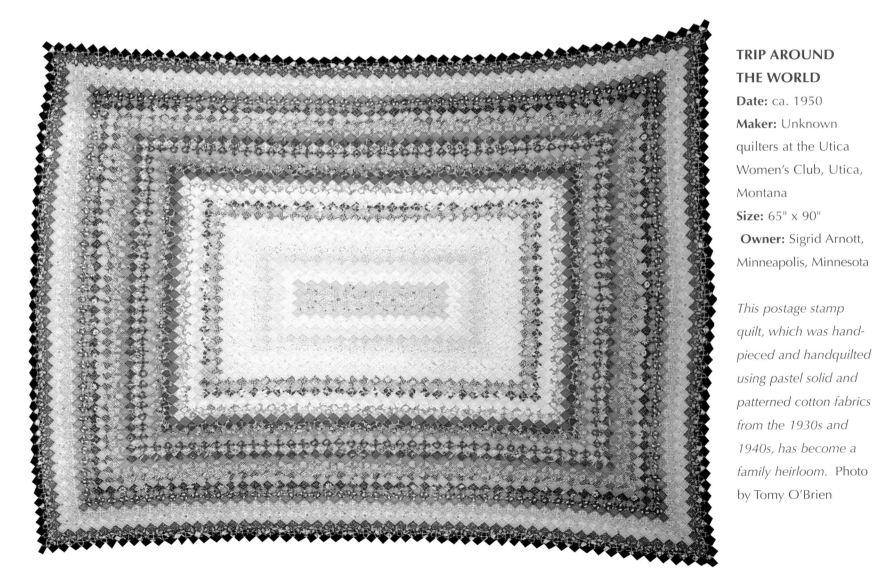

**TRIP AROUND
THE WORLD**
Date: ca. 1950
Maker: Unknown
quilters at the Utica
Women's Club, Utica,
Montana
Size: 65" x 90"
Owner: Sigrid Arnott,
Minneapolis, Minnesota

*This postage stamp
quilt, which was hand-
pieced and handquilted
using pastel solid and
patterned cotton fabrics
from the 1930s and
1940s, has become a
family heirloom.* Photo
by Tomy O'Brien

BIBLIOGRAPHY

"Afghan danger for migrating birds." BBC News. Wednesday, October 31, 2001. 13:45 GMT.

The African-American Mosaic: A Library of Congress Resource Guide for the Study of Black History and Culture. www.loc.gov/exhibits/african

Aldrich, Margret Ed. *Once Upon a Quilt: A Scrapbook of Quilting Past and Present.* St. Paul, MN: Voyageur Press, 2003.

———. *This Old Quilt: A Heartwarming Celebration of Quilts and Quilting Memories.* St. Paul, MN: Voyageur Press, 2001.

Allen, Gloria Seaman and Tuckhorn, Nancy Gibson. *A Maryland Album, Quiltmaking Traditions 1634–1934.* Nashville: Rutledge Hill Press, 1995.

"The American Anti-Slavery Society." United States Department of State International Information Program. http://usinfo.state.gov/usa/infousa/factors/democrac/18.htm. Retrieved December 14, 2006.

American Memory Project. The Library of Congress. "Quilts and Quiltmaking in America, 1978–1996." http://memory.loc.gov.ammem.qlthtml/qlthome.html

"The Amish: History in the U.S. and Canada: 1700 to Now." Ontario Consultants on Religious Tolerance. www.religioustolerance.org/amish2.htm. Retrieved December 21, 2006.

"The Amish: Their History, Beliefs, Practices, Conflicts." Ontario Consultants on Religious Tolerance. www.religioustolerance.org/amish.htm. Retrieved December 21, 2006.

"Appalachian Artistry" *Rural Cooperatives* 65, Issue 2 (March/April 1998).

"AQS Quilt Appraisal Program." *American Quilter's Society.* www.americanquilter.com/about_aqs/appraisal_program. Retrieved December 20, 2006.

Arkansas Quilter's Guild. *Arkansas Quilts, Arkansas Warmth.* Paducah, KY: American Quilter's Society, 1988.

Armstrong, Nancy Cameron. "Quilts of the Gulf War, Desert Storm-Participation or Protest." *Uncoverings* 13 (1993). P. 9-44.

Arnett, William, Alvia Wardlaw, Jane Livingston, and John Beardsley. *The Quilts of Gee's Bend: Masterpieces from a Lost Place.* Atlanta: Tinwood Books, 2002.

Atkins, Jacqueline M. and Phyllis A. Tepper. *New York Beauties, Quilts from the Empire State.* New York: Dutton Studio Books, 1992.

Aug, Bobbie. *An Introduction to Quilt Appraisal.* www.bobbieaug.com/html/appraisal. html. Retrieved December 29, 2006.

Aug, Bobbie, Newman, Sharon and Roy, Gerald. *Vintage Quilts: Identifying, Collecting, Dating, Preserving & Valuing.* Paducah, KY: Collector Books, 2002.

Austin, Mary Leman ed. *The Twentieth Century's Best American Quilts: Celebrating 100 Years of the Art of Quiltmakers.* Golden, CO: Primedia Special Interest Publications, 1999.

Bancroft, Hubert Howe. *The Book of the Fair.* Chicago: The Bancroft Company, 1983.

Bartlett, Ella. Works Progress Administration Interview. December 19, 1938.

Barton, Mary Pemble. *Notebook to Collections.* Unpublished manuscript. Des Moines, IA: State Historical Society of Iowa, 1988.

Becoming American: Trade Culture, and Reform in Salem, Massachusetts, 1801–1861. Salem State College. www.salemstate.edu/landmark/dbq7VT.htm.

Benberry, Cuesta. "Afro-American Women & Quilts: An Introductory Essay." *Uncoverings 1,* (1980). p. 9-44

Benberry, Cuesta. "White Perspective of blacks in quilts and related media." *Uncovering 4,* (1983).

———. "Woven into History, African American Quilters." *American Vision,* Dec.–Jan., 1993.

Berenson, Kathryn. *Quilts of Provence.* New York: Henry Holt and Company, 1996.

Better Homes and Gardens Century of Quilts. Des Moines, IA: Meredith Corporation, 2002.

Blehart, Debra. "Passage of Life in Thread." *Quilter's Newsletter Magazine,* October 2003.

Boggon, Sharon. "A Brief History of Embroidery Samplers." *In A Minute Ago.* http://inaminuteago.com/articles/samplerhist.html Retrieved October 25, 2006.

Booth, Mason. "Historic Quilts Great Legacies for Red Cross." American Red Cross. www.redcross.org/news/other/museum/030314quilt.html

Bowman, Doris M. *The Smithsonian Treasury of American Quilts.* Washington, DC: Smithsonian Institution Press, 1991.

"Boxes Under the Bed." The Center for the Quilt Online. www.centerforthequilt.org/boxes/boxes.html

Brackman, Barbara. *America's Printed Fabrics 1770–1890.* Lafeyette, CA: C&T Publishing, 2004.

———. *Clues in the Calico: A Guide to Identifying and Dating Antique Quilts.* Mclean, VA: EPM Publications, 1989.

———. *Encyclopedia of Pieced Quilt Patterns.* Paducah, KY: American Quilter's Society, 1993.

———. *Facts & Fabrications: Unraveling the History of Quilts & Slavery.* Lafeyette, CA: C&T Publishing, 2006.

———, *Quilts from the Civil War.* Lafeyette, CA: C&T Publishing, 1997.

Brackman, Barbara, Chinn, Jennie, Davis, Gayle, Thompson, Terry, Farley, Sara Reimer, Hornback, Nancy. *Kansas Quilts and Quiltmakers.* Lawrence, KS: University of Kansas Press, 1993.

Brady, Angela Hickman. "No B's for this Quilter." *Assisted Living Today*, October 2001.

Breneman, Judy Anne Johnson. "Charm Quilt History: The Ultimate Scrap Quilt. America's Quilting History." www.womenfolk.com/quilting_history/charm.htm . Retrieved October 25, 2006.

———. "The Power of Women's Temperance Movement Quilts. America's Quilting History." www.womenfolk.com/quilt_pattern_history/temperance.htm. Retrieved December 6, 2006.

———. "Quilted Reactions to Desert Storm: History of Quilts." www.historyofquilts.com/desertstorm.html. Retrieved February 20, 2007.

———. "Those Peculiar Biscuit and Puff Quilts: America's Quilting History." www.womenfolk.com/quilt_pattern_history/biscuit-quilt.htm

Burgess, Arene. "The Birth of the Kit Quilt Business". *Quilter's Newsletter Magazine.* May 2004.

Brown, Patti. "Quilts for the Coast." *The Quilted Butterfly.* http://albfabrics.com/quiltedbutterfly/quilts_coast.html. Retrieved December 6, 2006.

Carroll, Laurette. "Textile Tobacco Inserts and Premiums used in American Quilts and Related Household Articles." Fabrics.Net. www.fabric.net/laurettetobaccoquilts.asp. Retrieved March 14, 2007.

Carlson, Elaine. "Meet the "Founders" of the UQG." Utah Quilt Guild. www.utahquiltguild.org/spotlight.htm. Retrieved December 20, 2006.

Caruso, Hwa Young and John Caruso, Jr. "The Art of Quilting from Folk Art to Fine Art." *Electronic Magazine of Multicultural Education*, Vol. 7, No. 2, Fall 2005. www.eastern.edu/publications/emme. Retrieved February 21, 2007.

Cash, Floris Barnett. "Kinship and Quilting: An Examination of an African-American Tradition." *The Journal of Negro History*, Winter 1995.

Cerny, Catherine A. "A Quilt Guild: It's Role in the Elaboration of Female Identity." *Uncoverings 12*, (1991), P. 32-49.

Cord, Xenia. "Signature Quilts Part II." Published on August 30, 2001. www.quilt.co.uk/quilting-articles.asp.id.no=20.

Clarke, Mary Washington. *Kentucky Quilts and Their Makers.* Lexington, KY: The University of Kentucky Press, 1976.

Cochran, Rachel. New *Jersey Quilts 1776–1950: Contributions to an American Tradition.* Paducah, KY: American Quilters Society, 1992.

The Connecticut Quilt Search Project. *Quilts and Quiltmakers Covering Connecticut.* Atglen, PA: Schiffer Publishing, 2002.

"Constitution and Meeting Minuets of the Girls' Antislavery Society of Shrewsbury, Massachusetts, 1837–1840." Old Sturbridge Village-Online Resource Library. www.osv.org/learning. Retrieved February 21, 2007.

Covington, Kae. *Gathered in Time: Utah Quilts and Their Makers, Settlement to 1950.* Salt Lake City: University of Utah Press, 1997.

Cox, Patricia and Maggi McCormick Gordon. *American Quilt Classics from the Collection of Patricia Cox.* Woodinville, WA: Martingale and Company, 2001.

Crews, Patricia Cox and Ronald C. Naugle, eds. *Nebraska Quilts & Quiltmakers.* Lincoln, NE: University of Nebraska Press, 1991.

Cross, Mary Bywater. *Treasures in the Trunk: Quilts of the Oregon Trail.* Nashville: Rutledge Hill Press, 1993.

Cross, Mary Bywater. *Quilts & Women of the Mormon Migration.* Nashville: Rutledge Hill Press, 1996.

"The Culture of Civil Rights." *Voices of Civil Rights.* www.voicesofcivilrights.org/civil5_gees_bend.html. Retrieved December 15, 2006.

Cummings, Patricia Lynne Grace. "Hmong Textile Art: The Tie That Binds a Culture." Quilter's Muse Virtual Museum. www.quiltersmuse.com/hmong_textile_art.htm. Retrieved December 21, 2006.

Dallas, Sandra. *The Quilt That Walked to Golden: Women and Quilts in the Mountain West.* Elmhurst, IL: Breckling Press, 2004.

"Dane County Bicentennial Quilt." Dane County Area Agency on Aging. www.co.dane.wi.us/aging/quilt.htm. Retrieved October 10, 2006.

De Develyn, Kateryn. "Spellings/History of the Word Quilt." www.kateryndedevelyn.org/quiltorvw.htm. Retrieved February 25, 2006.

DeSpain, Eloise. Personal correspondence to Elise Schebler Roberts, email. December 9, 2006.

Ducey, Carolyn. "Quilt History Timeline, Pre-History-1800." International Quilt Study Center, www.quiltstudy.org/includes/downloads/4_1storytimeline.pdf. Retrieved February 25, 2006.

Eaton, Linda. *Quilts in a Material World, Selections form the Winterthur Collection.* New York: Henry N. Abrams, 2007.

Eddy, Celia. *Quilted Planet: A Sourcebook of Quilts from Around the World.* New York: Clarkson Potter Publishers, 2005.

"Eighteen-Thirty-Seven American Anti-Slavery Society Officials." Illinois Trails History and Genealogy. www.iltrails.org/1837 antislavery_members.html. Retrieved December 19, 2006.

"Elizabeth Keckley and the Mary Todd Lincoln Quilt." *Quilter's World* 27, No. 2 (March 2002), www.quilters-world.com

"Esprit Collection Heads Back to Pennsylvania." *Quilter's Newsletter Magazine,* November 2002.

Evans, Lisa. "Medieval & Renaissance Quilting," www.historyofquilts.com/precolonial.html. Retrieved February 25, 2006.

Evans, Lisa. "A Short Introduction to Pre-Colonial Quilting." www.womenfolk.com/historyofquilts/lisaevens.htm. Retrieved February 25, 2006.

Faoro, Victoria A. Ed. *MAQS Quilts: The Founders Collection.* Paducah, KY: Museum of the American Quilter's Society, 2004.

Farlow, Mrs. Albert. Works Progress Administration Interview, December 16, 1938.

Fellner, Leigh, Betsy Ross Redux: "The Underground Railroad Quilt Code." http://www.ugrrquilt.hartcottagequilts.com.

Ferrero, Pat, Elaine Hedges, and Julie Silber. *Heart and Hands: The Influence of Women and Quilts on American Society.* San Francisco, CA: The Quilt Digest Press, 1987.

Finley, Ruth. *Old Patchwork Quilts and the Women Who Made Them.* Charlottesville, VA: Howell Press, 1992.

Fisher, Laura. *Quilts of Illusion.* Pittstown, NJ: Main Street Press, 1988.

"Freedom Quilting Bee." Rural Development Leadership Network, www.ruraldevelopment.org

Freeman, Roland L. *A Communion of Spirits: African American Quilters, Preservers and their Stories.* Nashville: Rutledge Hill Press, 1996.

Frost, Helen Young and Pam Knight Stevenson. *Grand Endeavors, Vintage Arizona Quilts and Their Makers.* Flagstaff, AZ: Northland Publishing, 1992.

Fry, Gladys-Marie. *Stitched From the Soul: Slave Quilts from the Antebellum South.* Chapel Hill, NC: University of North Carolina Press, 2002.

Gallery of American Quilts 1849-1988. Paducah, KY: American Quilter's Society, 1988.

"The Garden Quilt." *Cool Things.* Kansas State Historical Society. www.kshs.org/cool2/coolquit.htm. Retrieved October 6, 2006.

Gaubatz, Caryl, Interview by Jana Hawley, October 23, 1999. Alliance for American Quilts, Tape Number 38. Transcription at www.centerforthequilt.org/qsos. Retrieved February 27, 2007.

Granick, Eve Wheatcroft. *The Amish Quilt.* Intercourse, PA: Good Books, 1989.

Goldman, Marilyn and Marguerite Wiesbusch. *Quilts of Indiana: Crossroads of Memory.* Bloomington, IN: Indiana University Press, 1991.

Greenhaw, Wayne. "Parks Felt "Determination Cover my Body Like a Quilt." October 25, 2005. www.cnn.com/2005/US/10/25/parks.greenhaw/index.html. Retrieved February 25, 2007.

Greenlee-Donnell, Cynthia. "Quilting to Remember." *Herald-Sun,* Durham, North Carolina, March 9, 2005.

Greer, Jane. "Quilting as a Spiritual Practice." *UUWorld Magazine,* Summer 2006.

Guensburg, Carol. "The Fabric of their Lives, Beauty, Tragedy Captured in Hmong Needlework." *Journal-Sentinel,* Milwaukee, WI, June 16, 1996.

"Gustafson, Eleanor H. Roberts and Ardis James Donate Quilts." *Magazine Antiques,* August 2002.

Hall, Carrie and Kretsinger, Rose G. *The Romance of the Patchwork Quilt in America.* New York: Bonanza Books, 1980.

Harding, Deborah. *Red & White: American Redwork Quilts and Patterns.* New York: Rizzoli International Publications, 2000.

Henley, Bryding Adams. "Alabama Gunboat Quilts." *Uncoverings 1987* 8 (1989): 11–23.

Hicks, Kyra E. "Martha Erskine Ricks: 19th Century Quiltmaker." *Masters of African American Art: An Online Journal of Publications by Professional Scholars Grant Recipients.* The Anyone Can Fly Foundation. www.anyonecanflyfoundation.org/library/Hicks_on_Ricks_essay.html. Retrieved March 4, 2007.

"The History of the Sunbonnet Sue Quilt Pattern." Sunbonnetsue.com. www.sunbonnetsue.con/suehistory.html. Retrieved October 4, 2006.

Hobgood, Mary Elizabeth, *Dismantling Privilege: An Ethics of Accountability.* Cleveland, OH: Pilgrim Press, 2000.

Holstein, Jonathan and Finley, John. *Kentucky Quilts 1800–1900.* Louisville, KY: The Kentucky Quilt Project, 1982.

Horton, Laurel. "Blue Ridge Quiltmaking in the Late Twentieth Century." July 1999. http://memory.loc.gov.ammem.qlthtml/qlthome.html.

———. "The Lands' End All-American Quilt Contest," July 1999. http://memory.loc.gov.ammem.qlthtml/qlthome.html.

———. "South Carolina's Traditional Quilts." *Uncoverings* 5 (1984): 55–69.

———. "Speaking of Quilts: Voices from the Late Twentieth Century." July 1999. http://memory.loc.gov/ammem/qlthtml/qltov.html.

"How A Hill Tribe From Laos Changed a Pennsylvania Tradition." *The Morning Call,* Allentown, PA, April 23, 2006,

Ickis, Marguerite *The Standard Book of Quilt Making and Collecting.* New York: Dover Publications, 1949.

The Indian Arts and Crafts Act of 1990. U.S. Department of the Interior, Indian Arts and Crafts Board. www.iacb.doi.gov/act.html. Retrieved December 21, 2006.

Ingram, J.S. *The Centennial Exposition Described and Illustrated.* Philadelphia, PA: Hubbard Brothers, 1876.

Irwin, John Rice. *A People and Their Quilts.* Atglen, PA: Schiffer Publishing Ltd., 1984.

"Jennie and Gerald LeFevre: Our Founders Story" Agent Orange Quilt of Tears. www.agentorangequiltoftears.com

Johnson, Mary Elizabeth. *Mississippi Quilts*. Jackson, MS: University Press of Mississippi, 2001.

Jones, Louis Thomas. *The Quakers of Iowa*. Iowa City, IA: State Historical Society of Iowa, 1914.

Keuning-Tichelaar, An and Lynn Kaplanian-Buller. *Passing on the Comfort: The War, The Quilts and The Women Who Made a Difference*. Intercourse, PA: Good Books, 2005.

King, Kim M. "Quiltmaker's Online Communities." *Uncoverings* 23 (2002): 81–100.

Kiracofe, Roderick and Johnson, Mary Elizabeth. *The American Quilt, A History of Cloth and Comfort 1750–1950*. New York: Clarkson Potter Publishers, 1993.

Klassen, Teri. "The Grand Opening of the Quilter's Hall of Fame." *Quilter's Hall of Fame Newsletter*, Fall 2004.

Kort, Ellen. *Wisconsin Quilts: Stories in the Stitches*. Charlottesville, VA: Howell Press, 2001.

Kramer, Hilton. "Art: Quilts Find a Place at the Whitney." *New York Times,* July 3, 1971.

"The Ladies Fair." *The Liberator,* January 2, 1837. The Historical Society of Pennsylvania. www.hsp.org/files/theliberator.pdf. Retrieved February 21, 2007.

Lasansky, Jeanette. "Southwestern Quilts and Quiltmakers in Context." *Uncoverings* 14 (1993): 97–118.

Laury, Jean Ray. "My Journey Through Quilting." *Quilter's Newsletter Magazine*, March 2004.

Laury, Jean Ray and California Heritage Quilt Project. *Ho For California! Pioneer Women and Their Quilts*. New York: E.P. Dutton, 1990.

Lee, Jean H. "Hmong Quilts-pa ndau-reflect Hmong History." www.hmongnet.org/culture/pandau2.html. Retrieved October 6, 2006.

Levie, Eleanor. *American Quiltmaking 1970–2000*. Paducah, KY: American Quilter's Society, 2004.

Lindenmeyer, Kriste. "Women's Christian Temperance Union." *Tennessee Encyclopedia of History and Culture*. Tennessee Historical Society. Online edition, 2002.

MacDowell, Marsha, ed. *Great Lakes, Great Quilts from the Michigan State University Museum*. Lafeyette, CA: C&T Publishing, 2001.

MacDowell, Marsha and Ruth D. Fitzgerald, eds. *Michigan Quilts, 150 Years of a Textile Tradition*. East Lansing, MI: Michigan State University Museum, 1987.

MacDowell, Marsha and Margaret Wood. "Sewing it Together: Native American and Hawaiian Quilting Traditions." *Native Americas* (December 31, 1994):109.

MacDowell, Marsha L. and C. Kurt Dewhurst. *To Honor and Comfort: Native Quilting Traditions*. Santa Fe: Museum of New Mexico Press, 1997.

MaGee, Jan. "A Class Act, The Electronic Quilting Classroom." *Quilter's Newsletter Magazine*, September 2005.

MaGee Jan and Marilyn Hollenback. "Roses for Lillie, Documenting the Design Process." *Quilter's Newsletter Magazine,* March 2006.

Maspero, G. *Manual of Egyptian Archaeology & Guide to the Study of Antiquities in Egypt*. Project Gutenberg Translation. www.gutenberg.org

Mazloomi, Carolyn. "About the Women of Color Quilting Network" www.carolynlmazloomi.com/wcqn.html. Retrieved October 4, 2006.

McCormick, Robert W. and Virginia E. "New England Culture of the Ohio Frontier." *Old Time New England*, Fall 1996.

Meiman, Lisa, 2nd Lt. "Bringing Comfort to Wounded Warriors." *F.E. Warren Air Force Base News*, November 9, 2006.

Mikelson, Terry. "Former Brainerd Man Publishes His First Novel." *Brainerd Daily Dispatch ,* February 21, 2002.

Milspaw, Yvonne J. "Regional Style in Quilt Design." *Journal of American Folklore* 110, no. 438 (Autumn 1997): 363–390.

Minnesota Quilt Project. *Minnesota Quilts: Creating Connections with Our Past*. St. Paul, MN: Voyageur Press, 2005.

"Molas." *Crossroads Trade, Ethnic Arts of the World*. www.crossroadstrade.com/molas.php. Retrieved October 4, 2006.

Murkin, Scott. Interview by Tomme Fent. October 25, 2005. The Alliance for American Quilts SOS Tape # NC27205-001. Transcription at www.centerforthequilt.org/qsos. Retrieved December 27, 2006.

Murkin, Scott. Personal correspondence, email to Elise Schebler Roberts, December 27, 2006.

Musgrave, Karen. "In their Own Words: Writing Quilt History a Little at a Time." *Quilter's Newsletter Magazine*. December 2002.

Musgrave, Karen. "Quilters' S.O.S. Save Our Stories." *AQSG Blanket Statements.* Spring 2002.

"National NAGPRA." U.S. Department of the Interior, National Park Service. www.cr.nps.gov/nagpra. Retrieved December 21, 2006.

"Oklahoma History Quilt." *Chronicles of Oklahoma* 13, no. 4 (December 1935)

"Oklahoma Jewish Experience, Oklahoma Memorabilia." Sherwin Miller Museum of Jewish Art. www.jewishmuseum.net/collections/memorabilia.html. Retrieved December 28, 2006.

Orlofsky, Patsy and Myron. *Quilts in America*. New York: McGraw-Hill Book Company, 1974.

Orr, Vanessa. "Quilts of Alaska: A Textile Album of the Last Frontier." *Alaska State Museum Bulletin.* Spring 2001.

"Owinja-Star Quilt." Akta Lakota Museum & Cultural Center. www.aktalakota.org/index.cfm?cat=54&artid=128. Retrieved December 21, 2006.

Papakakis, Brenda Manges. *Dear Jane: The Two Hundred Twenty-Five Patterns from the 1863 Jane A. Stickle Quilt.* West Warner, MA: Wright Publications, 1996.

Parrish, Kathleen. "The Global Business of Amish Quilts." *Quilter's Newsletter Magazine.* November 2006

"Pennsylvania Abolitionist Society." Historical Society of Pennsylvania. www.hsp.org/default.aspx?id=634

"Presenting Bonnie Leman. Quilt Treasures, Documenting the 20th Century Quilt Revival." Center for the Quilt. www.centerforthequilt.org/treasures/bl. Retrieved December 27, 2006.

Pulford, Florence. *Morning Star Quilts: A Presentation of the Work and Lives of Northern Plains Indian Women.* Los Altos, CA: Leone Publications, 1989.

"Quilters Comfort America: Hurricane Katrina Relief." Layers of Meaning. http://layersofmeaning.org/wp/?p=249. Retrieved December 6, 2006.

"Quilting." *Ohio Memory, An Online Scrapbook of Ohio History.* Ohio Historical Society. www.ohiomemory.org.

Quilting in America 2003—Summary. Quilter's Newsletter Magazine and Quilts, Inc. 2003.

Quilting in America 2006—Summary. Quilter's Newsletter Magazine and Quilts, Inc. 2006.

"Quilt's First Public Exhibition at the Sheldon." *Scarlet.* University of Nebraska-Lincoln. October 10, 2002. www.unl.edu/scarlet/v12n01/v12n01features.html. Retrieved December 20, 2006.

Ramsey, Bets. "Tennessee Quilts: Traditions & Innovation." The Decorative Arts Trust. www.decorativeartstrust.org/tennessee_quilts.htm. Retrieved October 6, 2006.

Ramsey, Bets and Merikay Waldvogel. *The Quilts of Tennessee: Images of Domestic Life Prior to 1930.* Nashville: Rutledge Hill Press, Inc., 1986.

Reese, Mrs. Mayme. Works Progress Administration Interview, September 21, 1938.

Report of the Twentieth National Anti-Slavery Bazaar. Samuel J. May Anti-Slavery Collection, Cornell University, 1854. http://dlxs.library.cornell.edu. Retrieved February 21, 2007.

Reynolds, Andi. "Leaving a Legacy: Donating Quilts to Museums." *Quilter's Newsletter Magazine,* October 2005.

Roach, Susan. *Documenting Quiltmaking.* Louisiana Regional Folklife Program, Louisiana Tech University. www.louisianafolklife.org/quilts. Retrieved December 1, 2006.

———. *"Keep Your Mind and Your Hands Busy" Expressive Dimensions of the Lone Quilter.* Louisiana Regional Folklife Program, Louisiana Tech University. www.louisianafolklife.org/quilts. Retrieved December 1, 2006.

———. *Quiltmaking in Louisiana.* Louisiana Regional Folklife Program, Louisiana Tech Univerisity. www.louisianafolklife.org/quilts. Retrieved December 1, 2006.

Roberson, Ruth Haislip. *North Carolina Quilts.* Chapel Hill, NC: The University of North Carolina Press, 1988.

Roberts, Deborah. "The Mountain Mist Historical Quilt Collection," 1997. http://quilt.com/collector/feature.html. Retrieved December 29, 2006.

Robinson, Barbara. "Welcome to the Friendly Circle Club." *Quilter's Newsletter Magazine,* October 2005.

Ruskin, Cindy. *The Quilt: Stories From the Names Project.* New York: Pocket Books, 1988.

Schmeal, Jacqueline Andre. *Patchwork: Iowa Quilts and Quilters.* Iowa City: University of Iowa Press, 2003.

Shannon, Jonathan. Interview by Flavin Glover. October 23, 1999. The Alliance for American Quilts SOS Tape #40. Transcription at www.centerforthequilt.org/qsos/show_interview.php?pbd+qsis-a0a0+2-a Retrieved December 27, 2006.

Shaw, Robert ed. *Art Quilts: A Celebration.* Asheville, NC: Lark Books, 2005.

Smith, Janet Jo. "The Charming One-Patch." *Quilter's Newsletter Magazine.* www.qnm.com/articles/feature15/index.html. Retrieved October 25, 2006.

Smith, Michael O. "Heartland Comfort: Bedcoverings from the Collections of the State Historical Society of Iowa." *Iowa Heritage Illustrated,* Spring/Summer 1999.

"Soldiers Remembered by Quilters." *Quilter's Newsletter Magazine,* November 2005.

Spencer, Carole A. "Victorian Crazy Quilts." *The Palimpsest,* Spring 1990.

Stalter, Beatrice. Works Progress Administration Interview, August 26, 1936.

"Stained Glass Windows." Trinity United Methodist Church, Houston, Texas. www.tumchouston.org/templates/System/details.asp?id=25742&PID=118839 Retrieved March 14, 2007.

Stalp, Marybeth C. "Negotiating Time and Space for Serious Leisure: Quilting in the Modern U.S. Household." *Journal of Leisure Research,* Winter 2006.

Stephenson, Shauna. "Quilting for Valor." *Wyoming Tribune-Eagle,* November 29, 2006.

Stuhlman, Tess Beck, "Catching the Shape of the Dreams, Quilts as a Medium." *Mosaics of Meaning.* Lanham, MD: Scarecrow Press, 1996.

"'Sun Sets' quilt, Tamastklikt Painted Hides Win Awards." *Confederated Umatilla Journal,* July 2006.

"Susan B. Anthony House Receives Reproduction Quilt from Genesee Valley Quilt Club." Susan B. Anthony House. Rochester, New York. June 8, 1998. www.susanbanthonyhouse.org/news/quilt.html. Retrieved December 6, 2006.

"Teacher's Certification Program." National Quilting Association. www.nqaquilts.org/teachers_certification.html. Retrieved December 20, 2006.

"Thirty Hour Quilt Marathon." *The Quilt: A Breast Cancer Support Project.* www.quiltmarathon.com. Retrieved December 12, 2006.

Tobin, Jaqueline L. and Raymond G. Dobard. *Hidden in Plain View: A Secret Story of Quilts and The Underground Railroad.* New York: Anchor Books, 2000.

Trestain, Eileen Jahnke. *Dating Fabrics: A Color Guide 1800–1960.* Paducah, KY: American Quilter's Society, 1998.

———. *Dating Fabrics 2: A Color Guide 1950–2000.* Paducah, KY: American Quilter's Society. 2005.

Twelker, Nancy Ann Johanson. *Women and Their Quilts: A Washington State Centennial Tribute.* Mineoloa, NY: Dover Publications, 1992.

"U.S.S. Kidd Veterans Memorial Museum." www.usskidd.com/museum.html. Retrieved December 18, 2006.

Valentine, Fawn. *West Virginia Quilts and Quiltmakers, Echoes From the Hills.* Athens, OH: Ohio University Press, 2000.

Waldvogel, Merikay. "Also known as Patty Shannon," *Quilter's Newsletter Magazine,* October 2004.

Waldvogel, Merikay Marie Webster, "The 20th Century's First Trendsetting Quilt Designer." *Vintage Quilts,* Spring 2001, www.mccallsquilting.com.

Waldvogel, Merikay. "One Man's Passion: An 1893 World's Fair Crazy Quilt." *Quilter's Newsletter Magazine*, September 2005.

———. *Soft Covers for Hard Times. Quiltmaking & The Great Depression.* Nashville: Rutledge Hill Press, 1990.

Waldvogel, Merikay and Brackman, Barbara. *Patchwork Souvenirs of the 1933 World's Fair.* Nashville: Rutledge Hill Press, 1993.

Webster, Marie. *Quilts, Their Stories and How To Make Them, A New Edition.* Santa Barbara, CA: Practical Patchwork, 1990.

Will of Cranage Wilcoxson, Sproston Chester Co England, January 25, 1731. Cheshire Will, www.geocities.com/pennytrueman/chswills.html

Wray, Dr. Tina Brewster. "From the Back Room—Quilts." *White River Journal: A Newsletter of the White River Valley Museum,* October 1998.

Wulfert, Kimberly. "Album & Signature Quilt History, 1830–Today." *New Pathways into Quilt History.* www.antiquequiltdating.com/AlbumandSignatureQuiltHistory1830-Today.html. Retrieved October 25, 2006.

Young, Carrie. *Nothing to Do But Stay: My Pioneer Mother.* Iowa City, IA: University of Iowa Press, 1991.

Zegart, Shelly. "Affairs of State: Documenting the Past for the Future." *Quilter's Newsletter Magazine,* November 2004.

Zegart, Shelly. "Appraising Your Quilts." *Shelly Zegart Quilts, Etc.* www.shellyquilts.com/Appraisingquilt1.html. Retrieved December 29, 2006.

———. "Since Kentucky: Surveying State Quilts." *The Quilt Index.* www.quiltindex.org/since_kentucky.php. Retrieved September 12, 2006.

Zopf, Dorothy. "Surviving the Winter: The Evolution of Quiltmaking Among Two Cultures in New Mexico," 1998. www.cla.purdue.edu/waaw/Zopf/index.html. Retrieved December 13, 2006

Website Resources

The Alliance for American Quilts, http://www.quiltalliance.org/index1.html

American Quilter's Society, www.americanquilter.com

Brian Dykhuizen, www.briandykhuizen.com

Center for the Quilt, www.centerforthequilt.org

Eduquilters, www.eduquilters.org

The Faith Quilts Project, www.faithquilts.org

Heather Fox, www.bellwoodcreations.com

Freedom Quilts, www.freedomquilts.net

Iowa Home of the Brave, www.homeofthebrave.quilts.org

J. Michelle Watts, www.jmichellewatts.com

Library of Congress: American Memory Project, http://memory.loc.gov/ammem/about/index.html

National Quilting Association, www.nqaquilts.org

Prayer Quilt Ministry, www.prayerquilt.org

Project Linus, www.projectlinus.org

Quilts of Valor Foundation, www.qovf.org

The Quilt Index, www.quiltindex.com

Quilts, Incorporated, www.quilts.com

Rising Star Quilters Guild, www.risingstarquilters.org

State Quilt guild of New Jersey. Schoolhouse Project, www.njquilts.org

Susan Deal, www.susandealdesigns.com

Susan Else, www.susanelse.com

Terry Clothier Thompson, www.terrythompson.com

The Village Quilters, www.villagequilters.com

QUILT-RELATED SOCIAL PROJECTS

The following is a list of all the quilt-related social organizations mentioned in the book. Contact the individual organization for more information about how to become involved.

Ovarian Cancer Quilt Project
Ovarian Cancer National Alliance
910 17th Street NW, Suite 1190
Washington, DC 20006
202-331-1332
www.Ovariancancer.org

Quilt4Cancer.Org
Frank Helden, Founder
P.O. Box 32
Craftsbury, VT 05826
802-586-2267
www.quilt4cancer.org

Quilt Pink
Meredith Publishing Company
1716 Locust Street
Des Moines, IA 50309
515-284-3575
www.quiltpink.com

The Names Project Foundation
AIDS Memorial Quilt
637 Hoke Street, NW
Atlanta, GA 30318-4314
404-688-5500
www.aidsquilt.org

AIDS Quilt Rhode Island
AIDS Quilt RI
P.O. Box 2591
Newport, RI 02840-0301
401-434-4880
www.aidsquiltri.org

Home of the Brave Quilt
Sandi Carstensen, State Coordinator
P.O. Box 126
Clinton, IA 52732
563-242-7213
www.homeofthebravequilts.com

Freedom Quilts
Betty Nielsen
13637 550th St
Fonda, IA 50540
712-288-5328
www.freedomquilts.net

Quilts of Valor Foundation
Catherine Roberts
P.O. Box 1003
Seaford, DE 19973
302-236-0230
www.qovf.org

Boise Peace Quilt Project
P.O. Box 6469
Boise, ID 83707
www.boisepeacequilt.org

Freedom Quilting Bee
www.ruraldevelopment.org/fqb.html

Agent Orange Quilt of Tears
Henry & Shelia Snyder
P.O. Box 90
Davenport, Florida 33836
863-422-7788
www.agentorangequiltoftears.com

Fibreart for a Cause
www.virginiaspiegel.com

Mennonite Central Committee
21 South 12th Street
P.O. Box 500
Akron, PA, 17501-0500
717-859-1151
1-888-563-4676
www.mcc.org

Project Linus National Headquarters
P.O. Box 5621
Bloomington, IL 61702-5621
309-664-7814
www.projectlinus.org

Quilts, Inc.
7660 Woodway, Suite 550
Houston, TX 77063
713-781-6864
www.quilts.com

Quilts for the Coast
ALB Fabrics
110 Little Nine Road
Morehead City, NC
252-222-0787
www.albfabrics.com

Alzheimer's Art Quilt Initiative
Ami Simms
Mallery Press, Inc.
4206 Sheraton Drive
Flint, MI 48532-3557
1-800-278-4824

Warm Embrace: Lakota Star Quilt Cooperative
Kathleen Kesner, Project Leader
www.warmembrace.org

Prayers and Squares
Prayers & Squares Intl.
3755 Avocado Boulevard, #248
La Mesa, CA 91941
www.prayerquilt.org

The Faith Quilts Project
111 Franklin Street
Allston, MA 02134-1411
617-787-7778
www.faithquilts.org

SILK STAR

Date: ca. 1880 **Maker:** Unknown

Size: 68" x 87" **Owner:** Minnesota Historical Society

The stars on this late nineteenth century quilt are pieced from various solid and patterned silks, placed on a gold silk taffeta background. The quilting along the border is in an oak leaf pattern. Photograph used courtesy of the Minnesota Historical Society, 62.117.2

QUILT HISTORY TIMELINE

1607
Jamestown, Virginia, colony founded

European quilting traditions imported to America by colonists

1619
First slaves brought to British North America at Jamestown

1620
Plymouth, Massachusetts, colony founded

1680
Quilts appear in colonial estates' inventories

1704
Saltonstall quilt made—oldest known surviving quilt

1756–1763
Seven Years' War (French and Indian War)

1775
Pennsylvania Abolitionist Society formed—American Revolution begins

1776
Declaration of Independence

1783
American Revolution ends

1790
Samuel Slater builds first water-powered cotton mill in U.S. at Pawtucket, Rhode Island

1794
Eli Whitney patents cotton gin

1803
United States acquires Louisiana Purchase from France

1804–1806
Lewis and Clark Corps of Discovery Expedition explores land acquired in Louisiana Purchase of 1803

1808
Congress bans importation of slaves

1812–1814 War of 1812

1833
American Anti-Slavery Society formed

Godey's Lady's Book publishes first named quilt pattern: Honeycomb

1835
New styles: block quilts, Star of Bethlehem, album-pieced, and appliqué

1843
Oregon Trail opens

Elias Howe patents sewing machine

1846
Mexican-American War

Baltimore Album quilt style flourishes until mid-1850s

1848
Gold Found at Sutter's Mill, California

Women's Rights Conference held at Seneca Falls, New York

1854
Kansas-Nebraska Act overturns Missouri Compromise

1861
Civil War begins

1862
Women in Mobile, Alabama, auction quilt to raise funds to buy gunboat—one of the first fundraising efforts involving quilts

U.S. Sanitary Commission issues more than 250,000 quilts to Union soldiers

1865
Civil War ends

Reconstruction begins

Thirteenth Amendment outlaws slavery in the United States

1869
National Woman Suffrage Association and American Woman Suffrage Association formed

Wyoming becomes first territory to grant woman suffrage

1870
Fifteenth Amendment grants suffrage rights to men regardless of race, color, or previous servitude

1876
United States Centennial International Exhibition at Philadelphia

George Custer is killed at Little Big Horn Battle, Montana

Telephone invented

Women's Pavilion at the International Exhibition features the work of women as an economic product for the first time

Japanese pavilion inspires quilters

1889
Ladies Art Company publishes one of the first pattern mail-order catalogues

Singer Company introduces first electric sewing machine

1890
United States soldiers massacre Lakota at Wounded Knee, South Dakota, ending warfare between United States and North American Indians

1893
Four-hundredth anniversary of Christopher Columbus's voyage

Columbian Exposition World's Fair in Chicago—Women's Pavilion features more than 100 quilts

1898
Spanish-American War

1908
Henry Ford introduces the Model T

1911
Marie Webster publishes her first quilting pattern, starts quilt kit company

1915
Marie Webster publishes *Quilts: Their Story and How to Make Them*

1917–1918
World War I

Women encouraged to make quilts as a way to save fabric resources during war.

Modern Priscilla magazine publishes Red Cross signature quilt pattern, signature quilts raise funds for war

1920
Nineteenth Amendment grants Woman Suffrage

Mennonite Coordinating Council formed, becomes major distributor of twentieth-century relief quilts

1924
Indian Citizenship Act grants United States citizenship rights, including suffrage, to Native Americans

1929
Great Depression begins when the stock market crashes in October

Kansas City Star begins publishing quilt patterns, becomes one of the enduring series of newspaper quilt patterns

1933
Depression at greatest depth, federal worker programs begin

Century of Progress World's Fair held in Chicago

Sears Roebuck holds Century of Progress quilt contest in conjunction with fair

1941
World War II begins when Pearl Harbor is bombed

Great Depression ends

1945
World War II ends when atomic bombs are dropped at Hiroshima and Nagasaki

1950–1953
Korean War

1954
United States Supreme Court bans segregation in public schools

1955
Rosa Parks refuses to give up her seat on a Montgomery, Alabama, bus, igniting a lengthy bus boycott, one of the first events in the Civil Rights Movement

1959
Alaska and Hawaii become the 49th and 50th states, respectively

1963
Betty Friedan publishes *The Feminine Mystique*, one of the early books associated with the Feminist Movement

1965
President Lyndon Johnson sends first regular U.S. Army troops to Vietnam

Congress enacts the Voting Rights Act, prohibiting discriminatory practices aimed at reducing the African-American vote

1966
Freedom Quilting Bee founded in Alabama to provide jobs for families who lost income by exercising their right to vote

1969
Bonnie Leman begins publishing *Quilter's Newletter Magazine* in Colorado

1970
National Quilting Association formed in Washington, D.C.

1971
Whitney Museum of Art in New York City presents exhibit Abstract Design in American Quilts—for the first time in a major exhibition quilts are presented as works of art

1974
Vietnam War ends

Richard Nixon becomes first president to resign after Watergate scandal compromises his presidency

1976
United States celebrates Bicentennial

Apple I microprocessor is invented

Group quilt projects flourish as communities create Bicentennial quilts

Art quilt

1977
First state-wide quilt guild founded in Utah

1978
Religious Freedom Act protects rights of Native Americans to practice indigenous religions

1979
First Quilt National held in Ohio

Lap Quilting with Georgia Bonesteel becomes one of the first televised quilting programs

1980
Americans are taken hostage in Iran, released more than a year later

American Quilt Study Group formed

1981
First state quilt project begun in Kentucky

American Quilter's Society formed

1984
Boise Peace Quilt Project presents the National Peace Quilt to United States Congress, challenges all 100 senators to sleep under it

Long-arm quilting machines are invented

1987
The Names Project is founded, becomes one of the first activist quilting projects

1989
Caryl Bryer Fallert's quilt Corona II becomes the first machine-quilted quilt to win the AQS Best of Show award, machine quilting becomes accepted at quilt shows nationwide

1990
Indian Arts and Crafts Act ensures that art marketed as Indian is indeed made by Indians

1991
Persian Gulf War

1999
Y2K concerns, new millennia preparations

2001
9/11

Afghanistan War

9/11 Quilters Relief and Memorial Projects

2002
Gee's Bend Quilt Exhibit tours country

2003
Iraq War begins

War quilt relief projects

2005
Hurricane Katrina destroys New Orleans and other towns along the Gulf Coast

Katrina quilt relief projects